The Avant-Garde in Exhibition

The Avant-Garde in Exhibition

New Art in the 20th Century

Bruce Altshuler

Harry N. Abrams, Inc., Publishers

Editor: MARK GREENBERG
Associate Editor: ELLEN ROSEFSKY
Designer: RAYMOND P. HOOPER
Photo Research: UTA HOFFMAN

Library of Congress Cataloging-in-Publication Data

Altshuler, Bruce.
The Avant-Garde in exhibition: new art in the 20th century / Bruce Altshuler.
p. cm.
Includes bibliographical references and index.
ISBN 0-8109-3637-2
1. Avant-garde (Aesthetics)—History—20th century—Exhibitions—
History. 2. Art, Modern—20th century—Exhibitions—History.
I. Title.
N6490.A612 1994
709'.04—dc20 93-34281

Text copyright © 1994 Bruce Altshuler
Illustrations copyright © 1994 Harry N. Abrams, Inc.

Published in 1994 by Harry N. Abrams, Incorporated, New York
A Times Mirror Company

ERRATA

Illustration Copyrights

*Because of the nature of the illustrations in this book (documentaries and installation photographs),
the copyrights are indicated by the artists's names:*

Acknowledgments

It was while working in the Zabriskie Gallery on Surrealism and on the *Nouveaux Réalistes* that I began to look seriously at avant-garde exhibitions, and Virginia Zabriskie has remained an inspiration in her unique way of combining intellectual curiosity with a joyful love of art. At Zabriskie I first saw how these exhibitions bring together so much that is important to understanding the art of our time, and this project originated there in discussions with Ann LaPides. From that germinal point the intrinsic interest of the material carried my research along, a process enriched by the opportunity to speak or correspond with some of those involved in the events that I relate: Alcopley, Arman, Robert Barry, Grace Borgenicht, John Cage, Nicholas Carone, Leo Castelli, Herman Cherry, Enrico Donati, Michael Goldberg, Douglas Huebler, Allan Kaprow, Joseph Kosuth, Gary Kuehn, Katherine Kuh, Conrad Marca-Relli, Kynaston McShine, Phillip Pavia, Pat Passlof, Adrian Piper, Milton Resnick, Connie Reyes, Corinne Robins, Sal Romano, Joop Sanders, Irving Sandler, Martica Sawin, Seth Siegelaub, Harald Szeemann, Esteban Vicente, and Lawrence Weiner. I very much appreciate their time and assistance, as well as their candid remarks.

I also must thank those who so often helped me to find obscure texts along with basic sources, especially Clive Phillpot and his staff at the Museum of Modern Art Library. Even without such strong research support, being able to walk from a beautiful reading room into galleries containing so much of the art that I was studying would have been an incredible experience. With their support I found myself in an ideal situation, one enhanced by the many suggestions from scholars met around card catalogue and Xerox machine.

Throughout this project I have been graced with the encouragement and confidence of my agent Ruth Nathan. Along with my editor Mark Greenberg and picture editor Uta Hoffmann, she has worked long and hard to make this book possible. I thank them for their efforts in bringing this all to fruition.

Finally, I am grateful for the friends and family who have accompanied me through the writing of this book. Curious about my progress and encouraging about my work, they have been a source of strength throughout a long process. Although there are many others, I especially want to thank Caroline Bynum, Paul Cohen, Susan Linfield, Max Rudin, and Amy Wolf, all of whom, at one time or another, had the right word to say. Most of all I thank Holly Hughes, whose intelligence, emotional support, and companionship have been critical to my research and writing. She has done the most to push me toward a clear view of art, artists, and the dynamics of the art world, and this book has profited immeasurably from her insight and from her good sense.

CONTENTS

Introduction

". . . I do not consider myself to be an artist of the avant-garde. I wish to make clear quite the contrary, that I think and believe myself to be a classic, perhaps even one of the rare classics of the century." Yves Klein, 1959[1]

Like many remarks from the advanced guard of our time, Yves Klein's words cannot be taken literally. Certainly the object of his comment, the exhibition of an empty gallery, displayed the purity of conception and clarity of execution of historic French classicism. But more significantly, his was the classic mode of the artist in the twentieth century—the artist as avant-gardist. From his first work, mentally signing the back of the sky above Nice, to the actions for which he is better known—painting with naked "living brushes" and with fire, creating and selling "zones of immaterial sensibility"—Klein sought to take the next step in a long line of artistic innovation. Even his denial of the term was an attempt to remain avant-garde in the face of increasing bourgeois demand for the new. For as the consummate avant-gardist he repudiated the accepted art of his time, no matter how advanced it claimed to be.

But Klein did not work in isolation, and an equally important aspect of his avant-gardism was its social character.[2] Art is made by individuals, and working alone, individuals can create radical pieces that subvert cultural and political assumptions. Yet without a community of acceptance—and rejection—such art remains irrelevant to the history of the avant-garde. The story of the avant-garde is that of mutual support among a community and reception of art by a public, all participants enmeshed in systems of personal and economic relations. Its manifestos were those of movements, and its force depended on confrontation with a complex social world. The central node of that confrontation was the exhibition, where artists, critics, dealers, collectors, and the general public met and responded in their various ways to what the artists had done. Group exhibitions bring this social aspect to the fore, and such shows will be my focus here, events that played a critical role in presenting what has come down to us as the historical avant-garde.

These exhibitions trace one path through the artistic modernism of our century, for the history of the avant-garde is the history of modernism, whose conditions and assumptions created the structure of its unruly child. Stemming from the Enlightenment faith in scientific progress, and grounded in its utopianism, cultural modernism moved through a succession of revolutions analogous to those of scientific advance itself. The engine of that change was avant-garde activity, motivated by a heady mix of conviction and anxiety, and fueled by a growing market for new and novel cultural products.[3] The steps were hardly inevitable, and only as presented by high modernist retrospection does the progression appear linear—as in Alfred Barr, Jr.'s classic installation of the Museum of Modern Art, or in Clement Greenberg's brilliant, if procrustean, theorizing. But its critical moments were governed by values inherent in the modernist enterprise, tenets that defined the avant-garde itself.

One of these was the claim to radical originality, and the concomitant rejection of what had gone before—the urge that lay behind Ezra Pound's exhortation, "Make it new." Supported by the needs of the cultural marketplace, and reinforced by personal ambition and psychological impulse, the call for new beginnings was central to avant-garde activity. Yet it also involved the Romantic quest for a pure state, uncontaminated by history and artifice, from which fundamental concerns could be directly

addressed. These fundamentals crisscrossed the spectrum of human endeavor, from the aesthetic to the political, from the transcendental to the technological. And for the artists of the avant-garde, these issues could be faced only with old slates wiped clean.

The avant-garde could maintain its oppositional stance just so long as it kept a decent distance from the dominant cultural and economic institutions. But with burgeoning middle-class prosperity after the Second World War, and the consequent expansion of cultural interest and support, that gap began inevitably to close. Ironically, this period of growth generated a profusion of avant-garde activity at the same time as it developed the cultural system that would quell the disorder. This book therefore naturally divides into two parts, those classic presentations of the avant-garde before World War II, and postwar exhibitions that suggest the diverse ways in which advanced art was integrated into the dominant culture at an increasing pace. Transition is provided by the Nazi exhibition of "Degenerate Art," an anti-avant-garde avant-garde show whose attendance exceeded any exhibition of the century, and the movement of European vanguard artists to New York, breeding ground of an art world that would subvert the subverters. I end with an exhibition of work that consciously sought to oppose the rising commercialization of art during the sixties, Harald Szeemann's great show of conceptual art, earth art, and sculpture of ephemeral material and process. But that exhibition was sponsored by a major international corporation, a circumstance symbolic of the fate of advanced art in our own time.

By the late sixties vanguard artists themselves were skeptical of the continued existence of an avant-garde. In 1967 Barbara Rose and Irving Sandler published the results of a large survey that they had conducted among New York artists. Responding to the question "Is there an avant-garde today?" most of these artists answered "No."[4] In addition to the impossibility of shocking the middle class, always a desideratum of the historical avant-garde, an artistic underground seemed untenable because there was no escaping media attention and the public's voracious appetite for the new. This immediate press coverage was much talked about at the time, since the notion of an advanced guard required being ahead of something, and in the sixties things appeared to be known and accepted from the moment of their creation. As John Ashbery put it in 1968, "Today the avant-garde has come full circle—the artist who wants to experiment is again faced with what seems like a dead end, except that instead of creating in a vacuum he is now at the center of a cheering mob."[5]

For some, like Harold Rosenberg, this situation, and the attendant lack of oppositional content, meant the death of the avant-garde.[6] And considered as part of the history of modernism, the avant-garde seems to have disappeared with the arrival of the cultural, social, and economic changes that together have been designated "postmodern." Judging by verbal practice, today young artists do not even use the term, burdened as it is with such notions as complete originality and faith in artistic progress. But the avant-garde has had a long history, and the diversity of its manifestations defy simple generalization. To find the spirit of this phenomenon, we must look at the many scenes of its introduction, the confluence of artistic practice, aesthetic theorizing, promotional skill, business acumen, and sheer energy that was the avant-garde exhibition.

CHAPTER 1 *Wild Beasts Caged*
The Salon d'Automne, Paris, 1905

In Paris before World War I, the greatest public outcry in the face of developing modernism arose at the huge public exhibitions of advanced art, the Salon des Indépendants and the Salon d'Automne. Established to provide a venue for painting unacceptable at the two official salons, the Salon des Artistes Français and the Salon de la Nationale, the progressive salons continued the tradition of large alternative exhibitions begun by the Impressionists during the 1860s and 70s. For by 1884, with the creation of the Indépendants by Redon, Seurat, and Signac, the French cultural establishment could no longer prevent an annual exhibition of the newest painting. With its motto of "No Jury, No Prizes," the Indépendants, held every May to exhibit work done over the winter, would be the site of the first grand presentation to the public of that paradigm of modern art, Cubism. But the initial bourgeois outburst of the century occurred at the new autumn salon, with its concentration in one room of the "wild beasts," the Fauves.

Established in 1903, the Salon d'Automne was headed by the architect Frantz Jourdain, designer of the landmark department store Samaritaine. Although a supporter of the Fauves early on, he soon became a conservative force, often to be ridiculed by Apollinaire in his role as apostle for the new painting.[1] The autumn salon was created so as to limit the unconstrained proliferation of art in the juryless Indépendants, while remaining a progressive venue without conservative prejudice. To this end there was to be a jury chosen by lot among the members. The Salon d'Automne also was distinguished by its retrospectives of modern masters, the first salon in 1903 mounting a large exhibition of Gauguin, who had recently died in the Marquesas. It opened on October 31, in the basement of the Petit Palais, to a fashionable crowd that included Marcel Proust. When this site was unavailable the next year, the new director of the Ecole des Beaux-Arts, Henri Marcel, shocked the establishment by giving the salon the use of the Grand Palais, previously reserved for the conservative Salon des Artistes Français.

Here the Fauves made their group debut at the third Salon d'Automne, held October 18 through November 25, 1905, and it was here that they were named. The occasion was the entry of the critic Louis Vauxcelles into Room VII, where he is said to have exclaimed, "Well, Donatello among the wild beasts" ("Donatello au milieu des Fauves").[2] His reference was to the Italianate sculptures of Albert Marque, surrounded by the striking paintings of Matisse, Derain, Vlaminck, Marquet, Manguin, and Camoin. Vauxcelles repeated this remark in print in his review of the salon in *Gil Blas*, and over the next two years the term *Fauve* came to characterize these painters of radically heightened color. It has been suggested that Vauxcelles was prompted by the proximity of Rousseau's *Lion Devouring an Antelope*, a work that provoked derision as strong as that heaped on the Fauves, or even by the sight of Matisse's hairy overcoat, but certainly it was the aggressive color and expressive drawing that made the name stick.[3] Even before their naming, however, salon officials knew of the challenge that would confront the public, and in the catalogue introduction Elie Faure appealed for tolerance: "To put ourselves in contact with the young generation of artists we must be free to hear and willing to understand an absolutely new language. Listen to them, these primitives."[4]

Maurice de Vlaminck. Portrait of Derain, *1905. Oil on cardboard, 10⅝ x 8¾ in. The Jacques and Natasha Gelman Collection*

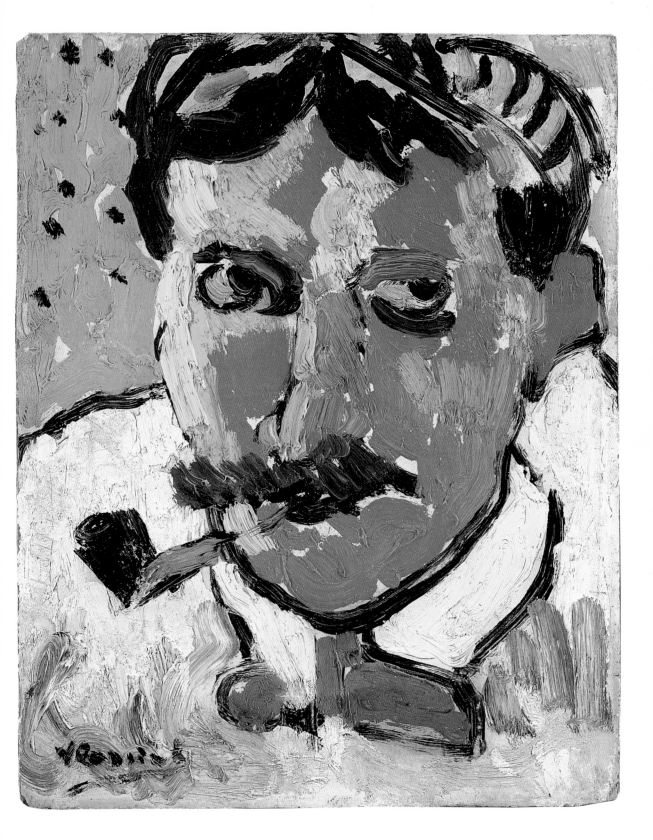

II

Vauxcelles also spoke of this public as wild beasts, as *fauves*, who would attack the canvases of Matisse as the animals of the Roman Circus had ripped into Christian virgins.[5] For contrary to common belief, the Fauves were not named by someone critical of their work but by one of the strongest early supporters of advanced art. The critic had hailed "our young victors of the Salon d'Automne" on the occasion of their group exhibition at Berthe Weill's gallery, which opened a few days after the salon; and of the Indépendants the previous spring he reported, "we possess today a luxuriant generation of young painters, daring to the point of excess, honest draftsmen, powerful colorists, from whom will arise the masters of tomorrow."[6]

This mention of luxury alludes to Matisse's early masterwork, *Luxe, calme et volupté*, displayed at the 1905 Indépendants and immediately acquired by the president of that salon, Paul Signac. The picture was painted following the summer Matisse had spent near Signac and Henri-Edmond Cross in Saint Tropez, a time of intense work as he engaged their divisionist style. After the salon Signac quickly shipped the painting off to his Mediterranean villa, La Hune, where it would hang in the dining room for the next forty years. It was this work that converted Raoul Dufy to the developing Fauvist movement: "I understood the new raison d'être of painting, and impressionist realism lost its charm for me as I beheld this miracle of the creative imagination at play, in color and drawing."[7] The new school of color was born, and as van Gogh predicted, it was born in the South.

The 1905 Salon des Indépendants included all of the Fauves-to-be except Braque. Matisse was in charge of the hanging of the show, assisted by Albert Marquet, Henri Manguin, Jean Puy, and Charles Camoin. He encouraged his colleagues from Chatou—André Derain and Maurice de Vlaminck—to submit paintings, and each sold work. (In a typical irony of the time, their pieces were purchased by a bourgeois from Le Havre, Ernest Siegfried, who wanted to give his son-in-law the worst examples of modern art that he could find.[8]) Including significant displays of Seurat and van Gogh—the former a model of divisionist technique and the latter of expressionist color, both critical in the development of Fauvism—the 1905 Indépendants was attacked by the critic Morice for the dominance of "pointillistes and confettistes".[9] It might have elicited the kind of public outcry greeting the Salon d'Automne five months later, but the work of the Fauves was dispersed in an exhibition of 4,269 pieces by 669 artists.[10] During the fall things were arranged quite differently.

It was Georges Desvallières, a vice-president of the Salon d'Automne, who decided to concentrate these provocative, highly colored paintings in a single room, which came to be known as the *cage centrale*. He was a friend of Matisse's from the studio of Gustave Moreau at the Ecole des Beaux-Arts, where they had studied in the 1890s, along with Marquet, Manguin, Camoin, and Georges Rouault. Moreau taught self-expression as the goal of art, and he encouraged his students to look at new work in the galleries and advanced salons, as well as to study the still unaccepted Impressionists at the Luxembourg Museum. Although Desvallières was one of the more conservative of the Moreau students, he had learned his modern lessons well, and he recognized that what had been accomplished by some of his former colleagues should be shown as a whole. It was this decision that focused attention on the Fauves, for while the autumn salon in 1905 was much smaller than the Indépendants, it was still an immense exhibition.

In all there were 1,625 works by 397 painters at the Grand Palais that October–November.[11] The large retrospectives were devoted to Ingres and to Manet, and across the exhibition could be seen work by artists whose names span the history of the early modern—Renoir, Bonnard, Vuillard, Nadelman, Villon, Duchamp-

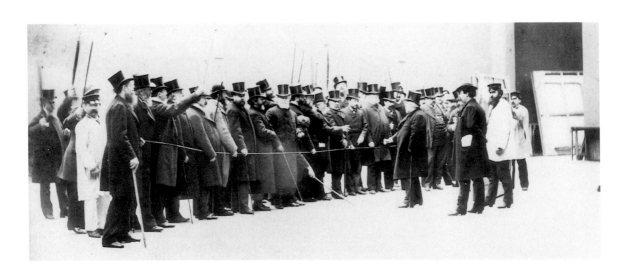

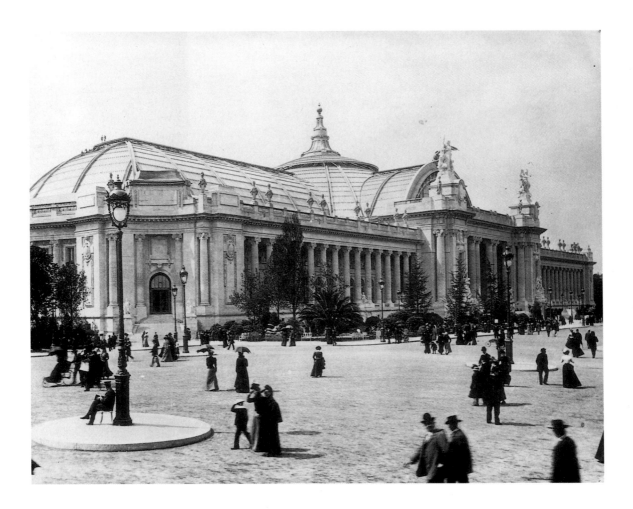

Villon, Picabia, Jawlensky, and Kandinsky. There also were ten paintings by Cézanne, whose work Matisse had studied closely since purchasing his small painting of three bathers in 1899 from Vollard, and whom Camoin had befriended on his visits to the south for military service. But the public would not get a full sense of Cézanne's achievement until the great retrospectives after his death, held at the Salon d'Automne and the Galerie Bernheim-Jeune in 1907.

The 1905 Salon d'Automne actually displayed the Fauves in more than one place, though their naming in *Gil Blas* and the concentration in Room VII fixed attention on that gallery. There, along with Matisse, was the work of André Derain, Maurice de Vlaminck, Albert Marquet, Henri Manguin, and Charles Camoin. While Room VII also included artists not associated with Fauvism—Ramon Pichot and a Girieud—the impression upon entering must have been dominated by the intense coloration and nontraditional drawing of the most radical selections. Much as this painting might appear to us now as somewhat decorative, in 1905 it had a wild look for a public that still rejected van Gogh and a great deal of Postimpressionism. Of the other artists who would be associated with the movement, Othon Friesz was in Room VI, Georges Rouault in Room XVI, Jean Puy in Room III, Louis Valtat in Room XV, with Kees van Dongen somewhere in an unidentified location.[12] Neither Dufy nor Braque exhibited in this salon, though Dufy was in the concurrent group Fauve show at Berthe Weill's (October 21–November 20), and Braque would first exhibit with the others at the 1906 Indépendants.

Room VII must have been overwhelming for those unaccustomed to such artistic license, especially given the number of pictures that were hung there. Matisse exhibited the most, eight paintings and two watercolors, many from the previous summer in Collioure on the Mediterranean, where he had worked with Derain. Most of Derain's nine entries—five painting and four pastels—were done there as well. Vlaminck showed five works painted around Chatou, not yet in his most intense Fauve manner, which he would develop by the next spring. The same number of works—landscapes and seascapes for the most part done near Saint Tropez during the summer—were contributed by Marquet, Manguin, and Camoin. This is about the number of works shown in the other rooms by Friesz, Rouault, Puy, and Valtat, with van Dongen exhibiting only two pieces.[13]

While it was a standard bourgeois activity to visit the progressive salons in order to ridicule the new art, the public response in the *cage centrale* was extreme. Both laughter and indignation greeted this apparent mockery of established standards, the display being too much even for many earlier supporters of advanced painting. Reaction was particularly strong before Matisse's *The Woman with the Hat*, a portrait of his wife—who ran a hat shop on the rue de Châteaudun—done after returning to Paris from the south. Leo Stein, despite first believing it "the ugliest smear he had ever seen," bought the painting with his sister Gertrude for 500 francs (just over $100). He recounts how the crowd "howled and jeered" and says that the response was such that Matisse visited the exhibition only once, while his wife would not come at all. Gertrude Stein had her own point of view, of course: "People were roaring with laughter at the picture and scratching at it. Gertrude Stein could not understand why, the picture seemed to her perfectly natural."[14] *The Woman with the Hat* was especially worrisome to Jourdain even before the salon, and he had urged the jury to reject it. But it was accepted, along with the bright view out on the harbor of Collioure, *The Open Window*, and his small yet intense image of Madame Matisse in a Japanese kimono.

It was at Collioure during the previous summer that Matisse and Derain painted together and developed their full Fauvist styles. The Fauves often worked in

Henri Matisse. The Woman with the Hat, *1905. Oil on canvas, 31¾ x 23½ in. San Francisco Museum of Modern Art, Bequest of Elise S. Haas*

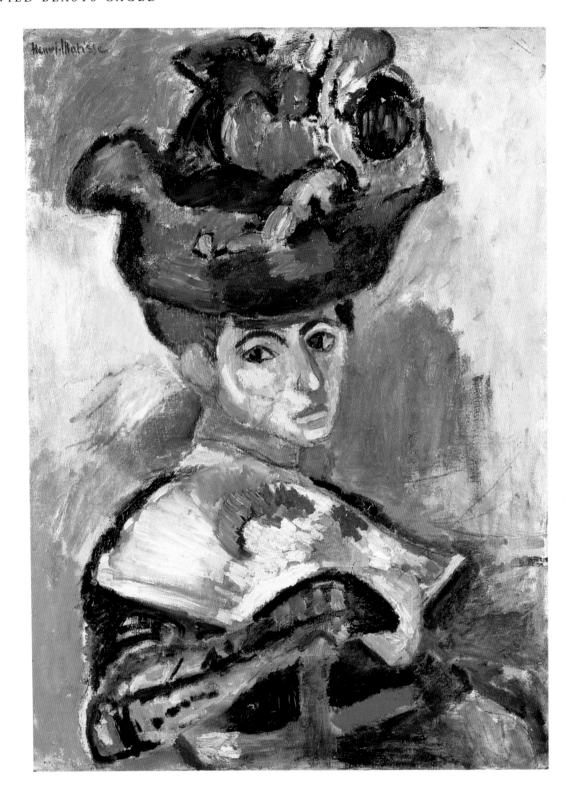

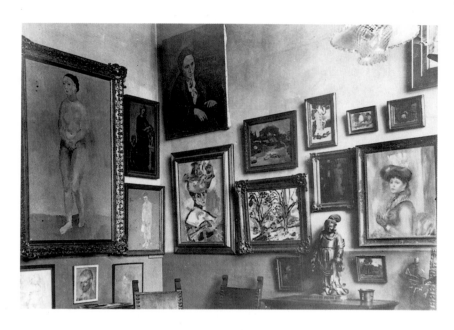

pairs—Matisse and Marquet at 19 Quai de Saint-Michel in Paris, Derain and
Vlaminck on the Isle of Chatou in the Seine, Dufy and Marquet around Le Havre,
Friesz and Braque in Antwerp. But this summer collaboration, reported by Derain in
his frequent letters to Vlaminck, seems in retrospect to have been the most important,
and it generated the most vibrant paintings in the autumn salon. Both theoretically
minded artists, Matisse and Derain constantly discussed their work as they painted
side by side in this town south of Perpignan near Spain. For additional stimulation
they were able to study the late Tahitian work of Gauguin, which was stored nearby in
the home of Georges-Daniel de Monfreid pending settlement of the artist's estate.

Derain observed Matisse's agitation as he moved from his divisionism to a
more expressionist phase of dramatic, expansive color, much as Henri-Edmond Cross
the summer before had described "Matisse the anxious, the madly anxious."[15] Anxiety
is something not ordinarily associated with Matisse, but in these years of radical
innovation the former lawyer was far from the "good armchair" that he later sought as
the end of his painting: ". . . we wanted to go directly to our needs for expression. The
artist, encumbered with all the techniques of the past and present, asked himself:
'What do I want?' This was the dominating anxiety of Fauvism." Motivated by the
avant-gardist ideal of wiping the slate clean, of starting completely anew, he marshaled
"the courage to return to the purity of means" that he later identified as the beginning
of Fauvism.[16] In October 1905, such courage also was needed to face the critics who
converged on the *cage centrale*.[17]

With rough brushwork many of these paintings expressed the direct
emotional contact with the seaside that was extolled by modern tourism in its flight
from urban artifice, but antagonistic critics believed them to be products of either
lunacy or farce.[18] Jean-Baptiste Hall wrote that Room VII was the site of "pictorial
aberration, chromatic madness, and the fantasies of men who, if they were not so
obviously jokers, would deserve the Spartan regime of the Ecole des Beaux-Arts." In
the *Journal de Rouen*, Marcel Nicole reported: "All attempts at description, judgment
or criticism are defeated. What we see—apart from the materials used—has nothing
to do with painting. Formless streaks of blue, red, yellow and green, all mixed up,

splashes of raw color juxtaposed without rhyme or reason, the naïf and brutal efforts of a child playing with its paint-box. . . . [This work] is either raving madness or a bad joke."[19] Camille Mauclair, who recently had completed a study of Whistler, applied Ruskin's comment on that artist to the Fauves, calling the display "a pot of colors flung in the face of the public"; and, in reviewing the 1906 Salon d'Automne, he recalled "those dozen or so artists [of the previous year] . . . with their pretentious, ignorant, and clownish works. . . ."[20] L'Intransigeant referred to the artists as the Incoherents, and François Monod, in Art et Décoration, wrote of their work as "deprivations of sick imaginations."[21]

While Matisse largely was subject to ridicule—one critic suggested that he might just as well have exhibited his palette as these pictures[22]—there were some positive responses other than Vauxcelles's. The most intelligent discussion was that of Maurice Denis in L'Ermitage, which emphasized the ideation and theoretical intention governing Matisse's new work. Denis marked it as "painting outside every contingency, painting in itself, the act of pure painting." And in contrast to the general horror at Matisse's wild coloration and drawing, Denis saw him as too rational and controlled. His view was echoed by André Gide, who had been asked to review the salon for the Gazette des Beaux-Arts: "I listened to the visitors and when I heard them exclaim in front of a Matisse: 'This is madness!' I felt like retorting: 'No, Sir, quite the contrary. It is the result of theories.' Everything can be deduced, explained. . . ."[23]

The conservative journal L'Illustration devoted a special section to the autumn salon in the issue of November 4. On one page were reproduced works associated with the new movement: Matisse's The Woman with the Hat and The Open Window, Manguin's The Siesta, Jean Puy's Lounging Under the Pines, Rouault's Peddlers, Actors, Clowns, a seascape by Louis Valtat, and Derain's The Drying of the Sails. The facing page showed Rousseau's lion and antelope, a Vuillard interior, a Cézanne scene of bathers, and a painting each by Charles Guérin and Alcide le Beau.[24] Accompanying these images were short excerpts of largely negative criticism, including Vauxcelles on Derain: "I believe him to be a poster artist rather than a painter. The parti pris of his virulent imagery, the easy juxtapositions of his complementary colors will seem to some no more than puerile. His paintings of ships, however, would happily decorate the walls of a nursery."[25]

Some of the most mocking comments in the press were reserved for Vlaminck. Maurice Duval in Le Nouvelliste related that he "throws a bowl of lemons, a vase of flowers, and a lot of red dots in a cloud of blue dashes . . . We advise him to let his subjects settle down before trying to paint them." Another critic received a similar impression: "He has thrown little blobs of color at a canvas and called the result La Maison de Mon Père. What are the red blobs? Where is the house? That remains a mystery. But M. de Vlaminck was pleased with his effort, and got some more little blobs of paint and threw them on some other canvases."[26]

Among the Fauves, Maurice de Vlaminck was in appearance and personality the most beastlike. Over six feet tall and close to 190 pounds, Vlaminck had been a champion cyclist. From a musical family, for a living he gave music lessons and played gypsy violin in cafés and dance halls. Although moralistic and somewhat puritanical, Vlaminck was known for his eccentric dress—bowler hat decorated with a jay feather, and waistcoats of yellow suede, purple velvet, or striped mattress ticking—and especially his brightly painted wooden ties, whose uses were described by Apollinaire: "If M. de Vlaminck is in a restaurant and wishes to summon the waiter, he unhooks his cravat . . . and bangs it loudly on the table. If he is in company and wants to organize a dance, he uses his cravat, on the back of which are stretched several lengths

of catgut, as a kind of little violin. . . ."[27]

Vlaminck had become an anarchist while in the army, attending the military retrial of Dreyfus in 1899, and he contributed articles to such left-wing publications as *Le Libertaire*, *L'Anarchie*, and *Fin de Siècle*. He took to painting in a similar spirit: "What I could have done only by throwing a bomb—which would have led to the scaffold—I attempted to realize in art, in painting, by using colors of maximum purity. Thus I satisfied my desire to destroy old conventions, to 'disobey,' in order to recreate a feeling, living, and liberated world."[28] "With my cobalts and vermilions, I wished to burn down the Ecole des Beaux-Arts and to render my impressions without any thought for what has been achieved in the past."[29]

Largely self-taught, Vlaminck had first met his Chatou neighbor André Derain after their train from Paris derailed in June 1900. They soon began painting together, and by September were sharing a studio for 10 francs a month in an old inn on an island in the Seine, near where Renoir in 1881 had painted the Impressionist icon *Luncheon of the Boating Party*. Eventually Vlaminck came to paint with colors squeezed straight from the tube; and when Derain introduced him to Matisse at the important van Gogh exhibition at the Galerie Bernheim-Jeune in March 1901, Vlaminck was expounding the virtues of pure colors. Van Gogh's expressive use of color was critical in the development of many of the Fauves, but Vlaminck's reaction was perhaps the most impassioned: "I was so moved that I wanted to cry with joy and despair. On that day I loved van Gogh more than I loved my father."[30] For Vlaminck, more than any of the others, "Fauvism was not an invention, an attitude, but a way of being, acting, thinking, and breathing."[31]

Although Derain and Vlaminck sold paintings at the 1905 salons—Vlaminck's proceeds from the Salon d'Automne covered the expenses of his third daughter's birth—this success paled before their good fortune with the dealer Ambroise Vollard. The role of the art dealers in Paris paralleled that of the salons, exhibiting the work of the founders of modern painting—the Impressionists, Gauguin, van Gogh, Cézanne—and providing what support could be generated by sales. But gallery exhibitions were more frequent, and the young painters of Paris were able to feed at least on a regular diet of the new art. And around 1905–1906 things began to pay off for some. In February 1905 Vollard visited Derain's studio on the advice of Matisse, and acquired eighty paintings for 2,000 francs. He also sent Derain to London to paint the Thames, attempting to duplicate Durand-Ruel's success four years earlier when he showed Monet's London paintings.[32] Derain's bourgeois father, who ran a pastry shop in Chatou, was so impressed that he decided to give his son an allowance for his painting, which now seemed a good investment. In the spring of 1906 Vollard visited Vlaminck and purchased 300 paintings for 6,000 francs, offering to buy his future output. Vlaminck stopped giving music lessons, took his family out of their Nanterre tenement, and moved to a house in the woods at Jochere.[33]

In addition to Vollard, the other important dealer of the Fauves was Berthe Weill. Beginning in February 1902 with her exhibition of the students of Gustave Moreau, including Matisse and Marquet, she continued to show many of these "wild beasts," alone and in groups. Between these two dealers there were many exhibitions leading toward the 1905 salons: At Weill's there was Dufy in February 1903, Matisse and Marquet again in May, and in April 1904 a large group show including Matisse, Marquet, Manguin, Camoin, and Puy, along with two Dufy exhibitions that year. And at Vollard's Matisse had his first one-person exhibition in June 1904, with van Dongen showing in November.[34] Despite this exposure in the galleries and at the salons, however, it took Desvallières's decision to hang the Fauves together in a single room to bring them, happily or unhappily, to a broader public. And in the fall of 1905

André Derain. Portrait of Matisse, *1905. Oil on canvas, 18⅛ x 13¾ in. Musée Matisse, Nice. During their summer of painting together in Collioure, Derain captured the intensity of the Fauvist Matisse. Here Matisse appears as described the previous summer by Henri-Edmond Cross: "Matisse the anxious, the madly anxious."*

opposite:
Albert Marquet. Matisse Painting in Manguin's Studio, *1905. Oil on cardboard, 39⅜ x 28¾ in. Musée National d'Art Moderne, Centre Georges Pompidou, Paris*

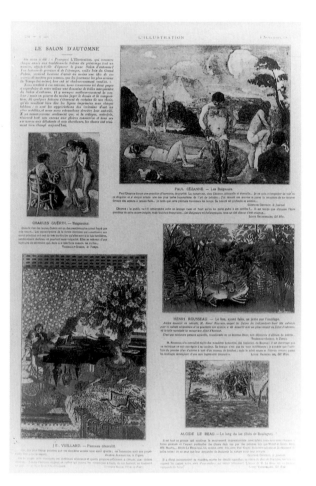

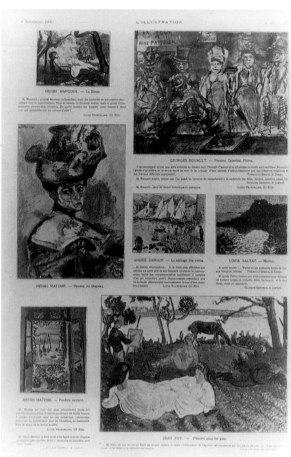

Special section of the journal
Illustration, *November 4, 1905,*
devoted to the Salon d'Automne

their current work could be seen in depth outside the Salon d'Automne, at Berthe Weill's group exhibition of Matisse, Derain, Vlaminck, Manguin, Marquet, Camoin, dominated in number of paintings by her favorite, Dufy, and in Kees van Dongen's one-person exhibition at the Galerie E. Druet.[35]

By the 1906 Salon d'Automne, the term *Fauve* was in wide use, but as a general phenomenon Fauvism would last only through 1907. It had been a special and intense moment, an "ordeal of fire" according to Derain, untenable for the long run but of great yield in the short. For by the time that the Fauves went their separate ways, they had secured for modern painting the full autonomy of color wrested from nature by Postimpressionism. Except for Vlaminck, all of the artists had trained in the academies, and in 1905 those showing at the Fauve salon ranged in age from Derain, twenty-five, to Matisse, thirty-six.[36] After Fauvism they were to continue their careers, becoming something of an establishment, influential in the Parisian art world and successfully selling work in an expanding market.

By the end of 1906 they also had brought African art into advanced French painting. Vlaminck discovered three pieces in a bistro in Argenteuil following hours of painting outdoors, and purchased them with a round of drinks for the house. After acquiring some more from a family friend, he sold a persistent Derain the large Fang mask that would be admired by Matisse and Picasso in his studio. Matisse began his own African collection with a small statue purchased on the rue de Rennes, reportedly showing it to Picasso that day at Gertrude Stein's.[37] Picasso's assimilation of this powerful source would emerge fully in 1907, and its connection with Fauvism jumps out from the pages of a remarkable article published in New York. The American painter Gelett Burgess conducted a series of interviews in 1908–1909, printed with photographs of the artists and their work as "The Wild Men of Paris" in the *Architectural Record* of May 1910. In discussions with Matisse, Derain, Friesz, Picasso, Metzinger, Herbin, and the Hungarian Béla Czobel, he sought the rationale for the "ugly" painting that shocked him at the Indépendants. Derain is shown holding one of his small carved sculptures, next to a larger stone work and an African piece on the floor. Picasso sits before African sculpture hanging on his studio wall. And Braque appears in standard pose, above a primitivist drawing of three women.[38]

Braque converted to Fauvism after seeing the paintings of Matisse and Derain in the 1905 Salon d'Automne, and the next summer he went off to Antwerp to paint with Friesz, his friend from Le Havre. Younger than the others—Braque was twenty-three in 1905—in a strange way he would signal the closure of the movement. Although Cézanne was important to many of the Fauves, it was Braque who would make the most radical moves under his influence, first in the fall of 1906 and especially after seeing the great 1907 retrospectives. Yet when he submitted his landscapes of L'Estaque for the 1908 Salon d'Automne, they were rejected. The jury was composed of Matisse, Marquet, and Rouault, and afterward Matisse complained to Vauxcelles of Braque's "petit cubes." Braque withdrew his pictures and exhibited them in November at the gallery of Daniel-Henry Kahnweiler. Reviewing that show, Vauxcelles wrote of Braque's reduction "à des cubes" and later spoke of his "bizarreries cubiques" at the 1909 Indépendants.[39] Vauxcelles had christened another movement, one that would greatly overshadow the short-lived flame of the "wild beasts."

CHAPTER 2 Cubism Meets the Public

The Salon des Indépendants
and the Salon d'Automne,
Paris, 1911
The Salon of the Section d'Or,
Paris, 1912

While Louis Vauxcelles might first have spoken of Braque's cubes, for the Parisian art public Cubism meant something very different from the pioneering work of Picasso and Braque that we now celebrate as central to the movement. In the first great exhibition marked as Cubist, Room 41 of the 1911 Indépendants, it was Metzinger, Gleizes, Le Fauconnier, Léger, and Delaunay who were "*les Cubistes.*" With the addition of Juan Gris, the Duchamp brothers, and their associates, the larger group shown at the Salon of the Section d'Or came to represent Cubism. In neither of these exhibitions, nor at major shows in between, were Picasso and Braque to be seen by the general public in France. In Munch, Berlin, Moscow, Amsterdam, London, Prague, Barcelona, and even New York, yes, but not in Paris, the home of Cubism.

In large part the explanation lies with the dealer Daniel-Henry Kahnweiler, whose exclusive arrangements with the two artists discouraged them from salon exhibition in Paris.[1] In this, as in much else, Picasso and Braque were ahead of their time, relying for sales and notoriety on a professional dealer, rather than on the traditional salon venues. After the war the private gallery assumed primacy over the salon system, and by 1925 the poet and critic André Salmon could say that it was no longer necessary to go to the salons to see what was happening in advanced art.[2] When Cubism came before the public, however, all attention was on the salons.

The 1905 Salon d'Automne had demonstrated the effect of concentrating the work of radical artists in a single room. But while the Fauves found themselves exhibited together thanks to the inspired hanging of a salon official, at the 1911 Salon des Indépendants the artists arranged things for themselves. Coming to see one another as part of a blossoming movement, and afraid that their work would remain in obscurity, dispersed across the huge salon, they took matters into their own hands.

Talk of Cubism had been in the air for some time. When the central five artists of the future Cubist salon were hung separately a year before at the 1910 spring Indépendants, Vauxcelles grouped them in his *Gil Blas* review as "ignorant geometers, reducing the human body, the site, to pallid cubes."[3] In May, André Salmon jokingly referred to Léger's work as *tubisme*, which indicates that for those in the know something called *cubisme* had arrived.[4] At the Salon d'Automne of that year the work of Gleizes and Le Fauconnier was put in one room, with that of Metzinger nearby, and the "geometric excesses" of all three were criticized in *La Presse*.[5] But in his review, Guillaume Apollinaire stated that "the cubism at the Salon d'Automne was like a crow in feathers borrowed from a peacock."[6] That peacock was Pablo Picasso.

In 1910 Picasso's work was known to only a few writers and painters,

H. V. G. Le Fauconnier. Abundance, 1910. Oil on canvas, 17¼ x 48⅜ in. Haags Gemeentemuseum, The Hague

although his paintings could be seen privately at Kahnweiler's, and the German collector-dealer Wilhelm Uhde had mounted a small exhibition in May. Apollinaire, lyric poet and energetic promoter of the avant-garde, had been his friend since 1905. His 1910 remarks on Picasso's priority reflect this friendship, but they are ironic for someone who soon was to become the close associate and chief defender of the salon Cubists.

Among these painters in 1910, the only one having any real familiarity with the radical new painting of Picasso and Braque was Jean Metzinger, who also lived in Montmartre and was a longtime friend of Apollinaire. That fall in the journal *Pan*, Metzinger extolled their work in terms that would become central to future discussion of Cubism, characterizing it as a realism that presents a more complete view of the work through a "free, mobile perspective," able to depict "the successive and the simultaneous."[7] Of the other two painters mentioned there by Metzinger, Robert Delaunay and Henri Le Fauconnier, Delaunay must at least have seen the founders' work. For in November 1910 he had married the Russian artist Sonia Terk, after a long relationship that ended her marriage of convenience to Wilhelm Uhde, owner and exhibitor of Picasso and Braque.

Le Fauconnier was not to view Picasso's Cubist painting until September 1911. After visiting the Salon d'Automne, he and Gleizes were taken to a bar by Apollinaire to meet Picasso, who then escorted them to Kahnweiler's gallery to see his pictures. But in 1910 Le Fauconnier already had developed what the public would think of as a Cubist style. Equally important, that fall he began to hold meetings in his studio on the rue Visconti, inviting artists and writers for discussion, and allowing them to follow the progress of his large work *Abundance*, which would be displayed in the 1911 Indépendants.

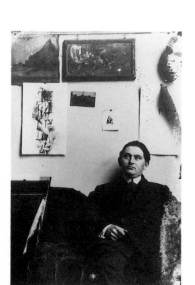

Such group meetings became characteristic of the Cubists who showed in the large Paris exhibitions, and their public discussion of wide-ranging themes of modern life distinguishes them from the more private interactions of the Fauves, and of Picasso and Braque. This sort of collective association finds an important precedent in the Abbaye de Créteil, an artists' commune situated about twenty kilometers southeast of Paris from 1906 to 1908.[8] The founders included Gleizes and Alexandre Mercereau, and the Abbaye was frequented by Roger Allard and the future "caffeine of Europe," F. T. Marinetti. Evoking the social ideals of Tolstoy and William Morris, as well as the small self-sufficient communities of the anarchist Kropotkin, the members of the Abbaye sought to establish a communal life of artistic production. But their gaze was directed outward, to the modern epic themes of the city, labor, and the machine.

Art dealer Daniel-Henry Kahnweiler, under whose influence Picasso and Braque refused to exhibit in the Cubist salons, photographed in Picasso's studio, 1910 or 1911

The Abbaye's Alexandre Mercereau was critical to the developing Cubist movement, and it was at his home in 1909–10 that many of the artists who would exhibit together in the Cubist salons met one another. Called by Marinetti "the Central Electric of European letters," Mercereau had lived in Russia as French editor of the elaborately produced Symbolist review *The Golden Fleece*. He was instrumental in exposing Eastern Europeans to Cubism, exhibiting Derain's proto-Cubist *Bathers* and Braque's *Large Nude* in *The Golden Fleece*'s 1909 Moscow show, assembling French work for the important Knave of Diamonds exhibitions in Moscow in 1910 and 1912 and for Vladimir Izdebsky's first salon in Odessa in 1910, and organizing major avant-garde exhibitions in Budapest in 1913 and Prague in 1914. Within France, Mercereau connected the older generation of Symbolist poets with the younger painters, co-editing the journal *Vers et Prose* with Paul Fort, whose Tuesday evenings at the Closerie des Lilas were a regular meeting place for writers and artists.

It was in the frequent discussions following the 1910 Salon d'Automne that the idea for the first Cubist manifestation developed. Because the salon des Indépen-

dants was not juried, all power lay with the hanging committee, which usually was elected as a matter of course from those proposed by salon officials. But the Cubists decided to elect their own committee, and the meeting on the boulevard Raspail became a battlefield of art politics. The radicals printed a list of alternative candidates, and their posters denounced the old order of Signac and the other officers. Argument lasted far into the night, and, as Gleizes later wrote, "Never had plural voting more honor. One voted, left, and then returned to vote again."[9] In the end the Cubists' candidates were elected by a majority greater than the total number of voters. Le Fauconnier became president of the hanging committee.

Because of publicity surrounding the general meeting, and articles in the press by friends of the painters, the opening of the 1911 Indépendants was a wild event. The Cubist work was displayed in two rooms, numbers 41 and 43, separated by a retrospective of Henri ("Le Douanier") Rousseau, who had died the previous fall. The center of attention was Room 41, and Gleizes recounts what he found at the vernissage about four o'clock on a lovely spring afternoon: "People were packed into our room, shouting, laughing, raging, protesting, giving vent to their feelings in all sorts of ways; there was jostling at the doors to force a way in, there were arguments going on between those who supported our position and those who condemned it."[10]

Among the pictures causing such a stir were Le Fauconnier's monumental depiction of mother and child against the modern countryside, *Abundance*, Léger's "tubist" *Nudes in a Landscape*, Gleizes's fractured interior *Woman with Phlox*, and Delaunay's *Eiffel Tower*, which the critic of *Petit Parisien* described as "toppled over, presumably with an eye to destroying the nearby houses which, dancing a cancan, are rudely sticking their chimney pots into each other's windows."[11] Also appearing in Room 41 were the completely non-Cubist figurative works of Marie Laurencin, included in deference to her companion Apollinaire. While Metzinger's was the only work in the salon that Apollinaire said should properly be called Cubist, the general press reacted otherwise.

From this time on the term *Cubism* entered popular parlance, and was used by critics to attack the new painting. Gabriel Mourey viewed the Cubist room at the 1911 Indépendants as "a return to primitive savagery and barbarity," and Régis Gignoux in *Le Figaro* explained that Cubists "render all their subjects indiscriminately in the form of cubes."[12] By the next winter there was such discussion that *L'Action* published a long "Inquiry on Cubism," canvassing critics and artists for their views. Summing up the conservative reaction, Camille Mauclair judged "these paintings and these theories [to be] the poorest, most ugly, most childish imaginable."[13] Even in the cabarets, the comedians regularly made jokes about the ridiculous *Cubus*.

Guillaume Apollinaire, poet and promoter of Cubism, ca. 1914

Apollinaire soon decided to retreat from his purist interpretation of the term and to apply it more broadly. So when many of the painters from Rooms 41 and 43 were invited to exhibit with the Brussels Society of Independent Artists in June, Apollinaire accepted the title *Cubist* for them in his catalogue introduction. He defended the painters again under this rubric at the Salon d'Automne, a defense all the more necessary as the public outrage was greater at the Grand Palais than it had been on the Cours-la-Reine in the spring.

Since the fall salon was juried, and therefore was thought to represent higher standards than the Indépendants, the exhibition of Cubists in Room VIII seemed even more insulting, and Vauxcelles attacked it as "the sort of art and ideology that would have delighted [Alfred Jarry's] Père Ubu."[14] Although the jury was antagonistic to the Cubists, they appear to have been persuaded by the sculptor Raymond Duchamp-Villon to accept Cubist entries. Their work was displayed together, thanks to the efforts of Duchamp-Villon and Roger de La Fresnaye, whose *Le Cuirassier*, a faceted

Cubist painting caricatured at the 1912 Salon d'Automne in the French press Le Rire, *October 26, 1912*

opposite above:
Fernand Léger. Nudes in a Landscape, *1909–11. Oil on canvas, 48 x 68 in. Rijksmuseum Kröller-Müller, Otterlo, The Netherlands*

opposite below:
Albert Gleizes. Woman with Phlox, *1910. Oil on canvas, 32⅛ x 39⁷⁄₁₆ in. The Museum of Fine Arts, Houston, Gift of Esther Florence Whinery Goodrich Foundation*

military figure based on a Gericault composition, had been shown in Room 43 of the Indépendants. Gleizes describes the opening scene: ". . . unbridled abuse comes up against equally intemperate expressions of admiration; it is a tumult of cries, shouts, bursts of laughter, protests. The artists, painters, sculptors, musicians are there; some of the writers, poets, critics; and that unholy Parisian opening-day mob, in which socialites, genuine art-lovers and picture-dealers jostle one another, along with the dairyman and the concierge who have been given an invitation by the artist who is a customer of theirs or lives in their block. . . . We were accused of the worst intentions, of seeking scandal, of making fun of the public, of trying to get rich quick by milking the snobs; . . . hanging was too good for us."[15]

The exhibition included Metzinger's *Le Goûter*, called by Salmon "The

Illustration in Le Rire, *October 10, 1912*

ENCORE L'ÉCOLE CUBISTE
— Ah ! non ! ma vieille ! pas tous les ans !

Mona Lisa of Cubism," as well as paintings by most of those from Rooms 41 and 43. Conspicuously absent was Delaunay, who had refused to submit work to the Salon d'Automne ever since one of his paintings was rejected by the jury in 1907. But compensating was the appearance in Room VIII of Jacques Villon and Marcel Duchamp, brother of the sculptor, and in Room VII—called by the critic André Warnod "the room of the frenzied colorists"[16]—paintings by Frantisek Kupka and Francis Picabia. For it was the combining of these two groups, the Cubists from the Indépendants and those around the Duchamps, that created the united front that would appear in the Section d'Or.

After the exhibition these two sets of artists, along with their writer friends, began regular meetings in the suburbs of Paris: Sunday afternoons at the studio and garden shared by Villon and Duchamp-Villon in Puteaux, and Mondays in Courbevoie at the studio of Gleizes. It was a varied and lively association, including Gleizes, Metzinger, Le Fauconnier, Léger, the Delaunays, Mercereau, Allard, Apolli-

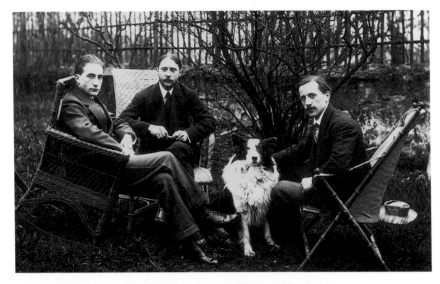

The brothers Duchamp—Marcel Duchamp, Raymond Duchamp-Villon, and Jacques Villon—in their garden in Puteaux, where artists and writers met on Sunday afternoons in 1911–12. Photograph courtesy Alexina Duchamp

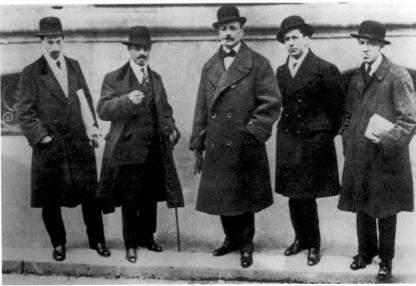

Italian Futurists in Paris in 1912, where their February exhibition challenged the avant-garde status of French Cubism by a radical use of techniques studied four months before on a tour of Parisian studios and the Salon d'Automne: (left to right) Luigi Russolo, Carlo Carrà, F. T. Marinetti, Umberto Boccioni, Gino Severini.

naire, Marie Laurencin, André Salmon, the Duchamp brothers and their sister, Suzanne, Picabia, La Fresnaye, Kupka (whose studio was next door to the Duchamps's), Henri Valensi, André Mare, Alexander Archipenko, and the American Walter Pach. And their discussion encompassed topics as diverse as their work.

One thread stemmed from the days of the Abbaye de Créteil, the role of art in coming to terms with modern life, and with its increasingly fragmented and condensed experience. The faster pace of communication and transportation, of technological and scientific discovery, of political and cultural change, demanded new pictorial expression. Other ideas entered from intellectual areas of general interest— Henri Bergson's notion of perception involving memory of experience over time; the development of non-Euclidean geometries; and talk of the Fourth Dimension, spiritualism, and psychic experience. In fact, when André Salmon announced plans for the Section d'Or in *Gil Blas* in June 1912, he suggested that Bergson would write the catalogue introduction. Unfortunately, the eminent philosopher denied knowledge of, or

sympathy with, the Cubists.[17]

The Duchamps had come from Rouen and, along with Picabia and La Fres-
naye, were members of the Société Normande de Peinture Moderne. They invited
their new associates from the Cubist salon to show with them at the Galerie de l'Art
Contemporain in Paris on the rue Tronchet in November and December, 1911—in
effect a prototype of the Section d'Or—and the combined group again exhibited in
Rouen at the June salon of the Société Normande. Apollinaire lectured at the Novem-
ber exhibition on the Fourth Dimension in contemporary painting, and in the cata-
logue for the Rouen show, Maurice Raynal—who would lecture at the Section
d'Or—saw the artists as working alongside scientists in presenting a view of the world
grounded in the most advanced knowledge. For these artists, painting was to depict
intellectual conception and not visual appearance, encapsulating what is known rather
than what is merely seen.

One idea very much in the air was that of simultaneity, the hallmark of the
Italian Futurists, who declared its expression to be "the intoxicating aim of our art."[18]
It was a commonplace of Cubist criticism that the new painting simultaneously
displayed various perspectives on the same subject, or combined images from disparate
times and places in a single composition. Extrapolating from Bergson's view that per-
ception involves remembered experience, and attempting to present full conceptions
rather than momentary impressions, artists like Delaunay, Metzinger, and Léger cre-
ated pictures synthesizing elements across space and time. The Italians took this
approach and turned it into an aggressive ideology, eventually promoting it in Paris as
an alternative to French Cubism.

Jean Metzinger. Tea Time, *1911.
Oil on wood, 29⅞ x 27⅝ in.
Philadelphia Museum of Art,
The Louise and Walter Arensberg
Collection. This painting, first
exhibited in the 1911 Salon
d'Automne, was called by critic
André Salmon "the Mona Lisa of
Cubism."*

Futurism's central figure was F. T. Marinetti, poet and publicist, whose pri-
mary art form was the manifesto.[19] Marinetti had announced his movement on the
front page of *Le Figaro* on February 20, 1909, his "Foundation and Manifesto of Futur-
ism," calling for an art that would "exalt the aggressive moment, the feverish insomnia,
running, the perilous leap, the cuff, and the blow."[20] Claiming to have received close to
ten thousand responses to this announcement, which he had paid the paper to print,
he embarked on promoting a movement that produced over fifty manifestos by 1915.
In 1911 Marinetti thought that Futurist painting was ready for Paris, and he arranged
an exhibition for December at the Bernheim-Jeune gallery, at that time managed by
the former anarchist and man of letters Félix Fénéon. But when Gino Severini, who
had been painting in Paris since 1906, visited the Milanese artists during the summer,
he found their work retrograde by advanced French standards. Although they had
published a "Technical Manifesto" of Futurist painting in April 1910, the painters—
Umberto Boccioni, Carlo Carrà, Luigi Russolo, and, in Rome, Giacomo Balla—were
working in the sort of divisionist technique long rejected by the Parisian avant-garde.
He suggested that they delay their exhibition, and go to Paris to see the Cubists.
Funded by the wealthy Marinetti, in October they did just that.

Boccioni, Carrà, and according to some accounts, Russolo were guided in
their tour by Severini, who knew the French art scene well. They visited the studios of
Picasso and Braque and attended the Salon d'Automne, where they were able to see the
Cubist work that had come before the public. Their visit was reported in the *Mercure
de France* by Apollinaire, and Picasso brought them to Gertrude Stein, who found
them boring. Fernande Olivier, Picasso's companion, remembered dawn coming to
Marinetti's hotel room after he had been speaking without interruption for ten hours,
and Boccioni wrote to a friend of arguing from seven until three in the morning in a
Left Bank restaurant with Apollinaire and Marinetti.[21]

Returning to Italy, they rushed to modify existing paintings and create new
work for the rescheduled exhibition, to be held February 5–24, 1912, at Bernheim-

Robert Delaunay. Eiffel Tower, *1911. Oil on canvas, 79½ x 54½ in. Solomon R. Guggenheim Museum, New York. Shown in the 1911 Salon des Indépendants, his most famous work was seen by Delaunay to anticipate Futurism, and to depict the collapse of Europe.*

opposite:
Marcel Duchamp. The King and Queen Surrounded by Swift Nudes, *1912. Oil on canvas, 45¼ x 50½ in. Philadelphia Museum of Art, the Louise and Walter Arensberg Collection. Judged by Louis Vauxcelles to be the most offensive work in the Section d'Or, it would travel to the Armory Show in New York, where it would be purchased for $324.*

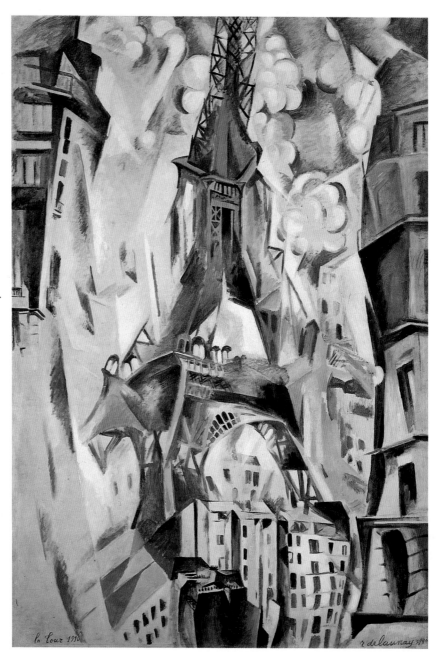

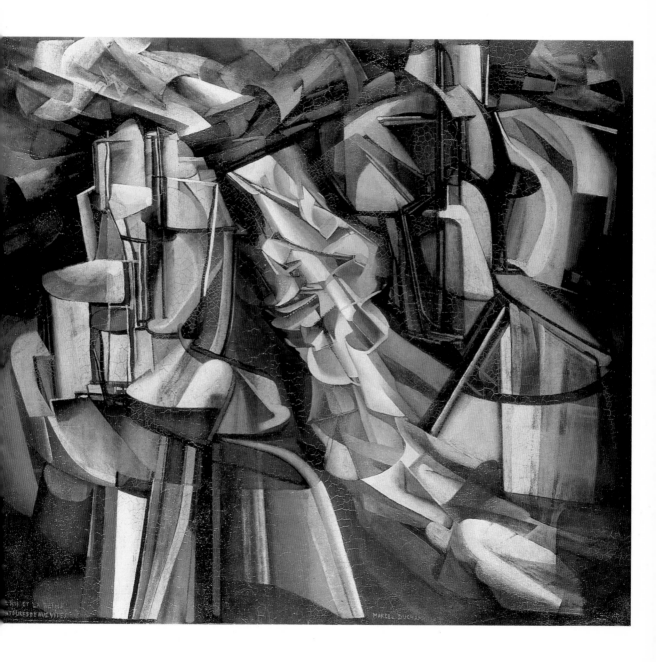

Jeune.[22] It was accompanied by a catalogue containing the earlier "Technical Manifesto"—written long before there were any true Futurist paintings—and a new statement, "The Exhibitors to the Public," in which the Italians accused the Cubists of a "masked academicism," of making paintings closer to the classical past of Poussin, Ingres, and Corot than to an art for the new century. In *Paris-Journal* André Salmon described viewers at the opening: "They were overwhelmed before Russolo's *Memories of Night*; they stamped their feet with rage in front of the *Funeral of the Anarchist Galli* by Carrà; they shrieked in front of *Pan-Pan Dance at the Monico* by Severini."[23]

Friends of the French painters certainly saw their influence on the Futurists, and Oliver-Hourcade remarked, "One would swear that a clever pupil of the Cubists and an ever cleverer pupil of Signac had painted the works in collaboration. . . . Can it be that our hot-headed guests want to burn the museums in order to destroy the evidence?"[24] But the bombastic appearance of the Futurists at Bernheim-Jeune challenged the Cubists, with Apollinaire lecturing on their work twice during the exhibition, and extensive press coverage in New York as well as throughout Europe. In March the show went to London's Sackville Gallery, and in April to the Sturm Gallery in Berlin, where most of the paintings were purchased by a single collector. The exhibition continued to travel through October, going to Brussels, The Hague, Amsterdam, and Munich.

Among those most put off by the Italians was Robert Delaunay, whose painting of the Eiffel Tower in the 1911 Indépendants had been described as Futurist in a review by Allard. Rather than presenting "the immobile, the frozen," as the Italians accused the French of doing, Delaunay's *Eiffel Tower* contained as much "universal dynamism" and "simultaneity" as had been seen in European painting. He later wrote about this work: "Light deforms everything, breaks everything, no more geometry, Europe collapses. Waves of madness (Futurism before the theory); dislocation of the 'successive' object. Planetary waves."[25] In the month following the Futurist show, he responded with his huge *City of Paris*, larger than 8½ x 13 feet, Delaunay's last epic commentary on modern life.

The City of Paris was shown in the 1912 Indépendants, which marked the appearance as well of the Spaniard Juan Gris. Friend and neighbor of Picasso, an illustrator who only had begun painting seriously in 1911, Gris exhibited three works, including his famous *Homage to Picasso*. Roger Allard, whose idea of Cubism centered on Gleizes, marked the newcomer's entries, along with those of Kupka, as "post-Cubist fantasies."[26] Gris would go on to show in the Rouen exhibition and in the Section d'Or before signing with Kahnweiler and thereby removing his work from public display. Gris's highly controlled portrait of his mentor was hung alongside a wild *Improvisation* by Kandinsky, no doubt emphasizing the austerity of his style. It also contrasted sharply with Léger's dreamlike unity of abstraction and Cubist figuration, *The Wedding*, described by a critic as "a conglomeration of soapbubbles which represent, higgledy-piggledy, quarters of faces, an assortment of profiles and of unattached eyes; the whole is sprinkled most harmoniously with breasts, thighs, and stomachs."[27]

The Salon of the Section d'Or seems to have been a response to the Futurist challenge, an attempt to recapitulate the achievements of French Cubism, minus Picasso and Braque, of course. The exhibition displayed more than 185 works by thirty-two artists, many showing a number of pieces in retrospective fashion. Held at the Galerie de la Boétie, October 10–30, it began with an evening vernissage lasting until midnight, something that Paris had not seen since the original opening of the Salon d'Automne in 1903. Preceded by much publicity, and accompanied by a special journal and a series of lectures, the Section d'Or was the last great manifestation of the French avant-garde before the war.

The title for the exhibition referred to the geometrical ratio of "the golden section," used since ancient Egypt in architectural design and the composition of paintings. The name seems to have been proposed by Jacques Villon, who at the time was reading Leonardo da Vinci's *Treatise on Painting*, recently translated into French. Leonardo and the topic of geometrical proportion were being discussed in the Puteaux-Courbevoie group, yet it appears that only Gris actually used the golden section to structure paintings.[28] But the use of this term suggests the relevance to their work of theory—of aesthetic, philosophical, social, and scientific ideas. And in contrast to the rabid tone of the Futurists, the theory it alludes to is classical and rational, and very French.

The *Bulletin de la Section d'Or* published a single issue, opening with a piece by Apollinaire entitled "Young Painters, Don't Get Excited!" ("Jeunes Peintres ne vous frappez pas!"). The front page listed as "Collaborateurs" nineteen writers and critics, including the insurance actuary Maurice Princet, who is credited with teaching the Cubists about non-Euclidean geometry. Maurice Raynal contributed the most extensive article in the eight-page publication, emphasizing the great variety of work included in the exhibition of a movement now so diverse that "the term 'cubism' is day by day losing its significance, if it ever had any very definite one."[29]

The poles of this diversity are seen in the entries of Albert Gleizes and Marcel Duchamp. Gleizes exhibited fifteen works, the earliest from 1908 and culminating in *Harvest Threshing*, at almost 9 x 12 feet one of the largest Cubist paintings. A rural analog of Delaunay's *The City of Paris*, this panoramic landscape celebrates cooperative work, modern agriculture, and village life. Its expression of the epic social impulses of the Mercereau group contrasts with the more intellectualized and hermetic paintings of Duchamp. Gleizes had asked Villon and Duchamp-Villon to have their brother withdraw one of these from the 1912 Indépendants, the notorious *Nude Descending a Staircase, No. 2*. With chagrin, Duchamp did so, but he went on to exhibit the work in Barcelona at the Galeries Dalmau, and after appearing in the Section d'Or, the painting would find its way to greater fame at the Armory Show in New York. Painted just before the Bernheim-Jeune exhibition had displayed the Futurist obsession with representing motion, the work utilized the results of Marey's "chronophotography" and Roentgen's x-rays to produce an image of the moving figure.[30] Duchamp used similar pictorial devices to depict a kind of psychological movement in others of his six works shown in the Section d'Or. One of these, *King and Queen Surrounded by Swift Nudes*, was marked by Vauxcelles as the most offensive of the new Cubist paintings.

The issue of abstraction was an important one at the Section d'Or, as much for what was not shown as for what was. Of the original Cubists from Room 41, both Le Fauconnier and Delaunay refused to participate. Le Fauconnier seems to have been put off by the increasingly abstract character of much advanced painting, and the corresponding move away from narrative content. Delaunay, on the other hand, actually was moving toward complete abstraction, and in an open letter to Vauxcelles in *Gil Blas* of October 25 he denied being a founder of Cubism and disassociated his work from that of "certain young painters" at the Section d'Or.[31] Delaunay would not exhibit his abstract work in France, having developed important foreign connections, beginning with Kandinsky's invitation to show at the first Blaue Reiter show in Munich in December 1911. Paul Klee, who visited Delaunay the next April as he was painting the first of his *Fenêtres* ("Windows"), wrote of them as "the model of the autonomous painting, living without a natural motif, with an entirely abstract plastic existence."[32] *Les Fenêtres* were shown as a group at the Sturm gallery in Berlin in January 1913, the catalogue prefaced by Apollinaire's radical poem of the same title, disjointed and unpunctuated.[33]

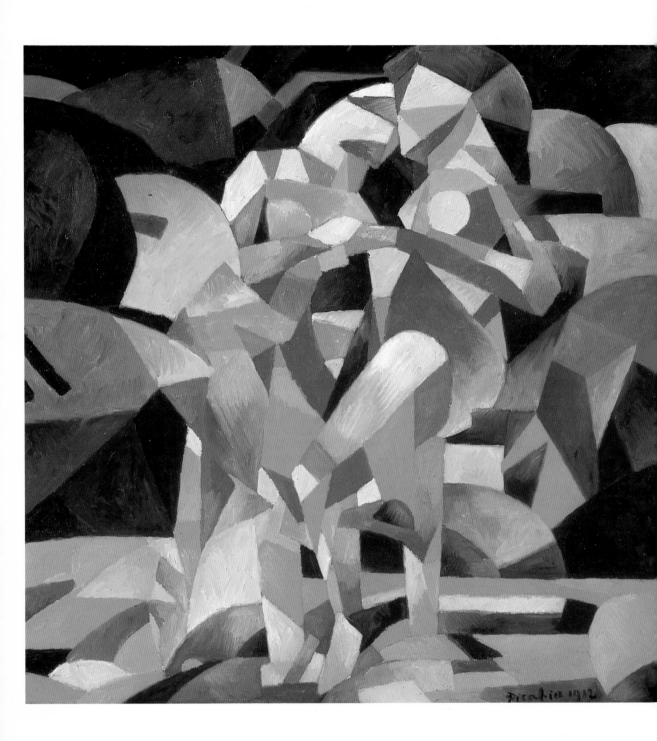

Among the painters of the Section d'Or, Delaunay was particularly annoyed at the attention paid to Picabia, the son of a wealthy Spanish family. Although Delaunay remained close to Apollinaire, who in fact lived with the Delaunays in the fall of 1912 while his own apartment was being renovated, the poet and Picabia had spent much of the summer together. Also a good friend of Marcel Duchamp, with whom he would later become a prime mover of Dada in New York, Picabia was developing an abstract art after a successful career painting Impressionist pictures. In paintings of 1912—such as *Dances at the Spring*, inspired by a peasant dance seen near Naples—Picabia referred to the connection between music and painting that would lead Apollinaire to mark his work, along with that of Delaunay and Henri Valensi, as Orphism. Planning meetings for the Section d'Or were held in Picabia's large apartment on the avenue Charles-Floquet, and it appears that he partially funded the exhibition. Certainly his importance to the group is suggested by the number of his works that were hung in the show—thirteen, second only to Gleizes's fifteen.

Developing the relationship between music and painting came naturally to artists steeped in the Symbolist tradition, as were those of the Section d'Or, who gathered around Paul Fort at the Closerie des Lilas, and, beginning in September 1912, at the monthly dinners of the Artists of Passy in the Place d'Alma. Using color and form as a composer uses notes, even arranging them in nonobjective patterns, the artist was thought to work like a musician, his creations directly affecting the soul of the viewer. Henri Valensi, who dubbed his own painting "Musicalism," exhibited works with such titles as *Rhythm of the Saint-Moscow* and *Harmony on Saint-Yves*. Yet while he argued from the music analogy to the idea of a "pure painting," Valensi's work remained tied to identifiable imagery. It was left to Czech Frantisek Kupka, neighbor of Villon in Puteaux, to make the first break into complete abstraction.

Kupka had been a medium in Vienna and remained a spiritualist in Paris. For him, talk of "simultaneity" suggested an all-inclusive state of consciousness, and the Fourth Dimension was more mystical than geometric. Kupka exhibited two monumental abstractions at the Salon d'Automne just before the Section d'Or opened, *Amorpha, Fugue in Two Colors* and *Amorpha, Hot Chromatic*, described by a critic as "geometrically bizarre, monstrously huge figures."[34] Dwarfing even the largest Cubist painting, one was close to 18 x 18 feet. The poet Nicolas Beauduin remembered Apollinaire presenting his conception of Orphic Cubism—"the art of painting new structures with elements which have not been borrowed from visual reality, but have been entirely created by the artist"—while standing before three canvases by Kupka at the Section d'Or, stressing the connection between painting and music.[35] But despite this account and Kupka's involvement with the other artists in Puteaux, he is neither listed in the catalogue to the exhibition nor mentioned in the published version of Apollinaire's lecture. Delivered on the afternoon of October 11, it was entitled *L'Ecartèlement du Cubisme*—The Quartering, as in drawing-and-quartering, of Cubism. Relating the term to artists as diverse as Fauves and Futurists, it suggests that virtually anything nontraditional could be called Cubist before the war.

The lecture was published in early 1913 in Apollinaire's *The Cubist Painters: Aesthetic Meditations*, a collection of writings on the new art. The book supplemented a growing critical literature on Cubism, joining André Salmon's *The Young French Painting*, with its "Anecdotal History of Cubism," and *Cubism* by Gleizes and Metzinger, the first volume entirely devoted to the subject. Growing out of conversations between the two artists after Metzinger moved to Meudon in the spring of 1912, *Cubism* presents many ideas discussed in the Puteaux-Courbevoie meetings. By 1913 a number of foreign translations had appeared, including English and Russian, exporting their perspective on the new movement. Gleizes and Metzinger begin with

Francis Picabia. Dances at the Spring, 1912. Oil on canvas, 47½ x 47½ in. Philadelphia Museum of Art, the Louise and Walter Arensberg Collection. This painting was inspired by a peasant dance that Picabia had seen near Naples.

Courbet expressing the first modern "yearning for realism," for in all contemporary criticism Cubism was taken to be a species of realism. More suggestively, they move to the view that there are as many ways to depict the world "as there are planes in the domain of meaning."[36]

The Section d'Or demanded such a broad outlook, displaying work that ranged from new experiments by Juan Gris through a Metzinger mini-retrospective to the conservative painting of Pierre Dumont and André Lhote. Gris exhibited twelve works, innovatively identified by numbers instead of titles. In one painting, now known as *Le Lavabo* ("The Washstand"), he placed an actual mirror along with paper elements. Gris thus provoked the first critical reaction to Picasso and Braque's invention of collage, Gustave Kahn's denunciation of such "baroque fantasies" in his *Mercure de France* review.[37] Dumont had been the founder of the Rouen group Les XXX, which became the Société Normande, and he was one of the principal organizers of the Section d'Or. Although continuing to paint Impressionist pictures after he developed a Cubist style, Dumont took Apollinaire's advice and signed his Impressionist works with a pseudonym. Lhote was active in the salons and had exhibited in Room 43 in 1911. But he remained at a distance from Cubist circles and remarked that his only claim to originality was to have never painted a guitar or a tobacco package.[38]

In addition to many other painters—including the Pole Louis Marcoussis (who changed his name from Markous to that of a small village outside of Paris, at Apollinaire's suggestion) and, of course, Fernand Léger and Jacques Villon—the exhibition contained a smattering of sculpture. Alexander Archipenko, who had been making sculpture of Cubist feel since 1909 or 1910 and had shown in the Brussels Indépendants along with the salon Cubists, exhibited a cement figure of a dancer, a work which would appear in New York's Armory Show under the name of *Salome*.[39] While Archipenko would go on to develop more innovative Cubist work, and to break ground with his use of the void as a positive formal element, after the Section d'Or he split with the group. There also were sculptures by the Spanish artist Auguste Agero, friend of Picasso, and by Raymond Duchamp-Villon.

Duchamp-Villon's most ambitious work to this point was the façade of the *Maison Cubiste*, a major element of the 1912 Salon d'Automne.[40] The brainchild of the painter and decorator André Mare, the *Maison Cubiste* displayed both paintings and household furnishings by artists of the Puteaux-Courbevoie circle. With wallpaper and furniture by Mare, woodwork and a clock by La Fresnaye, a coffee set by Jacques Villon, panels by Marie Laurencin, sculpture by Duchamp-Villon, and paintings by Gleizes, Léger, Metzinger, Duchamp, and La Fresnaye, this installation prefigured the better-known experiments in decorative art and design by Robert and Sonia Delaunay in the following years. Due to space limitations, only the first floor of Duchamp-Villon's façade was erected, constructed in pieces at Puteaux by his brothers and friends. Looking more classical than Cubist—and apparently designed using the golden section—the model later found its way to New York and the Armory Show.

Unfortunately, the *Maison Cubiste* was not finished for the vernissage; and, held in contempt by Frantz Jourdain, still president of the Salon d'Automne, the other Cubist works were poorly displayed. As Apollinaire reported, "The Cubists, bunched together at the Salon in a dark room at the far end of the retrospective of portraiture, are no longer being mocked as they were last year. Now they are arousing hatred."[41] That antipathy was political as well as aesthetic and had been simmering under the surface for a while. In 1912 it made its way to the Chamber of Deputies.

After seeing the Salon d'Automne, Pierre Lampué, a senior member of the municipal council of Paris, sent an open letter to the State Under Secretary for Fine Arts, Léon Bérard, published in *Mercure de France* on October 16. He protested the

government's providing a national monument to "a band of renegades who behave in the art world as the Apaches do in everyday life." The matter was raised in the Chamber of Deputies on December 3, when Jules Louis Breton proposed that the Grand Palais be denied to the Salon d'Automne, since such exhibitions ". . . run the risk of compromising our magnificent national heritage. And this is all the worse since it is mostly foreigners who in our national galleries wittingly or unwittingly bring our French art into disrepute."[42] The proposal failed, but it highlights the nationalistic and racist feelings that greeted much of the new art before the war.

Such views were advanced years earlier against the Fauves, as when the conservative Catholic newspaper *L'Action Française* railed on October 28, 1909, "Foreigners and Jews, by whom the Salon d'Automne has let itself be invaded in fantastic numbers, exploit this approach which is in keeping with their barbarian and imperfect souls. . . . When, in one of these brutal canvases, with shrieking colors, where the author reduces things to the level of his impoverished vision . . . you look for the artist's name in the catalogue, nine times out of ten you find the name of a Swiss, a Belgian, an American, a Hungarian or a Finn."[43] By 1912 these feelings had become more widespread, and in *Gil Blas* Vauxcelles published an attack on foreigners exhibiting in the salons, taking over the world of French art: "The Salon d'Automne and the Indépendants have been swarming with Moldo-Wallachians, Germans, Slavs, and Guatemalans. These foreigners are colonizing Montrouge and Vaugirard."[44]

Ironically, a nationalistic response to the Parisian avant-garde was not confined to its critics, for the promoters of the salon Cubists saw them as perpetuating the French tradition of rational order. Roger Allard viewed Cubism as a modern classicism, reviving a tradition lost during Impressionism. Metzinger described Gleizes as combining the logical with the sensual and saw Le Fauconnier's *Abundance* depicting the heroic response to the modern landscape of "men of our race" (despite it being a picture of a mother and child). Olivier-Hourcade took Cubism to be an Idealist art illustrating the "profound truth of race, of a country."[45] The Futurists seem to have been right in accusing these artists of perpetuating the French classical tradition.

Nationalism would receive its just deserts in the war that so radically changed the terms of European political and cultural life. But as the war commenced, advanced artists throughout Europe welcomed the conflagration. In addition to the bellicose Italians, the poets Apollinaire and Blaise Cendrars were enthusiastic. Cendrars, fresh from his collaboration with Sonia Delaunay on "the first simultaneous book"—the six-foot long *La Prose du Transsibérien et de la petite Jehanne de France*—wrote on his way to the front that "this war is a painful delivery, needed to give birth to freedom. It fits me like a glove."[46] Ironically, he was to lose his right arm before the delivery was complete. From Russia Kasimir Malevich echoed the Futurists' paean to war and technology, and in Germany Franz Marc wrote to Kandinsky, "I am not angry at this war; I am grateful for it, from the bottom of my heart. There was no other avenue to the time of the spirit; it was the only way of cleansing the Augean stables of the old Europe."[47] Marc himself was killed in 1916 near Verdun, five years after he had joined Kandinsky to become a messenger of such avant-garde purification in the activities of the Blaue Reiter.

CHAPTER 3

From Almanac to Exhibition
The First Exhibition of the Editors of the *Blaue Reiter*
Munich, 1911

The cleansing that Franz Marc expected the war to bring was a spiritual one. Materialism was the enemy, increasing since the nineteenth century with industrialization and the expansion of the middle class. For Marc and Kandinsky, the "inner necessity" of the artist required spiritual healing, pointing to a source lying beyond boundaries of history and culture. For an artists' almanac they gathered diverse materials suggesting this common ground, and when the politics of art deprived them of an exhibition space, they assembled a show that would encapsulate their radical perspective. The results extended far beyond Munich and the Bavarian countryside where they worked.

Before the war, Munich was the most important center of advanced art after Paris. The first artists' *secession* movement in the German world was established there in 1892, and at the turn of the century Munich was a center of Jugendstil design, a version of Art Nouveau that was an early influence on the members of the Blaue Reiter. It boasted an international artistic community in the district of Schwabing, including Russians and Americans along with artists from the whole of Europe. Writing from the Bauhaus in 1930, Kandinsky remembered this home of his early years as a painter: "Schwabing, that slightly comical, more than slightly eccentric and self-assured place where anyone, man or woman . . . , who was not carrying a palette or a canvas or at the very least a portfolio, was immediately conspicuous."[1]

Kandinsky arrived in Munich in 1896 at the age of thirty, having given up a promising legal career in Moscow in order to paint. The same year brought two other Russians to the city, Alexei Jawlensky and Marianne von Werefkin. An officer of the Imperial Guard, Jawlensky had transferred from Moscow to St. Petersburg in order to study painting, and there he met von Werefkin, a fellow student of Ilya Repin and daughter of a military commander. In Munich they all came to the school of Anton Abé, where they studied together in 1897. Kandinsky went on to work with the more academic Franz von Stuck, whose studio included Paul Klee and Hans Purrmann, later in Paris an important member of Matisse's school and frequenter of the Stein salon.

After a year with Stuck, in May 1901 Kandinsky established the first of the independent artists' organizations that he would found, the Phalanx. The Phalanx mounted twelve exhibitions before its dissolution in 1904, ranging from Jugendstil decorative arts and Symbolist painting, to a show of sixteen Monets and another of French Neoimpressionists. An art school was started in 1902, and there in his still-life class Kandinsky met Gabriele Münter, the painter who would become his companion until the outbreak of the war.

Kandinsky took his Phalanx classes to the countryside during the summers, and in 1902 and 1903 Münter painted alongside her teacher in Kochel and Kallmünz, and traveled with him throughout Germany. In September 1904, after going with Münter to Holland in the spring, Kandinsky separated from his wife (and cousin) Ania Shemiakina, who had accompanied him from Russia. For the next four years

Wassily Kandinsky. Composition V, *1911. Oil on canvas, 74¾ x 108¼ in. Private collection. With* Composition V *exceeding the size limitations for the New Artists' Association exhibition, Kandinsky's demand that it be shown precipitated the withdrawal of the Blaue Reiter artists and became the occasion for their own exhibition.*

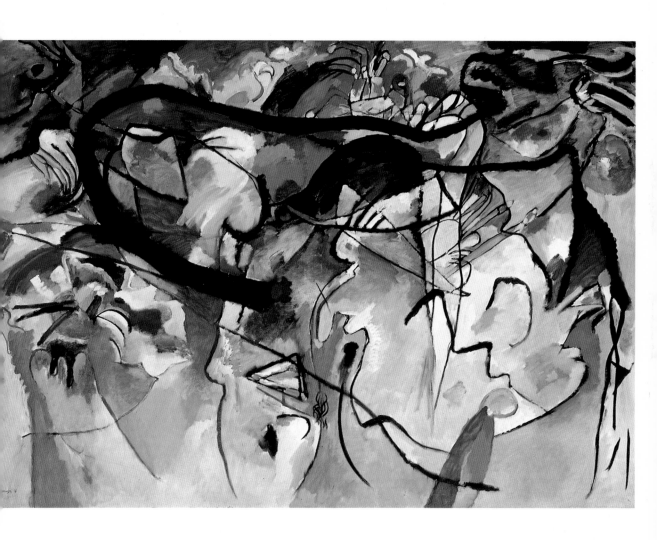

Kandinsky and Münter would travel and live throughout Europe—as well as Tunisia for the first three months of 1905—spending the winter of 1906 in Rapallo and June 1906–June 1907 at Sèvres outside of Paris. During these years Kandinsky was developing an international reputation, exhibiting in Moscow, Odessa, St. Petersburg, Berlin, Dresden, Angers, and Paris (at both the Salon d'Automne and the Salon des Indépendants many times). But in 1908 Kandinksy and Münter moved back to Munich, by September settling in Schwabing at Ainmillerstrasse 36.

In June they had made their first visit to the Bavarian town of Murnau, about 45 miles south of the city, where over the rest of the summer they vacationed and painted in the alpine foothills with Jawlensky and von Werefkin. Münter fell in love with the place, and the next summer she purchased a three-story house. The locals called it the *Russenhaus*, the Russian House, although Kandinsky often sported Bavarian peasant dress and decorated the woodwork and furniture with his versions of traditional Bavarian designs. There Jawlensky discovered the collection of more than a thousand pieces of *Hinterglasmalerei*, reverse-paintings on glass, from southern Germany and Bohemia, belonging to the master brewer Johann Krotz. The artists began to acquire examples—Jawlensky covered a wall of his Munich studio with glass paintings—and, more importantly, began painting their own. This activity would spread to other artists of the Blaue Reiter group, and the results were to be seen in the Blaue Reiter exhibition and in the *Almanac*.[2] As for the Blaue Reiter itself, that would be born in Munich and Murnau, product of the very special collaboration of Marc and Kandinsky.

The two artists met after Marc wrote a letter to the dealer Heinrich Thannhauser praising the second exhibition of the Neue Künstlervereinigung München (NKVM, or New Artists' Association of Munich) in September 1910. This organization was founded by Kandinsky and his associates in January 1909, at a time when the international avant-garde was growing exponentially, and finding support in progressive dealers such as Thannhauser.[3] Thannhauser gave the NKVM his Modernen Galerie in the Arco Palace for its exhibitions, encouraging the efforts of these artists to promote the kind of French painting in which he dealt. Jawlensky, who declined the presidency of the NKVM in favor of Kandinsky's leadership, had also spent much time in Paris. They both exhibited in the 1905 Salon d'Automne, and after a 1907 visit in Munich from Paul Sérusier, Jawlensky often foisted on his fellows the Nabis' concept of "artistic synthesis." The phrase would appear in the founding circular of the NKVM.

Six months before the second NKVM exhibition, Franz Marc moved to Sindelsdorf, a small village close to Murnau. He was already painting animals and, as can be seen from a 1908 letter to his publisher Reinhard Piper, had developed the sort of mystical turn that would so appeal to Kandinsky: "I try to intensify my sensitivity for the organic rhythm of all things; I seek pantheist empathy with the vibration and flow of the blood of nature—in the trees, in the animals, in the air."[4] By the time he came to Sindelsdorf, Marc also had developed a close friendship with the painter August Macke, who had sought him out in January 1910 after seeing a group of Marc's lithographs in a Munich gallery. It was a critical friendship for all of the artists of the Blaue Reiter, for Macke introduced Marc to his wife's uncle, the collector Bernhard Koehler, who would become their great patron.

Macke and Marc reacted very differently to the second exhibition of the NKVM. Macke was critical of those whom the press dubbed the Bavarian Fauves, writing to Marc that "*their means of expression are too big* for what they are trying to say. . . . It seems to me that they are *struggling* too hard to find a form."[5] This was mild compared with the words of the city's main newspaper, the *Müncher Neueste Nach-*

Wassily Kandinsky posing in Gabriele Münter's garden in Murnau, 1909. Photograph by Gabriele Münter. Courtesy Gabriele Münter and Johannes Eichner Foundation, Munich

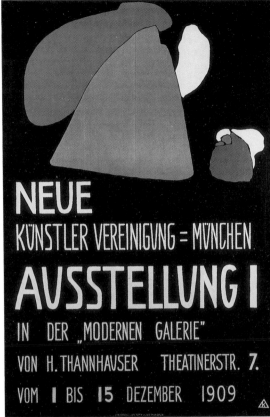

richten, echoing the alternatives so often presented in the face of avant-garde shows: "There are only two possible ways to explain this absurd exhibition: either one assumes that the majority of the members and guests of the Association are incurably insane, or else that one deals here with brazen bluffers who know the desire for sensation of our time only too well and are trying to make use of this boom."[6] In response, Marc wrote the letter to Thannhauser that brought him to Kandinsky's attention: "People react as if these paintings were isolated tumors growing in a few sick minds, whereas they are in fact simple and austere first steps in virgin country. Do they not realize that the same spirit of fresh creativity is at work today in every corner of Europe, defiantly self-aware?"[7]

The paintings truly were indicative of international developments, for the September 1910 NKVM exhibition was one of the first large group shows of the European avant-garde, prefiguring the 1912 Cologne Sonderbund and the 1913 Armory Show in New York.[8] It included pieces by Picasso (his early Cubist *Head of a Woman* was reproduced in the catalogue), Braque, Le Fauconnier, Derain, Vlaminck, Rouault, van Dongen, the Russians David and Vladimir Burliuk, as well as the Munich artists and a few other invitees. The catalogue was an important document in itself, containing essays by Kandinsky, Le Fauconnier, the Burliuks, Odilon Redon, and an unidentified writer's foreword to an earlier Paris show of Rouault. Also hosting exhibitions of Matisse, Gauguin, and an immense show of Islamic art (drawing visitors from throughout Europe, including Matisse and the English critic Roger Fry), Munich in 1910 provided a range of artistic stimulation rivaling that of Paris.

Kandinsky must have been especially gratified to find Marc writing of the

above left:
Staircase and chair painted in Bavarian style by Wassily Kandinsky in the Münter-Kandinsky house, Murnau, 1911

above right:
Wassily Kandinsky. Poster for the first exhibition of the New Artists' Association of Munich, 1909. Color lithograph on paper, 37 x 25¼ in. Städtische Galerie im Lenbachhaus, Munich. Two years later, the artists of the Blaue Reiter would withdraw from the New Artists' Association and mount an exhibition in Thannhauser's gallery alongside an exhibition by their former colleagues.

"completely spiritualized and dematerialized inwardness of feeling" displayed in the second NKVM exhibition.[9] For by the end of 1910 Kandinsky had finished organizing his notes from the past few years into the seminal volume *Über das Geistige in der Kunst* (Concerning the Spiritual in Art), published—through a connection made by Marc—by Reinhard Piper, Munich, in December 1911. This highly influential book spread notice of Kandinsky's modernist program, and by 1914 it had gone through three German editions and been translated into Russian and English. An abridged version was read to the Second Russian Congress of Artists in St. Petersburg in December 1911, and Alfred Stieglitz published selections in *Camera Work* in July 1912. The book began by describing the plight of modern man: "Our minds, which are even now only just awakening after years of materialism, are infected with the despair of unbelief, of lack of purpose and ideal. The nightmare of materialism, which has turned the life of the universe into an evil, useless game, is not yet past; it holds the awakening soul in its grip."[10] It went on to delimit a path to spiritual development through the expression of the artist's "inner need," emphasizing the emotional and symbolic dimensions of pure form, color, and, through synesthesia, sound. For Kandinsky, his book and the *Blaue Reiter Almanac* would have the same goal—"to awaken this capacity, absolutely necessary in the future, for infinite experiences of the spiritual in material and in abstract things."[11]

On first meeting, Marc and Kandinsky immediately sensed their affinity, as well as their common attraction both for the new and for the mystical. As Kandinsky said, "One conversation sufficed, we understood each other perfectly."[12] Marc became involved with Kandinsky and his friends, and on February 5, 1911 he joined the NKVM and was elected to serve with Jawlensky and the conservative Adolf Erbslöh on its governing board. He had been very impressed by Kandinsky's painting in the NKVM exhibition—he thought *Composition II* the only contemporary work to compare with the great Islamic tapestries shown in Munich during the summer[13]—and after seeing new paintings in the studio, he wrote to Macke on February 14: "I confess I have scarcely ever received such a deep and awesome impression from pictures as here; Kandinsky pierces the deepest of all. I am happy that I will be on rather neighborly terms with him and Fraulein Münter this summer (Murnau-Sindelsdorf)."[14]

Through the spring the two painters became close, and on June 19 Kandinsky wrote Marc of a new project: "Well, I have a new idea. Piper must be the publisher and the two of us the editors. A kind of almanac (yearbook) with reproductions and articles . . . and a *chronicle!!* that is, reports on exhibitions reviewed by artists, and artists alone. In the book the entire year must be reflected; and a link to the past as well as a ray to the future must give this mirror its full life. . . . We will put an Egyptian work beside a small Zeh [child's drawing], a Chinese work beside a Rousseau, a folk print beside a Picasso, and the like! Eventually we will attract poets and musicians."[15] Kandinsky suggested that the title be *Die Kette* ("The Chain"), and Marc proposed *Blaue Blatter* ("Blue Leaves"), but in the end the name *Der Blaue Reiter* was chosen over coffee in the Marcs' garden at Sindelsdorf—originating, according to Kandinsky, because "we both loved blue, Marc liked horses and I riders."[16]

The horse and rider had been a personal symbol for Kandinsky since 1901, a crusader against the materialism of his time, evoking the image of Saint George and suggesting the theme of the Apocalypse that would recur in his work through the Blaue Reiter years. As for the color blue, both Marc and Kandinsky independently had developed elaborate theories of color symbolism in which blue represented the spiritual. Marc also viewed blue as essentially masculine, making it doubly appropriate to the aggressive program on which they had embarked. His focus on horses in the "animalization" of art must have sealed the matter.

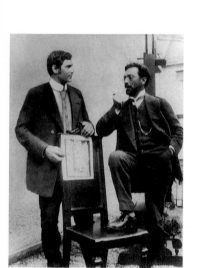

Franz Marc and Wassily Kandin-
sky with the woodcut cover of the
Blaue Reiter Almanac, *1911–12.*
Private collection

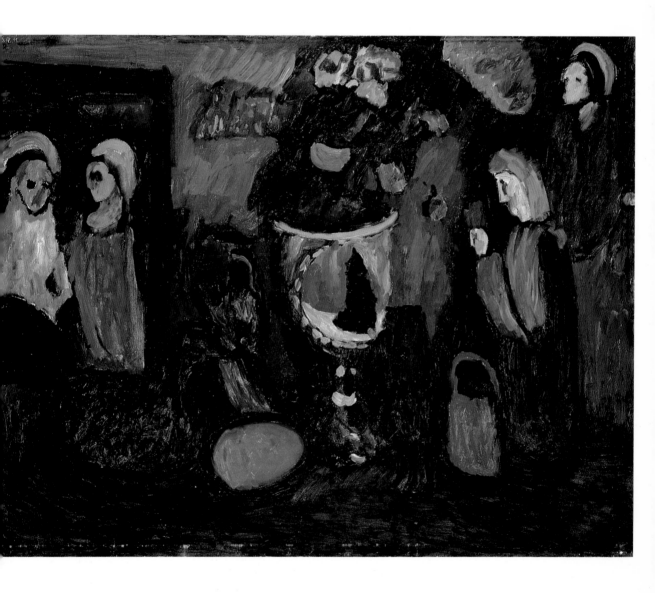

Gabriele Münter. Dark Still Life, *1911. Oil on canvas, 30⅞ x 39½ in. Städtische Galerie im Lenbachhaus, Munich*

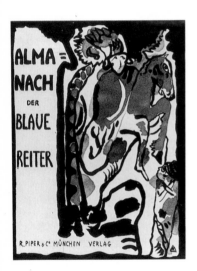

Discussions began that summer, punctuated by pleasant bicycle rides through the Bavarian countryside between Murnau and Sindelsdorf. In early September Marc enlisted the aid of his friend August Macke, whose interest in comparative imagery and artifact attracted him to Kandinsky's focus on diversity of artistic expression. Despite his qualms about the artists of the NKVM, Macke arrived from Bonn a month later and enthusiastically embraced the enterprise. His excitement is clear, as he wrote to his wife to join him: "All the days are like holidays. . . ."[17]

Marc had sent Reinhard Piper a preliminary table of contents in September, including sections of articles on painting, theater, and music. Noteworthy among the latter was an essay by Arnold Schönberg. The central artists of the NKVM, with the addition of Marc, had attended a Munich concert of Schönberg's music on January 1 or 2, 1911. After hearing his Three Piano Pieces, op. 11 (1909) and Second String Quartet, op. 10 (1907–8), their response was immediate. Marc wrote to Macke that Schönberg's suspension of tonality reminded him of Kandinsky's new work, and that "Schönberg seems, like the Association, to be convinced of the irresistible dissolution of the European laws of art and harmony."[18]

Kandinsky wrote directly to Schönberg on January 18, enclosing a portfolio of his woodcuts and photographs of his paintings. He hoped that the composer would see that "what we are striving for and our whole manner of thought and feeling have so much in common," including an "anti-geometric, anti-logical" method of construction, and the view that dissonance and consonance are relative to historically conditioned aesthetic norms.[19] Schönberg replied positively and mentioned that he himself was a painter, though of a very different sort than Kandinsky. After many delays, Kandinsky and Schönberg finally met in mid-September, while the composer was vacationing on a lake near Murnau, and Schönberg agreed to contribute an essay to the *Almanac*. Once he saw photographs of Schönberg's painting, Kandinsky wrote him in November that "It is the opposite of my own art . . . [but] grows spiritually out of the same root: a chair lives, a line lives—and that is finally, and fundamentally, equivalent."[20] He soon would set the "total realism" of Schönberg, and that of Henri Rousseau, alongside his own "total abstraction" in the Blaue Reiter exhibition, and would present them in the *Almanac* as two routes to the same spiritual end.

Governing the selection of illustrations for the *Almanac* was the principle that in art there are diverse manifestations of a single "inner necessity." This supported a profound pluralism in matters of aesthetic expression, a stance very threatening to conservative members of the NKVM. Kandinsky's own move to abstraction—he painted his first wholly abstract work in 1910—was a major source of difficulty, as was the acceptance of all forms that seemed to express a spiritual center. Typical was the reaction of art historian and NKVM member Otto Fischer: "A painting without object is senseless. . . . These are fallacies of empty fanatics and impostors. These confused individuals may talk about the spiritual—but spirit makes for clarity, not confusion."[21]

Certainly the editors' excitement around the compilation of the *Almanac*—with its illustrations ranging from Medieval woodcuts, children's drawings, African and South American masks, Bavarian glass paintings, and Egyptian shadow puppets, to paintings by El Greco, van Gogh, Delaunay, and members of the Blaue Reiter—steeled their commitment to aesthetic pluralism, and readied them for a break with their conservative colleagues. Kandinsky already had resigned from the chairmanship of the NKVM in January, citing "differences in principle between the basic viewpoints," and he was succeeded by his opponent Erbslöh.[22] In August Marc wrote to Macke that "Together with Kandinsky I foresee clearly that the next jury meeting (in late fall) will bring about a horrible argument that then or next time will result in a split or in the resignation of one of the two factions."[23] On December 2 the

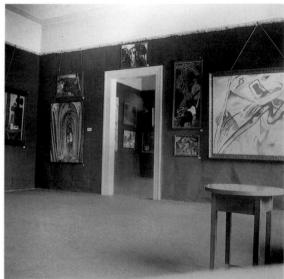

break came.

As Marc anticipated, the occasion was the next jury meeting, at which Kandinsky's large *Composition V* was rejected. Each member of the NKVM was allowed two nonjuried paintings, but neither could exceed four square meters in size. *Composition V* missed the mark at 190 x 275 centimeters, but the conservative faction would not stretch the rule as had been done the previous year for the slightly smaller *Composition II.* Immediately Kandinsky and Marc left the Association, to be followed by Münter, Kubin, Le Fauconnier, and the Russian composer Thomas von Hartmann. Strangely their friends Jawlensky and von Werefkin remained. The fact that Kandinsky might have substituted *Composition IV,* which fit the requirements, suggests that he did not want to avoid the breakup of the organization.[24] On the day after the jury's decision, Marc wrote to his brother, Paul, in London: "The die is cast. Kandinsky and I . . . have left the association. . . . Now it is the two of us who must continue to fight! The Editors of the *Blaue Reiter* will now be the starting point for new exhibitions. . . . We will try to become the center of the modern movement."[25]

Just two weeks later, on December 18, the First Exhibition of the Editors of the Blaue Reiter was hung in Rooms 4–6 of Thannhauser's gallery, indicating that alternative plans were underway before the split. In fact, on November 4 Marc wrote to Kandinsky that Thannhauser had offered them rooms for the latter part of December next to those of the third NKVM exhibition. In his postcard he proposed that their show contain Burliuk (he does not say which brother), Heinrich Campendonk, Macke, Marc's own paintings on glass, Schönberg, Albert Bloch, Rousseau, Delaunay, and "two or three old things."[26] Although Kandinsky later recalled that, anticipating the final break, prior arrangements had been made for an exhibition, there is no record of work being explicitly requested before he told Marc on December 4 that Bloch had agreed to show with them. Activity must have been frantic in any case, even with existing relationships and the connections established in the course of assembling the *Almanac,* for within sixteen days an exhibition was mounted of over forty-three works by fourteen artists from eight cities.

Fortunately much of the exhibition was photographed by Gabriele Münter, and we can see that the arrangement displayed the kind of contrast and juxtaposition devised for the *Almanac.* Schönberg's contemplative *Self-Portrait* sat beside Marc's ecstatic *Yellow Cow.* Delaunay's Cubist *The City, No. 1* hung next to Rousseau's *Street*

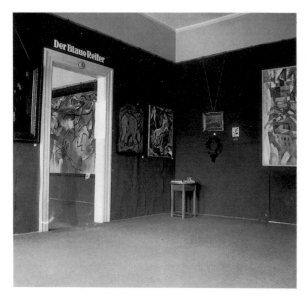

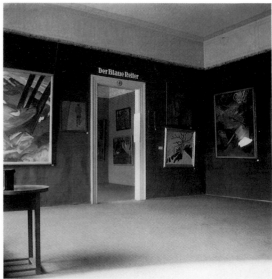

with *Chickens*, and Marc's painted-glass portrait of the Douanier and Delaunay's *St. Séverin* below Macke's *Indians* and across a doorway from Kandinsky's wild *Improvisation 22*. The large *Composition V* was adjacent to Marc's *Deer in the Forest*, and the third Kandinsky in the exhibition, *Impression 2 (Moscow)*, was alongside the sweetly realistic *Birds* by Jean Blois Niestlé and a stylized *Head* by the American Albert Bloch.

In the end, the exhibition did not include anything other than contemporary painting, presenting an explicit contrast of diverse modernist forms with the largely more conservative work of the remaining members of the NKVM, shown concurrently in adjacent rooms. In addition to the artists just mentioned, the Blaue Reiter show included the paintings of David and Vladimir Burliuk, combining Russian Neoprimitivism and the new Cubism; Münter's evocative landscapes and still lifes; richly colored images of Marc's friend and Sindelsdorf neighbor Heinrich Campendonk; dreamy figurative scenes by the Czech Eugene Kahler, who had died a week before the opening and was memorialized by Kandinsky in the *Almanac*; and Fauvist work by Kandinsky's former student, Elisabeth Epstein. It was Epstein who had alerted Kandinsky from Paris of the work of Delaunay, initiating a relationship that would make him one of the best-known French artists in Germany before the war. The exhibition was accompanied by a small catalogue, less than 6 x 5 inches in size, listing most of the works shown. The artists were cited along with their cities of residence, emphasizing the international character of the group. As might be expected, the catalogue was not ready when the show opened, and oddly for Kandinsky and Marc, it included only a single sentence as programmatic text: "In this small exhibition, we do not seek to propagate any one precise and special form: rather, we aim to show by means of the variety of forms represented how inner wishes of the artists are embodied in manifold ways."[27]

The exhibition marked the first time that Rousseau's paintings were shown in Germany, and his work was given very special treatment. For Rousseau was ideal for the Blaue Reiter, allying them with the French avant-garde through a shared icon, reinforcing their interest in folk forms, and providing additional evidence for Kandinsky's view that both realism and abstraction equally can express spiritual content. His name was listed first and separately in the catalogue, and his *Street with Chickens* was set up as a sort of shrine, with a wreath of laurel leaves and a band of black crepe beneath it. Kandinsky had first seen Rousseau's paintings when he and Münter lived in Sèvres in

Installation view of the First Blaue Reiter Exhibition at Galerie Thannhauser, Munich, 1911, showing (left to right) Gabriele Münter's Dark Still Life; *(through door) Wassily Kandinsky's* Composition V; *Albert Bloch's* Three Pierrots; *Heinrich Campendonk's* Leaping Horse; *Henri Rousseau's* Street with Chickens; *Franz Marc's* Portrait of Henri Rousseau; *Robert Delaunay's* The City No. 2. *Photograph by Gabriele Münter, courtesy Gabriele Münter and Johannes Eichner Foundation, Munich*

above right:
Installation view of the First Blaue Reiter Exhibition at Galerie Thannhauser, Munich, 1911, showing (left to right) Franz Marc's The Yellow Cow; *Arnold Schönberg's* Self-Portrait; *Wassily Kandinsky's* St. George II; *(above) Vladimir Burliuk's* Portrait Study; *(below) Gabriele Münter's* Country Road (in Winter); *Marc's* Deer in the Forest I; *and the edge of Kandinsky's* Composition V. *Photograph by Gabriele Münter, courtesy Gabriele Münter and Johannes Eichner Foundation, Munich*

August Macke. Indians on
Horseback, *1911. Oil on canvas,*
17⅜ x 23⅝ in. Städtische Galerie
im Lenbachhaus, Munich

Henri Rousseau. Street with Chickens, *1896–98. Oil on canvas, 9¾ x 13 in. Musée National d'Art Moderne, Centre Georges Pompidou, Paris. To mark Rousseau as spiritual father of the Blaue Reiter, in the exhibition this painting was enshrined above a laurel wreath and a band of black crepe.*

1906–07, and his interest was revived after Piper sent him Wilhelm Uhde's new monograph on the painter. Uhde's book reproduced several of the many Rousseaus belonging to Robert Delaunay, a loyal friend of the artist who began collecting his work at the age of twenty-two. By coincidence, Kandinsky had just received photographs of Delaunay's own paintings from Elisabeth Epstein, and in his first letter to Delaunay, written on October 28, he asked that he contribute an essay to the *Almanac* and help him obtain photographs of Rousseau's work for the publication. Kandinsky remarks that he was "struck again by the expressive power of this great poet," admires the pictures owned by Delaunay, and states his desire to acquire a Rousseau. Eventually, Delaunay would assist him in buying two.[28] Epstein's inclusion in the exhibition, and Kandinsky's purchase of the portrait that she showed there, no doubt were signs of gratitude for her role in obtaining Delaunay and Rousseau for the Blaue Reiter. Marc also was enthralled with Rousseau, painting his small glass homage after seeing the self-portrait reproduced in Uhde's monograph, and in a letter to Delaunay he offered to write an essay on the Douanier *"from the German point of view."*[29] His importance to the two artists is signified by Marc's giving Kandinsky the glass portrait of Rousseau for Christmas that year. The exhibition itself included two works, the *Street with Chickens*—reproduced on the announcement for the *Almanac* that was distributed at the exhibition and acquired by Kandinsky before the show—and a village scene with telegraph poles. Kandinsky also arranged a sale of two Rousseaus to Bernhard Koehler, and in thanks Delaunay gave him the drawing of the Eiffel Tower, which he exhibited in Munich.

Delaunay never did write for the *Almanac*, but two of his paintings were reproduced there—along with seven Rousseaus—and his painting of the Eiffel Tower was as impressive as anything else in the exhibition. The four paintings that were shown seem chosen to represent Delaunay's progression toward abstraction—moving from *St. Séverin, No. 1*, through *The City, No. 1* and then *The [Eiffel] Tower*, to *The City, No. 2*. Their strength and prominent display laid the ground for Delaunay's future success in Germany, and three of them were sold. Ironically, Kandinsky's opponent on the NKVM, Adolf Erbslöh, bought the painting of St. Séverin, and Jawlensky purchased the first of the city pictures. The great *Eiffel Tower* went to Bernhard Koehler.

Koehler purchased five of the eight works sold from the exhibition—Kandinsky's *Impression II (Moscow)*, Macke's *Indians on Horseback*, a Münter and a Campendonk, in addition to the Delaunay. He and his son were at Thannhauser's for the hanging of the exhibition, and his involvement with the Blaue Reiter extends through its entire history. The wealthy Berlin manufacturer first collected snuff boxes and Munich Jugendstil paintings, but advised by August Macke—friend of his son and future husband of his niece—he traveled to Paris and acquired paintings by the Impressionists, as well as by Cézanne, Seurat, Picasso, and the new French painters. After Macke led him to Marc in January 1910, Koehler began to buy Marc's work, eventually providing him with a monthly stipend. In addition to helping other artists—he gave Niestlé and his family a house in Seefeld—Koehler supported the institutional activities of the group. He sponsored the tour of the Blaue Reiter exhibition through Germany and, perhaps most importantly, provided the 3,000 mark guarantee required by Piper to cover the production costs of the *Almanac*. Six works owned by Koehler were reproduced there, including El Greco's magnificent *St. John*, shown facing Delaunay's *Eiffel Tower*. As Kandinsky said, "Without his helping hand, the *Blaue Reiter* would have remained a beautiful utopia."[30] Sadly, much of the Koehler collection—including his many Kandinskys, Klees, and *The Eiffel Tower*—was destroyed in Berlin during the Second World War.

Along with the Delaunays, the most imposing works in the exhibition—

both in size and in ambition—were those of Marc and Kandinsky. Marc showed four paintings and the Rousseau portrait, and Kandinsky three oils and two works on glass. The most striking of the Marcs was his leaping *Yellow Cow*. Responses ranged from that of the conservative Alexander Kanoldt, of the NKVM, who saw it as "an altogether deplorable work," to that of the poet and future Dadaist Walter Mehring, who extolled its "bellowing cow-yellow."[31] Marc himself had particular associations in mind for the intense colors used in his pictures, as he wrote in a December 1910 letter to Macke: "Blue is the *male* principle, severe and spiritual. Yellow is the *female* principle, gentle, cheerful, and sensual. Red is *matter*, brutal and heavy, the color that has to come into conflict with, and succumb to, the other two."[32]

Marc's symbolic program here, in which the use of color reflects the ultimate triumph of spirit over matter, was complemented by Kandinsky's work in the exhibition. Kandinsky showed an example of each of the three kinds of painting delimited at the conclusion of *Concerning the Spiritual in Art*, which Piper had rushed into print in time to appear during the exhibition and to be sold there. His *Impression II (Moscow)* was "a direct impression of outward nature, expressed in purely artistic form." *Improvisation 22* was "a largely unconscious, spontaneous expression of inner character, the non-material nature." And *Composition V* was "an expression of a slowly formed inner feeling, which comes to utterance only after long maturing," and in which "reason, consciousness, purpose, play an overwhelming part."[33] Together they were to signify a development toward the highest state of artistic practice, the use of intellect and consciousness to display significant feeling and reveal spiritual content.

In total effect the paintings of Kandinsky, Marc, and Delaunay overwhelmed much of the other work in the exhibition. Niestlé, in particular, was unhappy, both disappointed that the show did not contain the sort of historical and cultural variety that he had been led to expect, and upset at the way in which his modest work looked amidst the others. ". . . I felt such sadness in viewing the little painting that hung there so forsaken and lost, that I had to leave the exhibition in total frenzy and deeply depressed."[34] Koehler had loaned the piece, and Niestlé asked him to remove it from the exhibition before the show traveled to Cologne.

The artists with the largest number of works in the exhibition were Gabriele Münter and Albert Bloch, each showing six paintings. Münter contributed four country and village scenes, and two still lifes. Her contemporaries considered Münter's still lifes to be the heart of her work, and Macke was attracted to the sense of "the mysterious" in these interiors, and to their German vision "touched with the romanticism of church and family."[35] In his important theoretical essay in the *Almanac*, "On the Question of Form," Kandinsky used one to exemplify the inner harmony that can be revealed by the juxtaposition of dissimilar elements. Very different was the work of the American from St. Louis, Albert Bloch, who had come to Munich in 1908. Three of his pictures showed theatrical characters—harlequins and Pierrots—and they highlight the importance that the performing arts held for the Munich avant-garde.

Kandinsky in particular was involved with the theater, and with the expressive connections between the senses grounded in synesthesia. He admired Scriabin's experiments with musical sound and colored light—he and von Hartmann had translated Leonid Sabaneiev's essay, "Prometheus," for the *Almanac*—and he concluded the *Almanac* with his own essay, "On Stage Composition," and his original script for *Der gelbe Klang* ("The Yellow Sound"). Kandinsky performed experiments with the dancer Alexander Sakharoff and von Hartmann testing the validity of synesthetic relations: After showing a series a watercolors to von Hartmann, the composer created a piece of music based on one of them. Sakharoff then danced to the music, and attempted to identify the watercolor from which it was derived.[36] The ideal of coordinating music,

Franz Marc. Yellow Cow, *1911.*
Oil on canvas, 55⅜ x 74½ in.
Solomon R. Guggenheim Mu-
seum, New York

visual form and color, text, and movement in the synthetic *Gesamtkunstwerk* was a fundamental one for Kandinsky, stemming from his view of all human creativity as an expression of an underlying spiritual ground. Since *The Yellow Sound* never was produced—plans for a 1914 production in Munich were abandoned—the *Almanac* stands as his most successful monument to this ideal, with contributions from each of the arts and illustrations from Western and non-Western sources, both "high" and "low."

The spiritualism of Kandinsky and of Marc was quite alien to August Macke, who wrote in racial terms to Marc "that I must warn you, as a *Blaue Reiter*, not to think too much on the spiritual. Kandinsky stands alone (as an Asian)."[37] Macke was critical of Marc's work in the Blaue Reiter exhibition and obviously was unhappy about Kandinsky's strong influence on his friend. He was, in fact, less than enthusiastic about the show as a whole: "There are a lot of good things there, but also a lot of things which do not warrant the grossly exaggerated propaganda." After Macke and Marc visited Delaunay in Paris in October 1912, his work became strongly influenced by the Frenchman's visual, rather than psychological, theory of color, and he moved even farther from his Munich associates. By 1913, Macke was mocking the Blaue Reiter in a satirical drawing and attacking Kandinsky in a letter to Koehler.[38]

Macke did not see the exhibition in Munich before it closed on January 3, but he visited the show in Cologne, where it was displayed during the last week of January.[39] Like many of the advanced group exhibitions before the First World War, the Blaue Reiter show went on tour after its initial installation. Both of the first two NKVM shows had traveled extensively throughout Germany after being shown at Thannhauser's, exhibited in both museums and private galleries.[40] The Blaue Reiter exhibition was shown in Cologne at the Gereonsclub, headed by Emmy Worringer, sister of the art historian and theorist Wilhelm Worringer, whose *Abstraction and Empathy* (1908) influenced both Kandinsky and Marc. Its most important venue away from home, however, was the second and last, at the opening of Herwarth Walden's Sturm Gallery, March 12–April 10, 1912.

Herwarth Walden was the avant-garde impresario of prewar Germany. Beginning with the first issue of *Der Sturm* in March 1910, Walden developed this review of drama, literature, and music into a vehicle for the promotion of the visual avant-garde. Provoked by the public response to his use of Oskar Kokoschka's erotic graphics on the magazine's cover, he began regularly to feature the expressionist images of members of the Die Brücke group, by 1910 relocated in Berlin from Dresden. In 1911 he stood with the opposition to the conservative protest against the incursion of French art into Germany, Vinnen's *Protest deutscher Künstler*, publishing a response by Worringer in his August issue. By 1912 he was ready to expand his activities, and in celebration of *Der Sturm*'s one-hundredth issue he mounted an exhibition of Kokoschka, new French painting, and the Blaue Reiter, to be followed by the Italian Futurists fresh from Paris and London. The Blaue Reiter exhibition at the Sturm gallery differed from the Munich original—there was no Schönberg or Niestlé, and works by Klee, Jawlensky, and von Werefkin were included. Since the original show the *Blaue Reiter* editors had come to know better Kandinsky's Schwabing neighbor Klee, who reviewed the exhibition well in the Swiss journal *Die Alpen*. And Jawlensky and von Werefkin had left the NKVM, alienated by the sort of vicious attacks that were published by Fischer. In October 1912 Walden mounted Kandinsky's first one-man show, and he toured and promoted the work throughout Western and Eastern Europe during the next few years. Walden would go on to do a series of very important exhibitions, including Delaunay in early 1913, and the great show of the international avant-garde, the 366-painting *Erster deutscher Herbstsalon* ("The First German Autumn Salon") of 1913, funded by Bernhard Koehler. The initial Sturm exhibition of 1914 was the last group

exhibition of the Blaue Reiter, and it included many of the original paintings.[41]

While the Berlin version of their first exhibition was at Walden's, Kandinsky and Marc presented a second show in Munich, in the gallery above the bookstore of Hans Goltz.[42] Entitled *Schwarz-Weiss* ("Black-White"), it consisted entirely of drawings, prints, and watercolors. This second Blaue Reiter exhibition was much larger than the show at Thannhauser's, with 315 works listed in the catalogue. More importantly, while the center of gravity of the first show lay with the Munich artists, this exhibition ranged more broadly across the international avant-garde. From France came work of Picasso, Braque, Vlaminck, Derain, La Fresnaye, Robert Lotiron, and Paul Vera, though oddly no Delaunay. There were pieces from Russia by Kasimir Malevich, Natalya Goncharova, and Mikhail Larionov. Five members of the Swiss Der Moderne Bund were included, most notably Hans Arp and the Munich resident Paul Klee, who showed seventeen gouaches and drawings. And from within Germany came a vast number of prints and drawings by the Expressionist artists of the Brücke group.

It seems difficult to believe, but Kandinsky and Marc, despite their knowledge of far-flung avant-garde movements, were unaware of the radical work being done three hundred miles to the north. Having come together in Dresden in 1905, the original artists of Die Brücke ("The Bridge")—Ernst Ludwig Kirchner, Fritz Bleyl, Erich Heckel, and Karl Schmidt-Rottluff—lived and worked together in a former butcher's shop in the working-class section of the city. With the addition of Emil Nolde—who ended his isolation on the North Sea island of Alsen to join them—and Max Pechstein, in 1906 they held their first exhibition. Installed in a factory building in a lampshade and lighting-fixture showroom, obtained by Heckel while he was working as a draftsman on the design of the space, the show was ignored by the public. But it was followed by the publication of the first of the annual portfolios (1906–12) that would present the group's intense woodcuts and other prints to a greater audience. By 1911 all of the artists had relocated to Berlin, where Pechstein and his colleagues had founded the New Secession the previous year.

It was in Berlin that Marc, visiting his wife's parents over the New Years holiday, came upon their work. After seeing the studios of Kirchner, Pechstein, Heckel, Nolde, and Otto Mueller, he wrote to Kandinsky of "a tremendous untapped wealth that is as close to us as the ideas of our silent admirers in the land."[43] He arranged for the Brücke artists to exhibit in the second Munich exhibition and solicited material for the *Almanac*. Kandinsky, however, was less than enthusiastic, agreeing to include the work in the exhibition, but insisting that if Die Brücke images were to be reproduced in the *Almanac* that they be small ones. Writing to Marc on February 3: ". . . I think it is incorrect to immortalize them in the *document* of our modern art (and this is what our book ought to be) or as a more or less decisive, leading factor. At any rate, I am against *large* reproductions. . . . The small reproduction means: this *too* is being done. The large one: *this* is being done."[44] But the Brücke showing at Goltz's overwhelmed that of the Blaue Reiter: thirty-eight works of Pechstein, Kirchner's thirty-one drawings, twenty-eight prints and drawings by Heckel, Mueller's fourteen pieces, and seventeen graphic works of Nolde versus twelve Kandinsky watercolors, five animal studies of Marc, and a few works each by Münter, Macke, and Bloch. In Cologne, where the show went in May and June, the Blaue Reiter pictures must have seemed lost amidst the Berlin entries. But its stamp was set by the inclusion of a group of Russian folk prints.

The amount of work required in the organization and promotion of the Blaue Reiter was immense, and Kandinsky especially was overwhelmed. Writing to Schönberg on January 13, 1912, he complains of neglecting his painting and personal affairs because of his other activities—organizing the December exhibition and arrang-

ing for its move to Cologne, helping with the sale of pictures in the show, writing letters (eighty in two weeks), assembling the German, French, and Swiss contributions to the Second Knave of Diamonds exhibition in Moscow, and unrelenting editorial work on the *Almanac*.[45] The *Almanac*, of course, was the focus, the unifying effort on which the group's identity was based. And with the lack of public response to the December exhibition—although it is estimated that five hundred people saw the show, there are no known published reviews—the *Almanac* became without question the primary public expression of the Blaue Reiter.

After much travail, the *Blaue Reiter Almanac* was distributed to its subscribers in mid-May, the first printing enlarged to 1,200 due to the success of the subscription. The book was dedicated to the memory of Hugo von Tschudi, who, as head of the Bavarian State Museums (after being dismissed as director of the German National Gallery in Berlin for his support of modern art), had obtained Thannhauser's gallery rooms for the first NKVM exhibition, and had encouraged the *Almanac* project. Extensively illustrated—with 144 pictures for 144 pages, only one third showing contemporary works—the visual mix sought to display the "inner" connection of the new art with the old, the childlike, the self-taught, and the non-Western. There was abuse, of course—for the director of the Berlin Academy of Art it was "an interesting object for psychiatric study"[46]—but copies were in demand. In 1914 a second edition was published with new forewords by Marc and Kandinsky, statements that express fading hope for widespread spiritual change but a residual faith in its possibility. Marc ended his remarks this way: "We admire the disciples of early Christianity who found the strength for inner stillness amid the roaring noise of their time. For this stillness we pray and strive every hour."[47]

Certainly in 1914 the times were filled with roaring, with events that would send Kandinsky back to Russia via Switzerland and Münter to Sweden, Macke to his death within two months of the outbreak of the war, and Marc to his own end near Verdun in March 1916. The editors' contrasting attitudes to the imminent conflict are suggested by the books of the Bible that each chose to illustrate for an unrealized project of Marc's in 1913: Marc selected Genesis, and Kandinsky the Apocalypse. With Macke's death and his own experiences in the trenches, Marc became less sanguine about the moral and spiritual value of the war, and more discouraged about the achievements of the Blaue Reiter, eventually marking it a "complete failure" and renouncing artistic collaboration in a letter of March 27, 1915.[48] But in the *Almanac* one can still breathe the clear air that blew through Munich, Murnau, and Sindelsdorf in 1911–12, a utopianism of aesthetic aspiration that would resurface in many forms throughout the century.

CHAPTER 4 *Explosion at the Armory*
International Exhibition of
Modern Art, New York, 1913

Just as the *Blaue Reiter Almanac* was reaching its first subscribers, the immense International Exhibition of the Sonderbund was opening in Cologne, and on its last day, as the show was being dismantled, an American rushed through with intense and frantic interest. While painting in Nova Scotia, Walt Kuhn had received the exhibition catalogue from Arthur B. Davies with a short note: "I wish we could have a show like this."[1] The "we" was the Association of American Painters and Sculptors (AAPS), and the show would come to be known as the Armory Show. Kuhn wired Davies to make him steamer reservations, and he was able to get on the last ship to arrive before the close of the exhibition. What he saw on that September 30 became the model for the most famous art exhibition of the century.

It is difficult to imagine the shock to a painter like Kuhn, who had seen virtually no advanced European art. The centerpiece of the Sonderbund was a retrospective of one hundred twenty-five paintings by van Gogh, flanked by more modest retrospectives of twenty-five Gauguins, mostly Tahitian pictures, and twenty-six Cézannes. Neoimpressionism was represented by seventeen works by Henri Cross and eighteen Signacs. The sixteen Picassos extended across the rose and blue periods into important Cubist works, and there were seven Braques. Other French entries included Bonnard, Vuillard, Matisse, Derain, Vlaminck, Marquet, Manguin, Maillol, and Marie Laurencin. There was a retrospective of thirty-two works of Edvard Munch, and other Norwegian, Swiss, and Dutch painters, including Mondrian and van Dongen. The Germans, of course, were very well represented, including the artists of Die Brücke, the Blaue Reiter, and the NKVM.[2]

The kind of aesthetic education that Kuhn received that day in Cologne soon was to be provided to Americans in New York, Chicago, and Boston. However its nature and impact were very different than had been foreseen by the AAPS when it first assembled. For the AAPS was not a radical group, and almost a third of its membership also was affiliated with the rigidly conservative National Academy of Design. None of the members was associated with the most advanced group of the day, which met at Alfred Stieglitz's gallery known as 291. Yet exhibition opportunities were limited, and they sought a more open and interesting forum than that provided by the stultifying annuals at the National Academy.

The organization arose out of a discussion in December 1911 among four artists sitting around an exhibition of the Pastellists Society at the Madison Gallery, part of a decorating firm run by Clara S. Davidge. The artists were Jerome Myers, Elmer MacRae, Walt Kuhn, and Henry Fitch Taylor, the gallery's director. Within a week they had assembled sixteen others to form a society dedicated to "holding exhibitions of the best contemporary work that can be secured, representative of American and foreign art."[3]

Nonacademic, artist-organized exhibitions were not without precedent in America, and many of the initial members of the AAPS were veterans of such shows. After Robert Henri was unsuccessful in getting his students into the 1907 spring annual at the National Academy, he, along with John Sloan and William Glackens, organized the exhibition of The Eight in February 1908 at the Macbeth Galleries. There was a large Independent Artists Exhibition of some five hundred works by

Henri Matisse. Blue Nude, 1907. Oil on canvas, 36¼ x 55¼ in. The Baltimore Museum of Art, The Cone Collection. In Chicago on April 16, a copy of the painting was burned and an effigy of Matisse was battered by art students celebrating the close of the exhibition.

eighty participants in April 1910, again organized by Henri, in a warehouse at 29–31 West 35th Street, at which the police were called to keep order during the opening.[4] A year later Rockwell Kent organized another Independents exhibition, with the assistance of Arthur B. Davies, and Henri initiated an ongoing series of cooperative exhibitions at the MacDowell Club.

The founders of the new organization invited all of The Eight to join them—in addition to Henri, Sloan, and Glackens, they were Davies, Maurice Prendergast, George Luks, Ernest Lawson, and Everett Shinn, who declined—as well as such well-known establishment artists as Gutzon Borglum, the future sculptor of Mount Rushmore, and J. Alden Weir. Despite his many public commissions and conservative work, Borglum was a violent opponent of the National Academy and recently had led a campaign against their proposed new building in Central Park. Weir, on the other hand, one of the original American Impressionists, was the current head of the Academy, and the prudence of the AAPS is suggested by the fact that he was elected its first president. But Weir resigned almost immediately, and his place was taken by Arthur B. Davies. The change of leadership would alter the future of art in America.

Of the original members of the AAPS, Davies had the most knowledge of contemporary developments in European art. Although his own paintings were romantic and symbolist in style, he regularly visited exhibitions at 291, and in fact had purchased works by Cézanne, Picasso, and the young Max Weber from Stieglitz. He came with a strong reputation and was not identified with any sectarian tendency, as was true of the other obvious candidate for the position, Robert Henri. But—and this was a surprise to all concerned, given his mild and retiring manner—Davies had a strong will, definite opinions, and great energy and organizational ability. As Guy Pène du Bois later said, a "dragon evolved from that very gentle cocoon."[5] And while the AAPS from the first had planned to exhibit some foreign art along with its own work, the new president thought it much more important to show American artists and their public what the Europeans were doing. The consequence, as described by Jerome Myers, did not please much of the membership: "Our land of opportunity was thrown wide open to foreign art, unrestricted and triumphant; more than ever before, our great country had become a colony; more than ever before, we had become provincials."[6]

The first order of business for an organization founded to mount exhibitions was to find a location for their first show. Madison Square Garden was an obvious possibility, but it was too costly and larger than necessary. Borglum remembered the 1908 National Sculpture Society exhibition in Baltimore, held in the Fifth Regiment Armory, and Walt Kuhn visited New York's armories. He settled on the new building of the National Guard's 69th Regiment—known as the Fighting Irish—on Lexington Avenue between 25th and 26th streets. The rent would be $5,000 plus $500 for janitorial services, with a down payment of $1,500 and the rest due by February 1, 1913. Davies, who was well connected with wealthy patrons in addition to having some money of his own, committed himself to coming up with the funds. Kuhn's friend, the lawyer John Quinn, supplied free legal advice and became one of the most active participants in the exhibition.

The Cologne expedition was only the beginning of almost two months in Europe assembling the immense foreign component of the show. At the Sonderbund Kuhn met the sculptor Wilhelm Lehmbruck and secured his work for New York, and he made contacts that would lead him to much else. In The Hague on October 5 he discovered the little-known Odilon Redon and decided to feature his work at the Armory. He went next to Amsterdam, on October 7; Berlin on the 8th; and Munich on the 13th. When Kuhn arrived in Paris on October 25, he began by visiting American artists who were working there—Alfred Maurer, Jo Davidson, and Walter Pach. By

Walt Kuhn. Receiving word while painting in Nova Scotia of a great European art exhibition, Kuhn sailed to Germany and began assembling work for the Armory Show. Archives of American Art, Smithsonian Institution, Washington, D.C.

now overwhelmed with the magnitude of the project, he cabled Davies for assistance. Davies sailed on the S.S. *Minnehaha* on October 26, and arrived on November 6. Kuhn spread the word among dealers and artists about the great exhibition to take place in New York, and about a growing art market in America—certainly more hope than reality. He also was introduced by Jo Davidson to the Chicago lawyer Arthur T. Aldis, who expressed interest in the exhibition for the Art Institute.

Davies and Kuhn were shepherded around Paris by Walter Pach, whose knowledge of the Parisian scene was critical to their success. He took them to meet the Steins, to Puteaux to see the Duchamp-Villon brothers, to the studios of Brancusi and Redon. Davies bought Brancusi's marble *Torso* for himself, and he told Pach that Redon's *Roger and Angelica* was sold. It would go to Lillie P. Bliss, whom he advised. After seeing Redon, Davies concurred with Kuhn's view that his work should be featured, no surprise given his own Symbolist proclivities. Pach led them as well to Bourdelle and Archipenko, and to Elie Nadelman, Patrick Henry Bruce, and Morgan Russell. They also visited numerous dealers, and requested loans from Bernheim-Jeune, Uhde, Kahnweiler, Vollard, and Emile Druet, who sent over a hundred items. Their efforts brought them a full complement of van Gogh, Gauguin, and Cézanne, and a wide spectrum of strong works by Divisionists, Fauves, and the new Cubists. After appointing Walter Pach their European agent, the two painters set off for London on November 12.

In London they visited Roger Fry's Second Post-Impressionist Exhibition, which had opened a few weeks earlier at the Grafton Gallery. This was the sequel to Fry's exhibition of Manet and the Postimpressionists, held in the same location at the end of 1910, which had introduced the new painting to London. Unlike that first exhibition, the second contained Russian and English work, but the French, of course, were the stars. Matisse was the highlight, with forty-one works, followed by Picasso with sixteen. Yet Kuhn and Davies were not especially impressed, for they felt that they had secured a larger selection of greater range and historical depth for New York. Since Fry's show contained nothing earlier than Cézanne, and the Armory Show, like the Sonderbund, featured the earlier masters van Gogh and Gauguin, they were right in this. But they immediately cabled Pach to obtain as much Matisse as he could, asking him to have the Steins encourage the artist to loan them the works at Grafton as well as more from the studio. They especially wanted the great plaster of Matisse's *Back I*, which did come to America along with the rest. After making arrangements for loans from the Grafton Gallery exhibition, they finally departed Liverpool on the S.S. *Celtic* on November 21. On the voyage home, Kuhn translated the excerpts from Gauguin's *Noa-Noa* that they would publish as a pamphlet, and a series of van Gogh's letters, which in the end were not printed.

A press release was issued on December 12 stating that 399 paintings and 21 sculptures had been secured for the exhibition, and that there would be separate rooms devoted to Cézanne, Redon, Gauguin, van Gogh, Matisse, the Cubists, and the Futurists. By the time that the full Association heard Davies's report on December 17, it was clear that the show would, to say the least, offer a great challenge to the American artists. There was a Domestic Committee responsible for organizing the American works, chaired by William Glackens. They sent invitations to specific individuals asking for work by January 1, but advance publicity set off a cry by the uninvited. So the Domestic Committee agreed to jury such work on January 20–26, and as a consequence, many of the future American modernists entered the exhibition, including Oscar Bluemner, Stuart Davis, Andrew Dasburg, Edward Hopper, Joseph Stella, and William and Margaret Zorach.

Publicity was a major activity, and the Association had good press contacts.

Arthur B. Davies. Davies was elected as a mild-mannered leader of the Association of American Painters and Sculptors, but his aggressive inclusion of European modernism in the Armory Show changed the course of American art. As Guy Pène du Bois would remark, a "dragon evolved from that very gentle cocoon." Archives of American Art, Smithsonian Institution, Washington, D.C.

Public relations were handled by Walt Kuhn and Frederick James Gregg, a former writer for the New York *Evening Sun*. From the first they sought national publicity, contacting editors and writers across the country, sending press releases and eventually stories and photographs. As Kuhn wrote to Edward Gewey at the Kansas City *Post*, "We are doing this according to American methods and have already spent a good deal of money on advertising."[7] Color posters were printed featuring the symbol of the exhibition, the pine tree flag of the American Revolution, and these were disseminated nationally to colleges, libraries, and museums. Packets of ten color postcards reproducing the poster were distributed without charge. The Association even considered renting an electric billboard in Times Square.

There was much printing to be done in addition to these publicity materials, and its scale is suggested by the initial order of fifty thousand catalogues. Catalogue preparation was one of the most difficult tasks, for works continued to be added to the exhibition up to the last moment. But somehow the catalogue arrived for the first day of the exhibition on February 18. A supplement was printed correcting errors, listing additions and deletions, and since the catalogue had been printed before the show was hung, there was an index indicating the location of every work. The organizers also published four pamphlets that were sold at the show: A translation by Pach of Elie Faure's long essay on Cézanne, Kuhn's translations from *Noa-Noa*, and two essays written for the occasion by Pach, one on Redon and the other on Duchamp-Villon's *Maison Cubiste*, "A Sculptor's Architecture." Completing the publication effort was a set of half-tone postcards, one showing the interior of the Armory with the show fully installed, and fifty-six photographs of exhibited works, half foreign and half American.

After Kuhn and Davies returned from Europe, the Association rented an office in the Camera Building on East 25th Street, and as the show approached they took more office space as well as a stable on 32nd Street to accommodate the works arriving from Europe. There were some worrisome days in January as storms at sea delayed for a week the arrival of the S.S. *Mexico*, but it landed on the 13th, followed three days later by the S.S. *Chicago* with the rest of the European loans. Things by then were moving at a hectic pace, as new American works were juried, American loans arranged, and plans drawn for the layout of the exhibition itself and the fabrication of structural supports. Of course, there also was some internal politics. Although the membership meeting on January 22 officially approved Davies's arrangements for the exhibition, things were soured at the beginning of February by the resignation of Gutzon Borglum over the lack of attention given to sculpture and the rejection of his conservative selections as head of the Sculpture Committee. He later would characterize the show as a "farcical and foolish exhibition made up largely of paranoics."[8]

Davies conceived of the exhibition in an historical way, tracing the development of the modern movement from its roots in the nineteenth century. His general view of the Europeans was sketched in a chart published in the special exhibition issue of *Art and Decoration* (March 1913), edited by Guy Pène du Bois. There Davies identified three tendencies: Classicists, beginning with Ingres and Corot, extending through Cézanne, Gauguin, and Matisse, and culminating in Picasso and the Cubists; Realists, moving from Courbet, Manet, and most of the Impressionists to, again, Cézanne, and leading to the Futurists; and Romanticists, from Delacroix and Daumier to van Gogh and, appearing again, Gauguin. At the Armory the contemporary Americans also were given historical precedents, in the work of Whistler, the Impressionists Theodore Robinson and John Twachtman, and the important rediscovery of Albert Pinkham Ryder.

The physical arrangement of the eighteen octagonal rooms of the exhibition centered on the Europeans, with a row of six rooms on each of the north and south walls mostly showing American works. Entry was through the room of American sculpture, commanded by George Grey Barnard's marble *Prodigal Son*, from which one could walk straight ahead to the large room of French painting and sculpture. Off to the left was the show's main attraction, the Cubist room—known as the Chamber of Horrors—with the lines waiting to see Duchamp's *Nude Descending a Staircase*.[9] There were about 1,300 works in the exhibition, a third European, and many a visitor must have echoed Prendergast's remark when he came down from Boston to see the show: "Too much—O my God!—art here."[10] Amazingly, MacRae's diary indicates that the entire exhibition was hung in two days, beginning on the 13th. The process was facilitated by Davies preparing a watercolor sketch of every room, as he later would

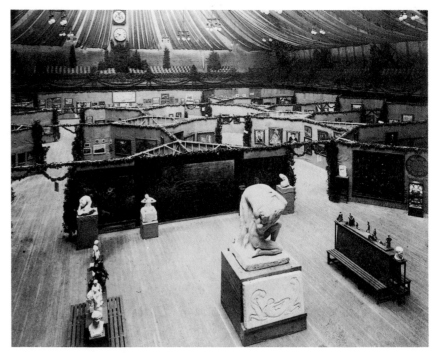

Installation view of Gallery A at the Armory Show. In the foreground is the entry room of American sculpture, featuring George Grey Barnard's Prodigal Son. *Archives of American Art, Smithsonian Institution, Washington, D.C.*

Entrance to the Armory Show on Lexington Avenue at 25th Street, New York City, 1913

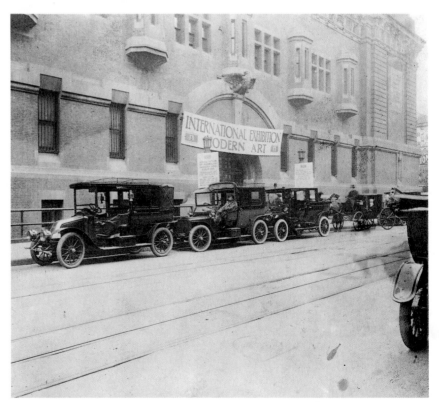

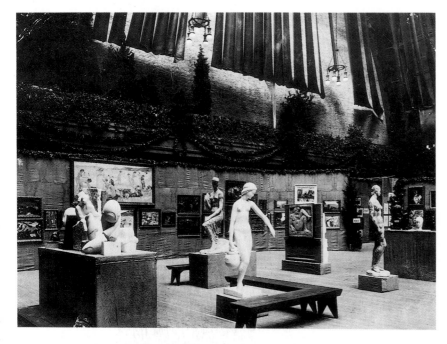

Installation view of Gallery H of the Armory Show. On the pedestal to the left is the plaster of Constantin Brancusi's Mlle. Pogany, described by a critic as "a hardboiled egg balanced on a cube of sugar." In the center of the gallery is Wilhelm Lehmbruck's Kneeling Woman, compared to a praying mantis by Teddy Roosevelt. Archives of American Art, Smithsonian Institution, Washington, D.C.

plan a complete layout for the show in Chicago.

By the time of the press preview on Sunday the 16th, the Armory had been decorated with pine trees, yellow cloth streamers forming a canopy from the ceiling, and garlands of greenery hung from the partitions and along the walls. All of the planning and preparations had cost a great deal of money, which had been raised by Davies and Clara Davidge among their society friends. But the organizers had high hopes that they would more than cover their expenses through admissions receipts, sale of publications, and optimistically, art work. They were not disappointed.

Although the reaction of the public and the press eventually was overwhelming, it did not start out that way. Certainly on the evening of February 17 the opening crowd of 4,000 was impressed by what the Association had accomplished. John Quinn in his speech touted the show as the most complete modern art exhibition of the past twenty-five years, and initial press coverage was positive. The *Sun* called the exhibition "sensational" and "an event not on any account to be missed," and the *Evening Post* noted, "In half an hour's visit . . . one may meet with ridicule, rage, helpless questioning, and savage enthusiasm, but not with indifference."[11] Yet the crowds at first did not come.

Three weeks into the exhibition, however, attendance began to mount, and it grew in the last week to a peak of approximately 10,000 on the final day. At best estimate, the total was close to 88,000.[12] On that last day—Saturday, March 15—lines circled the block, traffic jammed the streets around the Armory, and the doors had to be closed from 2 to 4 P.M. because of overcrowding. For by then the opposition press had marshaled its forces, providing many comic interpretations of Duchamp's *Nude Descending a Staircase* and describing Brancusi's *Mlle. Pogany* as "a hardboiled egg balanced on a cube of sugar." Even the sympathetic New York *American* entitled its February 24 piece on the show, "Is She a Lady or an Egg?"

Indeed, history has best remembered these attacks on the European art in the press, and here Matisse elicited the strongest reaction. The Boston *Transcript* of Febru-

ary 17 noted that "Among all these painters there is none whose work appears as perfectly childish, crude and amateurish," and the *New York Times* on February 23 exclaimed that "his pictures are ugly . . . they are coarse . . . they are narrow . . . they are revolting in their inhumanity."[13] The conservative critic Kenyon Cox claimed that, contrary to popular opinion, "it is not madness that stares at you from his canvases, but leering effrontery," and that "many of his paintings are simply the exaltation to the walls of a gallery of the drawings of a nasty boy."[14] For the Princeton professor F. J. Mather, Jr. in the *Nation*, Matisse's "is an art essentially epileptic."[15] During the last week of the exhibition the *Times* published a long interview with Matisse, conducted the previous summer by Clara T. MacChesny, in which the artist appeals to her to tell America that he is "a normal man, . . . a devoted husband and father" who indulges in the sort of domestic existence one would expect of a lawyer or a doctor.[16] It is unlikely that his plea would have affected author Carey Sheffield, interviewed by the New York *Evening Journal* laughing loudly before the work of Matisse and Picasso: "Well, if I caught my Tommy making pictures like that, I'd certainly give him a good spanking." The interviewer continued in the same vein on Kandinsky's *Improvisation 27*, which was purchased by Stieglitz: "just a page out of little Willie's copy book after he stole his sister's crayons."[17]

If Matisse provoked the most vituperation, Duchamp's notorious picture prompted the most hilarity. *American Art News* noted during the first week of the show, on February 22, that this painting "is already the conundrum of the season in New York. . . . no one has been able to make out of what looks like a collection of saddle bags, either the lady or the stairway"; and in the March 1 issue L. Merrick suggested that the work, which "draws shrieks and laughter from the crowds who gather around it eight deep," be renamed "Profit," given its role in increased admissions receipts. Having offered a prize of $10 to anyone who solved the puzzle of the "Nude Lady Descending a Staircase," *American Art News* on March 8 awarded the money for a poem identifying the lady as a man. It also published a selection of other responses, many as serious as Minnie Hendick's from New Haven: "Turn the picture upside down and look at it from the left, at about one-half inch from margin and two and one-half inches from bottom, you will see a tiny but discernible nude lady with flowing hair—descending stairs." In Pittsburgh, the *Chronicle Telegraph* suggested that readers hold the photograph of the work close to their eyes and move the newspaper side to side until the "well-rounded form of a woman becomes visible."[18] Responding to an editorial in the *Herald*, which referred to the image as a "pile of kindling wood," a Josephine Tighe wrote that it actually shows a woman falling down the stairs, and that so viewed "it is not only correct but replete with vivid sensations of the most bumpy variety. I know, for I recently fell down a long and hardwood flight." The editor suggested that the hanging committee erect a steep staircase before the picture for viewers to test this interpretation. Probably the most well-known view of the painting was published by Julian Street in his satirical piece "Why I Became a Cubist"—though his "explosion of a shingle factory" echoed an earlier critic's remark on a Prendergast in the exhibition of The Eight, "an explosion in a color factory."[19]

Despite the fact that the Italian Futurists refused to participate in the Armory Show because they were not given their own exhibition space, the name was bandied about in the press. The day of the opening the headlines in the *World* read "Nobody Who Has Been Drinking Is Let In To See This Show. He'd Have Bellevue For Next Stop After Futurist Art Exhibition, Scoffers Assert," and the *Times* interview with Kenyon Cox was headed "Cubists and Futurists are Making Insanity Pay." In his piece on the show Theodore Roosevelt spoke of its Futurist contributors as like "paleolithic artists of the French and Spanish caves."[20] Futurism here joined Cubism as a generic

term for the new art—in both New York and Chicago the exhibition often was called "the Cubist show."

Theodore Roosevelt's was one of the more famous visits to the exhibition, and the former president was shown around by Davies, Gregg, Kuhn, and his artist friend "Sheriff" Bob Chanler, whose decorative screens were a hit of the exhibition. Instead of attending Woodrow Wilson's inauguration on March 4, Roosevelt went to the Armory, and he published his account later in the month as "A Layman's View of an Art Exhibition." There T.R. extolled the strength of the American artists and denigrated the European "lunatic fringe," unfavorably comparing Duchamp's nude to the Navaho rug in his bathroom, Archipenko's *Family Life* to a set of children's blocks, and Lehmbruck's kneeling woman to a praying mantis. Another well-known visitor was the tenor Enrico Caruso, who entertained the public one Saturday by giving away his caricatures of the paintings drawn on exhibition postcards. And it is said that Mrs. Astor came every morning after breakfast, well able to afford the special $1 admission charged on weekday mornings to allow for quiet viewing apart from the crowds, who paid 25 cents in the afternoons, evenings, and weekends.

For the artists who visited the show, the experience inevitably was traumatic in one way or another. As Walt Kuhn remembered, "Old friends argued and separated, never to speak again. Indignation meetings were going on in all the clubs. Academic painters came every day and left regularly, spitting fire and brimstone—but they came—everybody came."[21] For the poet William Carlos Williams, who would become involved with the painters of the Grantwood artists' colony and the Arensberg salon, ". . . it was not until I clapped my eyes on Marcel Duchamp's *Nude Descending a Staircase* that I burst out laughing from the relief it brought me! I felt as if an enormous weight had been lifted from my spirit for which I was infinitely grateful."[22] Confronting this amount of radical art was a revelation even for those who had seen Stieglitz's shows in his small space at 291, exhibitions of Rodin drawings in 1908 and 1910, works by Matisse in 1908 (his first one-man exhibition outside of France), 1910, and 1912 (the first exhibition of Matisse sculpture anywhere), and eighty-three Picasso works on paper in 1911. It fixed modernist innovation indelibly in the minds of American artists, something not immediately welcomed by many of the local exhibitors. As Stuart Davis, one of the most positively affected, remarked with characteristic verve, "In retrospect it . . . suggests a masochistic reception whereat the naive hosts are trampled and stomped by the European guests at the buffet."[23]

The only European guest to actually attend the buffet was Francis Picabia, who, after Matisse and Duchamp, seems to have been most frequently mentioned in the press. Picabia gave many interviews, and with European charm and critical intelligence promoted the avant-garde cause, and his own, in society and in the press. While his statements seem straightforward enough now, to the uninitiated American public they could seem obtuse, and the *Sunday World* offered a prize for the best 150-word elucidation of one of his comments. Picabia became involved with Stieglitz during this visit, and immediately after the Armory Show there was an exhibition at 291 of sixteen of his New York studies. The artist and his wife, Gabrielle Buffet, would return during the war in 1915, and along with Duchamp, another expatriate of that year, he would develop around the Arensberg circle those activities to be known as New York Dada.

During the Armory exhibition Stieglitz had a show of thirty of his own photographs, something that he never had done before. Established in 1905 as the gallery of the Photo-Secession, his establishment soon was known as 291 for its Fifth Avenue address. (Actually, in February 1908 the gallery moved across the hall to what was really 293 Fifth Avenue, the two buildings having been combined.) Stieglitz began showing nonphotographic works in 1908 with an exhibition of Rodin drawings, sent to him

Wassily Kandinsky. Improvisation Number 27: The Garden of Love, *1912. Oil on canvas, 47⅜ x 55¼ in. The Metropolitan Museum of Art, New York, The Alfred Stieglitz Collection 1949. The only Kandinsky in the Armory Show, this painting was purchased by Alfred Stieglitz for $500.*

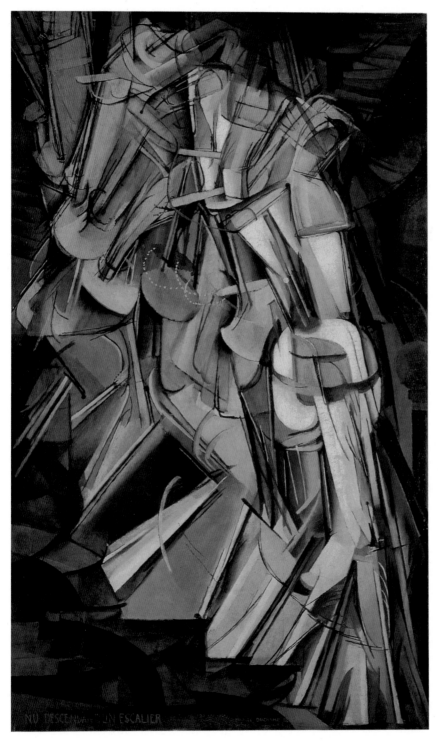

Marcel Duchamp. Nude Descending a Staircase, No. 2, *1912. Oil on canvas, 58 x 35 in. Philadelphia Museum of Art, The Louise and Walter Arensberg Collection. Displayed in what was called the "Chamber of Horrors," this painting became the most notorious work in the exhibition. It was the subject of a contest in* American Art News, *which offered $10 to whoever could locate the nude lady. It was purchased for $324 by a dealer in Japanese prints from San Francisco, Frederic C. Torrey.*

from Paris by photographer Edward Steichen, who would become his primary contact with Matisse. In addition to the French moderns, 291 displayed its stable of advanced American painters, children's drawings, and eventually primitive art and the sculpture of Brancusi. At the time of the Armory Show, critics frequently mentioned Stieglitz's role as precursor—even the conservative Royal Cortissoz of the *Tribune* applauded "his delightful breadth of mind, his enthusiasm for liberty and all those who fight for it"[24]—and an extensive interview was published in the New York *American* on January 26 as background for the show. Stieglitz ends with some advice for visitors: "Put yourself in an unprejudiced mental attitude, in a receptive mood. . . . Remember that what you have been accustomed to call 'art' is deader than Ramses. . . . Finally, if you decide that you would rather art stay dead, then go out with your kodak and produce some faithful imitations. Good machine work is always preferable to indifferent hand-made products."

Since 1903 Stieglitz had published *Camera Work*, which expanded beyond its photographic origins to become an elegant journal of advanced writing on the modern movement, reproducing works in all media. For the Armory Show he prepared a special June number, opening with Gertrude Stein's "Portrait of Mabel Dodge at the Villa Curonia" followed by Mabel Dodge's explication of Stein's writing and its significance for the modern art. It also included a paean to the irrational by Benjamin De Casseres, and a long critique of the show at the Armory by Oscar Bluemner, which praised the public for having more intelligence than the critics. But the new influence of Picabia was especially clear, with articles by Gabrielle Buffet and Maurice Aisen focusing on his work. The artist himself contributed a piece in French, "Vers L'Amorphisme," with high irony declaring the elimination of form, illustrated in proto-Dada fashion by two blank squares said to show works of a Popaul Picador.

The Mabel Dodge essay on Stein originally was written for the special March 13 issue of *Art and Decoration*, edited by Guy Pène du Bois and sold at the Armory. The journal served as a full introduction to the exhibition, including the catalogue preface by Davies and his chart of the modern movement, du Bois's elaboration of Davies's historical account, pieces by Glackens and Gregg on American art in the show, and an essay by Quinn "from a Layman's Point of View." Mabel Dodge had been approached by Gregg in January to write something on her friend Gertrude Stein, and her essay brought Stein's work to a much broader public, which would come to embrace the writer's own identification of her style with the new Cubist painting. It was presented as an article "about the only woman in the world who has put the spirit of post-impressionism into prose, . . . written by the only woman in America who fully understands it."[25] That same month Dodge established her well-known salon at 23 Fifth Avenue, frequented by a broad spectrum of radicals in politics and the arts, from Lincoln Steffens, Hutchins Hapgood, John Reed, and the I.W.W. organizer "Big Bill" Haywood—who had come to the area because of the great Paterson strike of textile workers—to Jo Davidson, Andrew Dasburg, Marsden Hartley, and Carl Van Vechten, who would make her a central character of his 1922 novel *Peter Whiffle: His Life and Works*.[26] To accompany her essay, Dodge had promised Guy Pène du Bois the Gertrude Stein piece written during her stay with Dodge in Florence in October 1912, which begins "The days are wonderful and the nights are wonderful and the life is pleasant." But when Stieglitz, who had published Stein's portraits of Picasso and of Matisse in August 1912, wanted to set the Villa Curonia work next to Dodge's in the Armory Show issue of his more elite publication, she pulled the Stein from *Art and Decoration*. Yet it was through *Art and Decoration* that Stein became associated with the Armory Show, leading the press to mock her prose along with the art.

Press artists had as much fun with the show as did the writers, as in J. F. Gris-

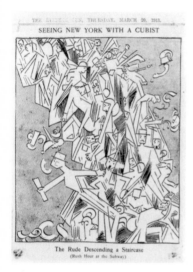

J. F. Griswold's "Seeing New York with a Cubist: The Rude Descending a Staircase (Rush Hour at the Subway)." In The Evening Sun, *March 20, 1913.*

wold's series of cartoons in the *Evening Sun* in March, "Seeing New York with a Cubist." Political cartoonists took up the Cubist theme as well, with John T. McCutcheon in the *Evening Sun* of April 9 showing Woodrow Wilson proudly painting a falling faceted figure entitled *Tariff Descending Downward.* A slew of humorous verses were printed; Mary and Earl Lyell published *The Cubies ABC*, with each letter of the alphabet lampooning some part of the show; and there were such mocking events as an exhibition by the "Academy of Misapplied Arts" for the benefit of the Lighthouse for the Blind.

Not all of the criticism in the press stemmed from ignorance, however, as some writers were fairly familiar with modern art. For instance, Royal Cortissoz had been to Paris and seen the Futurists at Bernheim-Jeune, and his account of their work is clear and accurate. The opposition of such critics emphasized two points, that the new work stemmed from a wholly individualistic point of view—"what he chooses to do in art is right because he chooses to do it"[27]—and that these artists lacked traditional craft and skill. There also were criticisms of the exhibition from inside the modernist camp, as when the astute Christian Brinton complained that the show did not include the artists of Die Brücke, the Blaue Reiter, the NKVM, the Berlin Neue Sezession, and the Italian Futurists.[28] With only Kirchner and Kandinsky representing the new painting from Germany, and knowing how much German art Kuhn had seen in Cologne, the anti-German bias seems clear. Gregg explained that the organizers felt recent German work to be largely derivative from that of the true innovators, the French, and the AAPS even had answered requests for participation from Die Brücke and the Neue Sezession by falsely stating that the show already was complete.

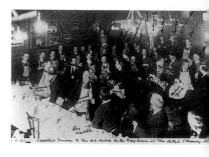

Beefsteak dinner held by Armory Show organizers for "our Friends and Enemies of the Press," Healy's Restaurant, 66th Street and Columbus Avenue, New York City, March 8, 1913. Archives of American Art, Smithsonian Institution, Washington, D.C.

There was some dissension within the avant-garde around the exhibition, in addition to the well-known unhappiness of the more realistically inclined American painters. Max Weber, who had loaned seven works by his Paris friend Henri Rousseau, refused to be included when only two of his own paintings were to be exhibited. From the French side, Robert Delaunay demanded that his work be removed from the exhibition because his huge *City of Paris* was not hung in the final installation. Although marked in the catalogue supplement as never having arrived, the large work was sent rolled and was to be restretched by Delaunay's friend, the painter Samuel Halpert. After Davies did not exhibit the painting, Halpert came to remove Delaunay's other pieces, and in solidarity the American Patrick Henry Bruce, working in Paris, demanded that his work be taken down as well. Davies and company refused to do so, but when the exhibition moved on to Chicago and Boston no Delaunays or Bruces were included. In Paris, the journal *Montjoie* attacked the Armory Show for its injustice to Delaunay and, ironically, for its poor installation of the French art.

Aware of how much the newspapers had contributed to their success, the AAPS invited "our Friends and Enemies of the Press" to a "beefsteak dinner" on March 8 at Healy's Restaurant at 66th and Columbus. All of the critics were there, along with Stieglitz and Quinn, and spirits were high. Waitresses sang and danced, speeches were made, comic telegrams were read. But Royal Cortissoz probably expressed the feelings of many who were both excited and disturbed by the exhibition, as he ended his speech: "It was a good show, but don't do it again."[29]

As it would turn out, it did not have to be done again, for the Armory Show triggered the sort of interest in the new art that ordinarily would have taken years to develop. Not confined to the art world, this interest was general, reflected in popular forms like the full-page ad for the John Wanamaker Store in the *Evening Sun* of March 13—"Color-Combinations of the Futurists, Cubist Influence in Fashions in the new Paris Models for Spring . . . At last the modern spirit is developing in the realm of women's dress." The show also made enthusiasts of many who would influence things

in years to come, such as the thirteen-year-old Betty Parsons, future dealer of Jackson Pollock and the Abstract Expressionists, and Walter Arensberg, who saw the exhibition on the last day and would move down from Boston to be at the center of modernist developments in America.

Although he initially bought only a Vuillard lithograph, which he exchanged for a small Villon painting when the show was in Boston, Arensberg would go on to amass the country's preeminent collection of avant-garde art, and his example highlights the impact of the exhibition on American collecting. For with Walter Pach as sales manager, helped by assistants working on commission, the new art did sell. In all, 174 works were sold, 123 foreign and 51 American, with gross sales coming to $44,148.75.[30] The most money was spent by John Quinn, who paid $5,808.75 for twenty works by Derain, Duchamp-Villon, Manolo, Redon, Signac, Villon, Eugene Zak, Walt Kuhn, and Edith Dimock (Glackens's wife), among others. Next came the Chicago lawyer Arthur Jerome Eddy, said to have been the first man in Chicago to ride a bicycle and to own an automobile, who purchased eighteen paintings and seven lithographs. He initially visited the show on February 27, and with a slow start of two works returned on the 29th and the 30th, each day buying more, including Gleizes's *Man on the Balcony* ($540), Picabia's *Dance at the Spring* ($400), and Duchamp's *King and Queen Surrounded by Swift Nudes* ($324). Eddy continued his acquisitions after the exhibition moved to Chicago, and went on to write one of the first books on modern art to be published in America, *Cubists and Post-Impressionism* (1914). Davies added to his own collection sculptures by Manolo and Duchamp-Villon, and paintings by Picasso and Villon, purchases totaling $648. And in addition to Kandinsky's great *Improvisation*, which cost him $500, Stieglitz bought a Manolo, a Davies drawing, and five drawings by Archipenko. Important collections also originated at the Armory, such as that of Lillie Bliss. Beginning there with Redon and assorted prints, under the direction of Davies, and then Pach, she assembled the stunning group of modern paintings, including twenty-six Cézannes, that would anchor the Museum of Modern Art at its founding in 1929.

The first Cézanne to enter an American museum, his *Colline des pauvres*, was sold for $6,700 to the Metropolitan Museum of Art, making it the most expensive purchase of the exhibition. Perhaps the best buy was also the most notorious, Duchamp's *Nude Descending a Staircase*, acquired by the San Francisco print dealer Frederic C. Torrey for $324. Torrey exhibited it in Portland, Oregon and in California, and was so enamored of the work that he went to Paris to meet Duchamp. (In 1919 Torrey would sell his prized picture to Arensberg through Pach for $1,000, removing from his home a cause of friction with his wife and a source of embarrassment to his daughter.)[31] All of the Duchamp brothers sold well, in fact, Duchamp-Villon selling three of his four sculptures, Marcel Duchamp selling each of his four paintings, and Villon selling all nine of his. And justifying the faith of Kuhn and Davies, Redon's commercial success matched his fine critical reception, with thirteen works on paper and twenty paintings sold by the end of the show's last venue.

The exhibition diminished in size as it traveled, with the American section in Chicago including only works by the members of the AAPS, and the Boston show containing foreign art alone. But in Chicago, during its three and a half weeks at the Art Institute, over 100,000 *more* people visited the exhibition than had done so in New York. The twelve extant photographs show an installation more elegant than was possible on the temporary dividers of the Armory, and the large galleries enabled the 634 works to be grouped more intelligibly. If the Chicago exhibition was more refined in appearance, however, the response of the public certainly was not.

In anticipation of the opening, the Chicago *Record-Herald* on March 20 tried

Odilon Redon. Roger and Angelica, ca. 1910. Pastel on paper on canvas, 36½ x 28¾ in. Collection, The Museum of Modern Art, New York, Lillie P. Bliss Collection. When Arthur B. Davies visited Redon's Paris studio in November 1912, he selected Roger and Angelica *both for the exhibition and for the collection of Lillie P. Bliss, who would include it in the Museum of Modern Art's first major bequest.*

to prepare its readers for what they would see:

> Cubist Art—The portrayal in one perfectly stationary picture of about 5,000 feet of motion pictures: a "woosy" attempt to express the fourth dimension.
>
> Futurist Art—Same as the former, only more so, with primeval instincts thrown in; Cubism carried to the extreme or fifth dimension.
>
> Post-Impressionism—The other two thrown together.
>
> How to Appreciate It—Eat three welsh rarebits, smoke two pipefuls of "hop" and sniff cocaine until every street car looks like a goldfish and the Masonic Temple resembles a tiny white mouse.[32]

The Chicago press was even more intent than the New York newspapers on identifying the unfamiliar and bizarre, and the public was more sensitized to the morally dangerous. The president of the Chicago Law and Order League strongly objected, and an investigator from the vice commission concurred that the "Futurist" art was immoral, noting also that one of the figures in Matisse's *Le Luxe* had only four toes.[33] In response to the moralistic mood in Chicago, the Association's pamphlet of provocative excerpts from *Noa-Noa* was taken out of circulation. Pach, Gregg, and Kuhn, who had come to coordinate things and handle public relations, felt that Chicago needed a more balanced view of the exhibition. They therefore published another pamphlet with articles both pro and con, *For and Against*.

Installation of the International Exhibition of Modern Art at the Art Institute of Chicago, Gallery 53, March 24–April 16, 1913. Photograph courtesy the Art Institute of Chicago

The conservative instructors at the school of the Art Institute were especially averse to the exhibition, lecturing their charges on the ills of the new work, and encouraging student reaction. Although plans to hang Matisse, Brancusi, and Pach in effigy were shelved, the end of the exhibition on April 16 was celebrated with a mock trial of the dummy Henri Hairmatress, and imitations of Matisse's *Le Luxe* and *Blue Nude* were burned.

There were requests for the exhibition to go to St. Louis, Kansas City, Milwaukee, Baltimore, Washington, and Toronto, but the only other venue was Boston, where it was shown at Copley Hall. Because no large exhibition space was available, it was decided to send only European works to Boston, and less than three hundred of these were shown. Kuhn felt that this concentration of modern European art actually made a better exhibition than the original. Attendance, however, was unimpressive at about 13,000. The wind seems to have gone out of the show's sails after the months of national attention, and from Boston the works went back to New York for return to their old and new owners.

Despite the great success of the Armory Show, the remaining days of the AAPS were not happy ones. The focus of attention on the new European art had turned the tables on the artists of the Henri group. Before 1913 these American Realists had been considered most advanced, at least to a public unaware of 291, but they now found themselves viewed as old-fashioned. The inertia was with the developing American modernists, many of whom had been to Europe and had allied themselves with the Europeans, and the sense of betrayal was palpable. Davies and his associates held no general membership meeting until the spring of 1914, where things fell apart over an attempt by the Henri group to replace the leadership. The organization limped along for two more years, when accounts finally were cleared with the U.S. Customs Office. It presented no more exhibitions, yet as a consequence of its efforts an environment had been created in which others would do so. The headline in the *Sun* as the exhibition left New York—"Cubists Migrate, Thousands Mourn"—turned out to be a bit premature, for they soon returned.

Actually, the Cubists first reappeared in New York under the auspices of Gimbel Brothers in July 1913, with a traveling exhibition of ten paintings organized by

the department-store chain. Attempting to capitalize on Armory Show publicity, Gimbels began the show at their Milwaukee headquarters in May and sent it along to stores in Cleveland, Pittsburgh, New York, and Philadelphia. There were paintings, some major, by Léger, Metzinger, Pierre Dumont (none of whom was included in the Armory Show), Gleizes, Jacques Villon, and two obscure Hungarians, all purchased by agents in Paris for $100 apiece.[34]

Stimulated by interest in the department-store exhibition, the Pittsburgh Art Society organized a show of American Cubists and Postimpressionists for December and asked Davies to select the pictures. Among the forty works were those of his AAPS colleagues Pach, Glackens, Prendergast, Kuhn, and MacRae, along with Morton Schamberg, Charles Sheeler, and Joseph Stella. About thirty of these paintings were included in the Davies-organized exhibition at the Montross Gallery in February 1914. The organizers of the Armory Show, in fact, were instrumental in the ongoing exhibition of new art in New York, where between 1913 and 1918 there were close to two hundred fifty shows of modern painting and sculpture.[35]

The largest of these, the first exhibition of the Society of Independent Artists in April 1917, almost seems an Armory Show reunion, presided over by officers Glackens, Pach, and Prendergast, with legal assistance from John Quinn. But it was governed by the spirit of the new American modernism of the combined Stieglitz group and Arensberg circle, on whom press commentary centered. It was an immense exhibition of 2,500 works displayed over two miles of aisles, alphabetically arranged by artist. All work entered was accepted, except for the urinal submitted surreptitiously by Duchamp as the *Fountain* of R. Mutt. The Europeans who were exhibiting—including Brancusi, Matisse, Derain, Picasso, and Delaunay—elicited no special notice.[36]

For by this time modern European art was a relative commonplace in New York. Soon after the Armory Show one obstacle to its exhibition had been removed, with John Quinn's successful fight for repeal of the 15 percent import duty on art less than twenty years old. And with the interest stimulated at the Armory, especially that of socially prominent collectors, new galleries and a new market blossomed. These new establishments actively exhibited American modernist painting and sculpture as well as European, but many felt that the Americans were getting the short end of the stick. The most focused response was the Forum Exhibition, held in March 1916 at the Anderson Galleries, which displayed about two hundred works by seventeen artists. They included the Synchromists, many members of the Stieglitz group, Man Ray, Charles Sheeler, and the Zorachs. Criticizing the neglect of American art since the Armory Show, the catalogue attacked the new galleries for directing so much attention to work of commercially desirable foreigners.

There is some irony in the reaction of American modernism to an exhibition instrumental in creating the conditions of its own existence. For while the Armory Show did not significantly influence the styles or greatly expand the knowledge of these American painters, many of whom already had worked in Europe, it did foster an environment receptive to their efforts. Bringing modern art to the attention of a greater public, inspiring collectors and patrons, creating a market in which galleries could survive, the Armory Show was of signal importance for the new American art. Additional irony lies in the presence of Robert Henri on the organizing committee of the Forum Exhibition. For in ultimately securing a future for advanced art in the United States, the Armory Show laid the ground for the development of American modernist abstraction instead of American realism. This move toward abstraction, of course, was a world-wide phenomenon, yet in different circumstances it would be touted as the highest form of realism. To see this we must look at a very different group of artists, halfway around the globe.

CHAPTER 5 *In the Zero of Form*

0–10, The Last Futurist Exhibition of Pictures Petrograd, December 19, 1915–January 19, 1916[1]

Although interpersonal rivalry and sectarian dispute are characteristic of avant-garde activity, rarely have they been seen in as focused a form as the conflict between Kasimir Malevich and Vladimir Tatlin. Well developed by 1915 and never fully resolved, their mutual antagonism divided the artists around them and set the terms for much postrevolutionary polemic. It structured the layout of 0–10, The Last Futurist Exhibition of Pictures, where just before the opening Malevich and Tatlin reportedly came to blows. But despite personal antipathy and differences in temperament, these two artists were united by similarity of purpose. For each was seeking a more direct variety of realism, independent of illusionistic devices and relying on nonobjective forms uncontaminated by past image and artifice.

It was at 0–10 that the radical break came in Russian art, with the juxtaposition of Malevich's Suprematist paintings and Tatlin's counter-reliefs. Moving to complete abstraction, they both departed from the Cubist imagery of their colleagues and established the ground for the development of Russian art after the Revolution. The name of the exhibition referred to this new beginning, with Malevich in his manifesto proclaiming "I have transformed myself *in the zero of form* and have fished myself out of the *rubbishy slough of academic art*. I have destroyed the ring of the horizon and got out of the circle of objects, the horizon ring that has imprisoned the artist and the forms of nature."[2] The exhibition was to display a complete renewal in art, as Malevich wrote to the composer Matiushin in May 1915, "we intend to reduce everything to zero . . . [and] will then go beyond zero."[3] It was to be the Last Futurist Exhibition, the end of Western European domination of the Russian avant-garde, and the beginning of a new age. And despite the prevalence of Cubist-inspired work in the show, it did mark a divide of this kind, a break whose significance would become apparent only with the developments of the early 1920s.

The dream of a purely Russian art, uncontaminated by Western influence, had been most forcefully pursued in the Neoprimitivism of Mikhail Larionov and Natalya Goncharova. Dominating Russian art from 1908 to 1912, Neoprimitivism took its inspiration from the folk art of the peasants, from shop signs and hand-colored woodblock prints (*lubki*). Like the artists of the Blaue Reiter, the Neoprimitivists collected examples of such peasant work, and their embrace of unrefined forms was similarly directed to a search for honest and immediate expression.[4]

Toward the end of 1910 Larionov, Goncharova, and David Burliuk formed an exhibition society in Moscow, the Knave of Diamonds, holding their first show in December 1910–January 1911.[5] The exhibition was hung four rows deep and contained the work of the Georgian sign painter Niko Pirosmanashvili along with the Neoprimitivist paintings of Larionov, Goncharova, the Burliuks, Malevich, and others. But in addition to the Russians, there were many paintings from both Munich and Paris.

After this first exhibition the Knave of Diamonds split into Western and Eastern factions, with Larionov and Goncharova soon leaving the group in response to

Kasimir Malevich. Suprematist Painting, *1915. Oil on canvas, 40 x 24½ in. Stedelijk Museum, Amsterdam*

its growing European focus. As we know, David Burliuk maintained and developed his connections with Kandinsky, and in the second Knave of Diamonds exhibition in January 1912 many of the Blaue Reiter artists were represented, along with Kirchner from Berlin, and from France, in addition to Le Fauconnier and Gleizes, Matisse, Picasso, Delaunay, and Léger. Also included was the work of the "crazy doctor" Nikolai Kulbin, whose support of the St. Petersburg avant-garde brought poets and artists to camp in his consulting rooms. Kulbin himself was in close contact with Kandinsky, reading Concerning the Spiritual in Art to the All-Russian Congress in December 1911 and publishing the essay on "Free Music" in the *Blaue Reiter Almanac*. He and Burliuk, who wrote on "The 'Savages' of Russia" for the *Almanac*, organized evening debates to accompany this second show. At Kulbin's presentation Goncharova arose to condemn the Knave of Diamonds for excessive theorizing and to lecture the audience on Cubism. Her announcement of a new group, the Donkey's Tail, was greeted with derision, but she challenged her laughing listeners with the promise of an exhibition the next month.

Mikhail Matiushin, Kasimir Malevich, and Alexei Kruchenykh with Malevich's cover drawing for The Three *("Troe"), in Uusikirkko, Finland, July 1913.* The Three, *published by Matiushin in September, and containing poems and texts by Kruchenykh, Velimir Khlebnikov, and Elena Guro, with drawings by Malevich, also included the musical prelude to the Cubo-Futurist opera* Victory over the Sun.

The Donkey's Tail was named for the notorious incident at the 1910 Salon des Indépendants, when journalist Roland Dorgelès successfully submitted three paintings done by a donkey with a brush tied to its tail.[6] Here Larionov and Goncharova directly confronted the Burliuks' Western orientation, and coming just after the second Knave of Diamonds show and coinciding with David and Vladimir Burliuk's exhibition at the Sturm gallery in Berlin, the contrast was an emphatic one. The Donkey's Tail exhibition was the culmination of Russian Neoprimitivism, with over three hundred works displayed in the Moscow School of Painting, Sculpture, and Architecture. Larionov and Goncharova contributed about a third of the show, Tatlin exhibited fifty-one and Malevich twenty-four works, and Chagall was also represented.[7] Well attended due to Goncharova's agitation at the Knave of Diamonds lecture, the exhibition gained notoriety with the censor's confiscation of her paintings on ecclesiastical themes.

The Donkey's Tail also included a section of paintings sent by the St. Petersburg Union of Youth, an exhibition society and cultural club founded in the fall of 1909 by a group of artists and writers, including Elena Guro, Mikhail Matiushin, and Olga Rozanova. Although the Union of Youth maintained contacts with European artists and published in its journal such critical texts as manifestos of the Italian Futurists and excerpts from Gleizes and Metzinger's *Cubism*, its five exhibitions (1910–14) focused on advanced Russian painting, from Neoprimitivism to Cubo-Futurism. It supported the publication of members' books, visits by foreign intellectuals, including Marinetti in 1914, lectures and debates, poetry readings, and ground-breaking theatrical performances. Through these activities, enlivened by artists' cafés such as the Stray Dog and the Comedian's Hat, St. Petersburg—renamed Petrograd in 1914 and Leningrad in 1924—became an important avant-garde center. Artists traveled regularly between St. Petersburg and Moscow, and their group activities formed a single, though multiform and conflict-ridden, advanced culture.

The shifting alliances among members of the Russian avant-garde before the war are complex, with Larionov and David Burliuk as primary antagonists. After the group exhibition, the Target, in March 1913, at which Larionov and Goncharova introduced Rayonist abstraction, Larionov broke with the Union of Youth over its new affiliation with Burliuk and his associates. David Burliuk and his siblings had been active painters from early on—the *Golden Fleece* review of the Wreath exhibition in 1907 had complained that it was "jammed full and clogged up" with Burliuks[8]—but like many other artists they also became involved in the new experimentation with language. The result was the Hylaea group of poets, by 1913 also known as Cubo-

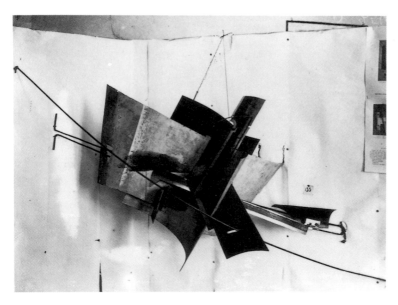

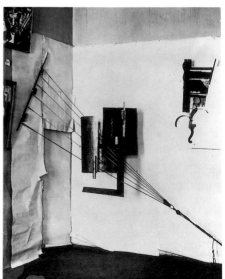

Futurists. Early interests in peasant and children's art developed into linguistic attempts to capture a more pure, prelogical state of mind, and the results were aggressively presented in collaborative text and performance. Their 1912 manifesto, published in the burlap-covered *A Slap in the Face of Public Taste*, proclaimed the right of poets to create completely new words out of an "insuperable hatred for the language that existed before them."[9]

The language created was called *zaum*, a contraction meaning "beyond significance," and it consisted of neologisms linked together with syntactic oddity, tonal peculiarity, and unanticipated juxtaposition. *Zaum* was to be independent of traditional patterns of thought and standard causal assumptions, appropriate to a world of radically different perception and consciousness. Nonrational intuition and chance phenomena were welcomed.[10] Emblematic of the uses to which *zaum* was put is the December 1913 production of *Victory over the Sun* in St. Petersburg, with text by Alexei Kruchenykh, music by Matiushin, and sets and costumes by Malevich. The work originated the previous summer at Matiushin's estate in Finland, where the three friends formulated plans for publications and performances designed "to destroy the antiquated movement of thought according to the law of causality, the toothless common sense, the 'symmetrical logic' . . ."[11] In the performance sponsored by the Union of Youth, Malevich's costumes reflect the cubistic forms of his current painting, but one of his sets, he later saw, was to anticipate the most startling image from 0–10: "The curtain depicts a black square, the embryo of all possibilities—in its development it acquires a terrible strength."[12]

The disjunctive language of *zaum* corresponded to contemporary developments in painting, with images dismembered under Cubist influence and reassembled in the alogical mode of works like Malevich's *An Englishman in Moscow*. Kruchenykh exclaimed, "We have cut the object! We have begun to see through the world!" and what appeared was taken to be a different perceptual order. When Matiushin translated passages of Gleizes and Metzinger's *Cubism* for the Union of Youth, he interpolated excerpts from Pyotr Uspensky's *Tertium Organum*, connecting French allusion to the Fourth Dimension with remarks about the higher consciousness to which artists

above left and right:
Installation of Vladimir Tatlin's large corner counter-reliefs at 0–10, The Last Futurist Exhibition of Pictures, Petrograd, 1915. Tatlin also allowed works by Liubov Popova and Nadezhda Udaltsova to be shown in this room, which he designated "Exhibition of Professional Painters." State Russian Museum, St. Petersburg

were said to have special access. In this new world that they were creating, Matiushin wrote in 1913, ". . . the conquered phantoms of three-dimensional space, of illusory drop-shaped time, and of cowardly causality . . . will reveal before everyone what they have always been in reality—the annoying bars of a cage in which the human spirit is imprisoned."[13]

The greatest of the *zaum* poets was Velimir Khlebnikov, student of ornithology and mathematics from Astrakhan on the Caspian Sea, obsessed with historical dates and calculations. Khlebnikov's first poetic success was his "Incantation by Laughter" of 1908, in which every word was derived from the term for laugh, *smekh*. For Khlebnikov words were primarily sounds and images, physical entities with which the poet worked. This materialist aspect of *zaum* would find its corollary in Tatlin's counter-reliefs, and it is no wonder that Khlebnikov was Tatlin's favorite poet, whose work he knew by heart and was said to recite in unforgettable fashion.[14]

Like the Italian Futurists, the Russians enjoyed provocative behavior and public scenes, appearing in the streets of Moscow and St. Petersburg in odd attire, with patterns painted on their faces, buttonholes decorated with radishes or wooden spoons. As Larionov and Ilya Zdanevich explained in *Why We Paint Ourselves* (1913): "To the frenzied city of arc lamps, to the streets bespattered with bodies, to the houses huddled together, we have brought our painted faces. . . . We have joined art to life. After the long isolation of artists, we have loudly summoned life and life has invaded art."[15] The tone is that of Marinetti and company, but the Russians protested any affiliation. Of course they were familiar with the Italians—Marinetti's 1909 manifesto was published in Russian just after its appearance in Paris, many of the important manifestos had been published in *Apollo* and by the Union of Youth, and David Burliuk had seen the Futurist show in Berlin in 1912. But Khlebnikov rejected the term *Futurist* in favor of *budetlyane* ("those who will be"), Goncharova criticized Italian Futurism as "emotional Impressionism," and in the fall of 1913 the poets held a wild performance in Moscow attacking Marinetti and asserting their own Futurist priority.[16] Marinetti responded with an angry letter to *The Russian Gazette*. His only visit to Russia came a few months later, in January 1914, and he arrived to a mixed reception. In Moscow, Larionov suggested that he be pelted with eggs, but Malevich defended Marinetti in a letter to the newspaper *Nov'*.[17] In St. Petersburg, Kulbin was his host and provided a cordial reception, though Khlebnikov distributed a highly critical leaflet at one of his lectures. Ironically, during Marinetti's visit David Burliuk, Mayakovsky, and Kamensky were on their extensive Futurist Tour of Russia, performing in seventeen cities in the south from December 1913 to March 1914. Their agitation brought a mixed response as well, with readings and speeches provoking a shower of gifts onto the stage, from candy and flowers to herring and a pike.

Though Italian Futurism was important for the Russian avant-garde, apart from a few exceptions—such as Malevich's *The Knife-Grinder*, shown at the Target, and Goncharova's more representational Rayonist works—the great influence in painting was that of French Cubism. Advanced French painting was assembled by Alexandre Mercereau for Vladimir Izdebsky's huge first Salon in Odessa, St. Petersburg, and Riga in 1910, and for the first and second Knave of Diamonds exhibitions in Moscow. By then the selections were largely Cubist, and Picasso and other Cubists continued to be shown in subsequent Knave of Diamonds exhibitions. In Moscow, Sergei Shchukin opened his magnificent collection to artists on Sunday mornings, with rooms wholly devoted to Picasso and to Matisse. The public also was invited to view the great Impressionist and Postimpressionist holdings of Ivan Morosov, along with his Matisses. But more influential, perhaps, was the time that the Russian artists spent in Paris, where many traveled and worked between 1910 and 1914. The effect could be

seen clearly at 0–10.

More than half of the fourteen artists in the exhibition had spent time in Paris, and most of those had worked there for a year or more. Maria Vasileva, in Paris from 1907, ran what was known as the Académie Russe, frequently visited by Léger, and the site of his important lectures delivered early in the summers of 1913 and 1914. Natan Altman and Zhenia Boguslavskaia worked there in 1911–12. Liubov Popova, Nadezhda Udaltsova, and Vera Pestel all painted at the Académie de la Palette in 1912–13, where Gleizes, Metzinger, Le Fauconnier, and Segonzac were teaching. Ivan Puni began working at the Académie Julian in 1910, returning to St. Petersburg in 1912, where he became involved with the Futurists. After he and Boguslavskaia were married, the two artists moved again to Paris in early 1914, only to be forced back to Russia by the outbreak of the war. The most famous excursion to Paris was the shortest one, however—Tatlin's visit to the studio of Picasso.

Tatlin traveled to Paris by way of Berlin in the early summer of 1913, where in the spring he had gone with a group of Ukrainian musicians to play at an exhibition of Russian folk art. Singing and playing the stringed bandore, he was able to make enough money to continue on to Paris. There was a large and active community of Russian artists in Paris at the time, including the sculptors Archipenko, Lipchitz, Zadkine, and Baranoff-Rossiné, and the month or so Tatlin spent there exposed him to at least some of the new Cubist sculpture. He certainly had good contacts in Popova and Udaltsova, who had worked with him at the studio called the Tower on Kuznetsky Bridge in Moscow.[18] But the critical experience was going to Picasso's studio at 242 boulevard de Raspail, where Tatlin saw his ground-breaking constructions and reliefs. Apparently Jacques Lipchitz acted as interpreter, and Tatlin entertained Picasso with Russian tunes. It is said that Picasso gave him some tubes of paint as a gift, and that Tatlin asked to be kept on as an assistant. Certainly he had seen the work that would inspire his imminent move from painting to sculptural relief.

Returning to Moscow, Tatlin began working with the kind of found materials that he had seen used in Paris, and his first relief represented a bottle in Cubist setting. By May 1914 he had constructed a large enough body of work to open his studio for a five-day exhibition of reliefs. The public was invited to 37 Ostozhenko Street for two hours each evening, where they also could hear Sergei Podchaevsky recite his "post-zaum" poetry.[19] Tatlin called the show Exhibition of Synthetic-Static Compositions, and in the pamphlet he published for 0–10—where it was called the First Exhibition of Painterly Reliefs—the works in it were described solely in terms of their materials: "wood, metal, putty, glass, plaster, cardboard, primer, tar, etc." whose surfaces have been treated with "putty, gloss paints, dust sprinkling and other means."[20] Unlike The Bottle and its Cubist precedents, these reliefs were largely abstract, emphasizing the inherent properties of their physical constituents rather than any representational function. This focus on materials—known in the Russian critical tradition as faktura, and first discussed with regard to quality of painting surface—was to reach its purest form in the "counter-reliefs" shown at 0–10.

The 0–10 show culminated a year of major exhibitions, beginning with Tramway V, the First Futurist Exhibition, in Petrograd in March 1915. This was the month that the police finally closed the Stray Dog café, where the Futurists had divided the world into artists and "pharmacists," regularly maligning a bourgeois audience that came to be both amused and abused. It also was the second month of Uspensky's lectures in Petrograd on Indian philosophy, theosophy, and the Fourth Dimension. Named for a trolley line, Tramway V was financed by Puni and Boguslavskaia, who later would use their independent wealth to support 0–10. The press looked askance at both shows, the Petrograd Bulletin treating them as "ambush-

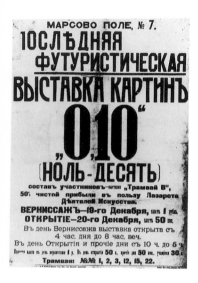

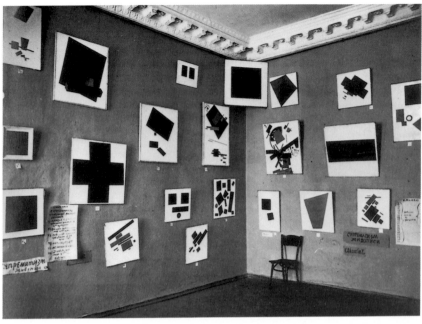

exhibitions" mounted to fleece the public of 50-kopeck admission fees, each presenting "the same formless daubings, the same cardboard-and-tin top hats, the cones and the bricks hammered onto boards."[21] As a mark of Futurist identification, at the opening all exhibitors wore a red wooden spoon. Just as they would be at 0–10, the strongest artists were Tatlin and Malevich, with Tatlin's six reliefs, five from 1914 and one from 1915, eliciting the greatest public response, "caus[ing] bewilderment and a torrent of ridicule."[22] Tatlin's notoriety was not lost on Malevich, who broke less ground in his seventeen paintings surveying work from 1911 to 1914, including such "alogical" pieces as *An Englishman in Moscow, Lady at the Advertisement Pillar*, and several works marked in the catalogue with the claim that "The contents of the paintings are unknown to the author."[23] Malevich's jealousy would only have increased if it is true, as has been reported, that Shchukin purchased a Tatlin relief for 3,000 rubles.[24] The other work in Tramway V was highly influenced by the Parisian scene recently left by so many of the artists, such as Puni's complex Cubist relief and the paintings of Popova and Udaltsova, who again were working at Tatlin's studio.

In Moscow, the big exhibition was The Year 1915, a broad survey of current Russian art held in April. There were paintings by David and Vladimir Burliuk, Chagall, less radical artists like Falk and Mashkov, and eleven Kandinskys. Although Malevich apparently was not in the show, being neither listed in the catalogue nor mentioned in any reviews, Tatlin exhibited reliefs that were rather brusquely described in the press: "Tatlin's picture is made up of a white tin plate, a piece of drainpipe, half a cylinder of glass and little more."[25] Larionov and Goncharova were included, back in Russia after working in Paris in 1914 on the Ballets Russes production of Rimsky-Korsakov's *Le Coq d'Or*, and soon to leave to rejoin Diaghilev in Lausanne. A Kiev newspaper described how Larionov, "the most enterprising of the scandal-makers," took advantage of a fan on the wall near his "plastic Rayonist" construction of general detritus and incorporated it into the piece.[26] The press also noted outrages by two poet-artists, Vladimir Mayakovsky's top hat cut in half with two gloves nailed next to it, and Vladimir Kamensky's display of a live mouse in a trap. The ex-stunt pilot

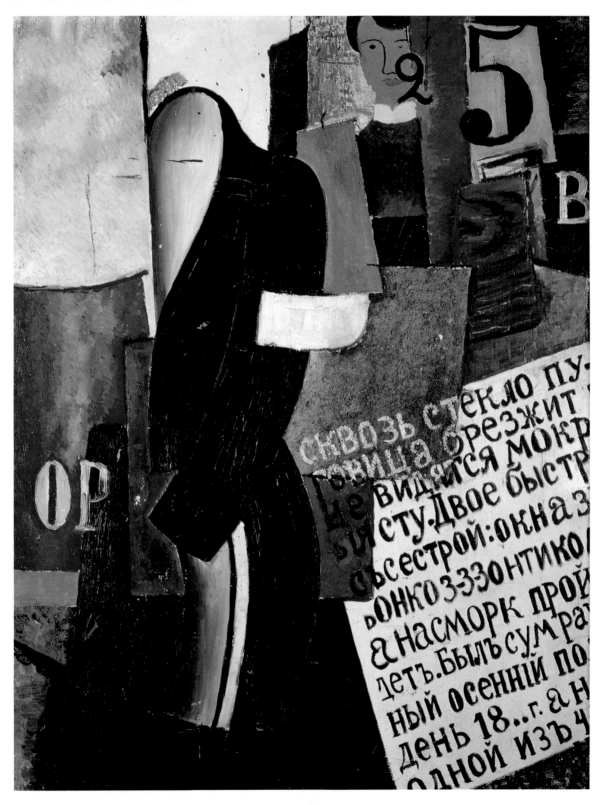

Kamensky was adept at such provocation, having shown *A Fall from an Aeroplane* the previous year at Larionov's exhibition No. 4, in which a heavy weight loudly crashed against a sheet of metal above bloody airplane fragments. (Kamenksy himself had given up flying after an earlier aerial accident.)

The antagonism between Malevich and Tatlin increased following the attention given to the sculptor's reliefs at Tramway V. Tatlin now called his pieces "counter-reliefs," which the contemporary critic Isakov understood in terms of a military counter-attack involving great energy and tension.[27] The counter-reliefs sat off the wall with no backing or framing, pure forms directly displaying the nature of their material constituents. In them Tatlin combined Cubist construction with the Russian icon tradition in which he had been trained early on, reportedly remarking, "If it wasn't for the icons, I should have remained preoccupied with water-drips, sponges, rags and aquarelles."[28] In 0–10 he introduced his "corner counter-reliefs," suspended where walls meet as were traditional icons.[29] But Malevich opposed Tatlin with something more clearly iconic, unveiling a completely new direction for painting in one of the most positive consequences of jealous competition among artists.

Reviewing 0–10, the conservative critic and painter Alexander Benois immediately identified as an icon the work that sat "high up in a corner just below the ceiling in the holy place," the traditional location of the icon in a Russian home.[30] A founder, with Diaghilev, of the World of Art group in the 1890s, Benois naturally saw this great black square on a white ground as the emblem of a "cult of emptiness, of darkness, of nothingness."[31] It must have seemed akin to the poet Gnedov's "Poem of Nothing," a blank page appearing in the 1914 volume *Death of Art*. As Ivan Kliun wrote in the catalogue to the Tenth State Exhibition, Non-Objective Art and Suprematism, in Moscow in 1919, "The corpse of the Art of Painting, the art of nature with make-up added, has been placed in its coffin and marked with the Black Square."[32] But in a long letter to Benois, Malevich insisted that this ground clearing was necessary for artistic progress, and Matiushin enthusiastically described the results at 0–10: "As after the Flood, there came the joy of new things, a new art, newly discovered spaces bursting into flower."[33] For Malevich, this icon of nihilism introduced a new mode of consciousness.

0–10 was held in Nadezhda Dobychina's Art Bureau on the Field of Mars, with its view of the Summer Gardens and grand palaces of Petrograd. In July Puni had urged Malevich to paint quickly, for "the hall is very large and if we—10 people—paint

25 pictures each, then it will only just be enough."[34] The original ten contributors grew to fourteen, belying the "10" in the title, and in the end only a few more than one hundred fifty pieces were shown. But Puni need not have worried about Malevich, who exhibited thirty-nine paintings in what became one of the most famous installations of the century.

He had been working largely in secret since the spring, hiding what would be called Suprematism from all but a few intimates. In September, however, Puni surprised Malevich in the studio, and, as he wrote to Matiushin, "I was caught like a chicken in soup."[35] Malevich wanted to exhibit these new paintings at 0–10 under the banner of Suprematism, but he was dissuaded by his Moscow circle, who sought to avoid dividing the group of advanced artists by explicit factionalism. Thus there is no mention of that term in the catalogue. However, concerned to establish the correct understanding of this difficult work, and to safeguard his own priority of discovery, Malevich decided to print a statement accompanying its presentation—the oracular pamphlet *From Cubism to Suprematism. The New Painterly Realism.*[36] It was sold at the exhibition, for by the opening there was no pretense of unity.

Malevich had been unsuccessful in convincing Puni to deny Tatlin space in the exhibition, and the ill feeling between the two artists increased as the show approached. Tatlin for his part refused to exhibit alongside Malevich's new work, which he considered amateurish, and the two artists reportedly had a fistfight just before the opening.[37] Alexandra Exter, who did not exhibit in 0–10 despite being in Tramway V, arranged a compromise whereby Tatlin, Popova, and Udaltsova would show in a separate section. Tatlin put a sign over the door: Exhibition of Professional Painters. Malevich now felt free to designate the new work correctly, and labeled his area Suprematism in Painting, K. Malevich. The opening itself was tumultuous, with its explosive mix of tense participants and skeptical public. But Puni managed to convince the police that neither the antagonistic artists nor the sculpture blocking the exit posed a real danger.

Although Puni—only twenty-three years old at the time—had insisted on the inclusion of Tatlin in the show, he and Boguslavskaia were partisans of Malevich, and showed in the Suprematist section of the exhibition. They produced one of the four Suprematist manifestos disseminated at 0–10, an enumeration of simple remarks ranging from the suggestive—"A picture is a new conception of abstracted real elements, deprived of meaning"—to the obscure—"2 x 2 is anything you like, but not four."[38] It was available without charge at the exhibition, as was another leaflet containing short statements by Kliun on pure sculpture and Mikhail Menkov on pure painting, and the first eight paragraphs of Malevich's booklet.

Among those who exhibited along with Malevich, Puni and Kliun seem to have come closest to showing Suprematist works at 0–10. Malevich had urged his associates to develop Suprematism in three dimensions, and some reliefs and sculptures in the show display their efforts. Although Puni exhibited Cubo-Futurist paintings, such as *Hairdresser*, he also developed a reduced geometric imagery in pieces like *White Ball in a Green Box*. Most extreme was his work reported in a Petrograd newspaper, the *Evening*, as number 107 in the exhibition, ". . . a simple board about 10 x 35 centimeters, painted green. The visitors were perplexed. . . . Some touched it, others smelled it secretly, for there was nothing to see." According to the *Petrograd Bulletin*, Maria Vasileva exhibited a similar work, a white board about 20 x 10 centimeters, one side of which was cut in a semicircle, displayed on a windowsill overlooking the Summer Garden and called *Spanish Landscape*.[39] Kliun also mixed Cubist work with Suprematist experiments, showing his humorous free-standing figure, *Cubist at Her Dressing Table*, along with seven works listed generally as "Basic principles of sculpture,"

Vladimir Tatlin photographed by Alexander Rodchenko, ca. 1916. Photograph courtesy V. A. Rodchenko Collection, Moscow

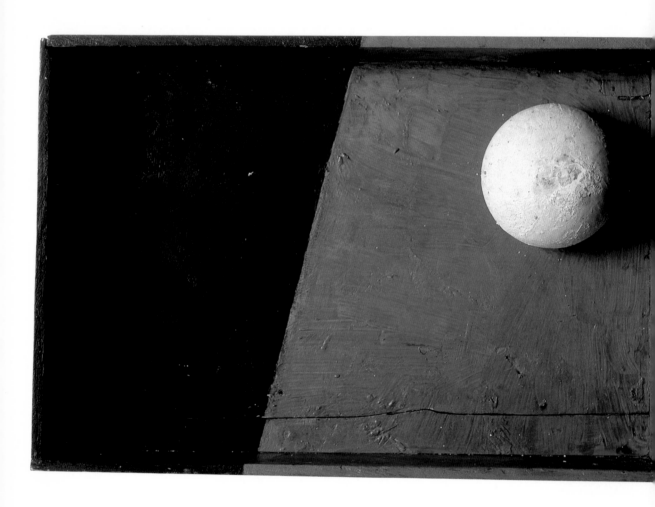

Ivan Puni. White Ball in a Green Box, *1915. Assemblage (glass and painted wood), 13⅜ x 20⅛ x 4¾ in. Musée National d'Art Moderne, Centre Georges Pompidou, Paris*

opposite:
Liubov Popova. Portrait of a Lady (Plastic Drawing), *1915. Oil and cardboard relief, 26⅛ x 19⅛ in. Museum Ludwig, Cologne*

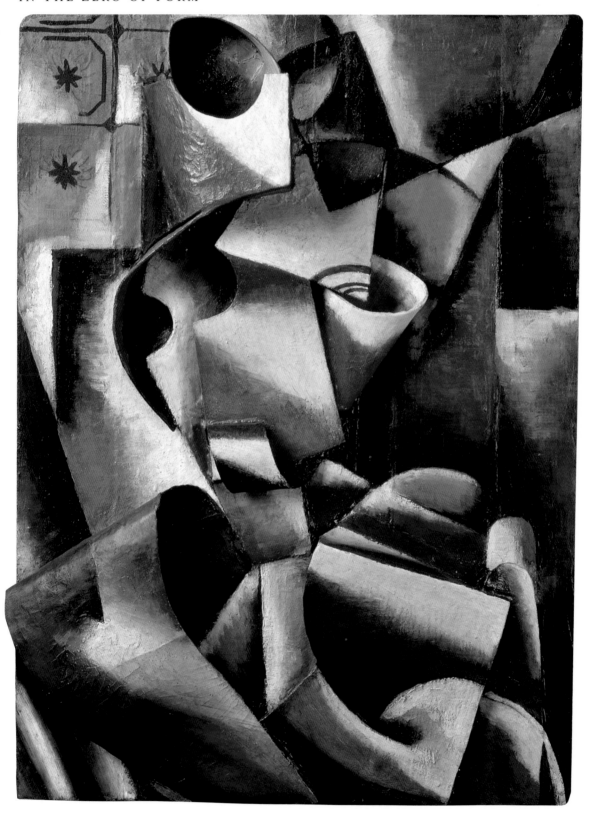

Vladimir Tatlin's booklet published for 0–10, Vladimir Evgrafovich Tatlin, showing two corner counter-reliefs, and painterly reliefs owned by Ivan Puni and Alexandra Exter. Its only programmatic statement was, "He has never belonged and does not belong to Tatlinism, Rayonism, Futurism, the Wanderers or any other group."

believed to be the "spheres, cubes, bars, etc." described in a newspaper article.[40] The catalogue also lists a collective work by Malevich, Boguslavskaia, Puni, Kliun, and Menkov, but it is not known whether it was painting, relief, or sculpture.[41]

Malevich showed only his new Suprematism in an asymmetrical installation that seems to both emanate from and culminate in the notorious *Black Square*. Actually, the black form is not quite square, and in the catalogue the work was called *Chetyreugolnik*, literally meaning quadrilateral, emphasizing its advance over the triangle, a traditional spiritual symbol important to both Kandinsky and Kulbin.[42] More suggestive titles were given to his other abstractions, some general—twelve works were entitled *Painterly Masses in Movement*—and some as specific as *Painterly Realism of a Football Player—Color Masses of the Fourth Dimension*. This dimensionality was a critical consideration, with four works marked as four-dimensional and twenty-one as two-dimensional. Eighteen of these fell under the general heading *Painterly Masses in Two Dimensions in a State of Rest*. The most complex of his paintings combined these appellations—*Lady. Color Masses of the Fourth and Second Dimensions*.[43] But the catalogue warns against searching his pictures for the entities mentioned: "In naming several pictures—I do not wish to show that one must look for their form in them, but I want to indicate that real forms were looked upon as heaps of formless pictorial masses from which was created the painted picture, which has nothing in common with nature."[44]

Malevich's warning not to look for objects represented in his Suprematist compositions, however, should not obscure the nonformal content of these works, their attempt to depict something beyond an array of shapes and colors. With very different means he returns to the Symbolist quest for a higher metaphysical reality, believing that the new man—and the new woman—would develop a sensibility able to transcend gross materiality. As he wrote to Matiushin in June 1916, "My new painting does not belong to the earth exclusively. The earth is thrown away like a house eaten up by termites. . . . The hung plane of painted color on a white canvas sheet gives a strong sensation of space directly to our consciousness. I am transported into endless emptiness, where you sense around you the creative points of the universe."[45] And writing about the black square to the critic Pavel Ettinger four years later, he gives the

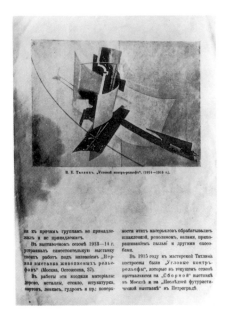

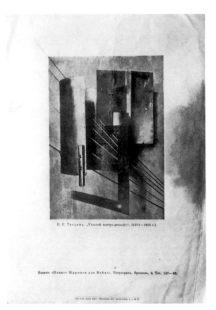

show away: "I see in it what people at one time used to see before the face of God."[46] Rather than the Gospels, Malevich would have had in mind the views of Uspensky, who sketched a route of spiritual progress analogous to that followed by Malevich's own painting, from the apprehension of a higher-dimensional reality through the abandonment of logic, to a more advanced stage of consciousness in the "sensation of infinity."[47] Malevich pushed Suprematism to this edge in his white "square" on a white background of 1918, and wrote ecstatically of his achievement as he concludes his statement for the 1919 Tenth State Exhibition: "I have breached the blue lampshade of color limitations and have passed into the white beyond: follow me, comrade aviators, sail on into the depths—I have established the semaphores of suprematism. . . . The white, free depths, eternity, is before you."[48]

Such high-blown prose was anathema to Tatlin, whose own brochure for 0–10 was written simply and concisely. Prepared with the help of Udaltsova, it reproduces photographs of two recent corner counter-reliefs along with two painterly reliefs owned by Puni and by Exter, and lists exhibitions in which Tatlin had participated. Its only programmatic statement, apart from the list of materials employed in the reliefs, is his denial of group affiliation: "He has never belonged and does not belong to Tatlinism, Rayonism, Futurism, the Wanderers or any other group."[49] In the exhibition Tatlin showed twelve or thirteen constructions, both "corner" and "center" counter-reliefs. One particularly large corner work supports its central assembly of metal and wood forms on a diagonal rigging of six ropes or cables, evoking both Tatlin's early days as a sailor and his beloved bandore. Yet despite their radical sculptural achievement, and unique combination of elegance and dynamism, Tatlin's reliefs at 0–10 received little critical notice compared with that garnered by Malevich and his colleagues. The exception was a long essay by Sergei Isakov, a central figure in the Apartment No. 5 group of artists and critics, and publisher of the *New Journal for Everyone*. Isakov saw Tatlin as providing a route "out of the frustrating dead-end of modernity" by discovering the laws of materials and "transposing them into the plane of the beautiful," achieving the sort of dominance over matter that can "cast off the humiliating yoke of the machine."[50] Equally gratifying to Tatlin, certainly, was

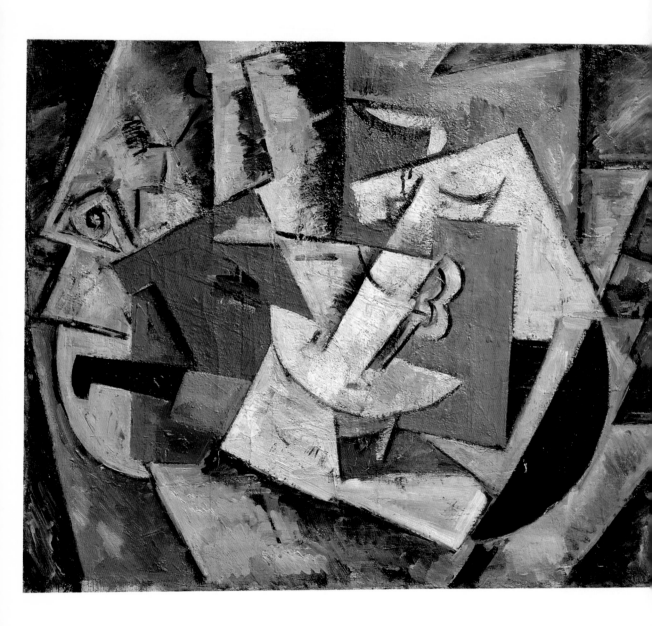

Nadezhda Udaltsova. Kitchen,
*1915. Oil on canvas, 26 x 31⅞
in. State Russian Museum, St.
Petersburg*

opposite:
Olga Rozanova. Writing Desk,
*1915. Oil on canvas, 26 x 19¼
in. State Russian Museum, St.
Petersburg*

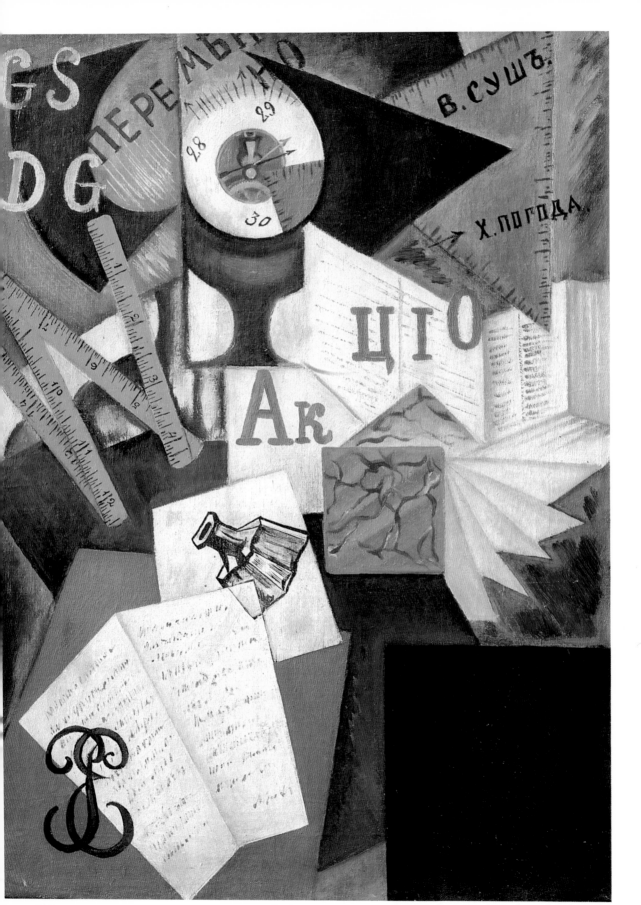

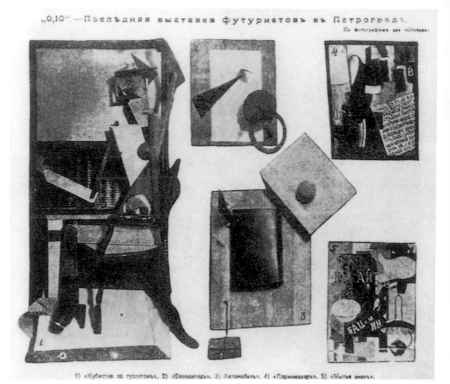

1) «Кубистка за туалетомъ». 2) «Велосипедъ». 3) «Автомобиль». 4) «Парикмахеръ». 5) «Мытье оконъ».

Page from journal Ogonek, *January 3, 1916, showing work from 0–10: (left to right) Ivan Kliun's* Cubist at Her Dressing Table; *(above) Olga Rozanova's* Bicyclist *and (below)* Automobile; *and (above) Ivan Puni's* The Hairdresser *and (below)* Window Dressing.

the poem that Khlebnikov wrote about him, and whose manuscript he treasured. Having visited 0–10, the poet spoke of Tatlin's "spidery vale of rigging" and "the tin objects which he had worked with a brush."[51]

The two other "Professional Painters" who showed with Tatlin, Popova and Udaltsova, exhibited works largely influenced by the Cubism that they had studied together in Paris. Close friends from before Paris, when they shared a Moscow studio and worked with Tatlin, they came again within his orbit on their return to Russia. Popova showed still lifes and portraits, three of which were designated "plastic" works in the catalogue. These pieces—*Portrait of a Lady, The Jug on the Table,* and *Compote with Fruit*—were fully three-dimensional sculpto-paintings, reflecting the influence of Archipenko's innovations in Paris. Popova also displayed some strong Futurist dynamism in her large painting *Traveling Woman.* As for Udaltsova, her paintings were interiors and still lifes. Though her work was little mentioned in reviews, Tatlin thought well enough of her *Bottle and Glass* to acquire it, and the next year to exhibit the piece at his exhibition the Store. He must have thought his support poorly repaid, however, when Udaltsova soon moved to the Suprematist camp, and her Moscow apartment became the group's meeting place and the office of its ultimately unpublished journal. By the end of 1916 both Udaltsova and Popova, and their friend Vera Pestel, had abandoned Tatlin and were working in the Suprematist style of overlapping planar elements.

The editorial secretary of the *Supremus* journal was Olga Rozanova, whose work at 0–10 included two constructed reliefs and collage-like paintings combining flat geometric areas of color with realistically rendered objects. Rozanova had never been to Paris, and she developed among the Futurist poets whose books she was active in illustrating. Her two reliefs, *Bicyclist (Devil's Walk)* and *Automobile,* were reduced

compositions using raw materials (glass, tin, wood) along with painted elements, and *Automobile* even contained a rubber ball and a brick or cobblestone. Probably alluding to Khlebnikov's obsession with the planet Mars, Matiushin described them as "humorous works for young Martians."[52] In 1916 Rozanova married the poet Kruchenykh, and after the Revolution she worked reorganizing the craft workshops with Rodchenko. But in November 1918 she died at age thirty-two from diphtheria, stricken in Moscow while decorating an airplane for the first anniversary of the October Revolution. She was the first of the new artists honored by the Bolshevik regime, with a large posthumous show of her work the following January. Both Kliun and Rodchenko designed monuments for Rozanova, Kliun's featuring imagery from the *Bicyclist*. At her funeral Malevich carried a black flag with a white square, reversing his signature image.

Other artists in 0–10 marked their sympathies with either Tatlin or Malevich in the titles of works. Natan Altman, who would decorate the square around the Winter Palace with Cubo-Futurist designs when he was in charge of Petrograd events on the first anniversary of the October Revolution, showed a single still life subtitled *faktura, space, volume*. Mikhail Menkov called his works *Painting in Four Dimensions*. But the press generally was unable to keep the parties apart and seemed to lump everything under the new word, Suprematism.

Although the exhibition was well attended, reportedly seen by 6,000 people, it was a disappointment to the press.[53] B. Lopatin wrote that he missed the colors of the old Futurists, finding the work in the show "dry and monotonous, without art and without individuality." For the critic of the *Petrograd Bulletin*, the exhibition signaled an impasse reached by advanced art, a dead end of anarchy. "The public roars with laughter, but for me, I am bored, bored. . . . After this, what can be done?"[54]

Malevich attempted to explain his new theoretical position at an evening lecture on January 12. Part of a performance with Puni and Boguslavskaia at the concert hall of Tenishevo College, the talk contained such sections as "The spread of the Inquisition in painting" and "Nero and you."[55] Judging by newspaper reports, Malevich failed to convince the unconverted, his messianic words provoking many to leave the hall—"I am the royal infant . . . before me there have been only stillborn children. Tens of thousands of years have prepared my birth."[56]

Despite their continuing antagonism, Malevich agreed to exhibit in a show that Tatlin organized in March in Moscow, the Store. Held in an empty storefront at 17 Petrovka Street, the exhibition oddly contrasted Tatlin's new formal innovations in the counter-reliefs with pre-Suprematist works by Malevich. While Tatlin's display seemed very much like that at 0–10 (with two corner counter-reliefs, a relief from 1915, and four reliefs from 1913–14), Malevich exhibited only earlier works. The catalogue lists the ten pieces under the heading *Alogism of forms*, and they include two paintings shown at Tramway V, *Aviator* and *An Englishman in Moscow*, and the absurdist *Cow and Violin*—with its vertical image of a violin superimposed on a synthetic Cubist composition, over which is set a realistic rendering of a cow. The two protagonists were accompanied by Udaltsova, Popova, Kliun, Exter, Vasileva, and Morgunov. Tatlin's friend, Lev Bruni, provocatively displayed a smashed barrel of cement and a pane of glass marked by a bullet-hole, in addition to a sculptural relief.[57] Unfortunately the press again was unappreciative, saying that the exhibition indeed resembled a store— an old junk shop—and repeating their claim that the new work was passé and boring, and the artists "in the grip of a senile and conservative stubbornness."[58]

The Store, however, introduced an important artist to the advanced group, Alexander Rodchenko. After seeing his work Tatlin had invited Rodchenko to participate without contributing any money—all of the other artists did so—if he would help sell tickets and hang the show. At the opening Malevich tried to lure the new-

comer into his camp through disparaging remarks about the other participants, but Rodchenko maintained his loyalty to Tatlin.[59] The sculptor later asked him to help with the designs for the Café Pittoresque in Moscow, a project involving partisans of both Tatlin and Malevich. Opening on January 30, 1918, the Café Pittoresque became a lively meeting place for advanced artists through the early revolutionary years. It was there that Khlebnikov wanted to assemble all the "Presidents of the Globe"—a group in which he included H. G. Wells, no doubt for his familiarity with Martians— announced by a banner over the float on which he rode up the Nevsky Prospect in early 1917, predicting a revolution before the end of the year. For his part, Rodchenko remembered Malevich's ill behavior at the Store, and in 1918 he mocked the latter's *White Square* with his own *Black on Black*.

Although Suprematism seemed stalled at the Store, by the end of 1916 it clearly was ascendant. At the eclectic Knave of Diamonds exhibition in November in Moscow, much attention went to Malevich and others working in a similar vein, with *Apollo* announcing that a journal called *Supremus* would appear in January or February. Despite the *Russian Word*'s view that Malevich and Kliun showed only "some crude daubings alternating with lines that exhaust the eyes," the future belonged to their Suprematism.[60] Recently so close to Tatlin, Udaltsova noted a change of heart in her diary entry of November 26, and she seemed to speak for many artists: "I have suddenly fallen for decorative drawing and Malevich."[61]

This was the last important exhibition of the Russian avant-garde before the Revolution, after which the advanced artists became highly involved with propaganda activities and the reorganization of art institutions. Unlike the political revolutionaries, avant-garde artists and poets had been largely free of Czarist censorship before the Revolution. Most were apolitical in the fall of 1917, but they would enthusiastically embrace the new regime insofar as it supported artistic programs and expressed their utopian aspirations. And the Bolshevik regime encouraged avant-garde activities in an unprecedented way. During the precarious early years of the Revolution, artists decorated the cities for political anniversaries, created temporary monuments and structures of inexpensive materials, and painted the "agit trains" that spread the Bolshevik message during the civil war. As Mayakovsky wrote in the first issue of *Art of the Commune* in 1918, "the streets are our brushes, the squares are our palettes."[62]

More long-term activity revolved around the state institutions for artistic training and research, in which virtually all of the prerevolutionary avant-garde participated. Under the leadership of Anatoly Lunacharsky, head of the People's Commissariat for Public Enlightenment (Narkompros), the most advanced artists were appointed to positions of power. Not surprisingly, factionalism was rampant in the politicized environment, and changes were many. Chagall was made director of the Popular Art Institute in his home town of Vitebsk in August 1918, and developed a program fostering abstract art, bringing his student El Lissitsky to the faculty. After Lissitsky encouraged the invitation of Malevich to join them, Chagall found himself displaced as the dominant influence in the school and departed early in 1920.[63] In 1918 Tatlin asked Kandinsky to become active in the newly established Department of Fine Arts (IZO) of Narkompros, which Tatlin headed. Through 1919 Kandinsky worked on the installation of provincial museums and became the first director of the Museum of Artistic Culture in Moscow. He was chosen to lead the Institute of Artistic Culture (Inkhuk) when it was established in Moscow in 1920, and he sought to direct its research programs to the psychologistic and mystical orientation of his own art. In this Kandinsky was opposed by those who considered his approach too aestheticized— including Lissitzky, Malevich, Popova, Tatlin, and Rodchenko—and he left Russia in 1921 for Berlin, and then a teaching position at the Bauhaus. Under Rodchenko and

his colleagues, Inkhuk was reorganized along Constructivist lines, in May 1921 issuing a declaration against easel painting and in the next three years focusing on "production art." State exhibitions displayed the history of the Russian avant-garde, and the individual institutions organized their own shows of current research. But by this time Lenin was beginning to move against the independence of the avant-garde in the name of democratic centralism, and against Constructivist abstraction toward what would become Socialist Realism. Initially resisting Lenin's pressure, Lunacharsky would turn to the right by 1924 and support more rigid state control of artistic production. By 1929 all artists were organized into a single cooperative, and within a few years every independent artists' organization was abolished and the Communist Party assumed control of artistic content.[64]

Through these years Malevich and Tatlin remained on poor terms, involved in their teaching and organizational work in both Moscow and Petrograd. Commissioned by Narkompros in 1919 to design a monument to the Third International, Tatlin conceived of an immense tower, twice as high as the Empire State Building later would rise. A dynamic abstract construction of steel and glass, its spiral lattice around an inclined cone enclosed four working structures, different geometrical forms devoted to particular levels of government activity and each revolving at its own speed. With three assistants he built a large model, which was exhibited in Petrograd in November 1920 and reassembled the next month in Moscow at the Eighth Soviet Congress. Mayakovsky called it "the first object of October"—the first to truly express the principles of the Revolution—and "the first monument without a beard."[65] Needless to say, it remained unbuilt, but "Tatlin's Tower" received great notoriety and must have reinflamed Malevich's jealousy. For when Tatlin organized a commemorative performance of Khlebnikov's long work *Zangezi* in May 1923—the poet had died the previous June—at the Petrograd Inkhuk, where both Malevich and Matiushin were teaching, Malevich forbade his students to attend. Malevich lived for the rest of his life in two rooms there, and while Tatlin never spoke well of his rival, Udaltsova reported that he shed tears on learning of Malevich's death in 1935.[66]

In the early 1920s Berlin became a center for advanced artists who had decided to leave Russia, and Puni and Boguslavskaia emigrated there in 1920 before resettling permanently in Paris in 1923. A show of Puni's work was held at the Sturm gallery in February 1921, providing the Germans with a hint of what had occurred in Russia since its isolation at the outset of the war. It took another year, however, before the Russian avant-garde could be seen in depth, when IZO sent a major exhibition to the Van Dieman gallery in Berlin. No longer would the West think of advanced Russian art only in terms of Chagall and Kandinsky. Yet some ideas had circulated in abbreviated form in 1920, when the nineteen-year-old Konstantin Umanskij published his book *New Art In Russia 1914–1919*, along with an article devoted to Tatlin in *Der Ararat 1*.[67] It was in Umanskij that the Berlin Dadaists read of "the machine art of Tatlin," and embraced the phrase as suitable for revolutionary use. Without much understanding the nature of Tatlin's work, Berlin Dada incorporated it in their collage of anger and disgust at the First International Dada Fair.

CHAPTER 6 *DADA ist politisch*
The First International Dada Fair
Berlin, June 30–August 25, 1920

While radical politics created a context to which the Russian avant-garde vigorously adapted itself in 1917, from the beginning it was essential to the work of Berlin Dada. Hanging from the ceiling of the First International Dada Fair was the *Prussian Archangel*, Rudolf Schlichter and John Heartfield's effigy of a German military officer with the head of a pig. It surveyed a scene dominated by Otto Dix's painting of war cripples and George Grosz's depiction of a frightened burgher surrounded by the chaos of his time. Underneath Grosz's image of church, military, and school supporting the fat philistine was a placard with the simple message "Dada ist politisch" ("Dada is political"). Other signs mounted on the walls made the politics clear: "Dadaist man is the radical opponent of exploitation," "Dada is fighting on the side of the revolutionary proletariat."

The Berlin Dada Fair culminated the activity of a group born amid nightmarish war, crumbling empire, and domestic political strife. Although its members differed in degree of partisan commitment, all laced their work with strident political commentary. Within the diverse international Dada movement, the Berliners occupied the most political end of a spectrum moving from the light-hearted antics of New York, through the literary focus of Zurich and Paris, to their own left-wing opposition to the war and then to the Weimar government. This, of course, largely was due to differences between the situation in Germany during these years and that in America and in Switzerland—New York was far from the battlefields of Europe and Zurich a neutral haven for expatriates, while Germany was suffering from severe shortages and military defeat and occupation, and would soon be the site of violent class warfare. The contrast is sketched in Richard Huelsenbeck's oft-quoted comparison of Zurich and Berlin in January 1917:

> In Zurich the international profiteers sat in the restaurants with well-filled wallets and rosy cheeks, ate with their knives and smacked their lips in a merry hurrah for the countries that were bashing each other's skulls in. Berlin was a city of tightened stomachers, of mounting, thundering hunger, where hidden rage was transformed into a boundless money lust, and men's minds were concentrating more and more on questions of naked existence.[1]

That month Huelsenbeck had returned to Berlin after the close of Zurich's Cabaret Voltaire, the birthplace of European Dada. He had gone to Zurich in February of the previous year, joining the group assembled around Hugo Ball and Emmy Hennings at their cabaret founded a week or so before. Ball had been active in Munich's experimental-theater community and was an adherent of Kandinsky's spiritualized notion of total theater, and like many others he had come to Switzerland to avoid military service. His companion was an experienced cabaret performer who once

Raoul Hausmann. Dada Siegt! 1920. Watercolor and collage on wove paper mounted on board, 23⅜ x 17¾ in. Private collection

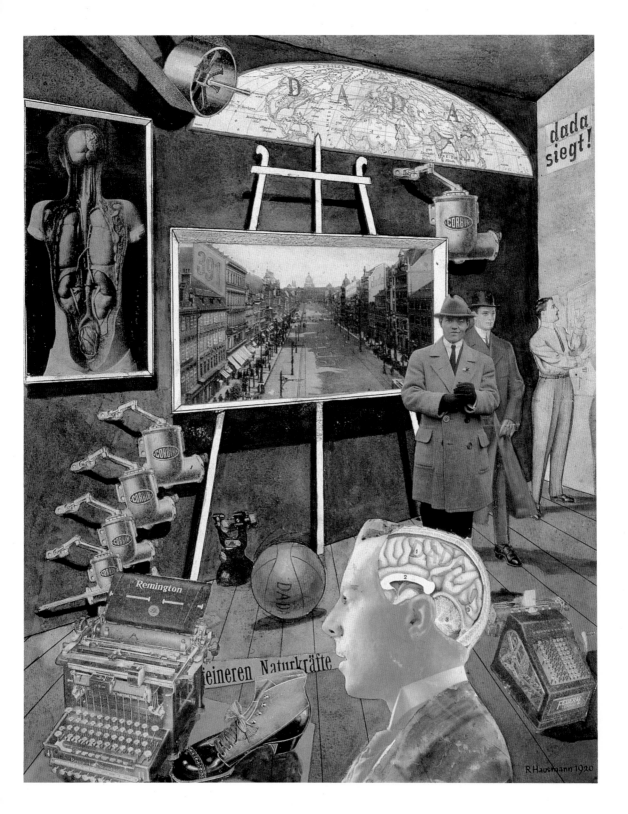

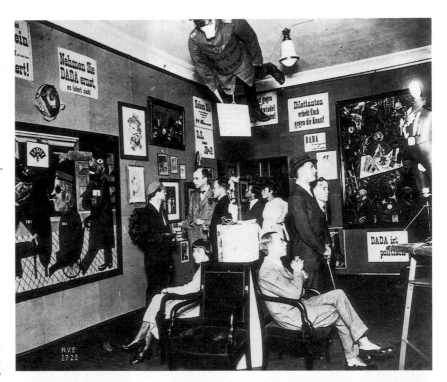

Installation view of the First International Dada Fair, at Galerie Otto Burchard, Berlin, Summer 1920. Posing under Rudolf Schlichter and John Heartfield's Prussian Archangel *are members of the Club Dada: (left to right) Raoul Hausmann, (seated) Hannah Höch, Dr. Otto Burchard, Johannes Baader, Wieland Herzfelde, Mrs. Herzfelde, (seated) Otto Schmalhausen, George Grosz, and John Heartfield. On the left is Otto Dix's 45%* Ablebodied *(also known as* War Cripples*), onto which was attached the first published photomontage showing the heads of Weimar leaders, and (out of the photograph) Grosz's* Victim of Society (Remember Uncle August, the Unhappy Inventor). *On the right is Grosz and Heartfield's* The Philistine Heartfield Gone Wild (Electro-Mechanical Tatlin Plastic). *On the back wall is Grosz's* Germany, a Winter's Tale. *Berlinische Galerie, Berlin*

Otto Dix. 45% Ablebodied *(also known as* War Cripples*), 1920 [destroyed]. Oil on canvas, 59 x 78¾ in. Otto Dix Foundation, Vaduz, Liechtenstein*

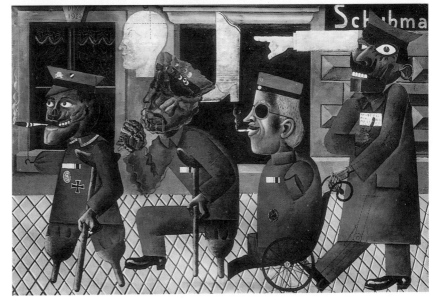

had been jailed for forging passports for draft dodgers. Together they approached the owner of a café at Spiegelgasse 1 to found an artists' cabaret, transforming the Hollandische Meierei café into the Cabaret Voltaire, a small place with fifteen to twenty tables and room for fifty or so patrons. Activities began on February 5, 1916 with an open newspaper invitation that attracted three artists who would assist with the festivities—the young Romanians Tristan Tzara and Marcel Janco, and the Alsatian Jean (Hans) Arp. They staged provocative events, primitivist dances, and radical sound poems interspersed with literary readings and songs, filling the smoky café to overflowing each night.

Zurich was a center of war resisters and political refugees—Lenin lived down the street from the Cabaret Voltaire at number 12—and the Dadas united in rejecting the society that had spawned the killing. As Ball wrote in his diary on April 14, "Our cabaret is a gesture. Every word that is spoken and sung here says at least this one thing: that this humiliating age has not succeeded in winning our respect."[2] The horrors of the war were seen as the insane consequence of bourgeois rationality, and absurdity and chance complemented the primitive as a means of reaching back to a purer state. Tzara, born Sami Rosenstock in Bucharest, increasingly emphasized the irrational, his 1918 Dada manifesto proclaiming his principle of rejecting principles, his adherence to "continuous contradiction," all in the contentious tone with which he would promote the spread of Dada across Europe:

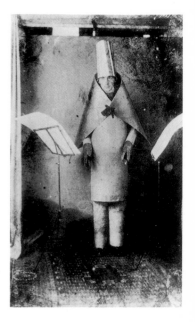

Hugo Ball reciting his sound poem "Karawane" in a Cubist costume by Marcel Janco, at the Cabaret Voltaire, Zurich, June or July, 1916. The performance ended with Ball fainting and having to be carried offstage.

> Ghosts drunk on energy, we dig the trident into unsuspecting flesh. We are a downpour of maledictions as tropically abundant as vertiginous vegetation, resin and rain are our sweat, we bleed and burn with thirst, our blood is vigor. . . . *On the one hand a tottering world in flight, betrothed to the glockenspiel of hell, on the other hand: new men. Rough, bouncing, riding on hiccups.*[3]

Dada in Zurich centered on performance and literary innovation, aggressive use of words and verbal imagery challenging the complacent values of the European middle class. At the Cabaret Voltaire there were evenings devoted to the advanced poetry of France and Russia. Arp recited passages from Alfred Jarry's *Ubu Roi*, and additional inspiration came from Italian Futurist sound poetry and bruitism, noise music. Emblematic of the collective, international, and disjointed spirit was the "simultaneous poem" performed at the end of March, *L'amiral cherche une maison à louer* ("The Admiral Looks for a House to Rent"), with lines spoken concurrently by Huelsenbeck in German, Janco in English, and Tzara in French.

Dada manifestos were read by Ball, Huelsenbeck, and Tzara at the first Dada evening at the Zunfthaus zur Waag on July 14, where Ball also intoned his nonsense vocables in a great conelike outfit by Janco before being carried offstage overcome by the experience.[4] Held in public halls, Zurich's Dada-Soirées set the model for events that would proliferate through Europe, reaching their height in Paris in 1920–21, programs of poetry, music, playlets, and proclamations. There were eight major Dada evenings in Zurich, spanning the history of the movement there, the last held at the Saal zur Kafleuten on April 9, 1919 before an audience of over one thousand. That evening climaxed as Walter Serner in formal dress read his anarchist piece *Final Dissolution*, provoking members of the audience to rush the stage and destroy the headless dummy to which Serner had dedicated his work.[5]

Due to exhaustion and increasing complaints to the owner of the café, the Cabaret Voltaire closed after about six months of frantic activity. In 1917 operations shifted to the Galerie Dada, formerly the Galerie Corray where the First Dada Exhibition opened at the end of January. On March 1 Tzara and Ball took over the space with

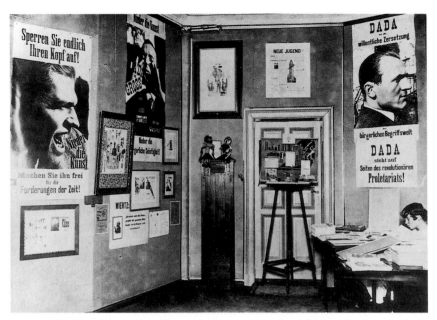

Installation view of the First International Dada Fair, at Galerie Otto Burchard, Berlin, Summer 1920. On the pedestal are two Dada dolls by Hannah Höch. Berlinische Galerie, Berlin. Hanna Höch Archiv

a show of Sturm gallery artists. Although there were more exhibitions for the next three months, showing a wide and somewhat slapdash range of modernist work along with children's and primitive art, the ongoing focus continued to be performance. And through Tzara's promotional efforts and the publication *Dada*, their activities began to attract international notice. In January 1919 Picabia arrived, by February producing a Zurich number of his journal *391*, 14 months after the last issue was published in New York and 9 months before the next would appear from Paris.

While the Zurich Dadas were involved in their exhibitions and performances, however, political developments in Germany directed attention elsewhere. The conjunction of two events in March 1917 symbolizes the difference—in Zurich the creation of the Galerie Dada, and in Berlin the founding of the leftist publishing house Malik-Verlag by John Heartfield and his brother Wieland Herzfelde. As an affront to German patriotism, Heartfield had anglicized his name from Helmut Herzfelde, the war and its social consequences having politicized him and other Berlin artists. George Grosz—who had changed the spelling of his first name from Georg for a similar reason—drew vicious caricatures of officers and their bourgeois supporters. Wieland Herzfelde continued to wear a filthy army uniform on the streets of Berlin, intensifying his disdainful look by shaving only one cheek.

There was more to react to than military miscreance and defeat, however, for 1918–1919 saw a series of events that set the tone of Berlin Dada: revolutionary insurrection and the abdication of the kaiser in November 1918, creation of the rightist vigilante Freikorps and fighting in the streets in Berlin in December, the formation of the German Communist Party at the end of the year. The next month there were worker uprisings in major German cities, and the radical Spartakist leaders Rosa Luxembourg and Karl Liebknecht were murdered by the Freikorps on January 15. (In contrast, on the 16th in Zurich, Tzara was holding a conference on abstract art.) The Freikorps suppressed the revolts in northern Germany in February as the Weimar Republic was established. In March, troops of the Ministry of Defense battled Berlin workers called to a general strike by the Communist Party, killing over 1,500 revolutionaries and wounding 10,000. April saw the creation of a Soviet Republic in Munich, with its

bloody suppression by the Freikorps in the first week of May.

The First International Dada Fair was held June 30-August 25, 1920, three and a half months after a failed Freikorps putsch in Berlin and renewed fighting in Dresden between troops and workers. Called The Great Monster Dada Show in the press, it contained reminders of the events of the previous two years, along with raging references to the military. Walls were covered from floor to ceiling with political and propagandistic material set among paintings, collages, and drawings. The suspended officer with pig's head was marked as "Hanged by the Revolution." Below stood the Grosz-Heartfield collaboration *The Philistine Heartfield Gone Wild (Electro-Mechanical Tatlin Plastic)*, a mannequin decorated with a war medal and rusty cutlery, with a light bulb for head and pistol and electric bell for arms, "dedicated to the Socialist Reichstag delegates who voted for the war." Heartfield and Herzfelde showed the May and June 1917 issues of their political weekly newspaper *Neue Jugend*, published by Malik-Verlag. Attached to Dix's large painting of the war wounded, *45% Ablebodied*—his only Dada appearance—was the first published photomontage, Heartfield's image of a fan embellished with the heads of Weimar leaders over the query "Open competition! Who is the most beautiful??"

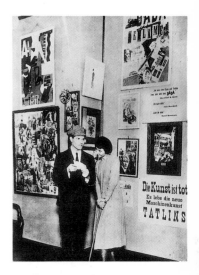

Installation view of the First International Dada Fair, at Galerie Otto Burchard, Berlin, Summer 1920. Raoul Hausmann and Hannah Höch stand between (left) Höch's Cut with the Cake Knife *and (right) Hausmann's* Tatlin at Home. *Photograph courtesy German Information Center, New York*

Photomontage was utilized in all of the Berlin publications, and both printed and original examples filled the exhibition.[6] Though it is generally considered the most important artistic innovation of Berlin Dada, like the term "Dada" in Zurich its first use is a subject of dispute. Heartfield and Grosz were said to have invented the technique while putting together subversive postcards assembled from advertisements and newspapers, sent to Herzfelde and others at the front in 1916. Hausmann and Höch claimed independent discovery while summering on the Baltic coast in 1918, after seeing mass-produced prints onto which had been glued photographs of friends or relatives.[7] Whatever the story, photomontage was developed in original and diverse ways by each of these artists, and by others among the Berlin Dadas. Hausmann wrote that they agreed together on the term "photomontage" to express their "aversion at playing the artist, and, thinking of ourselves as engineers (hence our preference for working-men's overalls) we meant to construct, to assemble [*montieren*] our works."[8] The word in German connotes a mechanical or engineering process of fitting things together, and Grosz and Heartfield often stamped *mont.* after their names. For all, the intent was to connect imagery more closely to the life of the times. Grosz and Heartfield did so with more explicit politics, and Heartfield would go on in the thirties to create his stunning series attacking the Nazis, using an airbrush to meld disparate photos into continuous images. But in their different ways all of the montagists used the imagery of commercial advertising to subvert the world of commerce and attack the politicians who supported it. And in the Dada period they each displayed the social condition in disjunctive and chaotic compositions, avoiding the structure of classical order that governed precedents in Cubist collage.

Heartfield himself was known as Monteurdada, and most of the Dadas were given titles, many fixed when he had calling cards printed for his colleagues in July 1919. Hausmann was the Dadasoph, Mehring was Pipidada, Grosz was the Propagandada Marschall, Huelsenbeck was World Dada, Gerhard Preiss (the inventor of the Dada-Trott) was Musikdada, and Johannes Baader was the self-designated Oberdada (Superdada). Other titles were bestowed later, probably around the Dada Fair: Rudolf Schlichter became Dadameisterkoch, Max Ernst was Dadamax, and Otto Schmalhausen, Grosz's brother-in-law, the Ozdada. Hannah Höch, the only woman in the group, seems to have remained untitled. Dr. Otto Burchard, in whose rooms the show was mounted and who funded the exhibition with 1000 marks, was designated the Finanzdada.

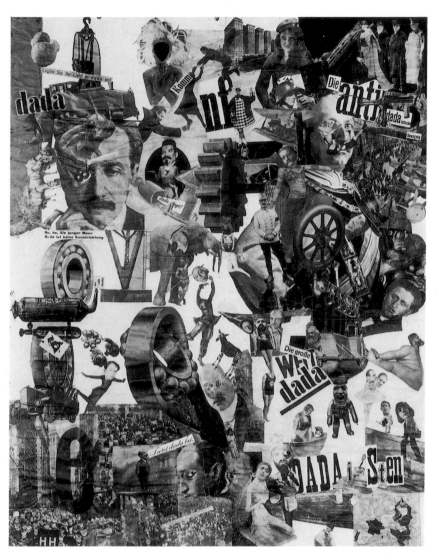

Hannah Höch. Cut with the Cake Knife, *1919–20. Photomontage, 44⅞ x 35⅜ in. Staatliche Museen zu Berlin-Preussischer Kulturbesitz: National Galerie. The title is taken from a quotation at the bottom of the work, which reads: "Cut with the cake knife of Dada through the last beer-swilling cultural epoch of the Weimar Republic." In fact, in the original, it is not clear whether the word is* kuchenmesser *(cake knife) or* küchenmesser *(kitchen knife).*

Burchard was an expert in Chinese Sung ceramics, and a director of the Van Dieman art dealership, which would present the great Russian exhibition in 1922. He gave the Dadas his own gallery at Lützow-Ufer 13 near the War Ministry, and was listed in the catalogue as exhibiting a *Nachtischzeichnung* ("Dessertdrawing") in the show. Admission of 3 marks was charged, but attendance seems to have been modest, with only 310 tickets sold by July 15. The catalogue appeared two weeks after the June 30 opening and was printed on the back of a poster for the exhibition. It listed 174 items by 27 exhibitors, though some of the unfamiliar names were fabricated as a Dada gesture. While the Dada Fair contained even more works than that, it was held in only two rooms and a connecting hallway, on the ground floor in a side wing off the first courtyard of the building. This necessitated the condensed and riotous installation seen in the posed photographs of members of the Berlin Club Dada at the exhibition.

Although it was called the First International Dada Fair, the only participants from outside of Germany were Picabia from Paris, Schmalhausen from Antwerp, the

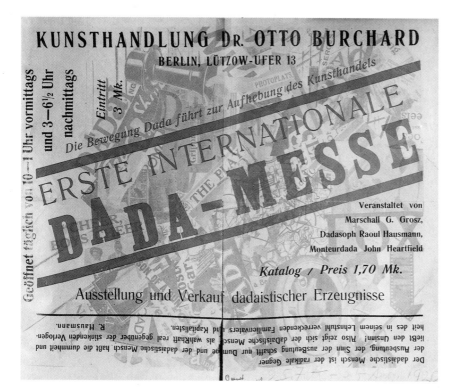

KUNSTHANDLUNG Dr. OTTO BURCHARD
BERLIN, LÜTZOW-UFER 13

Eintritt
3 Mk.

Geöffnet täglich von 10—1 Uhr vormittags
und 3—6½ Uhr nachmittags

Die Bewegung Dada führt zur Aufhebung des Kunsthandels

ERSTE INTERNATIONALE
DADA-MESSE

Veranstaltet von
Marschall G. Grosz,
Dadasoph Raoul Hausmann,
Monteurdada John Heartfield

Katalog / Preis 1,70 Mk.

Ausstellung und Verkauf dadaistischer Erzeugnisse

Der dadaistische Mensch ist der radikale Gegner
der Ausbeutung, der Sinn der ausbeutenden Mensch und der dadaistische Mensch haßt die dummheit und
liebt den Unsinn! Also zeigt sich der dadaistische Mensch als wahrhaft real gegenüber der stinkenden Verlogen-
heit des in seinem Lehnstuhl verreckenden Familienvaters und Kapitalisten.
R. Hausmann.

Poster for the First International Dada Fair, Berlin, July 25–August 25, 1920. The exhibition catalogue was printed on the reverse side of this poster, two weeks after the show opened. The Museum of Modern Art Library, Special Collection, New York

peripatetic Arp, and perhaps the Berlin correspondent for the *Chicago Daily News*, Ben Hecht, listed in the catalogue and a friend of the Dadas. Arp was the most truly international, a founder of Zurich Dada who recently had been working in Cologne with Max Ernst and Johannes Baargeld, but he had gone to Paris by the time of the show. There was some participation from other parts of Germany—such as Schlichter and Georg Scholz from the south, Alois Erbach along with Ernst and Baargeld from the Rhineland, and the gymnast Hans Heinz Stuckenschmidt from Magdeburg, who had come by fourth-class train to show Grosz the five small collages that the older artist added to the exhibition. But in essence it was an exhibition of the Berlin Club Dada. Hence the striking omission of Kurt Schwitters from Hannover, whose application for membership in the Club Dada—supported by Hausmann—was rejected by the more political members of the group. For Huelsenbeck especially, Schwitters's personality was too bourgeois and his work too aestheticized, and his explicit rejection of political content in art was an affront.

The Club Dada had been established in January 1918 by Huelsenbeck, Hausmann, and Franz Jung, leader of the Freie Strasse group. While Huelsenbeck had brought word of Zurich activities to Berlin a year before, it took until January 22, 1918 for Dada to be spoken of in a public presentation, when he lectured at I. B. Neumann's Graphisches Kabinett, emphasizing Dada's use of poetry and painting for political ends and the current irrelevance of Expressionism, Cubism, and abstraction.[9] When he offensively proclaimed that the war was not bloody enough, an amputee rose and hobbled out to audience applause. Grosz recited his poetry of rhymed insults—"You-sons-of-bitches, materialists/bread-eaters, flesh=eaters=vegetarians!!/professors, butchers' apprentices, pimps!/you bums!"—and pretended to urinate on the Expressionist pictures around him.[10] Neumann, one of the first dealers to exhibit the Brücke artists in

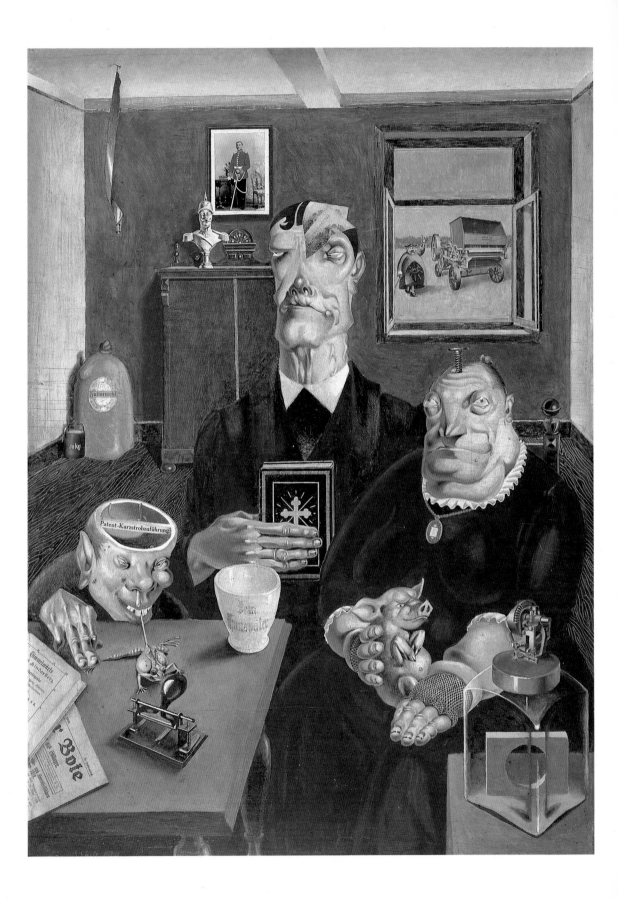

Berlin, barely was dissuaded from summoning the police. The next Dada event was held on April 12 at the hall of the Neue Sezession, where Huelsenbeck and Grosz were joined by others from the Café des Westens, including Hausmann, Gerhard Preiss, and Jung, who two years later would commandeer a steamer and present it to the Bolsheviks in Murmansk. Huelsenbeck read the first Berlin Dada manifesto—also signed in absentia by Tzara—claiming that only Dada can portray the "new new reality . . . a simultaneous confusion of noises, colors, and spiritual rhythms . . . with all the sensational screams and passions of its audacious quotidian psyche and in all its brutal reality."[11] Grosz presented more poetic insults, and Else Hadwiger read a Marinetti text extolling war to the accompaniment of toy trumpet and rattle, unfortunately interrupted by a soldier falling to the floor in epileptic seizure. The evening ended when the management, fearing trouble, turned on the lights, as Hausmann's talk on "The New Materials in Art" was greeted by the audience, in a reviewer's words, with "powerful nature noises."

Raoul Hausmann, Dada-Photo, 1919. This double portrait of Hausmann and Johannes Baader, showing Baader smoking a rose in his pipe, was published in Der Dada 2, December 1919.

Thus were initiated the series of performances that members of the group would hold over the next two years. By summer they had been joined by Hausmann's friend Johannes Baader, who appeared with him at the Café Austria on June 6, where Hausmann first read his sound poems constructed abstractly from letters alone. That year Hausmann printed four poster poems with lines such as "NVMWNAUR," which Baader would incorporate into the base of his monumental construction in the second room of the Dada Fair, *The Great Plasto-Dio-Dada Drama*. This huge five-level work contained mousetraps, a powder keg, an advertising dummy, miner's lamps, newspapers, and mixed ephemera to tell the story of "GERMANY'S GREATNESS AND DEMISE Through Teacher Hagendorf." According to the catalogue, Baader showed about fifteen other works, the same number as Hausmann. Only Grosz would display more works in the Dada Fair, twenty-eight of his own and ten collaborations with Heartfield.

The text of Baader's visiting card—"The Luggage of the Oberdada at the Time of His Escape from the Insane Asylum"—suggests something of his personality. Older than his fellows and a trained architect, Baader was the most outrageous of the Berlin Dadas. By 1900 he had come to see himself as the successor of Christ, and he was completely uninhibited in his public behavior. In 1916 he wrote to Prince Wilhelm Friedrich and insisted that the war be stopped immediately on his authority as the "Commander of the Empire of the Soul." Baader demanded a Nobel Prize during the summer of 1918, and that November he rushed into the pulpit at the Berlin Cathedral shouting that Christ was a sausage and indifferent to the world's ills. Arrested for blasphemy, he was acquitted on grounds of mental incompetence. In February 1919, recently having been proclaimed President of the Earth in the manifesto *Dada Against Weimar* published by the Central Dadaist Council for World Revolution, he got the movement into the international press by disrupting the first meeting of the National Assembly at Weimar. Demanding that the government be handed over to the Dadas, he showered delegates with a fictional broadside, *The Green Cadaver*, which reported "Johannes Baader rides into the National Assembly on the white horse of the Apocalypse. He declares it after the opening of the Seventh Seal as the offering of Dadaism."[12] Wild and unpredictable, he obtained much publicity for the group, but in early 1919 Huelsenbeck and even Baader's friend Hausmann warned Tzara that he did not represent the Club Dada in any way.[13]

Despite their distrust of Baader, in early 1920 Huelsenbeck and Hausmann took him along on their performance tour through Germany and Czechoslovakia. The evenings generally began with Huelsenbeck reading some of his *Phantastiche Gebete* ("Fantastic Prayers"), nonsense sound poems. Then Hausmann would continue with

opposite:
Georg Scholz. Industrial Farmers, 1920. Oil on plywood, 38⅝ x 27½ in. Von der Heydt Museum, Wuppertal

his own phonetic verse, followed by Baader's speech offensively invoking Christianity along with details of his paranoic universe. By then the audience would be well worked up, with further insults and provocations by Hausmann or Huelsenbeck pushing them over the edge. In Dresden on January 19 they stormed the stage and attacked the performers with chair legs, and in Leipzig soldiers were needed for protection. On February 18 armed troops were called to clear the hall in Hamburg, and in Prague and Karlsbad in early March riots barely were averted. True to his inconstancy, however, Baader disappeared on March 1 in Prague, abandoning the tour as Hausmann and Huelsenbeck nervously waited for him before a crowd of 2,500.

In Berlin the members of the Club Dada held a number of performances, the largest being the First German Post-War Renaissance of the Arts on May 24, 1919. It featured two events overseen by Grosz, a race between a sewing machine and a typewriter—after hectic typing and sewing, the sewing machine won—and the Pan-Germanic Poetry Contest, in which twelve seedy contestants simultaneously read different verses as loudly as possible.[14] Originally announced for May 15, it was rescheduled "on account of national mourning" after the soldiers responsible for the murder of Luxembourg and Liebknecht were let off with light sentences. Word of Dada was spread through other means as well, such as the slogans prepared by Grosz as Propagandada, printed on stickers and pasted all over the city—"Dada kicks you in the behind and you like it," "Come to Dada if you like to be embraced and embarrassed," "Dada, Dada *über alles*."[15] There also were publications such as *Der Dada*, whose three issues appeared between June 1919 and April 1920, the last listing as editors "Groszfield, Hearthaus, and Georgemann." But in Berlin before the Dada Fair, the only Dada exhibition was the largely ignored show at I. B. Neumann's in May 1919, organized by Hausmann and the Russian composer-painter Jefim Golyscheff, including their work along with that of Grosz, Hausmann, and Höch.

The most important predecessor of the Dada Fair opened in Cologne in April 1920 in the courtyard of the Brauhaus Winter, organized by Max Ernst and Johannes Baargeld. The *Dada-Vorfrühling* ("Early Dada Spring") was entered through the public urinal, and those arriving at the opening found a young girl in communion dress spouting obscene poetry. Ernst and Baargeld mounted the show after their work was rejected as it was being installed in a juryless March exhibition of the Artists' Union at the Museum of Decorative Arts. In the brewery courtyard Baargeld exhibited a junk relief containing a frying pan and old springs, along with his *Fluidoskeptrik*, an aquarium filled with blood-red water on which a female wig floated above a wooden arm and alarm clock. Ernst presented collage drawings, wire sculpture, and a wooden sculpture with an axe attached, inviting the public to destroy the object. There also was a drawing with lots of empty space and the legend "each visitor to the exhibition is qualified to write a dadaist or anti-dadaist sentence on this drawing. No punishment or prosecution."[16]

But prosecution threatened the organizers themselves, when the police closed the show for obscenity so as to avoid trouble with the British forces occupying the Rhineland. The British authorities already had prohibited two of their earlier publications, in March 1919 banning the revolutionary *Der Ventilator*, which was distributed at factory gates, and later confiscating *Bulletin D*, the catalogue for a November 1919 exhibition in which they had displayed found objects, children's and African art, mathematical models, and works of Klee and Arp along with their own. After an inquiry revealed that the work judged obscene at the Brauhaus Winter was a Dürer print of Adam and Eve, however, the exhibition was reopened in May.

Arp had been in Cologne in late 1919 and early 1920, before his departure collaborating with Ernst and Baargeld on the series of photocollages that they called *Fata-*

Richard Huelsenbeck (left) and Raoul Hausmann in Prague, 1920 during their international tour. Photograph courtesy Dr. Charles Huelsenbeck, New York

gaga (for "Fabrication des Tableaux Garantis Gazométriques"), and the show included a relief and two drawings of his. Ernst was already building his relations with Paris, and the exhibition contained the Picabia drawing *Oeil rond* which they published in their review *Die Schammade*, said to be financed by Baargeld's rich father in hopes of moving his son away from radical politics. Both these abstract biomorphic works of Arp and Picabia's quasimechanical drawing reappeared in Berlin at the Dada Fair, where the catalogue listed Arp's drawings as the work of "Hans Arp'ache." In all probability, the eight pieces by Ernst and three by Baargeld in Berlin had come from the Cologne show as well. Awareness of the international Dada movement also found expression in the Ernst-Baargeld collaboration *Simultantriptychon*, which included the names of the Paris *Littérature* group, Walter Arensberg, Duchamp, Tzara, and Serner, and the Berlin Dadas. Lastly, there were wooden reliefs by a "vulgar dilettante," Willy Frick, so called because his name sounded obscene and he had a full-time job.[17]

Ernst's sculpture with attached axe represents an attitude also seen throughout the Berlin Dada Fair, the attack on art as sacrosanct. Fine art to the Dadas was a means of ignoring political and social realities, "the head-in-the-clouds tendency . . . whose disciples brooded over cubes and Gothic art while the generals were painting in blood."[18] The antiaesthetic thus was the other side of the explicitly political, debunking art to redirect attention to politics. Placards at the Dada Fair announced "Down with art, down with bourgeois intellectualism" and "Art is Dead. Long live the new machine art of Tatlin." Here Tatlin represented the "conquering materialism" described by Umanskij, the enemy of the Expressionism that Herzfelde called in the exhibition catalogue "an attempt to deny the real."[19] Every aspect of the exhibition repudiated the fine art tradition—the aggressive and the ugly replacing the refined and the beautiful, collaboration as important as individual achievement, mechanical reproduction standing equal to the unique creation.

The purported purity of the masterpiece was mocked throughout the show in photocollages utilizing elements of known works—Baader's image of his face over the bust of the *Venus de Milo*, Schlichter's *Improved Paintings of Antiquity* with modern heads on the *Apollo Belvedere* and, again, the *Venus de Milo*, Hausmann's doctoring of Rubens's *Bacchanal* and Grosz's attack on Botticelli's *Primavera*. Heartfield and Grosz collaborated on two "corrected masterpieces," both reproduced in the catalogue: Dadaist lettering and photos over a Picasso Cubist collage, and a Rousseau self-portrait with Hausmann replacing the Douanier. Even Beethoven was slurred in Otto Schmalhausen's altered death mask, with bizarre painted eyes, moustache, and wild hair, chosen by Huelsenbeck for the cover of his *Dada Almanach* published just after the exhibition closed.

In his introduction to the catalogue, Herzfelde spoke of the exhibition actually presenting things themselves, instead of merely representing them in paint in the manner of high art. Newspaper texts and commercial images were given to the public in photomontage, and actual political materials plastered the walls. In addition to the pile of objects constructed by Baader, Hausmann showed what he called the first *Concretisation-Sculpture-Assemblage*, entitled *Industrial Revolution in the Year 1919*—a drawing board backed on a piece of wood painted black, to which were affixed slats from an umbrella stand and a blue faience plate, the whole littered with razor blades. And in his collage *The Art Critic*, Hausmann presented the collective Dada stance toward what art had become in their time. Incorporating the calling card of "President of the Sun, The Moon, and the Little Earth . . . Dadasoph, Dadaraoul, Director of the Dada Circus," against the background of a phonetic poem poster and marked with Grosz's signature stamp, the critic stood ready with sharpened pencil to spear the aesthete and the fine artist alike.

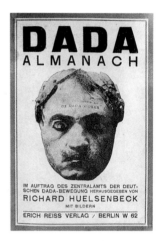

Cover of Richard Huelsenbeck's Dada Almanach, 1920, showing Otto Schmalhausen's altered death mask of Beethoven. Photograph courtesy Erich Pollitzer

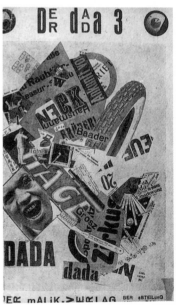

John Heartfield's cover of Der Dada 3, *April 3, 1920. This last issue of* Der Dada *was edited by "Groszfield, Hearthaus, and Georgemann." Akademie der Künste, Berlin. John Heartfield Archiv*

Like *The Art Critic*, many works in the exhibition referred to members of the Dada camp, a collective narcissism tempered by parody. Grosz especially depicted his fellows, showing drawings and montages of Heartfield, Herzfelde, Schmalhausen, Huelsenbeck, and others. Höch's photomontage *Cut with the Cake Knife* included photos of the Berlin Dadas, and Ernst exhibited a work called *Dada Fex Maximus and National Codex and Index of the Refinements of Dada Baargeld*. There was much humor in all of this self-reference, but it was humor with an edge, in line with the sharp tone of the exhibition.

The show was organized by Hausmann, Grosz, and Heartfield, and the installation itself presented the kind of aggressive statement found in the individual works. Like the large photographs of the organizers mounted in the first room, the exhibition shouted out its message to the public. A history of their agitation in newspapers, fliers, broadsides, and magazines was interspersed with works depicting what Germany had become—a nation crippled by the vicious actions of the military, the avarice of the industrialists, and the complicity and false ideals of the middle class. Views of military brutality vied with those of overfed self-satisfaction, and the two mingled in the drawings and collages of George Grosz, which outnumbered all else in the show. Works overlapped one another in a concentration of bizarre and angry imagery—the head of the officer leading the crippled procession of Otto Dix was completely covered by Grosz's collage painting *Victim of Society* also known as (*Remember Uncle August the Unhappy Inventor*).

The armed forces, not surprisingly, came in for particularly hostile treatment. Known from a newspaper account, Georg Scholz's painting *Hindenburg Headcheese. A Smelly Present for the Fieldmarshall Hindenberg* showed a bloody, crushed soldier's head under glass on a platter. In *Musketeer Helmhake on the Field of Honor*, Johannes Socrates Albrecht, perhaps a pseudonym of George Grosz, depicted an officer viciously beating Helmhake to death. Available for viewing on the book table, Grosz's portfolio of lithographs published by Malik-Verlag, *God with Us*, presented the military in its political role as oppressor of the people. In the end, it was with special reference to the Grosz portfolio, along with the *Prussian Archangel*, that charges were brought in court.

The case against the Berlin Dadas came to trial on April 20, 1921. The charge was insulting the German army, and it was lodged by the Minister of the Reichswehr, Otto Gessler. A Captain Matthai, who had attended the exhibition, served as witness

III

for the prosecution. Five members of the Dada group were arraigned at the *Dada Prozess*: Burchard as owner of the gallery, Schlichter as primary creator of the *Prussian Archangel*, Grosz as artist of the portfolio and Herzfelde as its publisher, and Baader, who, as "Oberdada" was somehow considered responsible for the whole show. The Dadas wisely called on cultural officials to testify in their defense, rather than attack the government and the court as one might expect. A state art curator, Edwin Redslob, spoke on behalf of Grosz, and the director of the Dresden State Collection, Paul Schmidt, discussed their work as a whole. He declared Dada to be a movement of satire and farce, commenting on its own foibles along with those of society. Grosz and Herzfelde prudently denied any intention to insult the Reichswehr, and were let off with modest fines. The other three defendants were acquitted. On this less than heroic note ended the last group event of Berlin Dada, whose members by 1921 had moved far apart.

The primary split concerned the relative merits of politics and art. From the beginning Grosz, Heartfield, and Herzfelde had focused on political agitation and publication, and only after the failure of the revolutionary movements of spring 1919 did they become deeply involved with the other members of the Club Dada. And despite his never having been Commissar of Fine Arts of the Berlin Revolutionary Council, a story that he apparently started and that has been perpetuated in the literature, Huelsenbeck's orientation more and more emphasized political over artistic commitment.[20] He had been the primary opponent of Schwitters, against Hausmann's support, and the period of the Dada Fair was one of increasing friction between Huelsenbeck and the Dadasoph.

Hausmann and Höch had been enthusiastic visitors to the Sturm gallery exhibitions after they met in 1915, and they maintained a more aesthetic stance than their colleagues during the Dada years. Hausmann's talk, which was cut short at the end of the first official Dada evening, extolled "miraculous constellations in real material, wire, glass, cardboard, tissue, corresponding organically to your own equally brittle bulging fragility," and the works of Hausmann and of Höch continued to instance this sort of poetic feeling.[21] Höch's dolls at the Dada Fair displayed aesthetic primitivism rather than political vituperation, and her photocollages, such as *Dada Dandy*, utilized colorful advertising and design elements to give a sense of modern life lacking the anger of Grosz and Heartfield. It is no wonder that Höch later grew close to Schwitters, who is said to have added the *h* at the end of her first name to create a palindrome like that of the subject of his popular poem "An Anna Blume." (She was listed in the Dada Fair catalogue as Hanna Höch.) Hausmann's montages in the exhibition, like *Tatlin at Home* and *Dada siegt* ("Dada Conquers"), created an open space and concatenation of images reminiscent of those with which Ernst would so impress the Parisians. The ambiguous way in which Hausmann and Höch each utilize the urban image of the machine lacks a sense of political partisanship as well. Their mechanical imagery subverts the romantic attraction to nature associated with Expressionism, but there seems little faith in the promise of technology, perhaps a natural attitude for those who had seen tanks rolling down the Berlin streets. When Hausmann added a mechanical brain to the figure from an American magazine representing the sculptor in *Tatlin at Home*, he created a highly evocative image, but one with no single interpretation. It was just the sort of work that Grosz and Herzfelde would mark as misguided in 1925, commenting on Berlin Dada: ". . . our only mistake was to have been seriously engaged at all with so-called art."[22]

For Hausmann and Höch, this was no mistake, and they soon linked up with Schwitters in Hannover. Schwitters had been associated with the Sturm group from June 1918, just before his breakthrough in the Merz collages and constructions early in

1919, and he maintained the focus on artistic autonomy that made Walden's associates anathema to Berlin Dada. Despite congenial contacts with Tzara and the Zurich artists, he was ostracized from Berlin Dada, and Grosz refused to see him on an attempted visit. Not only was he unable to exhibit in the Dada Fair, but he was mocked in Schlichter's work there, *The Death of Anna Blume*. Huelsenbeck was especially antagonistic, incensed over the publicity Schwitters received after "An Anna Blume" was published in *Der Sturm* in August 1919, and jealous of his developing relationship with Tzara. Their first personal contact in Hannover in November 1919 did nothing to improve relations. For his part, Schwitters had stickers printed for the cover of his portfolio of lithographs, *Die Kathedrale*, saying "Beware: Anti-Dada," though he denied that this meant he was against Dada. And in the January 1921 issue of *Der Ararat* he published a long article called "Merz," presenting the aesthetic ground of his work named for the word *Kommerz* that appeared in an early collage. Here he distinguished *Huelsendadaismus* ("husk dada") from *Kerndadaismus* ("kernel" or "core dada"), the former "politically oriented, being against art and against culture. . . . [But] Merz aims, as a matter of principle, only at art, because no man can serve two masters."[23]

Hausmann had maintained contact with Schwitters since their first meeting in fall 1918 at the Café des Westens—like Tzara and Arp, Hausmann was a "kernel" Dadaist—and after moving away from his more political colleagues in late 1920 their relations became closer. In September 1921 Hausmann and Höch traveled to Prague with Schwitters and his wife, and together they put on two performances advertised as "Anti-Dada and Merz." There Schwitters first heard Hausmann's early sound poem beginning "fmsbwtazau," inspiring his ambitious *Ursonate* and other abstract poetry.

Both Hausmann and Schwitters contributed to Theo van Doesburg's journal *De Stijl* that year. Van Doesburg—who had published Dada texts under the pseudonym I. K. Bonset—would invite Tzara, Arp, and Schwitters to the Weimar Congress of Constructivists in September 1922. Later that month an evening was held in Hannover around a Schwitters exhibition, bringing together Tzara, Arp, van Doesburg, Schwitters, Hausmann, Höch, Moholy-Nagy, and Lissitzky, recently arrived from Russia. From such performances developed the early 1923 Dada tour through Holland of van Doesburg and Schwitters, at which Schwitters in the audience would bark like a dog. In all of this we see the developing connections between Dada and Constructivism, which in an important sense succeeded Dada in Germany as Surrealism would in France. Much is suggested by the group that authored the "Call for an Elementary Art" in *De Stijl*, October 1921—Hausmann, Arp, Moholy-Nagy, and Puni.[24]

The Dada Fair represents the climax of Berlin Dada, reviewing its achievement and marking the moment from which its collective energy would dissipate. In 1920 Huelsenbeck was as much engaged in surveying Dada as agitating within it, publishing both the *Dada Almanach*—which attempted to give an overview of European Dada in a nonpartisan way, including from Berlin only Baader, Hausmann, Huelsenbeck, and Mehring—and the first history of the movement, his *En Avant Dada*. While after his Neoprimitivist days with Ball in Zurich he had developed an engaged leftist stance in Berlin, Huelsenbeck soon would depart from politics, moving to Danzig in 1922 for a position in neuropsychiatry. Amid all of the Berlin Dada agitation, he had finished his medical studies and been certified as a physician, perhaps not surprising for one who had written that "to sit in a chair for a single moment is to risk one's life."[25] Later immigrating to New York, Huelsenbeck would change his name to Charles R. Hulbeck and commence a distinguished career as a psychoanalyst. Heartfield, Herzfelde, and Grosz continued their political activities, Heartfield working intently for Malik-Verlag and the Communist press, illustrating books and creating propaganda materials. But while Grosz went on to spend five months in Russia in

Breton and Soupault's "Vous m'oublierez" ("You will forget me"), performed at the Festival Dada in Paris. (left to right) Paul Eluard (standing), Philippe Soupault, André Breton, and Theodore Frankel. The First International Dada Fair included the program for this event at the Salle Gaveau, May 26, 1920. The Museum of Modern Art Library, Special Collection, New York

1922—the next year publishing *Ecce Homo*, his great portfolio of biting political and social caricature—by the time he left Germany for America in 1933 he was wholly disillusioned with radical politics.

The sort of intensity that characterized Berlin Dada could not readily be maintained, and a group of such diversity could not long hold together. Activities continued—Baader even organized a Dada Ball in Berlin in January 1921, and other events in Potsdam and Leipzig later in the year—but by the end of 1920 there was little unity to Berlin Dada. In his parody of what traditional art criticism would say about the Dada Fair, published in the catalogue, Hausmann sketched the scene: "While Germany is trembling and shaking in a governmental crisis of unforeseeable duration . . . these boys come along making wretched trivialities out of rags, trash, and garbage."[26] Hannah Höch said that they were considered "Cultural Bolshevists," but some were more cultural and others more Bolshevist. And while the social and political climate that united them could not keep them together, they created a lasting and unique group portrait in their Dada Fair.

The Berlin Dadas were aware that Zurich innovations had taken another turn in France, for their exhibition included the program for the Festival Dada one month before at the Salle Gaveau in Paris. There Dada would take hold in a more literary context, and its subversive possibilities would develop in a wholly different direction. Eighteen years later, the exhibition that would sum up that movement could not have been more different in spirit from the First International Dada Fair.

CHAPTER 7 *Snails in a Taxi*
International Exposition of
Surrealism
Galerie Beaux-Arts, Paris,
January–February, 1938

Like the Berlin Dada Fair, the large Surrealist exhibition at the Galerie Beaux-Arts in 1938 both culminated and summarized a movement. Along the rue Surréaliste, behind the mannequins lining the passageway into the main exhibition space, there were posters, invitations, announcements, and photographs pointing back to earlier years. In the large room, decorated by Duchamp and lit by Man Ray, paintings from the 1920s were hung along with more recent works marking Surrealism's growing internationalism. Beginning as a literary movement, by the late 1930s Surrealism had dominated the visual avant-garde in Paris for close to fifteen years. It soon was to disperse with the war, after becoming an element of fashionable Paris, embraced by haute couture as, in a very different way, the Russian avant-garde was embraced by the Revolution. For there was a kind of style and elegance in the work that made this match a natural one, reinforcing the concrete relations established in society by many of the Surrealists. In the beginning, however, a connection with Dada was more natural for rebellious writers not especially interested in social accommodation.

In fact, when Tristan Tzara arrived in Paris on January 17, 1920 he was "awaited like a messiah" by the members of the *Littérature* group. He went immediately to the apartment of Picabia's companion, Germaine Everling, which soon was transformed into a center for the planning of a new series of Dada events. The Parisians who gathered around him were well aware of Zurich activities, and Tzara had published some of their work in the last Swiss issue of *Dada* (known as the *Anthologie Dada*). But the group that had founded the journal *Littérature* the previous March— André Breton, Louis Aragon, and Philippe Soupault—came with its own aesthetic program, one that soon would clash with the more anarchistic stance of Tzara and Picabia. For the Parisians' emphasis on serious practices of composition such as automatic writing and hypnotic trance, and their need to provide a theoretical ground for this activity, would come into conflict with the mocking spirit of Zurich that Picabia had found so congenial. In Paris Dada played into a germinal aesthetic, less generating Surrealism than serving as a vehicle for its development.

That vehicle rolled on for the next year and a half, treating Paris to, and outraging it by, a string of Dada performances. Among others, the Festival Dada at the distinguished Salle Gaveau ended in a melee, as the audience moved from throwing coins and paper to hurling fruit, vegetables, eggs, and a steak. Those in attendance to observe Breton wearing Picabia's signboard marking the audience as a bunch of idiots included Gide, Valéry, Léger, Metzinger, Gleizes, Brancusi, Romains, Mercereau, and Allard. Now established cultural figures, they reacted strongly to the Dadaist antics, and the Dadas were barred by Gleizes and Archipenko from a planned revival of the Section d'Or.[1] But no outside influence was necessary, for Paris Dada would be done in by internal dispute and Breton's move toward a different kind of subversion. By the summer of 1923, when Breton provoked police action by leading the Surrealists in a physical attack on Tzara's performance of the *Coeur à Barbe* ("Bearded Heart"), Dada

André Masson. Death of Ophelia, *1937. Oil on canvas, 44¾ x 57¾ in. The Baltimore Museum of Art, Bequest of Saidie A. May*

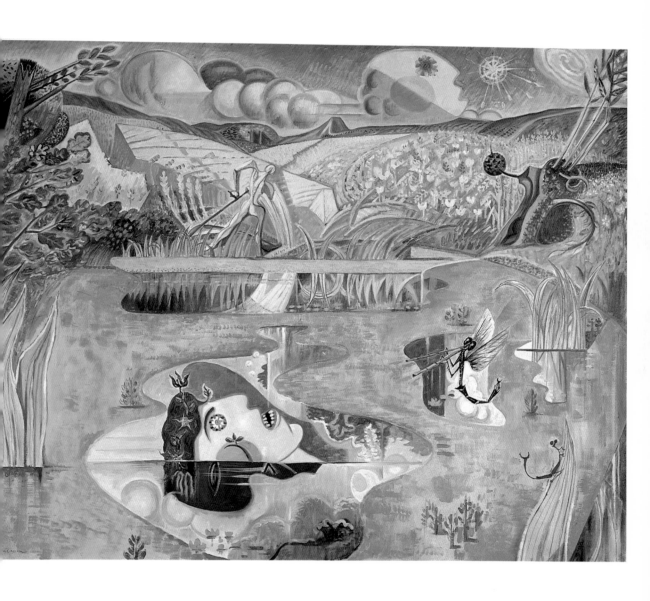

was behind them.

The previous November Breton had published an account of his friends' experimentation with hypnotism, "Entrance of the Mediums," a technique by which they sought to extend access to the magical realm that they had glimpsed through automatic writing. The trances of René Crevel, Benjamin Péret, and especially Robert Desnos gave free rein to the unconscious, and their answers to questions put by colleagues seemed to plumb its depths. Along with accounts of their dreams, also published by Breton in his new series of *Littérature*, the Surrealist writers pursued verbally what would be presented visually over the next two decades. *Desire* became a code word for revelatory personal impulse masked by social practice, and its display was a primary end of all Surrealist activity.

Although he did not publish his first Manifesto of Surrealism until 1924, Breton had already defined Surrealism as "a certain psychic automatism that corresponds quite well to the dream state."[2] And dreamlike imagery had appeared in May 1921 with the first exhibition in Paris of fifty-six of Max Ernst's collages and collage-drawings in the basement of Au Sans Pareil, a gallery and bookstore run by Breton's friend René Hilsum. The opening on May 2 was an event in itself, though it took place without Ernst, who was not allowed to leave Germany until the next year. At the door Jacques Rigaut called out the number of arriving cars and counted the pearls on the women who entered, while assorted revelers played hide and seek and made comments from inside a closet.

The group grew when Man Ray arrived from New York in July 1921 to join his friend Duchamp, and was introduced to Breton and company at their unofficial headquarters, the Basque bar-restaurant called the Certâ in the Passage de l'Opéra.

They arranged for a retrospective exhibit of thirty-five of his works from 1914 to 1921 in December at La Librairie Six, owned by Soupault, with a catalogue containing short statements by the artist and his new associates. Despite an exciting vernissage, the show elicited neither sales nor positive critical response, driving Man Ray to earn a living by fashion and society photography, in the process developing connections that would serve Surrealism well. But it was the occasion for his first Paris object, the disturbing flatiron with attached tacks—*Cadeau* ("Gift")—made on a walk back to the gallery after a drink with Eric Satie on the night of the opening.[3]

By the mid-twenties the movement had established a "Bureau of Surrealist Research" located at 15 rue de Grenelle and a journal in its own name, *La Révolution surréaliste*. The first issue opened with Man Ray's 1920 photograph of a mysterious blanket-wrapped object, *The Enigma of Isidore Ducasse*. It alluded to a text of Ducasse's pseudonym, the comte de Lautrémont—"the chance meeting on a dissecting table of a sewing machine and an umbrella"—a model for the creation of disturbing images by the uniting of disparate objects, and a paradigm of Surrealism. Just as the Berlin Dadas had distributed stickers with short provocative remarks, the Parisians posted small *Papillons* ("Butterflies"), saying things like, "If you love Love, you will love Surrealism" and "Parents! Tell your dreams to your children," along with phrases of more obscure significance.[4]

It was in this period that the writers were joined by painters, and many of the works to be shown at the International Exposition were created within a few years of their initial contact. In 1923 Yves Tanguy decided to become an artist after seeing two works by Giorgio de Chirico in the window of Paul Guillaume's gallery, and teaching himself to paint, he joined the Surrealists in 1925, developing his signature style of abstract dreamscapes by 1927. He and Jacques Prévert shared a house with Marcel Duhamel at 54 rue de Château, which supplemented Breton's studio as a center of group activity, and in May-June 1927 at the Galerie Surréaliste Tanguy's paintings were shown along with primitive objects from the Americas lent by Breton, Eluard, and Aragon. André Masson began making automatic drawings during the winter of 1923–24, and in 1927 he translated the visual impulses he found difficult to express with paint and brush in sand paintings done with glue spread by his fingers. Masson had a studio next to Joan Miró at 45 rue Blomet, and in 1924 he introduced the Spaniard to the Surrealists, moving him away from Cubism. Telling Masson, "I shall break their guitar," he created the poetic images that he would exhibit at the Galerie Pierre on the rue Bonaparte in June 1925.[5] Of the paintings shown by these artists at the 1938 exhibition, four of the eight Tanguys, five of the eight Massons, and seven of the twelve Mirós date from before 1930.

If the Miró show did not adequately refute Pierre Naville's denial of the possibility of Surrealist painting in the April 1925 issue of *La Révolution surréaliste*, the case was made by the first group exhibition of Surrealist painting, November 14–25, at the Galerie Pierre. Run by the important dealer Pierre Loeb, the gallery held its openings at midnight, and on this occasion there were far too many people to fit inside, filling the street well into the morning hours. The catalogue text by Breton and Desnos used the names of the pieces in the exhibition to describe a surreal landscape, creating a poetic analog of the show without any theoretical discussion of the work. Over the next two years Breton presented such an account in a series of articles on "Surrealism and Painting." He began with Picasso, who despite a reluctance to be called a Surrealist would appear in the 1938 exhibition with two paintings.

After Naville left the editorship of *La Révolution surréaliste* with the third issue, he was succeeded by Breton, who in the next number began to fill the journal with art and texts addressing it. Although literature remained the heart of their enter-

André Breton presents Francis Picabia's "Far-sighted Manifesto" at the Festival Dada, Salle Gaveau, Paris, May 26, 1920. He wears a signboard by Picabia reading: "In order for you to like something it is necessary for you to have seen and understood it a long time ago, you bunch of idiots." The Museum of Modern Art Library, Special Collection, New York

prise, visual art was beginning to stand on an equal footing. On March 26, 1926 a gallery devoted to such work, the Galerie Surréaliste run by Roland Tual, opened on the rue Jacques-Callot in the space formerly occupied by the leftist review *Clarté*. The first exhibition combined twenty-four works by Man Ray with more than sixty pieces of Oceanic art borrowed from various members of the group. It included his *rayograms*, cameraless photographs first created in Paris in 1922. Twelve of them had been published that year with an introduction by Tzara in the limited edition *Les Champs délicieux*, and four appeared in the November 1922 issue of *Vanity Fair* as "A New Method of Realizing the Artistic Possibilities of Photography."

The late twenties saw more than the efflorescence of surreal art, for in November 1926 Antonin Artaud and Philippe Soupault were thrown out of the group for their insistence on the autonomy of art from politics. Breton had become increasingly political, and he—along with Aragon, Eluard, Péret, and Pierre Unik—soon joined the French Communist Party. By the publication of his "Second Manifesto of Surrealism" in *La Révolution surréaliste* in December 1929, Breton had moved on political grounds against many of his associates, and he filled his text with diatribes that alienated others.

The new stance required a new journal, and in July 1930 Breton brought out *Le Surréalisme au service de la Révolution* (*SASDLR*), the official organ of the movement until it ceased publication in May 1933. Despite its title and opening statement of allegiance to the Third International in the event of a European war, the first issue was not wholly political. For it included Salvador Dali's article "The Putrid Ass," delimiting "a spontaneous method of irrational knowledge based on the interpretative critical association of delirious phenomena."[6] No doubt many on the left wondered what revolution Dali would serve with this "paranoiac-critical method" and his desire to "systematize confusion and contribute to the total discrediting of the world of reality."[7]

Dali injected new and obsessive life into Surrealism in the thirties, and his pictures were some of the most disturbing in the 1938 exhibition. The earliest of the six paintings shown was *The Great Masturbator* from 1929, a psycho-sexual scene of high symbolism, featuring Dada's immense head supported on its nose, its mouth attached to what he variously marked as a large grasshopper, locust, or praying mantis. Dali had seen Eluard's mantis collection and knew of the female's habit of devouring the male after sex, a fact especially significant for one who suffered when young from an intense fear of being eaten. The psychological range of Dali's image is suggested by his description of the onanist's flesh in a 1930 text: "triumphant, rotting, stiff, belated, well-groomed, soft, exquisite, downcast, marconized, beaten, lapidated, devoured, ornamented, punished."[8] Filling the kind of surreal space first created by Tanguy with acts from a psychoanalytic nightmare—Freud, in fact, found him to be the only truly interesting Surrealist painter—Dali came to represent Surrealism for the wider public, in large part a result of his active international self-promotion. Along with the Belgian René Magritte, who entered the scene about the same time, Dali reoriented Surrealist painting to the depiction of dream imagery, replacing the earlier abstract focus grounded in automatic techniques.

Dali also exhibited objects in 1938, most notably his lobster-shaped *Aphrodisiac Telephone*, and the surreal object became the major innovation of the movement during the thirties. Breton had suggested the creation of objects as early as 1924, in an account of a dream in which he came upon a book whose pages were black wool bound with a wooden Assyrian gnome. Georges Hugnet would later make a series of bizarre surreal bindings, one of which, *Locus Solus*, was exhibited at the International Exposition. But it was Dali who first discussed in detail the Surrealist object, delimiting six categories in an article in the December 1931 *SASDLR*, an issue that also con-

le corps
de ma brune

puisque je l'aime

comme . ma chatte
habillée
en vert salade

comme de la

grêle

c'est pareil

Hans Bellmer. La Poupée, *1934.*
Wood, metal, papier-mâché, 70⅞
in. Private collection

tained Giacometti's drawings of his strangely disquieting sculptures, *Objets mobiles et muets* ("Movable and Mute Objects"). Breton combined words and objects to make a "poem-object" in 1929, and he exhibited several of these in the 1938 exhibition. The first show of Surrealist objects was held at the Galerie Pierre Colle in June 1933, but the most famous was that of the Galerie Charles Ratton three years later.

In the catalogue to the Ratton show, Breton wrote that "Every piece of debris within our reach should be considered a precipitate of our desire," and the exhibition in May 1936 illustrated the diversity of what could so function.[9] Charles Ratton was a dealer in primitive art, and his show contained tribal works along with crystals and agates, a Picasso constructed guitar, Giacometti's *Suspended Ball*, mathematical objects discovered by Ernst at the Poincaré Institute, Duchamp "ready-mades," a Calder mobile, and bizarre creations by Oscar Dominguez, Dali, Miró, Tanguy, Man Ray, Hans Bellmer, Maurice Henry, and Marcel Jean. It also included that icon of Surrealism, Meret Oppenheim's fur-covered cup, saucer, and spoon, which would achieve special notoriety in December in New York at the Museum of Modern Art in Alfred Barr, Jr.'s exhibition *Fantastic Art, Dada, Surrealism*. The Oppenheim object had been sent directly from Ratton to the large International Surrealist Exhibition at the New Burlington Galleries in London that summer, as were a number of other works, and it would appear again in Paris in the 1938 exhibition. Surrealist objects featured prominently in London and at MOMA—other than the Oppenheim, the best-known Ratton piece to go to New York was the Miró construction with stuffed parrot.

Nineteen thirty-six might be called the year of the surrealist object, and a special issue of *Cahiers d'Art* appeared specifically devoted to the theme. It included Breton's essay "The Crisis of the Object" and reproduced many of the objects at Ratton in Marcel Jean's account of the show. The article by Dali, "Honor to the Object!" was illustrated with the sadistically manipulated doll of the German Hans Bellmer. Bellmer's photographs—"Variations on the assemblage of an articulated minor"—initially had been revealed to the French in the December 1934 *Minotaure*, a lavish magazine that became the primary Surrealist publication of the mid-thirties. They would appear again in all their creepiness at the International Exposition in Paris.

With the making of objects the Surrealists moved into three dimensions, actively creating what in the early years they had spent much energy passively appreciating. Open to impressions of mystery in both the peculiar and the commonplace, they had wandered through the city, an enterprise captured by Aragon in his 1924 classic *Le Paysan de Paris*. As Surrealism had progressed in painting from the receptivity of automatism to the fabrication of dream imagery, so in living space the next step was the assembling of environments. To some degree this was done privately in various studios and residences, but it was presented to the public in grand scale at the 1938 International Exposition. Breton had written in his introduction to Ernst's 1929 collage novel *La Femme 100 têtes* that "Surreality depends on our wish for a complete disorientation of everything," and that principle seemed to guide the installations of 1938.[10]

Emblematic was Dali's *Rainy Taxi*, which greeted viewers on entering the lobby of the Galerie Beaux-Arts, located at number 140 on the fashionable rue du Faubourg Saint-Honoré. Owned by Georges Wildenstein, also proprietor of the important magazine *Gazette des Beaux-Arts*, the gallery presented the Surrealists as the last in a series surveying the achievements of modern art. In turning the gallery over to the artists, however, Wildenstein got something very different from his earlier retrospectives of Impressionism, Fauvism, and Cubism, and Dali's cab suggested that this would be no ordinary exhibition. Inside an old vehicle sat two mannequins, the driver with shark's head and dark goggles, and his passenger, a disheveled woman covered with live Burgundian snails. Lettuce surrounded the passenger and sustained the snails,

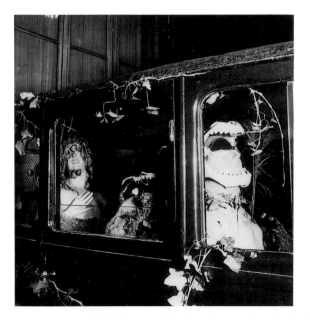
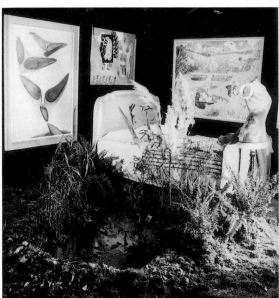

vines entwined the doors, and the interior was completely drenched by rain that fell from the ceiling. So popular was the piece that Dali recreated it the next year in New York for the 1939 World's Fair, along with his panoramic installation *Dream of Venus*.

A similar reversal of inner and outer dominated the main room of the exhibition, in which the floor was covered with leaves and moss, and a double bed with luxurious silk sheets sat at each corner. There was a pond encircled by ferns and reeds adjacent to one of the beds, above which hung Masson's *Ophelia* and Roland Penrose's *The Real Woman*. Next to the bed above the pond was a large painting by the Viennese Wolfgang Paalen, who was given credit for *Water and Brushwood* on the first page of the catalogue. The effect was analogous to a Magritte scene of nighttime street and daylit sky, following the Surrealist principle of "systematic displacement" that Ernst saw as the basis of collage, "a meeting of two distant realities on a plane foreign to them both."[11]

The installation as a whole was designed by Marcel Duchamp, marked in the catalogue as the *Générateur-Arbitre* (Producer-Referee) of the exhibition. He compounded allusions by covering the ceiling with 1,200 coal sacks filled, according to Man Ray, with a light, incombustible material, in deference to the insurance company. Masson remembered them as empty but continuing to shower coal dust on those below. There also was a glowing charcoal brazier, said to represent the friendship of those gathering around its warmth. Nearby two constructions of revolving doors were used to display graphic works, a reference to Man Ray's well-known early series of collages. Oscar Dominguez's phonograph *Jamais* ("Never") revolved silently, naked legs protruding from the speaker horn, a human hand suspended over the turntable. At the foot of the bed by the pond sat Marcel Jean's *Horoscope*, a dressmaker's dummy painted to depict its skeleton as geographic continents.

Paintings were hung on the walls, and Duchamp originally wanted electric eyes to trigger their illumination whenever a viewer approached. When that proved unfeasible, an alternative was arranged for the opening on January 17—as guests entered, they were handed flashlights by Man Ray, the show's Master of Lighting. Not surprisingly, many of the artists were upset to find their paintings in the dark at the

above left:
Salvador Dali's Rainy Taxi, *1938, installed in the lobby of the International Exposition of Surrealism. After its popularity in Paris, Dali would recreate* Rainy Taxi *for the 1939 New York World's Fair. International Surrealist Exposition, Galerie Beaux Arts, Paris 1938*

above right:
Installation view of the main gallery of the International Exposition of Surrealism, showing the pond and bed, and (left to right) Wolfgang Paalen's Untitled; *Roland Penrose's* The Real Woman; *André Masson's* The Death of Ophelia; *and Marcel Jean's* Horoscope. *Here, at Dali's request, dancer Helene Vanel ecstatically performed "The Unconsummated Act" during the vernissage. International Surrealist Exposition, Galerie Beaux Arts, Paris 1938*

vernissage. But Man Ray had constructed a system of hidden lights for use during the rest of the exhibition, which was fortunate since most of the flashlights were taken as souvenirs on the first night.

The opening itself was a great social event, filled with Paris society in the evening dress requested on the invitation. The announcement stated that "the authentic descendant of Frankenstein, the automaton Enigmarelle, constructed in 1900 by the American engineer Ireland, will cross the main hall of the Surrealist Exhibition at half past midnight, in false flesh and false blood," but even without his appearance there was much to entertain the celebrants.[12] André Breton and Paul Eluard were listed in the catalogue as the show's organizers, and Eluard made the welcoming speech dressed in coat and tails. On Dali's suggestion the dancer Hélène Vanel was engaged to perform a piece called *L'acte manqué* ("The Unconsummated Act") in the pond and on the bed.[13] It was so crowded that few could see more than feathers flying or hear more than hysterical cries, perhaps the recording of laughter of the insane that Man Ray remembered.[14]

Marcel Jean reported that German military music was piped in—certainly an ominous note that week in 1938 as Nazi aircraft executed surprise raids for Franco on Barcelona and Valencia. Closer to home there were rumors of a right-wing coup if the French situation did not improve, with the franc at its lowest point in eleven years and the country beset by strikes, and the week of the exhibition a new cabinet was formed in an attempt to resolve the political crisis. In its February 7 issue featuring the Surrealist show, *Life* seemed to sense a connection: "The news photographs on this page give an almost surrealist picture of five days that shook the souls of Frenchmen."

The dark grotto was host to a scene that was chic as well as foreboding, the atmosphere enhanced by the *Odeurs du Brésil* issuing from the coffee roaster installed by Benjamin Péret. *Vogue* described the mood this way:

> Unrest, claustrophobia, a feeling of some terrible disaster hung over the rooms. Out of the shadows, familiar faces loomed up and then disappeared: the lovely blond head of Mrs. John Wilson (Nathalie Paley) against the coal sacks; Bettina Bergery, being very interested and unafraid, saying it all reminded her of her childhood; Bérard, walking through quickly; Edward James standing patiently against the wall, waiting for the dancer to come out again and play in the mud puddle; Schiaparelli in paillettes; Madame Ralli, small and smart—and anxious to get out.[15]

But as anxious as Madame Ralli was to get out, many more were concerned to get in. Since the invitation called for a ten o'clock opening, the socially aware began arriving about eleven, but by then the police had closed the entrance because of the number of people already inside. Eric Sevareid's account of the vernissage in the Paris edition of the *New York Herald Tribune* (January 18) was titled "Police Get Taste of Surrealism as Crowd Fights to See Show." Dali reportedly ran along the sidewalk telling his fashionable friends to return in an hour when the crowd had thinned, and the decorator Jean-Michel Frank opened his shop next door, where those awaiting admission could view Dali's lip-shaped red satin sofa. Around midnight the doors reopened, and the party inside continued until after two.

From the lobby and Dali's *Rainy Taxi*, the crowd was led along the passageway of mannequins toward the two exhibition rooms. The mannequin was a Surrealist emblem, from its stylized use in the early paintings of de Chirico, through Breton's talk of it as a wholly modern manifestation of the marvelous in his "First Manifesto," to its most recent incarnation in surreal fashion display. The late 1930s found fashion jour-

Marcel Jean. Horoscope, *1938. Painted dressmaker's dummy with plaster ornaments and watch, H: 28 in. Morton Newmann Collection, Chicago*

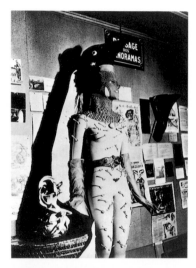

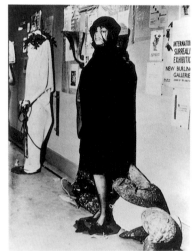

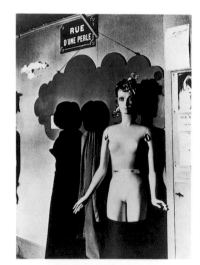

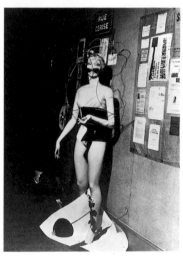

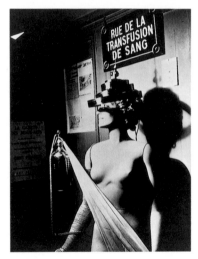

Salvador Dali's Mannequin, *1938. The penguin's head sat atop a hat by designer Elsa Schiaparelli, friend and supporter of the Surrealists. International Surrealist Exposition, Galerie Beaux Arts, Paris 1938. Photograph by Man Ray*

Joan Miró's Mannequin, *1938. International Surrealist Exposition, Galerie Beaux Arts, Paris 1938. Photograph by Man Ray*

Max Ernst's Mannequin, *1938. International Surrealist Exposition, Galerie Beaux Arts, Paris 1938. Photograph by Man Ray*

Oscar Dominguez's Mannequin, *1938. International Surrealist Exposition, Galerie Beaux Arts, Paris 1938. Photograph by Man Ray*

Man Ray's Mannequin, *1938. International Surrealist Exposition, Galerie Beaux Arts, Paris 1938. Photograph by Man Ray*

Leo Malet's Mannequin, *1938. Malet planned to have a fishbowl with live fish as his figure's stomach, but it was removed as too provocative. International Surrealist Exposition, Galerie Beaux Arts, Paris 1938. Photograph by Man Ray*

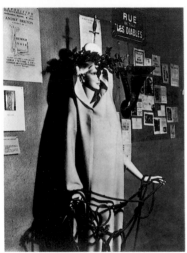
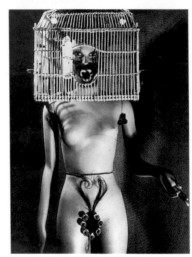
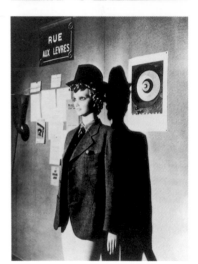

Wolfgang Paalen's Mannequin, *1938. International Surrealist Exposition, Galerie Beaux Arts, Paris 1938. Photograph by Man Ray*

Kurt Seligmann's Mannequin, *1938. International Surrealist Exposition, Galerie Beaux Arts, Paris 1938. Photograph by Man Ray*

Yves Tanguy's Mannequin, *1938. International Surrealist Exposition, Galerie Beaux Arts, Paris 1938. Photograph by Man Ray*

André Masson's Mannequin, *1938. Masson's figure received the most comment among those populating the rue Surréaliste. Photograph by Man Ray*

Marcel Jean's Mannequin, *1938. International Surrealist Exposition, Galerie Beaux Arts, Paris 1938. Photograph by Man Ray*

Marcel Duchamp's Mannequin, *1938. International Surrealist Exposition, Galerie Beaux Arts, Paris 1938. Photograph by Man Ray*

nals pervaded by Surrealist imagery, especially *Harper's Bazaar* and *Vogue*. The *Vogue* of March 1, in addition to covering the Galerie Beaux-Arts exhibition, included photographs of mannequins in the Bergdorf Goodman windows in New York, entangled with bird cages and pianos in distinctly surreal circumstances, and it spoke of Dali's windows at Bonwit Teller's the previous year rivaling the work in his show at the Julien Levy Gallery. Elsa Schiaparelli in particular was involved with surreal motifs in 1937–38, and Dali's mannequin in the show wore a Schiaparelli hat, underneath a penguin's head, being otherwise largely naked except for a sprinkling of tiny spoons.[16]

There were seventeen female mannequins along the rue Surréaliste, marked in the catalogue as being from the Maison P.L.E.M. Max Ernst displayed a figure in black cape and veil, standing over a fallen man. Man Ray's cried crystal tears and her hair was adorned with pipes blowing glass bubbles, Paalen's had a huge bat on her head and was covered with mushrooms and moss, Tanguy's was obscurely decorated with wooden spindles. Marcel Jean dressed his in a fishing net, Miró encircled the mustached head of his figure with wire, and a seltzer bottle seemed to spray fabric over the spring-coiffed model by Oscar Dominguez. Leo Malet had planned to display a globe with live fish over his mannequin's stomach, but it was removed as somehow too provocative, and the piece appeared only blindfolded with peculiar headgear. A knife penetrated the large egg atop Kurt Seligmann's, and the most notoriety seems to have been garnered by the mannequin of André Masson, her head in a wicker bird cage decorated with goldfish, a green velvet gag and a pansy over the mouth, a tiny stuffed bird in each armpit. She wore only a small *cache-sexe*, made from an oval mirror circled by glass eyes and crowned with feathers, and stood above a base of coarse salt with tiny traps holding phallic red pimentos.[17] Duchamp, in contrast, merely put his coat and hat on a mannequin, inserting a small red lightbulb in the breast pocket. Man Ray considered it "the least conspicuous of the mannequins, but most significant of his desire not to attract too much attention."[18] On this principle Duchamp did not appear at the opening, taking a train for London after finishing the installation that afternoon.

Along with the ephemera displayed on the walls of the rue Surréaliste, there were blue enamel street signs above each mannequin. Some were actual streets of Paris, such as the rue Vivienne, where the poet Lautréamont had lived, or the rue de la Vieille Lanterne, where the poet Gérard de Nerval had committed suicide, or the passages des Panoramas. But many were made up by the Surrealists, such as rue de la Tranfusion du Sang, rue de Tous les Diables, rue Faible, and rue Cerise. Despite its theatricality, the rue Surréaliste served to memorialize the magical engagement with Paris that had been essential to the movement from the beginning.

The change from receptive vision to conscious fabrication was well demonstrated in the second gallery of the exhibition, where things could be seen more easily than under the coal sacks. Sevareid reported that "The second room was well lighted by a chandelier artfully fashioned from an oversize pair of beribboned panties. In here the utilitarian and practical side of the surrealist's nature was expressed in umbrellas made of sponge, vases of goose feathers, wheelbarrows satin-lined, and footstools with legs encased in silk stockings and dancing pumps."[19] The wheelbarrow was Oscar Dominguez's *Armchair*, and it was one of the more well-known pieces of Surrealist furniture since Man Ray's photograph of a model seated inside in a long lamé gown was published in *Minotaure* the year before.

Furniture, in fact, was the focus of *Life's* coverage of the show. Their piece "Surrealist Furniture Draws Paris Crowd" stated that the "newest fillip for the Parisian smart world is surrealist furniture." It also featured the stool supported by three legs in pink stockings and pink and black shoes, noting that "The legs are designed to suggest to the subconscious the idea of sitting down."[20] This was Kurt Seligmann's *L'ultrameu-*

ble ("Ultra-Furniture"), perhaps derived from the similarly constructed *Überstuhl* exhibited by a B. Möhring in 1900 at the First Great Berlin Joke-Art Exhibition.[21] Other furniture included Georges Hugnet's table with compartments where hands floated in fluorescent liquid, and André Breton's gilded antique chest standing on female legs, surmounted by a glass case of stuffed birds.

Breton called this piece *Le Cadavre Exquis*, a reference to the group game whose discovery he dated to 1925 at the Duhamel-Tanguy-Prévert residence in the rue de Château. Initially it was a verbal game, in which five participants passed a folded piece of paper around to the right, each secretly writing a word—the first putting down a noun, the second an adjective, the third a verb, the fourth another noun, and the fifth a final adjective. The sentence said to be first generated by this process gave the game its name: *Le cadavre exquis boira le vin nouveau.* ("The exquisite corpse will drink the new wine.") The procedure was extended visually in drawings and collages, and collective works of this kind were shown in many group exhibitions. The 1938 catalogue lists *Cadavres Exquis* as a separate category, but does not specify how many were exhibited.

The International Exposition included numerous examples of another sort of chance creation, *decalcomania*, discovered by Oscar Dominguez in 1936. Breton introduced this newest automatic device in the June 1936 issue of *Minotaure*, explaining the method of laying black gouache down on slick paper, and pressing a second sheet onto the first. Removing it yielded Rorschach-like images of suggestive shape, sometimes more fully designated "*decalcomania* with no preconceived object" or "*decalcomania* of desire."

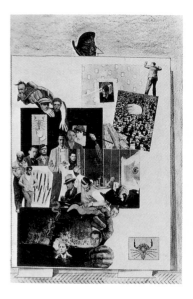

Max Ernst. Au Rendezvous des Amis, *1931. Photomontage, 19¾ x 13¼ in. Collection, Museum of Modern Art, New York*

Decalcomania was one of the many terms defined in the *Dictionnaire Abrégé du Surréalisme* ("Abridged Dictionary of Surrealism") that was published by the Galerie Beaux-Arts in conjunction with the exhibition. Compiled by Breton and Eluard, the *Dictionnaire Abrégé* contained entries provided by many of the Surrealists, or excerpted from their writings. The artists themselves were "defined": Duchamp was "the most intelligent and (for many) the most troublesome man of this first part of the twentieth century"; Breton, "the glass of water in the storm"; Dali, "the prince of Catalan intelligence, colossally rich"; Ernst, "the superior of the birds" (in his incarnation as Loplop); Arp, "the dune-eel"; Miró, "the sardine-tree"; Masson, "the man-feather"; Magritte, "the cuckoo's egg"; Tanguy, "the guide from the age of mistletoe druids"; and of Man Ray it was said that "He paints to be loved."[22] But most of the words listed were Surrealist terms of art, often defined by quotation from one or more members of the group and from its appropriated literature.

In a way, the *Dictionnaire Abrégé* served as the illustrated catalogue for the International Exposition, complementing the printed list of pieces in the show. Some of the exhibited works are reproduced, but more often it illustrates others of similar date. This is useful in giving a sense of the more obscure artists, and what it shows of painters like Remedios, Elsa Thoresen, Wilhelm Bjerke-Petersen, Paul Nash, and Freddie suggests that the exhibition was filled with dreamlike images in the manner of Dali and Magritte, with an admixture of Hieronymus Bosch. For a well-known figure such as Giacometti, whose catalogue entry lists only sculptures, it illustrates his gameboard-like *On ne joue plus* ("No more play") and a studio photograph showing the primitivist *Invisible Object*, which Roland Penrose recalled being shown. Like the exhibition itself, the *Dictionnaire Abrégé* was a reprise of a mature movement, recapitulating the past and consolidating an ethos. Its texts featured the unlikely juxtaposition and poetic resonance for which Surrealism was known, and double-pages illustrated such themes as the surreal object and the erotic Women of Surrealism, along with group photographs of the artists over the years.

The size of the exhibition allowed for condensed retrospectives of the founding artists, and there were works spanning the twenties and thirties by Arp, Ernst, Magritte, Masson, Miró, Man Ray, Tanguy, and Duchamp. Arp exhibited early wooden reliefs with more recent biomorphic sculptures and objects made of newspaper. He also showed a collaborative work done with his wife, Sophie Taeuber, and another he created with Georges Hugnet. There were fourteen paintings and an object by Ernst, along with early collages and the original pages from his third collage novel, *Une Semaine de bonté* ("A Week of Kindness") of 1934. Magritte showed nine paintings, including one version of his famous mislabeling of familiar objects, *La Clef des songes* ("The Key of Dreams"), a commentary on the arbitrary connection of sign and signified. Masson, Miró, Man Ray, and Tanguy each exhibited both paintings and objects, some among their most famous images—such as one of Miró's *Dutch Interiors* and Man Ray's *A l'heure de l'Observatoire—les amoureux* ("Observatory Time—The Lovers"). This Man Ray, depicting the elongated red lips of Lee Miller floating in the sky, had welcomed visitors to the MOMA exhibition in 1936 before being removed from the entrance as too provocative, and then was shown by Helena Rubinstein at her Fifth Avenue salon to publicize a new lipstick.[23] And while Duchamp's two paintings and three objects listed in the catalogue were done before 1926 (three before 1915), along with the installation they do in some way survey his work, given his decision in the mid-1920s to give up the creation of artworks.[24]

The important exception to such a chronological spread was the work of Giorgio de Chirico. De Chirico spoke deeply to the Surrealists early on, with his rich use of symbolic objects and the evocation of mysterious urban spaces. His paintings had struck Ernst as a revelation when he saw them reproduced in an Italian journal while visiting Klee in 1919, and their discovery had converted Tanguy to painting in 1923. But the works to which they responded were done in the teens, haunting metaphysical scenes prefiguring the dream images of Magritte and Dali. Two of them, both from 1918, were in the first exhibition of Surrealist painting at the Galerie Pierre in 1925. That year De Chirico moved to Paris, but the Surrealist press already had begun to attack his recent work, rejecting everything done after 1919 as an aesthetic betrayal. Breton, especially, condemned him, and in February–March 1928 the Galerie Surréaliste presented an exhibition of early de Chirico against the artist's expressed wishes. The organizers actually retitled the paintings, and constructed a grave marker in the form of a plaster Leaning Tower of Pisa with rubber horses and tiny pieces of furniture around it. It was shown in the issue of *La Révolution surréaliste* that reproduced the pictures in the exhibition with their revised titles, along with an article by Raymond Queneau distinguishing two periods of de Chirico's work, the early and the bad.[25] In the 1938 show, eight de Chiricos were exhibited, all done between 1913 and 1917, some bearing the titles bestowed by others ten years before.

Although Dali's artwork remained in Surrealist favor—he was listed in the catalogue, along with Ernst, as a Special Advisor of the exhibition—his person created difficulties. In addition to antics of aggressive self-promotion, he displayed a tendency to aesthetic reaction in his praise of the painter Meissonier. More important were his politics, support of the clergy in a movement that had proudly published a photograph of Benjamin Péret insulting a priest, and—worse still—explicitly pro-Nazi attitudes. Dali expressed admiration for Hitler, and his 1936 article "Honor to the Object!" included positive remarks about the German swastika. After refusing to join his colleagues in the Association of Revolutionary Writers and Artists in 1933, in 1934 he was severely criticized by the Surrealists for pro-Nazi sympathies just before right-wing riots almost toppled the government in early February. Finally, with war on the horizon, in 1939 Dali was excluded from the group.

Max Ernst. La Joie de vivre,
*1936. Oil on canvas, 28¾ x 36¼
in. Collection of Sir Roland Pen-
rose, London*

Unlike the Berlin Dada Fair, the 1938 Paris exhibition truly was international. The catalogue listed sixty artists representing fourteen nations: Germany, England, Austria, Belgium, Denmark, Spain, the United States, France, Italy, Rumania, Sweden, Switzerland, Czechoslovakia, and Japan. Magritte and E. L. T. Mesens had established a Surrealist group in Brussels in the mid-twenties, and the Parisians collaborated with the Belgians in preparing the June 1929 issue of their magazine *Variétés* on the current state of the movement. By 1935 there were Surrealist groups active in many countries, words and images spread widely through publications and personal contact. That year the first book in English on the movement appeared in London, David Gascoyne's *A Short Survey of Surrealism*, although in the United States the first exhibition—entitled Newer Super-Realism—had been held much earlier at the Wadsworth Atheneum in Hartford in November 1931.[26]

Breton traveled widely in 1935. In April he and Eluard lectured in Prague, where they found an active Surrealist group two of whose members, Toyen and Jindrich Styrsky, would be shown in the 1938 exhibition. Breton then spoke in Zurich before visiting Tenerife in the Canary Islands with Péret in May. There they attended a Surrealist exhibition organized by Oscar Dominguez, a native of the Canaries who recently had joined the group. By the end of the year Breton was working with the English Surrealists on planning the great London exhibition. The four-issue run of a new journal, the *Bulletin International du Surréalisme*, largely followed his movements. It was published in April 1935 in Prague, in May in Tenerife, in August in Brussels, and a year later in London in September 1936, reporting on the past summer's show at the New Burlington Galleries.

During the International Exposition in February 1938, Breton set off on another trip, this time to Mexico. The foreign ministry had offered him a lecture mission to either Czechoslovakia or Mexico. In need of funds, he left Paris after closing the Galerie Gradiva that he had opened the previous year on the rue de Seine, named for a story by the German writer Wilhelm Jensen that had been analyzed by Freud. He chose Mexico largely because of his desire to meet Trotsky, who was living in a house owned by Diego Rivera and Frida Kahlo, whose work oddly enough was not to appear in the 1938 show. Breton stayed with the two painters, and met often with Trotsky, the two taking numerous excursions together. In July Breton and Trotsky co-authored the manifesto "Toward an Independent Revolutionary Art," but at Trotsky's request Rivera's name was substituted for his on publication. Returning to Paris in August, Breton broke with Eluard over the latter's publishing some poems in a Stalinist journal. Ernst sided with Eluard and left the group, as did Hugnet soon afterward. The united front presented at the International Exposition was disintegrating.

The exhibition itself had been very large, the catalogue listing 229 items, quite a few of them multiple entries. With many of the non-French artists living in Paris, the strongest foreign groups working abroad were the Belgians—Magritte, Mesens, Paul Delvaux, and Raoul Ubac—and the English. Roland Penrose and David Gascoyne in 1935 had brought London first-hand word of French activity, and around them assembled English artists working in the surreal mode. At the New Burlington Galleries the group participated along with international figures selected by Breton and Eluard, and it emerged with a strong identity. The work in the 1938 show by Paul Nash, Eileen Agar, Roland Penrose, Henry Moore, Humphrey Jennings, Edward Burra, P. Norman Dawson, Stanley William Hayter (working in Paris) and Leonora Carrington (then living with Max Ernst at Saint-Martin d'Ardèche near Avignon) constituted the largest non-French national contribution. The sole American sending pieces from abroad—joining Man Ray working locally—was Joseph Cornell.

Of the German artists in the exhibition, two—Ernst and Richard Oelze—

had been living in Paris, and Bellmer was to move there later in 1938, escaping an intolerable situation under the Nazi regime. Surrealism itself, and modern art in general, had been vilified the previous year in the Exhibition of Degenerate Art in Munich. While the International Exposition might have been viewed by disaffected Parisian poets as too bourgeois, and by some members of society as *démodé* and somewhat boring—*Life* reported the former, and *Vogue* the latter—in Germany such art still seemed advanced and threatening. A few hundred miles to the east lay a different world, one soon to encroach on the Parisians who had mounted their last prewar extravaganza.

The Galerie Beaux-Arts show was the last of the three great international Surrealist exhibitions of the 1930s, and it is striking to find that many paintings and objects appeared in them all. There almost was a package of works, first assembled for the New Burlington Galleries in June 1936, with many of the objects coming right from Charles Ratton the month before. Quite a few of these pieces were sent five months later to New York, to be presented with Dada by Alfred Barr, Jr. in terms of an historical tradition of Fantastic Art and related cultural artifacts.[27] When Breton and Eluard organized the Paris exhibition, they reassembled much that had appeared in one or both of the 1936 shows, setting it amidst their installations as the record of a mature movement, a view by now familiar throughout the world. Among the works that appeared in all three exhibitions are de Chirico's *Child's Brain*, Duchamp's *Pharmacie*, Eileen Agar's painting of abstracted horse heads, *Qadriga*, Victor Brauner's *Kabiline in Movement*, Oelze's *Daily Torments*, the Oppenheim fur teacup, and Man Ray's *Observatory Time—The Lovers*. Other specific works by Duchamp, Mesens, Tanguy, Masson, and Man Ray appeared at MOMA and the Galerie Beaux-Arts, with the 1938 Paris exhibition sharing additional pieces from London by Arp, Tanguy, and Masson.[28] Certainly most works appeared in only one of the shows, but the artists overlap to a large extent, creating a very similar picture of Surrealism across all three exhibitions.

The difference in 1938 was the physical setting, installations that clearly overwhelmed the works shown within them. This constituted the show's unique aspect, turning the exhibition itself into a work on a par with its content. To an extent this was true of the Berlin Dada Fair, the chaotic and aggressive presentation expressing the same message as the pieces presented. But at the Galerie Beaux-Arts the intention was more explicit, the installation designed to evoke the disquiet of repressed desire on the verge of self-recognition, the viewer placed into a world displaying its own Surrealist interpretation. The setting was appropriately nightmarish, theatrical, and self-conscious and, more in the spirit of Duchamp and Man Ray than of Breton, entertaining. In addition to Schwitters's transformation of his own home into a shrine to his obsessions, the *Merzbau*, the 1938 exhibition is an important model for what would become installation art.

Thus, while Surrealism by 1938 had become part of a cultural establishment, fixed through great international surveys and embraced by high society, this exhibition expanded in presentation the advanced work that had been initiated years before. And in doing so, Surrealism moved beyond its particular theories to a new form of art making. More than this, through expatriation Surrealism would continue to develop, its roots in automatism generating anew in the fertile soil of America.

Giorgio de Chirico. A Child's Brain, *1914. Oil on canvas, 31½ x 25⅝ in. Statens Konstmuseer, Stockholm*

opposite:
Yves Tanguy. The Sun in Its Jewel Case, *1937. Oil on canvas, 45⅞₁₆ x 34¹¹⁄₁₆ in. Peggy Guggenheim Collection, Venice, The Solomon R. Guggenheim Foundation, New York*

CHAPTER 8 *Displacement of the Avant-Garde*

Exhibition of Degenerate Art,
Munich, 1937
First Papers of Surrealism,
New York, 1942
Art of This Century,
New York, 1942

ronically, the century's most highly attended exhibition of advanced art was mounted as an attack on the new painting and sculpture. Over two million people visited the Exhibition of Degenerate Art (*Entartete Kunst*) in Munich, with crowds averaging more than 20,000 a day during the exhibition, which lasted from July 19 to November 30, 1937, extended from September due to popular demand. Some came to see old friends, works confiscated from museums and marked for elimination. But most came to view the mental and moral degeneracy that National Socialism sought to eradicate, art so shocking that no children were allowed into the show. The exhibition displayed, the accompanying pamphlet explained, "the decades of cultural decadence that preceded the great change," uniting phenomena of purported ethical, aesthetic, and political anarchy under the label of *artistic Bolshevism* (*Kunstbolschewismus*).[1] For the Führer's war against avant-garde and modernist culture was of a piece with his opposition to Marxism and to the consequences of socio-economic modernization.[2] This spurned painter took art very seriously, and Nazi functionaries followed his lead in creating an elaborate bureaucratic apparatus for its control. Commenting on Hitler's speech at the opening of the House of German Art, the English critic Herbert Read remarked on how extraordinary it was for the head of a major nation to speak for an hour and a half on the nature and function of art.[3] Just how extraordinary could be seen that summer in Munich.

The Exhibition of Degenerate Art opened on the day after the festivities inaugurating the Great German Art Exhibition, the first of the eight shows of officially sanctioned work held at the House of German Art between 1937 and 1944. A pet project of Hitler's, the House of German Art was the first major architectural undertaking of the Third Reich, its cornerstone laid by the Führer in October 1933, on the day following Germany's withdrawal from the League of Nations. The building was designed by Paul Ludwig Troost with Hitler's active involvement. Troost was known for creating rich interiors for luxury liners, and he was charged with designing a lavish temple to the anticipated achievements of art under the National Socialists. In addition to Hitler's speech, the opening featured an elaborate pageant with more than 6,000 participants depicting Two Thousand Years of German Culture. But the Nazi exhibition attracted less than a third of the visitors who walked through the cramped rooms in the Hofgarten arcades to view artistic expressions of the degeneracy that would be expunged by the Thousand Year Reich.

The exhibition that they saw had been thrown together hastily in a little

Ludwig Gies's Crucified Christ, *ca. 1921 [probably destroyed], wood, dimensions unknown, was placed at the top of the stairs at the beginning of the Exhibition of Degenerate Art. A photograph below showed its original installation in Lübeck Cathedral, from which it was removed in 1922 in response to public protest. Photograph courtesy Dr. Mario von Lüttichau, Museum Folkwang, Essen*

Man staune!

Die prononcierte Vereinfachung aller
Motive ist nicht bloß primitive Primi-
tivität, sondern auch voll auf die
Erzielung ästhetischer ... gerichtet ...
Auch die ästhetischen Werte
sind von so tiefer und eigener Prä-
gnanz, daß vor allem schon das Werk
zu einem der wertvollsten Dokumen-
te sakraler ... wird ...
Erlebens ... können
schwerlich ... Symbol ... finden
werden, das gewaltiger und tiefer den
Sinn des Weltkriegs und seiner gefal-
lenen Helden der Nachwelt vor Augen
hielte."

"Christus"
von
Prof. Gies
BERLIN

Dieses ... HELDENEHRENMAL ...

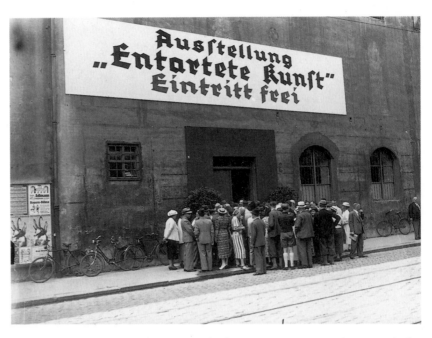

more than two weeks, yet its roots went back many years. In 1930, three years before the Nazis came to power, the National Socialists were voted into a coalition government in Thuringia, and Wilhelm Frick became their first ministerial appointment. His ministry's decree of May 4, "Against Negro Culture—For Our German Heritage," led to the banning of leftist films, theater, and modern music. By autumn in Weimar, all twenty-nine members of the Bauhaus faculty had been dismissed, Oscar Schlemmer's murals in the school stairwell had been painted over, and seventy works of modern art were removed from display at the Schlossmuseum.

The Nazi cultural program began on the national level with Hitler's assumption of power in 1933. The right-wing Führer's Council issued a manifesto, entitled "What German Artists Expect from the New Government," calling for the suspension of progressive museum personnel, the removal of modern art from public collections, and an exhibition presenting the confiscated material along with information on what the government had paid for these abominations. After this display, it noted, they "can serve as fuel for heating public buildings."[4] The first such shows opened in April that year, Government Art from 1918 to 1933, in Mannheim, and Government Art from 1918 to 1933, in Karlsruhe. They were followed by such exhibitions as the Chamber of Horrors in Nuremberg, Chemnitz's Art that Did Not Issue from Our Souls, and Stuttgart's The Spirit of November: Art in the Service of Subversion. In all of these exhibitions, and in other regional shows during the next four years, the art of the avant-garde was linked with moral and social subversion, and with the failures of the Weimar regime under which much of it had been purchased by state museums.[5]

Throughout the nation museum directors and art professors sympathetic to advanced art were dismissed, replaced by reactionary administrators and artists. When the head of the Mannheim museum, Gustav Hartlaub, was removed, some of his modern purchases were paraded around the city in an open cart. Included was Chagall's *Rabbi*, which would appear in the Degenerate Art show before being auctioned in Switzerland to raise funds for the state. Among those forced out of their teaching positions were Otto Dix, Oscar Schlemmer, Käthe Kollwitz, Willi Baumeister, Paul Klee,

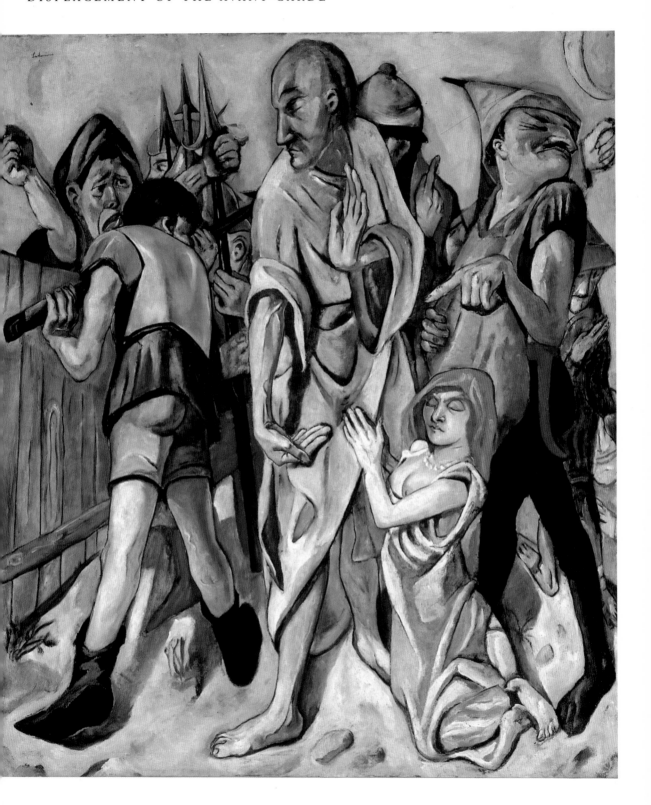

Heinrich Campendonk, and Max Beckmann. During that first year of Nazi rule Grosz fled to America, Kandinsky left for France, and Klee to Switzerland. Max Beckmann remained in Germany until he heard Hitler's speech opening the House of German Art in 1937, during which, it was said, the Führer actually frothed at the mouth. Beckmann and his wife left for Amsterdam the next day. In the face of police harassment, the faculty of the Bauhaus in Berlin, recently relocated in 1932 after being dissolved by the Dessau city legislature, voted itself out of existence on July 19, 1933.

The program of cultural suppression was administered by the newly formed Reich Chamber of Culture, led by Joseph Goebbels. As Reich Minister for National Enlightenment and Propaganda, Goebbels organized the entire cultural field into a structure of "chambers"—including separate sections for visual arts, music, theater, radio, film, and the press, each with subdivisions governing particular areas. Membership in these chambers was obligatory for everyone working in each field, including those who promoted and sold cultural products. In November 1936—the month after the modern section of the Nationalgalerie in Berlin was closed—Goebbels decreed that art criticism must be solely descriptive, appreciations of what the state viewed as permissible. He spoke of the four years that the Führer had given the nation to adapt to Nazi principles, and his words soon were echoed in the threatening phrase on the wall at the Exhibition of Degenerate Art above Lehmbruck's *Kneeling Woman*, which we know from the Armory Show: "They had four years' time."[6]

Early in those four years, in the fall of 1933 in Dresden, the first exhibition entitled Degenerate Art was held. There 207 works were assembled in the courtyard of the Neues Rathaus, and selections were sent on tour to eight other cities. But in scale and depth they paled beside the Munich show, which exhibited more than three times as many pieces by 112 artists. In early 1937 the idea arose of having such an exhibition coincide with the initial juried display of Nazi art, but bureaucratic infighting prevented its swift implementation. By the time that Goebbels gave the task to Munich painter Adolf Ziegler on June 30, things had to move very quickly.[7]

Ziegler, called "the master of pubic hair" for his highly realistic Neoclassical nudes, was a favorite artist of Hitler's and had been head of the Chamber of Visual Arts since late 1936. For the Munich exhibition he was given power to assemble from public collections works of "German degenerate art since 1910," and in less than ten days Ziegler and a committee of five others ranged throughout the country, ransacking the storerooms of the museums that they had time to visit. The commission exceeded its mandate, taking pieces done before 1910 as well as work of non-Germans, including that of Archipenko, Derain, Braque, de Chirico, Ensor, Gauguin, van Gogh, Léger, Rouault, Lissitzky, Ernst, Matisse, Mondrian, Vlaminck, Kandinsky, and Picasso. The confiscations would continue into 1938, eventually totaling about 16,000 works by 1,400 artists. The Folkwang Museum in Essen lost the most—1,273 works—closely followed by the Hamburg Kunsthalle and the Berlin Nationalgalerie.[8]

Hitler had inscribed over the entrance to the House of German Art the words *Art Is a Mission Demanding Fanaticism*, but the installation by Ziegler and company shocked even the Führer.[9] In contrast to the luxurious setting of The Great German Art Exhibition, the more than 650 degenerate works were displayed in an annex of the Municipal Archaeological Institute, which normally housed plaster casts. In the two narrow ground-floor rooms, opening three days late because of the frantic schedule, graphics and works on paper were tacked onto the walls or stuffed into display cases. The main exhibition was upstairs, in a long row of seven galleries. There paintings were hung with and without frames, on temporary panels covered with political invective and derogatory remarks. In some rooms the installation itself was an insult, reinforcing the venomous comments. In others paintings were arranged in an almost

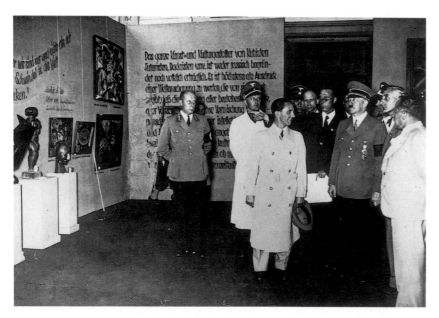

elegant, if crowded, display. But in all galleries the Nazi view of modern art was clear. It was an amazing, if appalling, achievement, for the actual process of confiscation, shipping, and installation had been accomplished in less than two weeks.

To enter the exhibition visitors climbed a flight of narrow wooden stairs, where they were met by Ludwig Gies's large sculpture of Christ on the cross, removed in 1922 from Lübeck Cathedral after public protest. This first gallery was devoted to religious imagery, and was dominated by the work of Max Beckmann and Emil Nolde. Featuring Nolde's nine-painting cycle *The Life of Christ* taken from the Folkwang Museum, the room illustrated "Insolent mockery of the Divine under Centrist rule."[10]

Nolde, who had been a member of the Nazi party since 1920, objected strenuously to being included in the exhibition, writing to Goebbels of his loyalty and of the Germanic spirit of his painting. Yet despite his strong anti-Semitism and committed party affiliation, the Gestapo closed one of his exhibitions and vast numbers of his works were removed from museums. Similar objections by Oscar Schlemmer also went unheeded, and his nine works remained in the exhibition. More touchy for the authorities were the five or six paintings by Franz Marc, since Marc had earned an Iron Cross and died in service to the Fatherland near Verdun. The German Officers' Federation protested, and the *Tower of Blue Horses* was removed from Room 6. But Marc's other works were left on display.

Anti-Semitism, of course, was a major theme of the exhibition, despite the fact that just 6 of the 112 artists were Jewish. Only Jewish artists were shown in the second smaller gallery, which included Chagall's *Rabbi* that had been pilloried in Mannheim. Throughout the show walls were covered with anti-Semitic comments, often applied to works by non-Jewish artists. In the next gallery paintings by Kirchner, Mueller, and other Aryans were labeled "German farmers—a Yiddish view," and, more oddly, "The Jewish longing for the wilderness reveals itself—in Germany the negro becomes the racial ideal of a degenerate art."

This third gallery was the most outrageous in the exhibition. On walls devoted to Dada and abstraction the paintings were hung askew with offensive slogans written around them, though after the Führer's initial visit they seem to have been

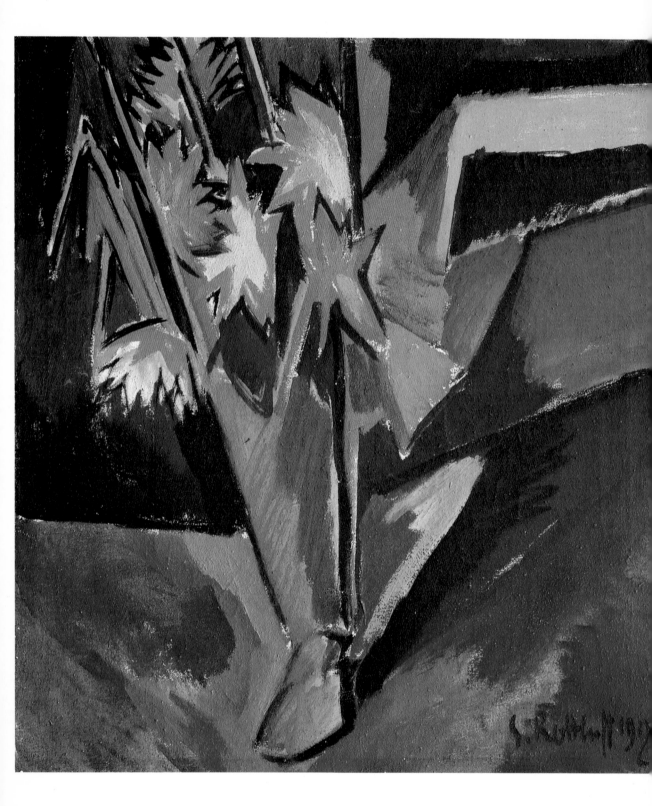

straightened.[11] The most striking panel was decorated with a simplified version of Kandinsky's abstraction, *The Black Spot*, on which were hung some Dada broadsides and works by Schwitters and Klee. Scrawled above were Grosz's words from the Berlin Dada Fair poster, now used as Nazi admonition: "Take Dada seriously! it's worth it." Across the room Expressionist nudes were displayed as "An insult to German woman-hood" and "The ideal—cretin and whore." Farther along the same wall were two of Otto Dix's twenty-six works—the painting from the Dada Fair, now called *War Crip-ples*, and his vision of wartime horror, *The Trench*. Both had provoked public outcry during the twenties and did so again in Munich, where they were marked "An insult to the German heroes of the Great War" and "Deliberate sabotage of national defense."[12]

Since the exhibition was intended to show the degree to which things had degenerated during the years of the Weimar Republic, it highlighted works of German Expressionism, which had become popular with progressive curators during the 1920s and were abundant in museum collections. Schmidt-Rottluff led the group with twenty-seven paintings and twenty-four prints—in Room 5 his still lifes were labeled "Nature as seen by sick minds"—followed by Kirchner's thirty-two works and Nolde's twenty-seven. There were twenty-one Beckmanns, and ten or more works by Kokosch-ka, Pechstein, Mueller, and Heckel. Despite the prominence given to Dada in the wall decoration, it was much less well represented, but the show did include twenty works by Grosz and four by Schwitters. From the Blaue Reiter came fifteen Klees, fourteen Kandinskys, thirteen Feiningers, and less than ten each by Campendonk, Jawlensky, and Marc. Most of the sculpture was figurative—Ernst Barlach's reunion of Christ and St. John was seen as "two monkeys in nightshirts." But there was some abstract sculpture such as Rudolf Belling's *Triad*, which had to be removed by embarrassed officials after discovering that his bronze of the boxer Max Schmeling was on display in the Great German Art Exhibition. There also was a large animal-like form by Richard Haizmann, compared in the exhibition guide to a cat modeled by a mental patient.

The comparison between avant-garde art and mental illness was natural to the Nazi perspective on culture, reinforcing the connection between modernism and degeneracy in all its forms. The guide to the exhibition juxtaposed works by Klee, Kokoschka, and Eugen Hoffmann with pieces from the Prinzhorn collection of art of the insane, and the seventh group of works demarcated in the text were said to repre-sent "the *idiot*, the *cretin*, and the *cripple*."[13] Advanced art was charged with presenting images of Africa and Oceania as the racial ideal, as it was said to portray the prostitute as a moral one. To represent degeneracy in all its forms, the cover of the guide showed a primitivistic sculpture installed in the ground floor lobby—*The New Man* by "the Jew" Otto Freundlich, who would die in the Lublin-Maidanek concentration camp after being captured by the Gestapo trying to escape from occupied France.

Bolshevism itself was viewed as the epitome of degeneration, a debasement of politics to anarchy. The guide stressed the political ends served by two groups of degenerate artworks, those depicting social misery and class exploitation, and others attacking the German military. Yet it was not only that advanced art served political ends, but that the destructive anarchy of aesthetic form was an expression of the same degeneracy of spirit that issued in leftist politics. Modern art was seen as an expression of what had happened to society during the modern period, a time of political, moral, and psychological dissolution, a condition that in Germany had led to the disastrous years of Weimar. For Nazi theorists, it was no coincidence that much of the degenerate art had entered museums at just this time.

One alleged manifestation of this situation was the amount of money that the state museums had spent on degenerate works. At the exhibition most works were listed by artist, title, museum from which confiscated, date of acquisition, and price of

Karl Schmidt-Rottluff. Vase with Dahlias, 1912. Oil on canvas, 33¼ x 30⅛ in. Kunsthalle, Biele-feld. Under the words "Nature as seen by sick minds" in Room 5, this painting was hung along with other Expressionist still lifes and landscapes by Schmidt-Rottluff, Ernst Ludwig Kirchner, Emil Nolde, Erich Nagel, and Heinrich Davringhausen.

above left:

Page from the Degenerate "Art" Exhibition Guide *showing "a highly revealing racial cross section." The works reproduced are: (top left to right) Emil Nolde,* Man and Female; *Karl Schmidt-Rottluff,* Portrait of B. R.; *(middle) Karl Schmidt-Rottluff,* Red Head; *(bottom left to right) Wilhelm Morgner,* Self-Portrait; *Otto Dix,* Portrait of Franz Radziwill; *and Ernst Ludwig Kirchner,* Portrait of Oskar Schlemmer

above right:

Page from the Degenerate "Art" Exhibition Guide *illustrating "the whore as moral ideal." It quotes "the Bolshevik Jewess Rosa Luxembourg" as admiring Russian literature because it "ennobles the prostitute...to the heights of moral purity and female heroism." Works are by (left) Karl Schmidt-Rottluff,* Portrait of a Woman; *(above right) Paul Kleinschmidt,* Duet at the North Café; *and (below right) Ernst Ludwig Kirchner,* Yellow Dancer

below left:

The cover of the Degenerate "Art" Exhibition Guide, *showing* The New Man, *1912, a sculpture by Otto Freundlich*

below right:

Last page of the Degenerate "Art" Exhibition Guide, *showing "the ultimate in stupidity or impertinence—or both—pushed to the limit." The quotation is from a 1915 artist's statement in the radical journal* Action, *claiming, "We can bluff like the most hardened poker players...In our impudence we take the world for a ride and train snobs to lick our boots...." Works are by (left) Max Ernst,* Belle Jardinière; *(above right) Willi Baumeister,* Figure with Pink Stripe III; *and (below right) Johannes Molzahn,* Twins

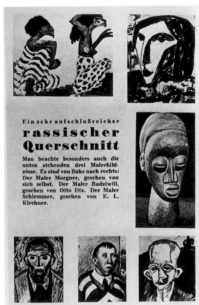

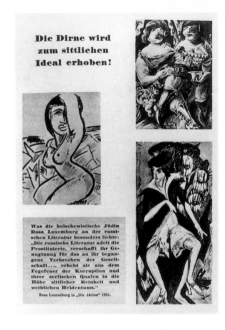

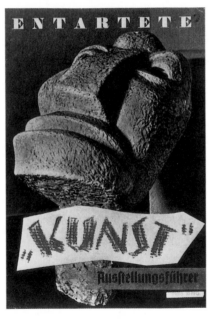

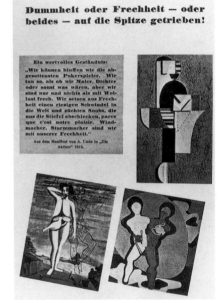

purchase, cited to exaggerate the effect in the inflated currency of the twenties. Everywhere red stickers marked pieces as "Paid for by the taxes of the German working people."[14] Not only had the public been fooled by these things being passed off as art, but its coffers had been depleted by their purchase. At the House of German Art, on the other hand, the works in the Great German Art Show were for sale at comparatively low prices in current marks, reinforcing Hitler's populist attack on the pretensions and obfuscations surrounding advanced art.

The Führer's words decorated many walls of the Exhibition of Degenerate Art, and long excerpts from his speech opening the House of German Art, along with remarks made on National Party Day in 1933 and 1935, were reprinted in the exhibition guide. There Hitler states his view of the only possible explanations for the distortion of degenerate art—physiological malfunction or intentional malice. Genetic weakness

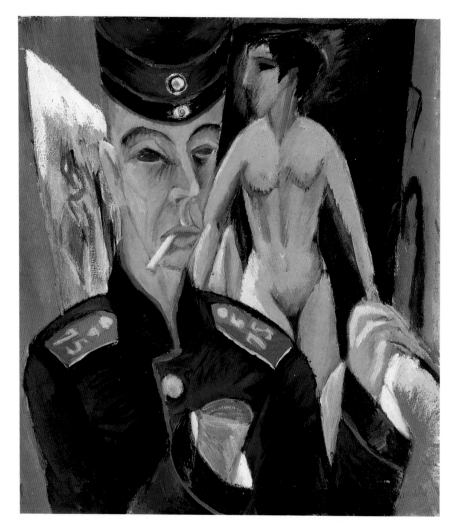

Ernst Ludwig Kirchner. Self-Portrait as Soldier, *1915. Oil on canvas, 27¼ x 24 in. Allen Memorial Art Museum, Oberlin College, Oberlin, Ohio, Charles F. Olney Fund, 50.29. Exhibited as* Soldier with Whore *with other Kirchners in Room 3, this painting was hung next to a quotation meant to be mocked along with the art—a remark by "democratic" curator Edwin Redslob, art commissioner of the Weimar Republic, extolling the artist as comparable to Dürer. Overhead were the words "Deliberate sabotage of national defense" and "An insult to the German heroes of the Great War."*

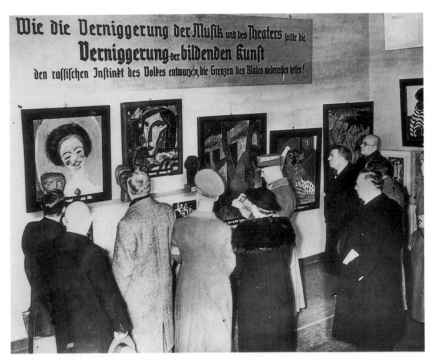

Wie die Verniggerung der Mufik und des Theaters follte die Verniggerung der bildenden Kunft den raffifchen Inftinkt des Volkes entwurzeln, die Grenzen des Blutes niederreißen helfen!

Wall statement and paintings indicating the "Niggerizing" of music and the theater, as well as the visual arts, at the Degenerate Art Exhibition. Emil Nolde, The Mulatto; *Karl Schmidt-Rottluff,* Portrait of B. R.; *Emil Nolde,* Husband and Wife

opposite:
Group portrait by George Platt Lynes of the expatriate Europeans represented in the Artists in Exile exhibition, Pierre Matisse Gallery, New York, March 1942. From left to right: (front row) Matta Echuarren, Ossip Zadkine, Yves Tanguy, Max Ernst, Marc Chagall, Fernand Léger; (back row) André Breton, Piet Mondrian, André Masson, Amédée Ozenfant, Jacques Lipchitz, Pavel Tchelitchew, Kurt Seligmann, Eugene Berman. Museum of Modern Art, New York. Photograph by George Platt Lynes

would account for such medical problems, in which case matters should be turned over to the Ministry of the Interior "to forestall any further hereditary transmission of such appalling visual defects." If the imagery was intentional, it was a matter for correction by the criminal courts. Utilizing sterilization, euthanasia, and prosecution, the problem of artistic degeneracy would be controlled.[15]

The first category of degenerate art isolated in the guide illustrates this "progressive deterioration of perception of form and color" with Expressionist works, but the height of degeneration ultimately is identified with abstraction. This final section of the guide is marked as "Sheer Insanity," the last straw in the duping of the German public by the Jewish dealers and museum directors. Pieces by Willi Baumeister, Walter Dexel, Kandinsky, Mondrian, Schwitters, and Metzinger were displayed as ludicrous and self-impugning. Oddly enough, the installation of abstraction in the fifth gallery was rather elegant, especially the steplike arrangement of six Kandinskys from his Bauhaus years.

While there was a mocking tone to many of the exhibition texts and in the printed guide—which appeared at the end of the Munich exhibition and whose structure would govern the presentation as the show traveled—the organizers preferred the German people to react with anger. Certainly the right response was that of an Essen newspaper to some of the pictures: "[O]ne is tempted to tear down every single one of them and hang the criminals who committed such follies on nails instead."[16]

Although this might have been the preferred way of dealing with the artists, a more pressing question concerned the fate of the confiscated art. Goebbels reportedly was in favor of burning it all, but Heinrich Hoffmann—who had made the main selections for the House of German Art exhibition—encouraged Hitler to think of these works as assets to be exchanged for much-needed foreign currency. The Commission for the Disposal of Products of Degenerate Art was created to determine what would have most value in the international marketplace, and works began to be sold abroad.

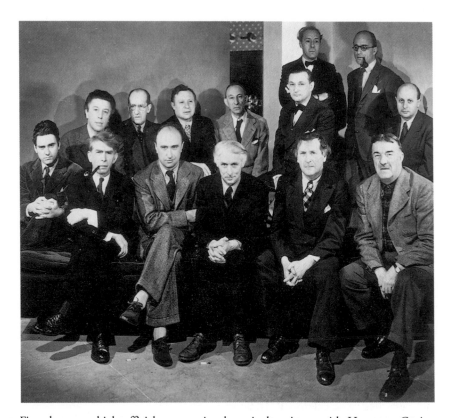

First, however, high officials appropriated particular pieces, with Hermann Göring adding to his personal collection a number of Impressionist pictures along with Gauguin's *Riders on the Sand*. Foreign dealers vied for the right to sell the other works, but four German dealers were given priority. However, 125 of the outstanding pieces were reserved for an auction to be held in Lucerne on June 30, 1939 at the Galerie Fischer. Among others, paintings by Corinth, Marc, Kokoschka, Braque, Derain, Chagall, Klee, Beckmann, Pascin, Gauguin, van Gogh, Picasso, Marc, Modigliani, Nolde, and Ensor were put on the block. Despite attempts at a boycott, the auction attracted dealers, museum representatives, and collectors from around the world. Many works would make their way to the United States, including some of the most important paintings now in American museums.[17]

International sale saved relatively few of the confiscated works, for most met the fate that Goebbels intended. Three months before the Lucerne auction, on March 20, the art deemed unsalable was burned in the yard of the Berlin Fire Brigade in the Köpernickerstrasse. That day 1,004 oil paintings and 3,825 works on paper were incinerated.[18] Like the mass book burnings of May 1933, this act points to the deep fear of art and intellect that was built into National Socialism—fear of the madness of political protest, fear of degeneration to the weakness of compassion, fear of moral decline to a state of human decency.

Before sale and destruction, however, two additional traveling shows of degenerate art were organized in late 1937, the Great Anti-Bolshevist Exhibition, and The Eternal Jew.[19] And *Entartete Kunst* itself went on tour, adding over 1.2 million people to its total attendance. In Berlin, the exhibition opened at the Haus der Kunst in February 1938. It then traveled to eleven other cities around the Reich through the

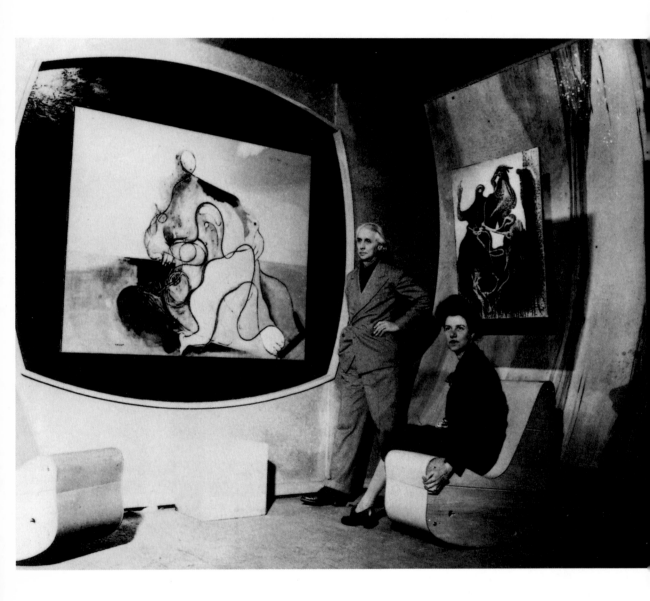

*Max Ernst and Peggy Guggen-
heim in the Surrealist gallery of
Art of This Century, New York,
October 1942*

spring of 1941, including Leipzig, Düsseldorf, Hamburg, Frankfurt am Main, Salzburg, and Vienna.[20] On a gray day in Hamburg, a young man waited in line to see works by old friends who had visited his parents' Cologne apartment years before, and he discovered a painting by his father in the section entitled "Insults to German Womanhood." Max Ernst's *The Beautiful Gardener* was hung between works by Kirchner and Dix, and to see it Jimmy Ernst would rejoin the waiting line many times that day. After his last viewing a man approached to ask why he was so interested in the exhibition, and in fear and confusion he resolved to escape Germany at any cost.[21]

As a consequence of his flight from Europe, Jimmy Ernst became a central witness to the shift in critical mass of avant-garde activity from the old world to the new. From a childhood in Cologne Dada and later time spent with his father in Surrealist Paris, he moved to a New York fast becoming the central refuge for the advanced artists of Europe. As a young artist and assistant to Peggy Guggenheim, he would participate in the birth of the first postwar avant-garde. From his experience in Hamburg to his time tending the desk at Art of This Century, Jimmy Ernst watched world art enter a new phase.

More than any other institution, Peggy Guggenheim's museum-gallery, Art of This Century, encapsulates this transition. Her opening exhibition in October 1942 displayed masterpieces of the prewar avant-garde, and in the next five years she would give their first one-person exhibitions to Jackson Pollock, Hans Hofmann, William Baziotes, Robert Motherwell, Mark Rothko, Clyfford Still, and Richard Pousette-Dart. Her support of progressive painting had begun in London at the outset of 1938, with the opening of her first gallery, Guggenheim Jeune. There she exhibited work by the major Surrealists along with advanced abstraction, and there she decided to create a museum of nonrealistic twentieth-century art. While Guggenheim had lured Herbert Read away from the *Burlington Magazine* with a five-year contract, the European political situation was less than propitious for the founding of a new museum, and the plan was abandoned. But she kept Read's list of what such a museum should contain, and in France, as the Germans approached, she continued to assemble a collection based on his suggestions.

Peggy Guggenheim arrived back in New York on July 14, 1941, traveling with Max Ernst, to whom she would be married in December. She also arranged travel for André Breton, whose Villa Air-Bel outside of Marseilles had been host to many of the artists gathered in the south awaiting exit visas from Varian Fry and his Emergency Rescue Committee. By diverse routes many members of the European avant-garde would assemble in New York during the war, and their presence could not but significantly affect the indigenous artists. New York, of course, was not unfamiliar with advanced European art, having seen its full range and depth at the galleries and in Alfred Barr, Jr.'s exhibitions at the Museum of Modern Art. Even Picasso's legendary *Guernica* had been shown at Kurt Valentine's gallery in 1939. But actually to see and speak with such artists as Mondrian, Léger, Ernst, and Duchamp was critical to the development and growing self-confidence of the Americans, and much of this interaction occurred within the orbit of Peggy Guggenheim.

Although Guggenheim seriously considered establishing her museum in San Francisco or New Orleans rather than New York, by early 1942 she had decided to convert to her purposes two former tailor shops on the 7th floor of 28–30 West 57th Street. On the advice of Howard Putzel, a former California dealer who had introduced Peggy to Max Ernst while showing her around Parisian studios in 1938–39, she hired Frederick Kiesler to design her new space. It was a brilliant selection, for Kiesler's innovative plan brought immediate notoriety to Art of This Century, and set a tone of radical experimentation surrounding the new gallery's activity.

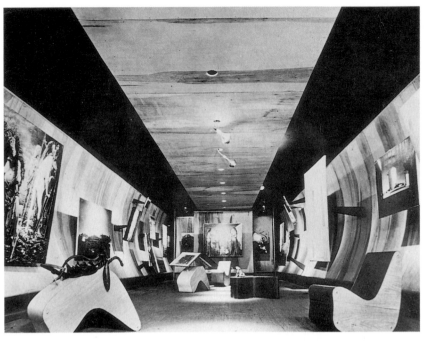

Frederick Kiesler had been the youngest member of the De Stijl group in 1923, and was invited to New York in 1926 to recreate his acclaimed Paris installation of avant-garde theatrical designs for the opening of Steinway Hall. Deciding to remain in the United States, he rapidly became an important force for modernist architectural ideas. In 1929 Kiesler designed the first theater in America specifically meant for showing motion pictures—the Film Guild Cinema on West 8th Street—and he was included by Alfred Barr, Jr. in the important 1936 exhibition Cubism and Abstract Art. Kiesler worked on the design and construction of Art of This Century for eight months beginning in March 1942, and his ambitious plans and cost overruns brought him into frequent conflict with his stingy employer. But the result was the most famous gallery space of our time.

Art of This Century was divided into four areas—three fixed installations presenting Guggenheim's collection of modern art, and a gallery for changing exhibitions of new work—with environments designed in the style of the art displayed. The gallery of Cubist and abstract art gave the sense of being inside a Cubist world, with unframed paintings hung both parallel and perpendicular to the walls on lines forming great V's between floor and ceiling. Similarly suspended in the center of the room were triangular clusters of paintings and triangular sculpture platforms, all under strong fluorescent lighting. The walls of this gallery were of stretched dark blue canvas, and the floor was painted Peggy's favorite color, turquoise. A kinetic gallery contained a conveyor belt displaying about nine Klees, triggered by an invisible light beam, along with a large wheel that turned another contraption showing fourteen objects from the miniature museum of Duchamp's work, his recently completed *Boîte en Valise*, viewed one at a time through a peep hole. There also was a shadow-box arrangement displaying André Breton's *Portrait of the Actor A.B.*, where a lever swung around a picture of Breton and a shutter opened to reveal a poem-object within. The most notorious room was wholly devoted to Surrealism, in which the pictures projected at various angles from modified baseball bats attached to the curved gum-wood walls. The lighting was

Matta: La Terre est un homme (1942)
 (Coll. Clifford)

Max Ernst: Le Surréalisme et la Peinture (1942)

Matta

Max Ernst

Pages 40–1 from André Breton's catalogue of First Papers of Surrealism, showing "compensation portraits" of Matta and of Max Ernst. Two works painted that year are reproduced: (left) Matta, The Earth is a Man*; (right) Ernst,* Surrealism and Painting *(1942). The Ernst was marked by* Newsweek *as the "central canvas" of the exhibition. New York, Coordinating Council of French Relief Societies, Inc., 1942. Offset, printed in black, each page: 10½ x 7⅜ in. The Museum of Modern Art Library, Special Collection, New York*

timed to go on and off every two seconds, illuminating one side of the gallery and then the other, pulsating, as Kiesler said, "like your blood."[22] While certainly surreal, the effect was too disruptive for most, and Putzel later convinced Peggy to allow continuous illumination. The last space—devoted to changing exhibitions—faced 57th Street, and was illumined by daylight diffused through a screen of ninon, a chiffon-like material commonly used for lingerie. It also functioned as a room for browsing among minor works from the collection, where visitors could sit on folding stools and look through open storage bins of framed pieces. Another sort of seating was provided in the Abstract and Surrealist galleries, a feature welcomed by reviewers. Kiesler had designed a biomorphic multifunctional piece that could serve as a chair, lectern, coffee table, pedestal, sofa, and hat rack. Variously oriented, one of these "correalist tools" could be found supporting a tired visitor, while Giacometti's *Woman with Her Throat Cut* crawled across another.[23]

Altogether, the design of Art of This Century exemplified Kiesler's developing conception of architectural space as fluid and organically related to the activity within, ideas that achieved their visionary height in his *Endless House* of 1949–59. With sculpture and frameless paintings on variable supports to be adjusted for optimal viewing, and rooms designed to evoke the mood of the work displayed, Kiesler's goal, as stated in his unpublished notes on the gallery design, was to "dissolve the barrier and artificial duality of 'vision' and 'reality,' 'image' and 'environment,' . . . [where] there are no frames or borders between art, space, life. In eliminating the frame, the spectator recognizes his act of seeing, or receiving, as a participation in the creative process no less essential and direct than the artist's own."[24] It was natural for Kiesler to evoke his friend Duchamp's notion of the viewer completing the work, for Duchamp arrived in New York in the midst of the project in June 1942, and stayed with the Kieslers until October.

Peggy hoped to have the opening of Art of This Century coincide with the publication of the catalogue of her collection designed by Breton, but planning and

construction delays made that impossible. More importantly, as the probable opening date moved toward late October, Kiesler feared that his thunder would be stolen by another event scheduled for earlier that month. From October 14 to November 7 the Coordinating Council of French Relief Societies was to hold an exhibition at their headquarters in the Whitelaw Reid Mansion, 451 Madison Avenue. And as installed by Duchamp, First Papers of Surrealism threatened to rival the surprises of Kiesler, which were kept secret even from Max Ernst.

Elsa Schiaparelli had approached Peggy Guggenheim about mounting this benefit exhibition, but completely involved with constructing her new gallery Guggenheim recommended Breton for the job.[25] Assisted by Ernst and Duchamp, Breton assembled the large exhibition of work by close to fifty artists, and put together a publication that was more classic Surrealist document than catalogue. Duchamp contributed the cover—on the front a wall pierced by bullets, with actual holes, and on the back a close-up of a piece of Gruyère cheese. Along with a Breton essay on myth, it presented Surrealist paintings with anonymous "compensation portraits" of their creators. Among others there was Masson as an Eskimo, Magritte as an explorer, Matta as a young boy in sailor suit, Ernst as an old man with flowing white beard, and Leonora Carrington as a Depression farmwife by Walker Evans. The title of the exhibition referred to the immigration papers of recent arrivals, the new status of so many of the contributors.

The catalogue credits Breton with the hanging, but then cites Duchamp for "his twine," and the "sixteen miles of string" mentioned in the press release became the hallmark of the show. Actually, only a mile of twine was strung around the galleries by Duchamp, though he had procured sixteen miles of it just to be safe. To be more exact, two miles were used, but the first mysteriously caught fire and another had to be looped across ceilings and in front of the pictures.[26] There have been many interpretations of this striking installation. Marcel Jean imagined that the cobweb effect could symbolize either quality or decay, reminding him both of fine old wine bottles and of abandoned rooms. Harriet and Sidney Janis viewed the obscuring of the pictures to represent the difficulties that must be overcome in understanding modern art. More critically, Robert Coates in the New Yorker took the string to suggest the current situation of European Surrealism, ideas once fresh being tediously wound back and forth.[27]

Newsweek called Duchamp's string the most important work in the exhibition, and marked Max Ernst's Surrealism and Painting of that year as "the central canvas."[28] Like this painting, a fair amount of the work was done in the last year or so by European émigrés such as Tanguy, Kurt Seligmann, Masson, Matta, and even Breton, who contributed an object called A Torn Stocking made of thread, twigs, cigarettes, leaves, and a watch. There also were paintings from the heroic early days of the movement by de Chirico and Magritte, along with pieces by Miró, Picasso, Klee, Henry Moore, Arp, Delvaux, Duchamp, Calder, Giacometti, Wilfredo Lam, Victor Brauner, Frida Kahlo, Gordon Onslow-Ford, Richard Oelze, Meret Oppenheim, Laurence Vail, the American primitivist Morris Hirschfield, and Marc Chagall. Jimmy Ernst was included, along with some of his new American associates such as William Baziotes, David Hare, and Robert Motherwell, who had unsuccessfully invited Jackson Pollock. Conspicuous in his absence was Salvador Dali, called "Avida Dollars" by Breton for his commercialism, and generally disdained by the émigrés for his right-wing politics. Much of the exhibition was borrowed from the collections of participating artists and other individuals, such as Pierre Matisse and Claude Lévi-Strauss, as well as from the Museum of Modern Art and the Brooklyn Museum.

The formal opening was a memorable affair, and not only for the guests' surprise in having to view the work through skeins of string. Via Harriet Janis, Marcel

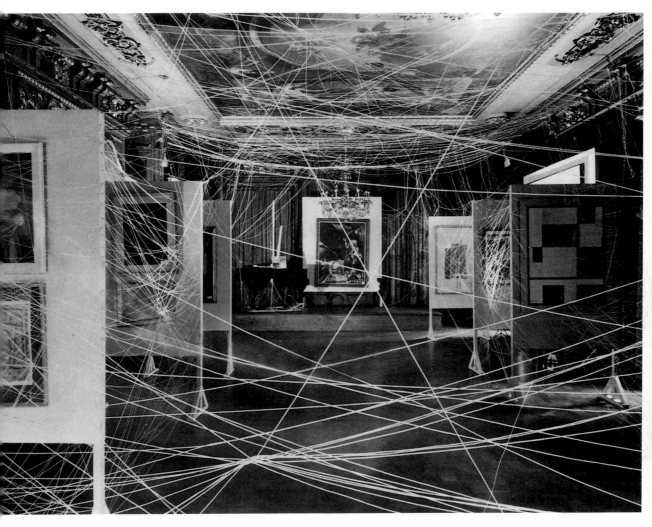

Installation view of First Papers of Surrealism, Whitelaw Reid Mansion, 451 Madison Avenue, New York, October–November 1942, with hanging by André Breton and twine by Marcel Duchamp. The challenge to clear viewing was taken by Harriet and Sidney Janis to represent the difficulty of understanding modern art, but critic Robert Coates saw it to embody once-fresh ideas tediously wound back and forth. Photograph by John Schiff

Duchamp had asked her two sons to gather their friends to play ball during the reception, and that evening six children played in pairs in three rooms of the show. With an eleven-year-old's idea of Surrealism, Carroll Janis outfitted himself in a football jersey, baseball pants, and basketball sneakers, and he and his friends tossed footballs and softballs for about three hours in the long galleries with their high twine-covered ceilings. Duchamp's directions were just to play ball and not talk to anyone, and if asked to stop say that Marcel Duchamp told them to play there. Of course, they were requested to stop but were allowed to continue after their orders were explained. Eventually some of the guests wanted to join in, and knowing that it was a benefit the kids demanded an extra dollar from each participant, raising more money for the cause. Not surprisingly, the adults soon became more wild than the children. All of this greatly amused Duchamp when he heard about it from Carroll Janis about two years later, for following his usual practice Duchamp did not attend the opening.[29] Had he done so, one wonders how he would have reacted to Matta's leading a group of the younger artists in protest over a bust of Marshal Pétain in the lobby.[30]

A week later, the crowded October 20th opening of Art of This Century also was held as a benefit, each guest contributing $1 to the American Red Cross. To show that she was not partial to either Surrealism or Abstraction, Peggy wore two earrings, a tiny Tanguy dreamscape and a wire mobile by Calder. While the *New York Times* called its feature and photo spread on the gallery "Modern Art in a Modern Setting," the effect on the public is better suggested by *Newsweek*'s headline: "Isms Rampant. Peggy Guggenheim's Dream World Goes Abstract, Cubist, and Generally Non-Real."[31] Critics, of course, were especially struck by Kiesler's design, and Robert Coates saw the gallery as a cross between the Museum of Modern Art and Coney Island. In the *New York Times*, Edward Alden Jewell called the opening the "most piquant" event of the week, but he found that the art "liberated" from the wall looked "faintly menacing—as if in the end it might prove that the spectator would be fixed to the wall and the art would stroll around making comments, sweet or sour as the case may be." (Peggy's advertisement in *View* magazine responded: "WE *will* DO JUST THAT—SWEET or SOUR AS THE CASE *will* BE.")[32] John Cage, who stayed with Ernst and Guggenheim when first coming to New York in the summer of 1942, remembered the gallery in similar terms, as "a kind of fun house, . . . you couldn't just walk through it, you had to become part of it."[33]

About this time a group of American artists gathered around Matta for weekly sessions in his studio. Lasting through the winter of 1942–43, the Saturday afternoon meetings brought Pollock, Baziotes, Motherwell, Gerome Kamrowski, Peter Busa, and perhaps Arshile Gorky together to experiment with automatic and free associative techniques.[34] Matta, the youngest of the émigrés, was interested in assembling a circle of American artists who would develop Surrealism under his influence, offsetting their antipathy for the older Europeans. For the American artists who had worked together in WPA projects during the thirties, while impressed with the achievements of the Europeans now in their midst, did not take kindly to the snobbism they felt pervaded the émigré community. Breton, who refused to learn English, was particularly offensive. Among themselves, the Americans referred to him as "Mr. God."[35]

The year before Breton, Ernst, and Duchamp arrived in New York, American artists received a detailed exposition of Surrealism in the series of four lectures by Gordon Onslow Ford at The New School for Social Research, which began in January 1941. Entitled "Surrealist Painting: An Adventure into Human Consciousness," these lectures were accompanied by four exhibitions organized at The New School by Howard Putzel. Putzel even gave the public a participatory taste of *cadavre exquis*, attaching folded papers on the wall for their use, blue for poems and pink for

drawings.[36]

With some knowledge of Surrealism and its automatic techniques, then, American artists found themselves frequenting Art of This Century.[37] Howard Putzel succeeded Jimmy Ernst as Peggy's assistant in 1943, and he worked hard to interest her in the young Americans. After Matta brought Guggenheim to Pollock's studio, Putzel encouraged her reluctant acceptance of his work, eventuating in the large mural commission for Peggy's apartment and his first exhibition at Art of This Century in November 1943. American artists—including Hare, Baziotes, Pollock, Motherwell, and Ad Reinhardt—began to be shown in force earlier that year, in Peggy's collage show and in her Spring Salon, and they soon dominated the special exhibitions at the gallery. The spring after Pollock's first show, Peggy mounted Hans Hofmann's initial American exhibition, and in the great 1944–45 season she held the first exhibitions of Baziotes, Motherwell, and Mark Rothko.[38] Against a backdrop of the achievements of European Modernism, Peggy presented to the public some of the most important members of the future New York School.

Although the inertia of avant-garde activity had shifted across the Atlantic, more than a few exhibitions were needed to create a viable center of advanced art. A community of artists was constituting itself, and along with postwar prosperity a germinal market was forming. The late forties in New York witnessed more shows by the young American abstract painters and less by the Surrealists, whose last hurrah was the undulating Kiesler installation of Nicholas Calas's 1947 group exhibition, Bloodflames. That year Peggy closed Art of This Century, and Pollock was taken on by Betty Parsons, in whose gallery he introduced his poured paintings in January 1948. Four months later the long-awaited first exhibition of Willem de Kooning was held at the Egan Gallery. But it would take a few more years for the extended New York School to show itself in exhibition, at an old storefront on 9th Street.

CHAPTER 9 *Downtown*
Ninth Street Show, New York
May 21–June 10, 1951

On the first day of an artists' symposium in 1950, attempting to focus an increasingly centrifugal discussion, Barnett Newman recast Adolph Gottlieb's concern with abstraction as a query about community.[1] Newman's worry about community looked back to the public isolation of advanced artists during the Depression and the war, but it also looked forward to divisions that would come with the successes of the next decade. The Ninth Street Show of 1951 falls on the cusp of this history. It included many of those who had created the germinal New York School, yet it signaled the passing of their legacy to a larger body of artists. The exhibition itself marked moments of both recognition and self-awareness—notice by a public of the extent of that greater group, and this community's first view of its own compass and wider-ranging achievement.

The public that came to that recognition was a narrow and elite one, people who had brought the "first generation" to critical notice and some success by the late 1940s. Alfred Barr, Jr., the only nonartist participating in the symposium, is a good example. An advocate of contemporary painting before the Acquisitions Committee of his museum, he helped bring works by Pollock, de Kooning, and their colleagues into the Museum of Modern Art collection. But when he came down to the opening of the Ninth Street Show with MOMA's chief curator, Dorothy Miller, Barr was shocked that he knew so few of the artists. He asked Leo Castelli, who had assisted with the show's organization, about all of these artists whose work he never had seen, and they retreated to the Cedar Street Tavern around the corner. There Castelli marked the back of a photograph with the names of the artists whose work was pictured—even today, it still seems incredible to Castelli that he had with him two installation photographs—and he told Barr about the genesis of the exhibition.[2] It was a revelation to Barr, and to the uptown dealers and collectors who made their way to East 9th Street that spring, just how large and accomplished the downtown art world had become.

Barr and the others, of course, knew of the Club, an artists' organization that met at 39 East 8th Street, and many had been invited by members to attend its Friday night lectures. These talks, and eventually panel discussions, continued the tradition established in the fall of 1948 at Subjects of the Artist: A New Art School, organized by William Baziotes, David Hare, Robert Motherwell, and Mark Rothko, later joined by Barnett Newman. Subjects of the Artist lasted only two semesters, but its 35 East 8th Street space was taken over in fall 1949 by three New York University art teachers—Robert Inglehart, Tony Smith, and Hale Woodruff. It became Studio 35, a site of Friday evening lectures whose demise was marked by the 1950 symposium. That same autumn saw the creation of the Club, intended to be a place of their own for artists to congregate, away from harassment by the manager of the Waldorf Cafeteria on Sixth Avenue where they had gathered for years.[3]

The Club was organized in the loft of Ibram Lassaw, after Franz Kline learned of a space available on the north side of 8th Street between Broadway and University Place. Once a number of the founders—including Lewin Alcopley, Giorgio Cavallon, Willem de Kooning, Milton Resnick, and Joop Sanders—decided that the place was adequate, $500 key money was raised with the help of the sculptor Phillip Pavia, the only member with sufficient funds to back the enterprise. The twenty char-

Joan Mitchell. Untitled, ca. 1950. Oil on canvas, 69 x 72 in. Robert Miller Gallery, New York. Collection of Cy and Lissa Wagner. Mitchell and Leo Castelli carried this large painting across town for the Ninth Street Show from her West-Side studio.

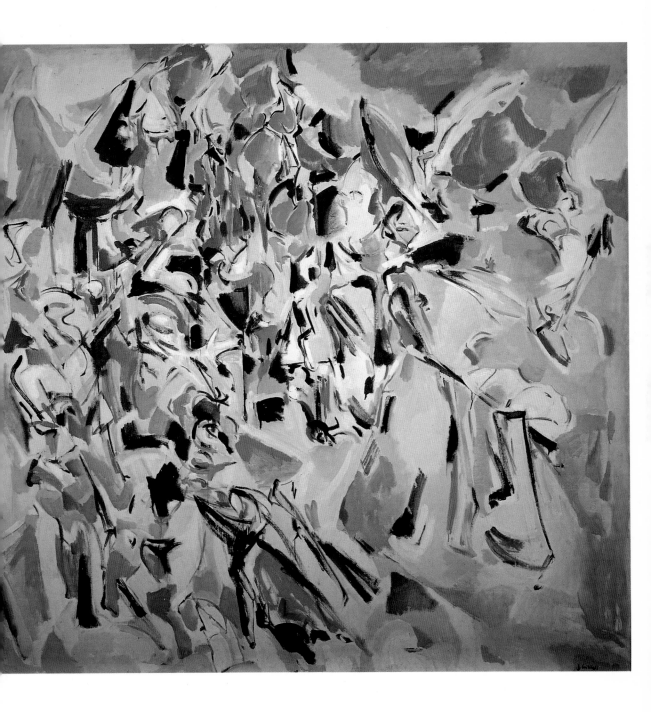

ter members removed existing partitions, painted the room white, purchased folding chairs and tables, and allocated operating responsibilities on a rotating basis.[4] The initial group was expanded to a voting committee of thirty to forty, which governed the Club, with general members admitted from proposed candidates when no more than two voting members objected. (At first only one negative vote denied membership, but this was changed because Landes Lewitin voted against everyone.) Typical of the times, an attempt was made to exclude women from membership, though within a year or so that rule fell with the addition of Elaine de Kooning and Mercedes Matter. By 1952 general membership was close to 150 and included art and book dealers, critics, writers, and composers. Club members met on Wednesday evenings at 9:30, with discussions lasting far into the night. Friday evenings were reserved for lectures or panels, arranged by Pavia until 1955, and open to anyone who claimed that he had been invited by a member. These events became a center of New York intellectual activity during the fifties, with speakers from music, philosophy, and literature augmenting the regular fare of artists and critics.[5]

Like the Club itself, the Ninth Street Show responded to a felt need, yet was occasioned by happenstance. Stories vary as to who found the place and proposed that an exhibition be held, but certainly the idea was in the air, and an empty storefront in the artists' neighborhood was a probable site. Among those credited with suggesting 60 East 9th Street, most frequently mentioned are Conrad Marca-Relli and Franz Kline, who, along with John Ferren, had their studios next door. Across 9th Street were Frederick Kiesler, Milton Resnick, and Jean Steubing, and Steubing also is said to have proposed the space.[6] In any case, with artists walking by the vacant building every day, it was likely that someone would make the suggestion.

The Ninth Street Show was organized by charter and voting members of the Club. But it was not a Club function and included artists from outside the general membership. After the idea was raised, meetings were held at the Club and in the studios of Marca-Relli and Ferren. Kline and Marca-Relli immediately rented the first floor and basement from the owner for two months at $50 a month, since the building was slated for demolition and the show had to happen quickly. The organizers worked together to clean up the place, painting the walls and columns white, installing lights, and building a partition to increase wall space.[7] Artists could be readily contacted using the Club's membership list, and according to Marca-Relli, the whole event was put together in a week or two. But naturally the major issue concerned just who would be included in the exhibition.

Phillip Pavia remembers a planning meeting at the Club where it was decided that each voting member would invite one guest to exhibit. If this was the system, however, it broke down under pressure from both within and outside the Club, and in actuality the process was much less structured. On some accounts the word just was passed from artist to artist, with each person bringing one work to 60 East 9th Street a few days before the opening. Others recall that there was an informal committee that chose the participants, actively viewing work by newcomers along with notifying artists in and around the Club. Along with Marca-Relli and Kline, those particularly active included Willem de Kooning, John Ferren, Milton Resnick, Esteban Vicente, Ludwig Sander, Alcopley, Jack Tworkov, and Leo Castelli.[8]

This was six years before Leo Castelli opened his gallery, and in 1951 he was a collector of modest means who knew the dealers and liked to spend time with the artists. Castelli was one of the first nonartist members of the Club, and when work needed to be done for the exhibition, he was anxious to help. Marca-Relli asked him for assistance, since he was familiar with the uptown galleries, and Castelli worked from the artist's studio in making arrangements. While stories differ as to his role in

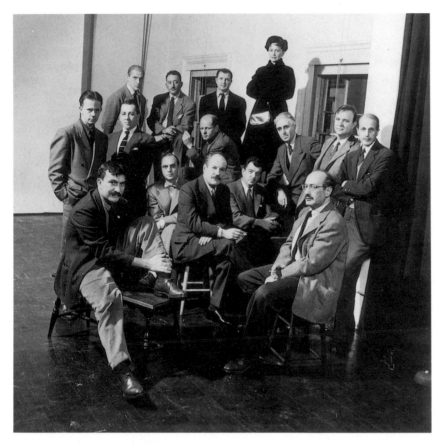

"The Irascibles," 1950. In Life, January 15, 1951. (from top left) Willem de Kooning, Adolph Gottlieb, Ad Reinhardt, Hedda Sterne, Richard Pousette-Dart, William Baziotes, Jackson Pollock, Clyfford Still, Robert Motherwell, Bradley Walker Tomlin, Theodoros Stamos, Jimmy Ernst, Barnett Newman, James Brooks, and Mark Rothko. The photograph shows fifteen of the eighteen artists who refused to submit paintings to the Metropolitan Museum of Art's exhibition American Painting Today—1950. They boycotted the show because of the conservative jury that was to select the work.

covering expenses, and in the selection of artists, certainly Castelli was actively involved in many facets of the exhibition. And in hanging the show he was a crucial figure, since he exhibited nothing. For no single artist could have organized the installation without major problems, and Milton Resnick seems to have approached Castelli for just this reason. It is easy to understand the reluctance with which he agreed.[9]

Castelli's position as impartial installer was a taxing one, for with about seventy artists and relatively limited space, discontent was inevitable. On the day of the hanging, Castelli and a group of artists set to work. Marca-Relli, who wanted the installation to be done by the artist organizers, remembers that Franz Kline started the process, picking up his large black-and-white picture and putting it on the wall. But Castelli soon began to give directions, and Marca-Relli left in a huff. In the end Castelli seems to have coordinated things, also taking the brunt of anger from artists unhappy with the location of their pieces. As he said in 1956: "Hung the show! . . . I hung it twenty times. Each time it was done, an artist would come in and raise hell about the placing of his painting."[10] Even after the exhibition opened some artists insisted on changes, as Pearl Fine did in switching her painting with that of Alcopley, moving his next to Lee Krasner's. At least every artist selected his or her own work and delivered it to the show. Most paintings were just walked through the streets—Castelli and Joan Mitchell carried her large canvas across 9th Street from her studio on the west side—for the majority of artists lived within the downtown area bordered by 8th and 12th streets between First and Sixth avenues.[11]

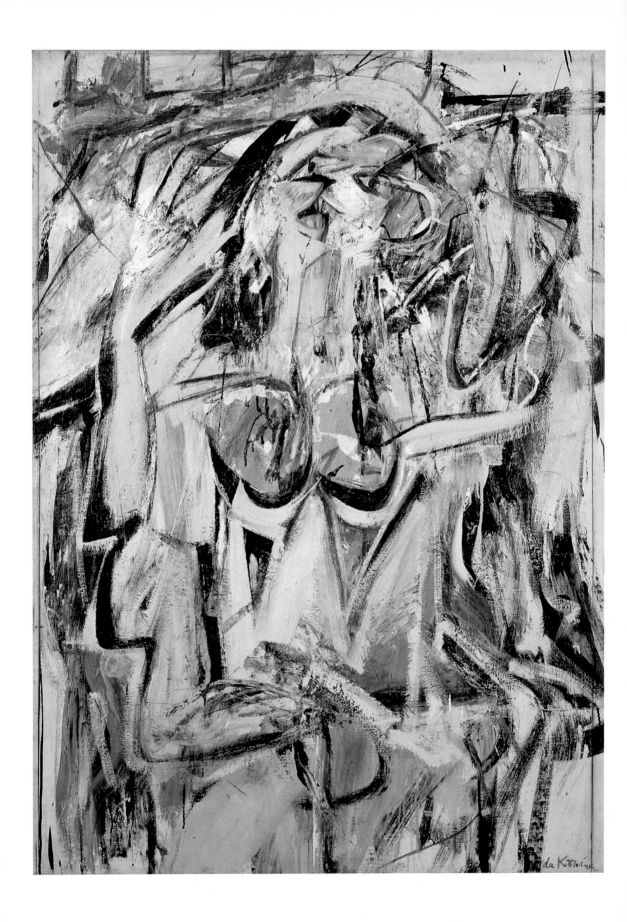

This larger artists' community was the one that the exhibition sought to present, something less parochial than even the broad-based membership of the Club. Significant here in his absence was Phillip Pavia, who did not initially exhibit in the show despite his help with planning and construction. At the insistence of Frederick Kiesler, who referred to him as "Mr. Club," Pavia was dissuaded from exhibiting. Kiesler argued that the show should display the achievements of the New York School as a whole and that efforts should be made to disassociate it from the Club. His view fit with a long-standing prejudice within the Club against anything that might suggest self-promotion or partisanship; even members fortunate enough to have shows could not post exhibition announcements on its premises, and no paintings were hung there. Pavia agreed to drop out, though during the show he placed a figurative sculpture in the exhibition. Kiesler himself sought contributions from the "uptown boys," inviting artists like Gottlieb and Motherwell by telegram.[12]

In a sense the vanguard New York art world was relatively homogeneous in 1951, living downtown and united by poverty and a lack of commercial interest in their work. For the vast majority of these artists, their only public was the community of other artists, and studio visits were the sole means of exposure. For them, the Ninth Street Show was as unique in prospect as it is historically important in retrospect. But for a small group of artists there were exhibitions and a germinal public, and Peggy Guggenheim's work with the founders of the new painting was carried on in the uptown galleries of Betty Parsons, Charles Egan, Samuel Kootz, Marian Willard, and Sidney Janis. Sales were slow, yet there was growing recognition that a body of American painting was challenging European hegemony, and that there were masters of the new genre. In fact, Kiesler's invitation to exhibit with the many unknowns from downtown struck Sam Kootz as insulting, and he prohibited his artists from showing there. Gottlieb and Baziotes concurred, but Motherwell broke ranks and was applauded at the Club for so doing. Betty Parsons was willing to include her artists, but Rothko, Still, and Newman refused. Bradley Walker Tomlin and Jackson Pollock agreed, however. Pollock told her to send something down, and Parsons chose a large painting, *Number 1, 1949*, from his third show at her gallery. The horizontal work mistakenly was hung on its side, but the artist allowed Castelli to leave it that way since wall space was so scarce.[13] Also exhibiting from the more well-known members of the first generation were the sculptor David Smith, and the painters Philip Guston and Hans Hofmann, whose school was a training ground for so many of the younger artists in the show.

Among the successful painters, there was no question about the involvement of Willem de Kooning. He was the central figure of the downtown scene, an artist whose purity of purpose and commitment to the painterly process became a model for the generation of the fifties. De Kooning's inability to finish a picture was legendary, and it often was told how he had wiped many a masterpiece off the canvas. Most notorious, perhaps, was his two years' work on *Woman I*, completed and painted out literally hundreds of times before the art historian Meyer Shapiro encouraged him to return to the canvas and finish it. This work, purchased by MOMA and one of the most widely reproduced pictures of the decade, was begun just after de Kooning let his great abstraction *Excavation* leave the studio for the Venice Biennale in June 1950. There it hung alongside the work of Pollock and Gorky, stunning the Europeans with what had been accomplished in New York.[14] During the Ninth Street Show, *Excavation* dominated MOMA's exhibition Abstract Painting and Sculpture in America. For the gallery and museum public de Kooning was an abstract painter, his reputation established by black-and-white abstractions shown at the Charles Egan Gallery in 1948 and by the colored abstractions exhibited in Venice, at the Whitney Museum, and at

Willem de Kooning. Woman, *1949–50. Oil on canvas, 64⅛ x 46 in. Weatherspoon Gallery, Greensboro, North Carolina*

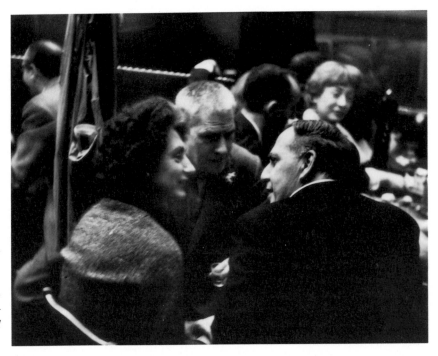

Cedar Street Tavern, New York, 1950s. (left to right) Mercedes Matter, Willem de Kooning, Frank O'Hara, Philip Guston, Elaine de Kooning. Mercedes Matter and Elaine de Kooning were the first women admitted into the Club, despite initial efforts at their exclusion.

MOMA, and at Egan's in 1950–51. But on 9th Street de Kooning chose to exhibit a large gestural painting of a woman from 1949. None of the artists seemed to find this at all strange, for they knew that he had worked both abstractly and figuratively for years.[15]

De Kooning's attitude toward art set the standard of fifties painting as much as did his "loose elbow" and exquisite drawing. In discussions at the Club and over drinks at the Cedar Street Tavern—actually located on University Place near 8th Street—his emphasis on honesty and integrity of expression became the banner of downtown painting. John Ferren's epitaph for his generation describes the perceived situation: "We faced the canvas with the Self, whatever that was, and we painted. . . . The only control was that of truth, intuitively felt. If it wasn't true to our feeling, according to protocol it had to be rubbed out. In fact, painters boasted of their paintings as a tangible record of a series of errors."[16]

For Thomas B. Hess who, as managing editor, converted *Art News* into something like the house organ of the New York School, the transformation occasioned by these artists was "a shift from aesthetics to ethics; the picture was no longer supposed to be Beautiful, but True—an accurate representation or equivalence of the artist's interior sensation and experience." Even the supremely tasteful Motherwell introduced a 1950 exhibition of New York painting in Beverly Hills with the claim that "Fidelity to what occurs between oneself and the canvas, no matter how unexpected, becomes central. . . . The major decisions in the process of painting are on the grounds of truth, not taste."[17]

The rejection of taste was a matter of more than aesthetics, for beauty and taste were the hallmarks of French painting. And by 1950 the New York painters saw themselves surpassing Paris. The occasion was a show organized by Leo Castelli and Sidney Janis in October at Janis's 57th Street Gallery, pairing each of fifteen American painters with a French counterpart. Following the lead of Samuel Kootz, their strategy

Cedar Street Tavern, New York, 1950s. (left to right) Nicholas Carone, Franz Kline, Christopher Kaldis.

Cedar Street Tavern, New York, 1950s. (left to right) Norman Bluhm, Joan Mitchell, Franz Kline.

was to legitimate American efforts before a public that uncritically accepted the value of European painting. Apart from a monumental Dubuffet woman next to one by de Kooning, and Matta alongside Gorky, the French suffered by comparison.[18]

To spurn good taste, however, accepting the ugly in the service of the authentic, struck many critics as too easy. By the time of the Ninth Street Show, it was feared that ready mastery of gestural technique would yield an artistic assembly line with "no model, no subject, no composition, and soon—'Look, Ma! no hands.'"[19] Even within the avant-garde camp, Ad Reinhardt mocked the new stance in satirical comics about the art world. His 1951 "Museum Racing Form" ("The Latest Racing Dope . . . to pigeon hole the ponies") cites such exemplary attitudes as "I'm a primitive . . . I don't know what I'm doing . . . Please buy my masterpieces anyway," "My painting paints me," "I don't think . . ." and "Reason is unreasonable."[20]

This anti-intellectual tone, a refusal to give explanations apart from the claim to authenticity, found theoretical ground in a kind of Existentialist rhetoric. The locus classicus was published in *Art News* in December 1952 by Harold Rosenberg, a Club regular and longtime friend of the artists. His article, "The American Action Painters," was thought misleading and somewhat silly by the artists, but it became a primary vehicle for a public increasingly anxious to understand what was happening in the art world. Rosenberg put in succinct, if somewhat grand, terms what he had heard so often at the Club and at the Cedar bar, describing "a certain moment [when] the canvas began to appear to one American painter after another as an arena in which to act. . . . What was to go on the canvas was not a picture but an event." Confronting a world of moral and political confusion, the artist created his essence through an active encounter with his materials: "The act-painting is of the same metaphysical substance as the artist's existence. The new painting has broken down every distinction between art and life."[21]

Here Rosenberg attempted to reestablish the connection with the world that Clement Greenberg had severed with his formalist reading of the work of the early New York School. Greenberg developed his position in the late thirties and early forties, claiming that advanced painting was meant to focus more and more on its material conditions—on its nature as paint on flat support—and less on any kind of representational function. (Greenberg also painted, yet ironically, he did landscapes, one of which was included in the Ninth Street Show.) While he saw such increasing self-concern as issuing from the logic of modernism, Greenberg also was aware of its connection with political circumstances during the period, in which disillusion with Stalin on the part of leftist artists led to a retreat from politics into aesthetics.[22] True to their roots as intellectuals of the thirties, both Rosenberg and Greenberg found in the New York artists' marginalized position a motivation for what they were to create. Alienated from both Communism and an increasingly conformist postwar America, facing the lure of commercial success from their moral bohemia—all under the shadow of the Bomb—artists turned to self-creation through formal investigation.

Although Greenberg had established his reputation as an advocate of the first generation in the forties, he continued to be a dominant force during the fifties. And while his primary hope for the future moved from Pollock to the nongestural direction of Still, Newman, and Rothko, he also gave critical encouragement to the younger followers of de Kooning.[23] In the spring 1950 debut of a large number of these artists, the important New Talent exhibition curated by Greenberg and Meyer Shapiro for the Kootz Gallery, the twenty-three painters included many who would appear a year later in the Ninth Street Show, such as Robert de Niro, Friedel Dzubas, Robert Goodnough, Elaine de Kooning, Alfred Leslie, Grace Hartigan, and Joe Stefanelli.[24] And when John B. Myers sought his advice about young artists to represent at the new

JACKSON POLLOCK

Is he the greatest living painter in the United States?

"NUMBER TWELVE" reveals Pollock's liking for aluminum paint, which he applies freely straight out of the can. He feels that by using it with ordinary oil paint he gets an exciting textural contrast.

Recently a formidably high-brow New York critic hailed the brooding, puzzled-looking man shown above as a major artist of our time and a fine candidate to become "the greatest American painter of the 20th Century." Others believe that Jackson Pollock produces nothing more than interesting, if inexplicable, decorations. Still others condemn his pictures as degenerate and find them as unpalatable as yesterday's macaroni. Even so, Pollock, at the age of 37, has burst forth as the shining new phenomenon of American art.

Pollock was virtually unknown in 1944. Now his paintings hang in five U.S. museums and 40 private collections. Exhibiting in New York last winter, he sold 12 out of 18 pictures. Moreover his work has stirred up a fuss in Italy, and this autumn he is slated for a one-man show in *avant-garde* Paris, where he is fast becoming the most talked-of and controversial U.S. painter. He has also won a following among his own neighbors in the village of Springs, N.Y., who amuse themselves by trying to decide what his paintings are about. His grocer bought one which he identifies for bewildered visiting salesmen as an aerial view of Siberia. For Pollock's own explanation of why he paints as he does, turn the page.

ALCOPLEY • BOUCHE • BROOKS • BUSA • BRENSON • CAVALLON • CARONE • GREENBERG • DE KOONING • DE NIRO • DZUBAS • DONATI • J. ERNST • E. DE KOONING • FERREN • FERBER • FINE • FRANKENTHALER • GOODNOUGH • GRIPPE • GUSTON • HARTIGAN • HOFMANN • JACKSON • KAPPELL • KERKAM • KLINE • KOTIN • KRASSNER • LESLIE • LIPPOLD • LIPTON • MARGO • MCNEIL • MARCA-RELLI • J. MITCHELL • MOTHERWELL • NIVOLA • PORTER • POLLOCK • POUSSETTE DART • PRICE • RESNICK • RICHENBERG • REINHARDT • ROSATI • RYAN • SANDERS • SCHNABEL • SEKULA • SHANKER • SMITH • STAMOS • STEFANELLI • STEPHAN • STEUBING • STUART • TOMLIN • TWORKOV • VICENTE • KNOOP

COURTESY THE FOLLOWING GALLERIES: BORGENICHT, EAGAN, TIBOR DE NAGY, THE NEW, PARSONS, PERIDOT, WILLARD, HUGO

MAY 21ST TO JUNE 10TH, 1951
PREVIEW MONDAY, MAY 21ST, NINE P. M.
60 EAST 9TH ST., NEW YORK 3, N.Y.

9TH ST.

EXHIBITION OF PAINTINGS AND SCULPTURE

Franz Kline. Poster for the Ninth Street Exhibition of Paintings and Sculpture, 1951. Offset lithograph, 10⅛ x 8⅜ in. The Museum of Modern Art Library, Special Collections, New York

Tibor de Nagy gallery, Greenberg suggested Hartigan, Leslie, Frankenthaler, de Niro, Goodnough, Larry Rivers, and Leatrice Rose.[25]

Myers went on to show all of them but Rose, and from the time Tibor de Nagy opened on East 53rd Street in December 1950 it was a primary showcase of the second generation. A former puppeteer who during the forties had been managing editor of the Surrealist magazine *View*, Myers devoted his extraordinary energy to a wide range of avant-garde activities. As director of the Tibor de Nagy gallery he actively promoted his artists, and he lobbied on their behalf with the organizers of the Ninth Street Show.[26] During the exhibition his gallery presented The New Generation, artists who also could be seen down on 9th Street: Helen Frankenthaler, Robert Goodnough, George (a.k.a. Grace) Hartigan, Harry Jackson, and Alfred Leslie.

In the spring of 1951 Helen Frankenthaler was more than a year away from her first stain painting and was working with lyrical biomorphic forms reminiscent of de Kooning. She was a close friend of Clement Greenberg's, through whom she met Pollock, and her own breakthrough would be inspired by his show of black-and-white paintings at the end of 1951 and by a subsequent visit to his studio. In this she came under Pollock's influence later than did Robert Goodnough, who published "Pollock Paints a Picture" in *Art News* the month of the Ninth Street Show. His account of Pollock's intense working method—"To enter Pollock's studio is to enter another world"[27]—was illustrated by Hans Namuth's dramatic photographs, showing the art world what had long been known only through hearsay. For most of the artists of the fifties, however, it was de Kooning, rather than Pollock, who represented painting as still full of possibility. Although a model of freedom from tradition and artistic self-assertion, Pollock seemed a dead end, his poured technique allowing for only the creation of *faux* Pollocks. De Kooning's personal charisma and ready accessibility downtown, as opposed to Pollock's retreat to Springs on Long Island and aggressive inebriation at the Cedar bar when he was in town, only reinforced that situation.

The general public, however, would think of Pollock when it thought of contemporary art. Since 1949, the magazines of Henry Luce had ridiculed him as exemplifying the absurdities of highbrow culture. That year *Time* described his work as "apt to resemble a child's contour map of the battle of Gettysburg," and *Life*—in "Jackson Pollock: Is He The Greatest Living Painter in the United States?" with its striking photo of an imperious artist posed before a scroll-like painting priced at $100 a foot—described how his Springs grocer identified the Pollock hanging in the store "as an aerial view of Siberia." But while the Luce journals continued into the late fifties to attack advanced abstract painting and its elite clientele—in the summer of 1951 *Time* mocked Mrs. John D. Rockefeller III for buying "the smear-technique of such avant-garde Manhattanites as Baziotes, Motherwell, Rothko, and Tomlin"—upscale periodicals such as *Harper's Bazaar*, *The New Yorker*, and *Vogue* presented a more positive view. Just before the Ninth Street Show, in fact, *Vogue* featured Cecil Beaton's photographs of models posed in "the new soft look" against the monumental Pollock abstractions *Lavender Mist* and *Autumn Rhythm* at Betty Parsons, touting their acquisition by "some of the most astute private collectors and museum directors in the country."[28]

The year 1951 began with *Life* focusing on the controversy around the Metropolitan Museum's national juried exhibition American Painting Today—1950. The January 15 issue juxtaposed color reproductions of the conservative prizewinning paintings with Nina Leen's black-and-white photograph of "The Irascibles," fifteen of the eighteen advanced painters who had boycotted the show. The eighteen painters, supported by ten sculptors, had sent a letter on May 20 to the museum's president refusing to submit pictures to juries that were "notoriously hostile to advanced art." The *New York Times* gave the story front-page coverage, and the next day the *Herald Tribune*

provided the group with a name in its editorial criticizing the dissenters, "The Irascible Eighteen." Half of the protesting artists would be shown on 9th Street.[29]

Although Franz Kline created a striking black-on-white poster for the Ninth Street Show, its list of sixty-one participants was composed before the exhibition was hung and is not entirely accurate. At least one artist listed on the announcement, Richard Pousette-Dart, did not exhibit. A member of the first generation who showed with Betty Parsons, Pousette-Dart had moved out of the city to Rockland County in 1950, and perhaps there was difficulty getting a picture to an exhibition that was considered relatively unimportant uptown.[30] Also in Rockland County during the show was Michael Goldberg, who legally had changed his name for a year or so, and thus appears on the poster as (Michael) Stuart. Goldberg did not see the exhibition, since he had committed himself to Rockland State Hospital for a while, but his painting was chosen and delivered by his then girlfriend, Joan Mitchell.[31]

More significant than misleading inclusions were the omissions, for about thirteen artists were left off the poster.[32] Some were neglected through inadvertence, such as Ludwig Sander, but most failed to be included because they were late additions. There was a photograph by Aaron Siskind, the only one in the show, whose abstract images were compared with the paintings of Franz Kline. Siskind often photographed other artists' work, and he took installation shots of the exhibition. In one of these we can see a particularly odd addition, hanging between the works of Cavallon and Pollock—a box by Joseph Cornell. Although the show also included a painting by Enrico Donati, close associate of the Surrealists during the forties and affiliated with Betty Parsons, this backward glance is striking in the muscular world of gestural painting, where such work was considered rather effete. The most interesting omission looks toward the future, for the exhibition contained a small white painting by a young artist who later that year would be invited to join the Club, Robert Rauschenberg.

Rauschenberg removed the painting from his first exhibition in order to show it on 9th Street, and its incised pattern of numbers and words, drawn in a childlike manner, was a peculiar anomaly in the midst of de Kooning protégés. His show at Betty Parsons had opened on May 14, and alerted by Jack Tworkov, Castelli and a few other Ninth Street organizers went up to take a look. Within the week their invitation brought them a work now called 22 The Lily White, painted in Morris Kantor's class at the Art Students League, and named for the inscribed words from a song that the artist remembered from his Texas childhood. In the corner its white ground was punctuated by a small red star, a comic reference to the red stars with which galleries marked paintings as sold.[33] Yet there were to be no such stars at the Ninth Street Show, for while a price list was available, no one purchased anything from the exhibition.

Not that the participants actually expected sales, for it was a time before money became a factor in the vanguard art world. In 1950, even Jackson Pollock barely earned more than $2,500.[34] Survivors of the period look back on it as a blessed time, when real community was possible among those undivided by the envy that would follow more widespread commercial success. This situation lasted until mid-decade, with de Kooning's 1955 sold-out exhibition of landscape-like abstractions at Janis often mentioned as initiating the new age. But in 1951 most of the artists in the show were without galleries.[35]

Kline's poster credited six galleries for works in the show—Borgenicht, Egan, Tibor de Nagy, The New, Parsons, Peridot, Willard, and Hugo. The newest was that of Grace Borgenicht, a painter who had opened her gallery that month in the same building as Charles Egan. Among the artists in the show she would exhibit Calvin Albert, Jimmy Ernst, Louis Shanker, and both Peter and Florence Grippe. Peridot just had presented James Brooks in March, showing anticipations of Frankenthaler in paintings

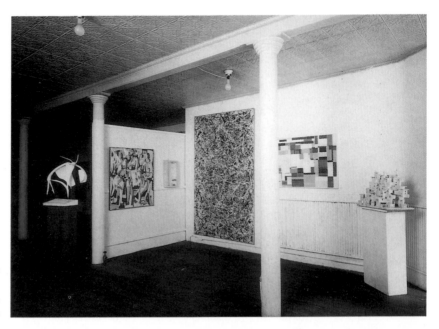

Installation view of the Ninth Street Show, 60 East 9th Street, New York, May–June 1951, showing works by (left to right) James Rosati, Jack Tworkov, Joseph Cornell, Jackson Pollock, Giorgio Cavallon, Peter Grippe. Pollock's Number 1, 1949, *a horizontal work, initially was hung on its side by mistake; the artist allowed the painting to remain so installed due to the lack of space.*

Installation view of the Ninth Street Show, 60 East 9th Street, New York, May–June 1951

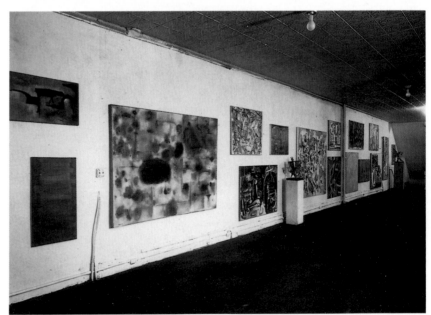

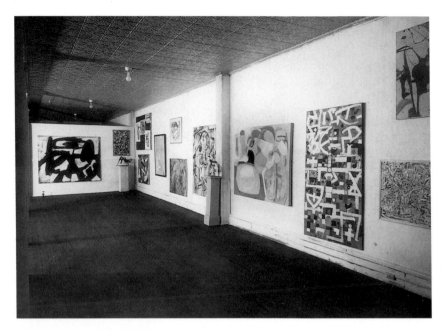

Installation view of the Ninth Street Show, 60 East 9th Street, New York, May–June 1951. Franz Kline began the installation by placing his large black-and-white painting at the end of the room on a short wall, where it could be seen from a distance without the distraction of surrounding pictures.

Installation view of the Ninth Street Show, 60 East 9th Street, New York, May–June 1951

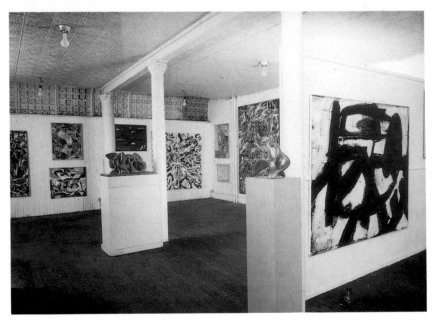

Joop Sanders. Death and En-
trances, *1951. Oil on canvas, 40½
x 14 in. Milwaukee Art Museum,
Bequest of John Lloyd Taylor*

stained from the back, and the gallery would exhibit Guston's new pink-toned abstractions the next year, one of which probably was shown on 9th Street. Coinciding with Brooks at Peridot was Cavallon at Egan, where the next month de Kooning had his second one-man exhibition. The April *Art News* marked de Kooning as one of the "Four Stars of the Spring Season," along with Beckmann, Léger, and Fantin-Latour.[36] Up at Parsons during the Ninth Street Show, following Rauschenberg, was the new work of another participant, Ad Reinhardt.

While a few of the artists of 9th Street were showing—and there were some gallery exhibitions of advanced painting—the number of painters had far outstripped available venues, and it was growing. So one of the artists' great thrills was to see gallery and museum people appearing at the preview of their exhibition. No one really had expected such a turnout, despite the banner stretched across 9th Street and the spotlight mounted to shine on the storefront. But after nine o'clock on the warm spring evening of May 21, shocking numbers of taxis, and even some limousines, pulled up to 60 East 9th Street. The opening was crowded and festive, with the artists retiring to the Club afterward for continued celebration. Speeches were given thanking Castelli for his help and acclaiming the phenomenal turnout. It appeared as though a line had been crossed, a step into a larger art world whose future was bright with possibility. And while it seemed crazy to think that vanguard art could participate in the general postwar prosperity, there was a sense of something major having been achieved.

For something special had happened with this assembling of work by close to seventy artists, something that took the artists themselves by surprise. Certainly frequent studio visits had made them aware of each others' work, and there were few individual revelations. But once that ground floor and basement were filled with painting and sculpture, the whole looked remarkably coherent. Although quality was not uniform, and styles and techniques were diverse, there was a sudden awareness that artistic activity had achieved a critical mass. The artists celebrated not only the appearance of dealers, collectors, and museum people on 9th Street, and the consequent exposure of their work, but they celebrated the creation and the strength of a living community of significant dimension. From the small dark Reinhardt at the entrance, past Tomlin's abstract calligraphy and Kline's slashing black forms, to the slew of works by lesser-known painters such as Theodore Brenson, Al Kotin, John Stephan, and Robert Richenberg, visitors were surrounded by manifestations of what looked like a wide-ranging movement.

Such a movement seemed to call for a name, though de Kooning had concluded the discussion of this topic at Studio 35 with the assertion that "It is disastrous to name ourselves."[37] Eight months earlier, for their September 1949 show of the first generation, Kootz and Rosenberg had proposed The Intrasubjectives, from an essay by Ortega y Gasset. When Castelli again assisted Janis to assemble an exhibition of twenty artists, most of whom had shown on 9th Street, for exhibition in Paris in January 1952, they were referred to only as the American Vanguard.[38] By the time of a series of eight panel discussions organized by Pavia at the Club later that year, earlier suggestions such as Abstract Symbolists and Abstract Objectionists had been eliminated in favor of Abstract Expressionists, a term used in America since 1929 by Alfred Barr, Jr. to characterize Kandinsky's early abstraction.[39] Since among these artists, as Ferren said, "[i]t is practically law . . . that everybody agrees to disagree with everybody about everything," many remained unhappy with the name.[40] But despite its procrustean effect, it did fit the gestural style of de Kooning, which dominated downtown painting.

During the two and a half weeks of the Ninth Street Show, however, Kline's poster identified the group by a street name at the heart of an artists' community. The exhibition stayed open until ten or eleven o'clock, a volunteer sitting by the door to

keep an eye on things and talk with the occasional guest. In addition to artists and their friends, people from the community wandered in to take a look. Others were alerted by a brief mention in the *New York Times* two days after the opening. Following a longer notice of the Stieglitz Collection at MOMA, the *Times* speaks of the "unusual exhibition" on 9th Street in which the work of familiar artists "is interspersed in a highly democratic manner among that of newcomers to the exhibition field."[41]

The two art magazine reviews, by Thomas B. Hess in *Art News* and by Belle Krasne in *Art Digest*, agree in the tone of their overall assessments.[42] Both critics focus on the enthusiastic spirit of, in Hess's words, "this lively manifestation of energy and accomplishment." They are impressed by the size of the show, and by the way in which such an immense production displays both the strengths and weaknesses of the current scene. For Krasne, "Strength includes vitality, conviction, freedom, and above all high per capita painting skill. But weaknesses are lack of concept, tendency to settle for mere decoration, inclination to confuse motor skill and therapeutic self-expression with meaningful art." Hess identifies the strong artists, noting less well-known painters—Milton Resnick, Elaine de Kooning, Robert de Niro, Manny Farber, and Joop Sanders—along with more familiar names, but states that "a number of others seemed amateurishly avant-garde, attempting to pick up a technique which had been created to express complicated ideas, and simply elaborate cleverly upon it. The results are pretentious, huge, but nevertheless dainty and feminine."

When Hess later mentioned the Ninth Street Show, he wrote of it as a salon where qualitative judgment was "irrelevant," something "intra-professional" into which "some people have wandered by mistake; others fail to show up due to a mistake, or to pride or fear . . . an action which cannot be helped or, for that matter, meaningfully judged."[43] It was a place to see what was going on, a place of observation rather than discernment. He was reviewing the second of the Stable Annuals, a series of large group exhibitions modeled on the Ninth Street Show. For when the artists of 9th Street felt the success of their enterprise, a natural thought was to do it again, creating a regular overview of their progress. The occasion presented itself with the availability of Eleanor Ward's Stable Gallery, a huge former stable never completely without its smell of horse and hay. But there would be one great difference. The Stable Gallery was uptown on Seventh Avenue at 58th Street. In this move from downtown Tom Hess saw a threat to the spirit of Ninth Street.

The Stable Annual was the concrete legacy of the Ninth Street Show, providing a yearly cross-section of the New York vanguard from its inception in January 1953 until being discontinued in 1957. With its greater size—beginning with more than 90, and growing to about 150 artists—and regular schedule, it required a selection mechanism more structured than that of 9th Street. But what was lost in spontaneity was gained in democratic process. Each year the participants would elect a committee to choose the next year's artists, as well as selecting a group to hang the exhibition. Every artist would pick his or her own work for the show. Thus a kind of institution was created, supplementing the gallery system with a mass forum for younger artists to introduce their work to the growing community.

Reviewing the third Stable Annual in *Art News*, John Ferren called it both "a state of mind" and "a state of friendship." It also was, he said, "a family affair . . . loving at times to the point of plagiarism, and sometimes incestuous. Just a normal New York family."[44] And it was such features that many felt were coming to predominate in the late fifties, as the gestural style of painting seemed to dilute in its expansion. The relatively small community of 1951 had grown enormously, with money becoming more of a factor after mid-decade as a market developed and more galleries opened to serve its needs. The uptown/downtown division was maintained in that sphere as well, with

close to ten cooperative galleries around East 10th Street between Third and Fourth avenues forming the heart of an active downtown scene.[45] In that world, generically known as Tenth Street, a primary concern was whether the advances seen on 9th Street had calcified into a new academy.

In his 1955 Stable review, Ferren concluded that they had not, but doubts proliferated as the decade progressed. In 1958 and 1959 the Club debated the issue, with such panels as "Has the Situation Changed?" and the series "What Is the New Academy?"[46] With artist statements reproduced in *Art News*, the discussion went more public. Tom Hess led the defense, but many of the 9th Street artists mourned the loss of vigor and originality, the lack of authentic statement grounding energetic gesture. None expressed it with more verve than Friedel Dzubas: "Why is it after an evening of openings on Tenth Street I come away feeling exhausted from the spectacle of boredom and the seemingly endless repetition of safe sameness? . . . The finished product rubber-stamped with the imitable flick of the wrist of the masters."[47] Perhaps equally worrisome to a group that had grown-up cultural outcasts, in 1959 *Life* would do a two-part feature on the "abstract expressionists, world's dominant artists today."[48]

By then, of course, vanguard New York painting was being displayed around the globe, from Paris to Tokyo. It was promoted as a triumph of American culture, an expression of the personal freedom available to those living in the Free World. Central to these efforts was New York's Museum of Modern Art, which in 1958 organized a vast traveling show of The New American Painting for circulation throughout Europe. Before this grand presentation, however, smaller bodies of New York School painting had been sent abroad, sometimes with surprising consequences. One of the most interesting developments, and certainly one of the least known, was the formation of the Gutai Art Association in Osaka, Japan.

CHAPTER 10 *To Challenge the Sun*
Exhibitions of the Gutai Art Association
Ashiya, Osaka, Tokyo, 1955–57

n the spring of 1951, just before the Ninth Street Show, a group of New York School paintings was brought to Tokyo for the third Yomiuri Independent Exhibition. Freed from the constraints of postwar occupation, the Japanese cultural establishment sought to renew international contact through large exhibitions funded by newspaper publishers like Yomiuri and Asahi, and this show was the first to include a section of work from the United States. While most critics focused on the French artists, a single writer was transfixed by two of Jackson Pollock's large dripped and poured paintings. Jiro Yoshihara wrote of their "impact not so much on the purely visual perception, but rather directly on ourselves," and he found Pollock pushing abstraction to a new limit with his display of the substantial materiality of paint and line.[1] Himself an abstract painter, Yoshihara was a founder of the group Kyushitsu-Kai in the late 1930s, and his own gestural abstraction of that period prefigures work done in New York fifteen years later.[2] In the early fifties Yoshihara was mentor to a circle of young artists in the Osaka area, a group that became the Gutai Art Association in 1954. And it was with the Gutai that Yoshihara would fully develop what he had discovered in Pollock's investigation of matter and nature.

Pollock's death in 1956 was announced in a letter from B. H. Friedman printed in the October issue of the Gutai journal. The second and third issues of *GUTAI* had been found among Pollock's books, and Friedman wrote of the artist's admiration for their work. But by October 1956 the Gutai had gone far beyond what they had seen in Pollock, for that month their second exhibition at the Ohara Kaikan in Tokyo contained some uniquely dynamic forms of "action painting"—Kazuo Shiraga hanging from a rope and painting with his feet, Shozo Shimamoto smashing bottles filled with paint and debris, Saburo Murakami violently breaking through layers of paper.[3] These actions were performed for the press before the opening of the exhibition, creating pieces to be shown alongside others focusing on the twin themes of time and material. As extreme as these actions were, however, they were but further experiments enlarging the concept of an exhibition, a move first taken in a pine forest along the banks of the Ashiya River in the summer of 1955.

The Experimental Outdoor Modern Art Exhibition to Challenge the Burning Midsummer Sun was the first major activity of the Gutai Bijutsu Kyokai (Gutai Art Association) after its founding in December 1954. Since 1951 Jiro Yoshihara had been meeting with younger artists of the Kansei region, an area delimited by the cities of Osaka, Kobe, and Kyoto. As an established artist of the prewar avant-garde, Yoshihara assumed the role of master to his young disciples, a relationship that would last until his death in 1972, when the Gutai abolished itself at his passing. Yoshihara also was a wealthy man, head of the largest cooking-oil business in Japan, and he was able to fund Gutai activities through the years of critical and commercial neglect. By the time that he had assembled the group that would show under the name of Gutai at the seventh Yomiuri Independent in March 1955, he already had published the first issue of their journal. There Yoshihara's international ambitions were clear, for his essay was translated into English, and every artist's name was printed in European characters.[4]

Kazuo Shiraga. Please come in, 1955. 9 wooden posts, each: 158⅝ x 2⅜ in. Photograph courtesy Sinichiro Osaki, Hyogo Prefectural Museum of Modern Art, Kobe. For the Experimental Outdoor Modern Art Exhibition to Challenge the Burning Midsummer Sun, Ashiya, July 1955, Shiraga erected a cone of ten posts painted red, scarring the inside with an axe to create a violent "drawing." Here he makes another version for photographers from Life *at the One Day Outdoor Exhibition, April 1956.*

Yet when the Gutai group finally received international attention, ironically their avant-garde moment was past and their work would appear retrograde.

The name *Gutai* was proposed by the secretary of the association, Shozo Shimamoto, who as early as 1950 had done radical work with random pencil marks, administered with such violence that he punctured the picture surface.[5] One of its two ideograms, *tai*, means body, and *Gutai* generally is translated in English as "Embodiment." It also has been rendered as "Concrete," in the sense of immediate and direct expression, and related to the behavior of children, so important to the Western avant-garde since the Blaue Reiter.[6] Central to the Gutai was the use of nonstandard materials—water, mud, air, smoke, fabric, chemicals—and a view of time as another sort of matter to be manipulated. This focus on temporality arose with their outdoor debut, where the physical setting directed attention to issues of perception, process, and the interaction of environment, work, and observer.

The first outdoor exhibition was held for thirteen days in July 1955, over a large area of Ashiya city's pine forest. Since it was sponsored by the local art association, it included seventeen others in addition to the twenty-three Gutai members.[7] But the Gutai work was the most remarkable, breaking free from standard forms to utilize and embrace the natural setting, emphasizing changes in perspective and viewing conditions. Shozo Shimamoto set up a tin wall with holes in it, one side painted dark blue and the other white. Standing close one looked through to see the pines beyond, but from afar the holes became tiny points of light. Atsuko Tanaka stretched 30 square feet of bright pink nylon about 7 inches off the ground, suspended another large piece of fabric vertically between two posts, and at the center of the site she attached seventeen 6-foot cedar boards together, snaking into the air to the top of a 45-foot pole. Kazuo Shiraga erected an open cone of ten log beams that he had painted red, violently scarring the inside with an axe. He called it *Please come in*, its gestural display of white gashes said to "express instinctive destruction." Equally aggressive was Tsuruko Yamazaki's *Danger*, about fifteen sheets of tin attached along a diagonal line to the top of a tall pole, their sharp points threatening anyone who approached. Sadamasa Motonaga sought to exhibit water itself, hanging 1½ red-dyed gallons from a tree in a great tear of clear plastic, fully realized only "when the fluid began to burn together with the setting sun in the west."

In addition to all the work suspended in the air, the woods were filled with strange objects and constructions. Motonaga lodged two posts in the ground, one white and the other red, into which he hammered nails painted various colors. Jiro Yoshihara elevated two crossed wooden beams on a system of thin metal supports, and his son Michio set out objects made from junked machine parts. Akira Kanayama displayed a small red sphere on a huge base. There was a long row of wooden stakes placed by Toshio Yoshida, a pile of belts by Itoko Ono, and various abstract sculptural constructions. Toshiko Kinoshita dispersed hundreds of cylindrical objects across the ground.

Despite the outdoor setting there were many paintings. Yasuo Sumi stretched a 30-foot messy abstraction between the trees, and Shozo Shimamoto erected a large work of four panels. Most paintings were displayed on the ceiling of a building constructed for the occasion, and under water lining the bottom of a pond.

While the exhibition title suggests an attitude of scorching defiance, the mood varied with the weather and the time of day. As evening brought a cool breeze off the river, the pine forest was filled with strollers in their summer gowns, a crowd that ordinarily would go nowhere near a show of vanguard art. To accommodate these visitors, the exhibition was illuminated by seventy 100-watt bulbs strung among the trees. But the show elicited little response other than bemusement, and as with future

efforts of the Gutai group, it was largely ignored by the Japanese critical establishment. One person who was impressed by the exhibition, however, was the Ikebana master Houn Ohara, who offered the Tokyo hall of his flower-arranging school to the Gutai Art Association for its first indoor exhibition.

This two-floor installation of about sixty works, The First Gutai Exhibition, consolidated the radical moves taken in the Ashiya pines. And for the first time the artists performed before the public, extending to the creative act the status of artwork. They called these events "actions," the same term that Joseph Beuys would use in the sixties, and they were shocking in their violence and aggressive treatment of materials. Perhaps unaware of the analogy, Kazuo Shiraga and Saburo Murakami enacted ferocious versions of Pollock's physical entry into his work. At a gathering of the press on opening day, October 19, 1955, Shiraga thrashed around for twenty minutes in a ton of clay that he had piled in the courtyard, wearing nothing but his shorts. As he attacked the material it began to rain, and the wet, muddy artist emerged from the process cut and bruised. Murakami had spent night and day stretching layers of packing paper over three large frames, which he set one in front of the other. Before the startled reporters he smashed his upper body through the structure six times, creating his *Making Six Holes in One Moment*. Evoking birth trauma and the notion of artistic rebirth, the last foray was followed by an emotional experience in which, he recounted, "I became a new man." The piece would be displayed in the center of the first room of the exhibition, which visitors entered through another frame over which Murakami

above left:

Tsuruko Yamazaki's Danger *(metal plates and wire) in the Experimental Outdoor Modern Art Exhibition to Challenge the Burning Midsummer Sun, Ashiya, July 1955. Photograph courtesy Sinichiro Osaki, Hyogo Prefectural Museum of Modern Art, Kobe*

above right:

Sadamasa Motonaga. Nails, *1955. Wooden posts, paint, nails, 86⅝ x 9 in. Collection of the artist. Created for the first Gutai outdoor exhibition in Ashiya, July 1955. Photograph, courtesy of Sinichiro Osaki, Hyogo Prefectural Museum of Modern Art, Kobe*

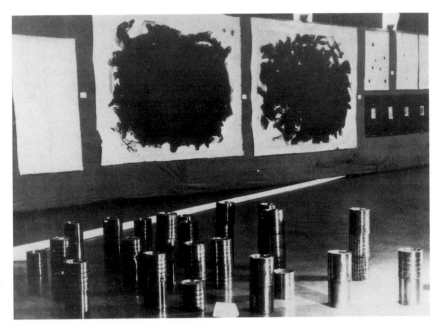

had stretched gold paper. Yoshihara had the honor of literally opening the show by crashing through it.

About a week before the exhibition seven of the artists went to Tokyo to prepare for the show, an expedition that Yoshihara compared to a kindergarten excursion from Kansai to the capital.[8] Since many works were to be created at the site, they wanted to get a feel for the place, and they spent a night in the areas that would be devoted to the exhibition. An entire room on the second floor was given to Motonaga, and he soon went off to the scenic Okutama district to collect stones for his installation. He returned with 130 pounds of rock from the Tamagawa River. Painted with enamel they were displayed along with his childlike paintings. By the window he hung an array of about twenty-five plastic bags of colored water, requiring a day of adjustment so that the light would filter through correctly. Another room was dominated by a large white balloon that Akira Kanayama had borrowed, illuminating one side with a red light that transformed works installed nearby. Yoshihara's yellow ocher cement painting became red-brown, the collection of fifty-two empty tin cans by Tsuruko Yamazaki took on a mysterious hue, and her mirrored wall piece reflected the red light at all angles. Across the room, visitors could shakily traverse two of Shimamoto's wooden paths mounted on springs. These were works, Yoshihara said, "to be appreciated through the whole body."

Shiraga's mud works, created with his gyrating body and bearing its impress, were a three-dimensional development of the foot painting that he had begun in late 1953. Two such paintings were mounted in the Ohara Kaikan. Meant as a variant of New York "action painting," they seem an avant-garde update of centuries-old Asian finger-painting techniques, with which Shiraga had earlier experimented. Not surprisingly for most critics Shiraga's work appeared to be the deranged product of mindless activity. More tranquil was the minimal fabric installation of Atsuko Tanaka. With a 100-foot wall to herself, Tanaka hung large rectangles of yellow cloth across the entire room, and suspended a single piece of pink fabric outside the window.

Yoshihara arrived in Tokyo one day before the exhibition, discovering what

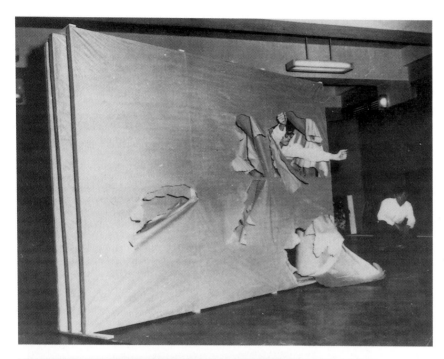

Saburo Murakami. Making Six Holes in One Moment, *1955. Wood, packing paper. Photograph, courtesy of Sinichiro Osaki, Hyogo Prefectural Museum of Modern Art, Kobe. In this "action" performed before the press at Ohara Kaikan, Tokyo, October 19, 1955, Murakami created the work that he would install in the initial gallery of the First Gutai Indoor Exhibition.*

Sadamasa Motonaga. Stones. *Installed at the First Gutai Indoor Exhibition, Ohara Kaikan, Tokyo, October 1955. Photograph, courtesy of Sinichiro Osaki, Hyogo Prefectural Museum of Modern Art, Kobe*

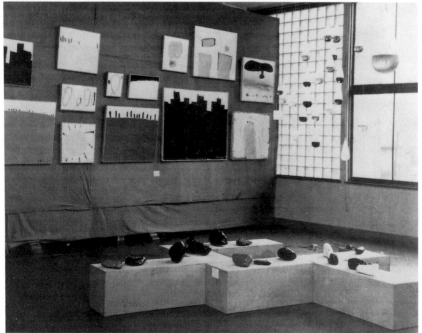

his artists had concocted and helping with the installation. As they worked late into the night to finish the show, they suddenly heard a sequence of bells. As Yoshihara recounted, "We all stood and listened. The sounds, like living creatures, flew about upstairs and downstairs." This was the first of Tanaka's pieces using electric bells, snaking through the entire exhibition and triggered by visitors. An interactive work like Shimamoto's springy boards, it also emphasized the element of time that was increasingly central to the Gutai artists.

The exhibition included quite a few paintings, many in the first room of the show surrounding Murakami's work of six holes. Entering on the right were eight pieces by chemistry teacher Toshiko Kinoshita, who created chance abstract images by dissolving chemicals onto filter paper. Michio Yoshihara showed three large paintings, which he had done on the train in one night. There were batik-like works by Itoko Ono, and other paintings by Toshi Yoshida and Chiyu Uemae. And prefiguring future Gutai painting that would reject the brush, there was Yasuo Sumi's configuration of lines done with an electric vibrator.

The rain that had soaked the press during Shiraga's mud wrestling continued through the course of the exhibition, contributing to the low attendance to be expected outside the center of Tokyo in Aoyama. Most of the visitors were young art students. But this was the occasion for the first English language story on the Gutai, I. G. Edmonds's "Art Is a Hole in the Ground" in the U.S. Army newspaper, *Pacific Stars and Stripes*. While his own account was favorable, Edmonds quoted another critic's characterization of the exhibition as like the "physical therapy room in an advanced mental hospital."[9] It probably was Edmonds's story that reached the offices of *Life* magazine, which approached the Gutai group for a feature on their new art. Well aware of the importance of such exposure, Yoshihara and company arranged something special.

When *Life* sent two photographers in April 1956 to Osaka, they were met with an exhibition organized for themselves alone. The One Day Outdoor Exhibition was located in an old shipyard between Kobe and Osaka. Its most impressive work was set in a large fuel tank bombed during the war, and now flooded. Yoshihara covered the inside walls with dark fabric, and drove painted timbers into the bottom so that they jutted from the water. Floating a white sphere, a white box, and a yellow box in the tank, Yoshihara rowed through these objects in a rubber boat. On land he showed three live chickens, which he had painted red, yellow, and green. Murakami exhibited a yellow wooden cube, a variant of the simple box that he had invited visitors to sit on in February at the All-Kansai Exhibition in Osaka. Along the shore Kazuo Shiraga made another version of his timber and axe piece, which he also had re-created outside the Tokyo exhibition. Unfortunately, the *Life* story never appeared.

Three months later the Gutai artists returned to the Ashiya forest for their largest outdoor exhibition. There Shiraga displayed two heaps of mud covered with cellophane to maintain a slimy look, one sprouting green hemp that resembled hair, which visitors were invited to touch and mold. One oval and one round, they reminded Yoshihara of jellyfish and summer candy. Motonaga hung long tubes of colored water between the trees, successfully cascading the refracted light, and floated cellophane lanterns in a narrow pool in the tradition of the summer lamp festival. For the hazardous entertainment of his Kansai friends, Shimamoto made one of his spring-driven catwalks.

The Second Outdoor Exhibition also contained special environments. Jiro Yoshihara erected a house of dark blue walls with an enticing red light inside. When visitors tried one of its three entrances, the corridor immediately narrowed, just allowing them to reach a hand into a mysterious space. Nichiei Horie constructed a large

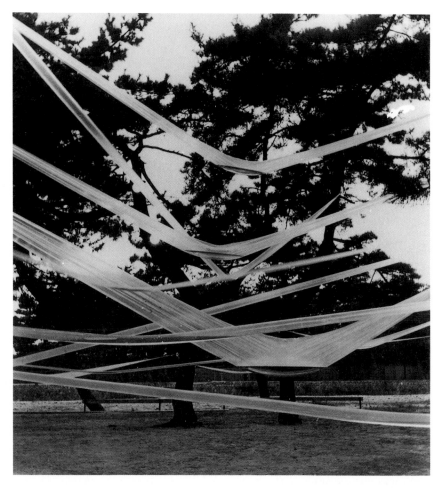

Installation by Sadamasa Motonaga of tubes of colored water in the pine trees of Ashiya, during the Second Outdoor Exhibition mounted by the Gutai Art Association, July 1956. Photograph, courtesy of Sinichiro Osaki, Hyogo Prefectural Museum of Modern Art, Kobe

cube in which a ray of sunlight traversed the wall as the day passed. And Murakami put up a great cylindrical tent, surmounted by an open metal cone. Entitled *Sky*, the piece isolated a section of the heavens for personal view inside the pink interior. As Yoshihara commented, it was "a trap to catch . . . nature itself."[10]

Murakami made the point again by suspending an empty frame in the trees, and many artists took advantage of the setting to hang work in the air. Nobora Sukamitsu hung a row of white gloves from strings, and Takeshi Shibata put up a large six-cornered kite and an array of geometric shapes. Yasushi Murano made a convoluted construction of wire netting, and in the trees Kimiko Ono suspended a long line of wooden slats resembling the *gohei* at Shinto shrines.

Akira Kanayama tied the show together with about 300 feet of white vinyl. Imprinted with black footprints, it meandered through the exhibition until finally running up a pine tree. He also connected things through light and sound, borrowing a signal light and bell from the railroad, which he set to flash and clang continuously through the duration of the show. These coincided with the sequence of lights in Tanaka's seven giant human figures, whose fluorescent "bones" were timed to resemble flowing blood. Her other illuminated piece, a large cross of light bulbs, slowly turned on and off.

181

金の箱

大林正夫

Shota Obayashi's installation of gilded boxes, in the Second Outdoor Exhibition of the Gutai Art Association, Ashiya, July 1956. Photograph, courtesy of Sinichiro Osaki, Hyogo Prefectural Museum of Modern Art, Kobe

Installation view of the Second Outdoor Exhibition, Ashiya, July 1956. In the foreground are floating lanterns by Sadamasa Motonaga, and in the background is Atsuko Tanaka's illuminated cross. Photograph, courtesy of Sinichiro Osaki, Hyogo Prefectural Museum of Modern Art, Kobe

opposite:
Akira Kanayama's footprints on approximately 100 yards of plastic, ending up a tree after snaking through the Second Outdoor Exhibition of the Gutai Art Association, Ashiya, July 1956. In the background is Shozo Shimamoto's painting done by firing paint from a small cannon. Photograph, courtesy of Sinichiro Osaki, Hyogo Prefectural Museum of Modern Art, Kobe

Atsuko Tanaka in her electric dress, at the Second Gutai Exhibition, Ohara Kaikan, Tokyo, October 1956. Behind her on the floor is Akira Kanayama's inflated Football, *in front of the large foot painting by Kazuo Shiraga. Takamatsu City Museum of Art. Photograph, courtesy of Sinichiro Osaki, Hyogo Prefectural Museum of Modern Art, Kobe*

opposite:
Atsuko Tanaka. Electrical dress, *1956. Lamps, neon tubes, 65 x 31½ x 31½ in. Takamatsu City Museum of Art, Japan. Photograph, courtesy of Sinichiro Osaki, Hyogo Prefectural Museum of Modern Art, Kobe*

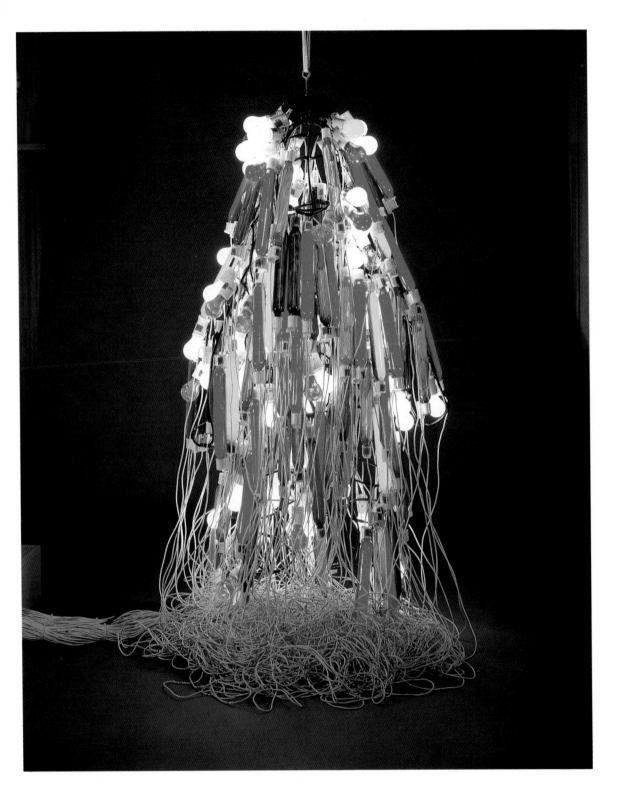

There were simpler works as well, continuing the Zen-like strain among the Gutai. Tsuruko Yamazaki suspended a large structure of red vinyl sheeting, illuminated at night like a great red lantern. Shota Obayashi half-buried a group of golden boxes, and Kitani arranged a hundred tin plates in rows of ten on the ground. Especially evocative were Michio Yoshihara's three small holes in the earth. Named *Shining Water*, *Discovery*, and *Mirror in the Center of the Earth*, they presented simple pools of water or light glowing under the sand.

The major action of the exhibition was Shimamoto's "painting" a huge piece of red plastic hung from the trees. Firing volleys of enamel from a homemade cannon, he dramatically expressed his view that "paint does not start to live until it is liberated from the brush."[11] Such liberation would display the materiality of paint, an investigation that some members of the group had begun before they were Gutai—Shiraga with his feet, and Murakami with a rubber ball coated with ink. These experiments would continue, and new results would be seen in October at the group's second indoor exhibition.

Like the first, this 1956 exhibition was held in Tokyo at the Ohara Kaikan, following a show of smaller works by Gutai artists at the Sanseido Gallery in the Kanda area of the city. Leading from the gate to the entrance was Kanayama's footprint path, quickly substituted for Motonaga's red plastic tunnel, which was destroyed by high wind the night before the opening. And continuing their Tokyo tradition, the exhibition was preceded by actions done for the press, including more paper breaking by Murakami, this time running through about ten frames. Indoors Shiraga did his foot painting on 9 x 24 feet of paper, and on the roof Shimamoto placed a large rock on a piece of canvas, smashing bottles of paint mixed with yarn and vegetable seeds to create his work.

Another sort of automatic painting was done by Toshio Yoshida, who poured India ink from a watering can about 10 feet above the canvas. He also used an air rifle to make paintings filled with holes, anticipating Niki de Saint-Phalle's *Tirs* done in Paris in 1960. Somewhat less violently, Yasuo Sumi continued his rejection of the brush, applying black enamel with blows of umbrella ribs, then smoothed with a vibrator and walked on in clogs. Yoshihara found the messy smudges left when he cleaned his fingers on the canvas "a charming dirtiness," for Sumi wrote that dirt "is the only object in which I can find my sense of life."[12]

Like the first indoor exhibition, the second contained some imposing large objects. Murakami constructed a giant cube of paper on wooden frames, its inside a maze that tempted visitors to break through the walls that he had left intact. Kanayama inflated a long low balloon decorated with dots, and its slight movement suggested to the artists that a huge creature was living in the hall with them. Nearby, Tanaka displayed an elaborate electric costume, a hanging assemblage of colored fluorescent and incandescent bulbs. She occasionally would walk around the exhibition with her lights blinking, but the piece also functioned as a free-standing sculpture. And in his most elegant display of water, from the ceiling Motonaga suspended five large horizontal frames stretched with clear plastic, the colored liquid forming graceful depressions in the vinyl.

Michio Yoshihara contrived two new forms of display for the show, one a machine into which he set a 300-foot scroll whose agitated lines suggested a seismograph. He also projected abstract images on the wall, making tiny paintings on film as well as using found misdeveloped images. These were a technological complement to Kinoshita's chemical works, as well as a contrast to the many paintings in more traditional media, such as the wall of single-image abstractions by Fujiko Shiraga, wife of the foot painter.

Akira Kanayama hanging his painting done with a remote-control mechanical car on vinyl, during the First Gutai Indoor Exhibition, October 1955, Ohara Kaikan, Tokyo. Viewed by his colleagues as developing the work of Jackson Pollock, Kanayama anticipates by two years Jean Tinguely's mechanical drawing machines. Photograph, courtesy of Sinichiro Osaki, Hyogo Prefectural Museum of Modern Art, Kobe. Kyoto Municipal Museum, April 1957

There were quite a few nonstandard smaller paintings in the show, including Yamasaki's pieces of foil and tin. Works by Yasushi Murano and Kimiko Ohara were of distressed paper, and Miyuko Hara showed just a sheet of paper partially rolled up on the wall. The strategy of using distressed material, however, was most impressively displayed at the third indoor exhibition, held in their native Kansai at the Kyoto Municipal Museum in April 1957.

At this first Gutai museum show, Murakami abandoned his paper crashing and exhibited a large work of paint already peeling off the surface, revealing the connection between time and material as no stable painting could.[13] Shiraga continued his foot painting, which he had begun to rework with layers of podiatric gesture. The most striking innovation, however, was made by Kanayama, who Yoshihara felt now "went even further down the road marked out by Pollock." His work resulted from experiments he had made with children's mechanical cars and tanks. It was painterless painting, done by a remote-controlled model car rigged with a can of quick-drying paint. The device made all-over compositions, substituting mechanism for the effects of drip and spatter, and looking forward to Jean Tinguely's *meta-matic* drawing machines of 1959.

After two years of Gutai exhibitions, Jiro Yoshihara began to articulate for the public some theoretical issues raised by the group's activities. His account of the second indoor exhibition emphasized the way that Gutai works question their own artistic status, noting that with Murakami "it was the frame of the concept of art that he tore through so bravely." Such Duchampian lessons, however, were suppressed in the manifesto that he published two months later, in the art journal *Geijutsu Shincho*.[14] Here Yoshihara focuses on *material*, on its murder by traditional art and its renewal by more direct and honest presentation. Crashing through paper, throwing paint, displaying water alone—these serve to bring the spirit of material to life, rather than dominating it with brush or chisel. He extols the various automatic methods used by the Gutai artists as strategies in this quest, from Kinoshita's chemical reactions to Shimamoto's cannon fire. But he distances their work from Dada. His model, of course, is Pollock, yet Yoshihara also mentions a group he has only recently learned of—the *art informel*

of Michel Tapié and Georges Mathieu. Within a year he would know much more, and the direction of the Gutai would irrevocably change.

In the course of his manifesto Yoshihara speaks of things that had not yet appeared in public, such as Shimamoto's Gutai music and Motonaga's work with smoke. Since the first outdoor exhibition, he had been thinking of a new forum for display, one that would focus on the temporal. So after confronting the Ashiya forest and the midsummer sun, the group adopted the theatrical stage as a new challenge. The results were presented two years later, a product of studio experimentation and the experience of the intervening exhibitions. At Osaka's Sankei Hall on May 29, 1957— repeating the program in Tokyo on July 29—the Gutai introduced their works for stage exhibition. Along with the earlier actions, these would be marked by Allan Kaprow as the first Happenings.[15] More than this, the stage event itself was an exhibition of working process, the elevation of creative activity to the level of the objects that it produced. Without the existential anguish, Rosenberg's painterly drama had literally moved onto the stage, to be exhibited alongside its issue.

The program consisted of twelve works, beginning with a highly stylized performance in which Kazuo Shiraga and his friends attacked the back wall of the stage with arrows and a spear. There was Gutai music by Shimamoto, described by Ray Falk in the *New York Times*: "It sounds like the screeching of tires, the tearing of a bolt of cotton, the grinding of metal against metal and most often the distorted recordings of ultra-high frequency radar and radio signals."[16] Shimamoto also violently destroyed a series of three objects lowered from the ceiling, sending debris out onto the audience. In other pieces paint was thrown toward the viewers from behind clear plastic, and a giant balloon was inflated and deflated to more monotonous sounds by Shimamoto. Jiro Yoshihara displayed an empty stage, and his son gave a slide show whose abstract images mixed and melted from the heat of the projector. Among the other works was Saburo Murakami beating through huge stretched paper panels, to great amplified crashes. Atsuko Tanaka removed costume after costume, some electrified, and the exhibition closed with Sadamasa Motonaga presenting his smoke work, which had been developed earlier but saved for the stage. Colored lights played on drifting smoke, and large smoke rings were directed toward the audience. Unfortunately, things were a bit more smoky than anticipated, and the audience fled the theater choking and coughing. At the second stage-art presentation, Motonaga aimed his smoke cannon straight up.

Art on the Stage was the last in the series of challenges that Yoshihara had set the Gutai artists, provocations to create art in and for new contexts. Many of them had come to the group already experimenting with novel forms of picture making, their interests focused on new means and materials. Yoshihara set these efforts in the context of European avant-gardism, the tradition of trying to be rid of the weight of the past, layers of obsolete culture distancing the artist from the sources, and goals, of creativity. His motto was "Do only what never has been done," and his exhortation to the new prompted the artists to fix on the novel materials and techniques that they displayed indoors and out. But the very notion of an artwork was also up for revision, and the Gutai experiments led them to display working processes as substantial entities. For the Gutai, not only was a picture an artwork, but so was the process of its creation. In the Ashiya pines their focus on matter had led to a concern with physical change and perceptual process, naturally developing through their actions to a theater of artistic production. But all of the Gutai exhibitions contained paintings, and most of the artists showed works of conventional media alongside their more radical pieces. Events soon conspired to bring them to the fore.

The crucial occasion was the arrival in Japan of the French critic Michel

Jiro Yoshihara performing for photographers from Life *during the One Day Outdoor Exhibition staged in their honor, April 1956. For this work he used a flooded fuel storage tank, in the abandoned shipyard between Kobe and Osaka where the event was held. Photograph, courtesy of Sinichiro Osaki, Hyogo Prefectural Museum of Modern Art, Kobe*

Tapié in September 1957. Tapié was the leader of *l'art informel*, which since the early fifties had advanced a French version of gestural painting. In November 1956 this work appeared in Tokyo at the Takashimaya Department Store in the Asahi-sponsored exhibition, The World of Art Today, causing a form of local excitement dubbed the "*Informel* Whirlstorm."[17] By this time European interest in *l'art informel* was waning, and Tapié had embarked on a campaign to revive the failing movement. Japan played into his plans perfectly. He had learned of the Gutai group when the painter Hisao Domoto showed him copies of their bulletin in Paris, and Tapié decided to come to Japan to meet Yoshihara and associates. His goal was to teach them the truths of *l'art informel*, but instead of finding malleable material, he discovered a mature movement. So rather than pursue Japanese converts, he sought membership in the Gutai Art Association. Such is the account Tapié presents in *GUTAI* 8, devoted to "*L'Aventure Informelle*" and published during this first visit to Japan. Not surprisingly, Yoshihara welcomed him into the organization.

A preview of what was to come for the Gutai could be seen at their fourth indoor exhibition in October 1957 at the Ohara Kaikan. Introduced by Tapié, the show contained only paintings. All of the Gutai, of course, were painters, and much of their most experimental work was intended to extend the bounds of painting while remaining true to the painterly impulse. In developing a close association with Tapié and *Informel*, however, they entered the world of international gesture painting, accepting that their work be judged in this context. Reinforcements came from Paris the same month that Tapié arrived: Georges Mathieu, who would paint to great acclaim in department store windows, the American Sam Francis, and the returning Japanese artist Toshimitsu Imai. All were affiliated with *l'art informel*.

The involvement with Tapié was a complex matter of the critic's enthusiasm and real appreciation of the Gutai, his aspiration for a renewal of *Informel*, and Yoshihara's ambition for his artists and their work. Michel Tapié was the first serious critic, inside or outside of Japan, to acknowledge the importance of these artists, and after the years of ridicule and neglect his attention was very welcome. While he associated their efforts too closely with those of his European colleagues, the Gutai artists raised no objection, following the lead of Yoshihara as master. The older painter, of course, saw the benefit to his artists of international attention, and he encouraged Tapié.[18] It was a situation of mutual use and advantage. And as a committed painter Yoshihara knew that the Gutai had made radical advances in two dimensions, developments that he thought should be shown abroad as well as developed further. It was during Tapié's next trip to Japan that the Gutai saw more fully the context within which their painting would be judged.

When Michel Tapié returned in April 1958 it was to stage a large exhibition at the Takashimaya Department Store in Osaka, International Art of a New Era: *Informel* and *Gutai*. Held as part of the Osaka International Festival, the show included eighty-four artists—twenty-seven from Japan, twenty-six from Europe, and thirty-one from the United States. Among the Americans were many from the Ninth Street Show, including Brooks, Carone, Donati, Frankenthaler, Goldberg, Hartigan, Leslie, Mitchell, de Kooning, Krasner, Pollock, Marca-Relli, Motherwell, and Tworkov. Europeans included Appel, Mathieu, Tàpies, Riopelle, and Fontana, whose hole-filled work was produced by the Gutai artists according to his written directions. Certainly it was a thrill for Yoshihara to see his painting on the same wall with one of Jackson Pollock's, and for Kanayama to find himself in a room with Franz Kline. The show traveled to Nagasaki, Hiroshima, Tokyo, and Kyoto, finally giving the Gutai artists some status in Japan by their association with members of *Informel* and the New York School. It also was the occasion of their last performance of art for the stage, introduced by Tapié at

Osaka's Asahi Hall.

Tapié continued to promote the Gutai group. He arranged for an exhibition of their paintings at the Martha Jackson Gallery in New York that fall, where Yoshihara showed a film of the Gutai stage actions. It was a year before the first Happening—Allan Kaprow's *18 Happenings in 6 Parts* at the Reuben Gallery in October 1959—but early work had been done in John Cage's class at the New School for Social Research, and the new art form was already germinating. He also introduced the Gutai to Italy, where they showed twice in Turin—in the *Arte Nuovo* exhibition during May, and with an exhibition of their own in June at the Galleria Arti Figurativi. The April 1959 issue of the Italian journal *Notizie* was devoted to their work, presenting the first long texts other than those they had published themselves, and paralleling the radical work being done in Europe by such artists as Piero Manzoni and Yves Klein. From the beginning Yoshihara and Shimamoto had sent out *GUTAI* to members of the international art community, but it took the efforts of a promotor like Tapié to get them broad notice.

His last project with the Gutai was the strangest of all, the International Sky Festival held above the roof of the Takashimaya Department Store in Osaka in April 1960. Collecting drawings from a group of international artists, including Alfred Leslie, Claire Falkenstein, and Sam Francis, the Gutai artists enlarged the images and sent them aloft attached to balloons. In form a radical exhibition concept, its transfer of standard media to larger format failed to engage the substantial concerns of the early shows. But it maintained the element of humor that from the outset characterized the exhibitions of the Gutai.

By this time, however, the Gutai group had done its work. Ironically, as it was assimilated by Tapié as a mode of gesture painting, the most advanced international artists were embracing the kind of thing that the Gutai had done in the mid-fifties. For in Europe and America the avant-garde was in revolt against such painting, concerned more with the new consumer society than with existential expression. Reversing the direction of the Gutai, they moved off the canvas into assemblage, installation, and performance. Their general route embraced a junk aesthetic, which in the United States would be cleaned up for middle-class consumption as Pop. Yet the most outrageous of these artists grounded his project in a spiritual quest not unlike that of Yoshihara. For Yves Klein, this enterprise led into the void.

11 *Pop Triumphant:*
A New Realism
Yves Klein's Le Vide, Galerie
Iris Clert, Paris, 1958
Arman's Full-Up, Galerie Iris
Clert, Paris, 1960
New Realists, Sidney Janis
Gallery, New York, 1962

On the evening of his thirtieth birthday, April 28, 1958, Yves Klein escorted small groups of visitors into the empty gallery of Iris Clert. He had spent the previous three days preparing the space, first removing the furniture and slowly painting the walls white to eliminate all trace of other art and of other artists. Purification was followed by meditation, and by the visualization exercises that Klein had mastered through years of Rosicrucian practice.[1] His intention was to transform by mental effort the intangible spirit that filled the place, creating an exhibition of immaterial painting. For the subtitle of the exhibition known as Le Vide ("The Void") was "The specialization of sensibility from the state of prime matter to the state of stabilized pictorial sensibility," and the artist insisted that "It was in short a gallery of paintings, although it was empty."[2] This spiritual dimension was lost to the thousands who filled the rue des Beaux-Arts outside the gallery, and that night few were able to enter the Void. One who did, however, seems to have appreciated something of Klein's mystical purpose when he signed the guest book: "With the void, full powers. Albert Camus."

Le Vide publicly introduced what Klein called his "Pneumatic Period," in which he focused his work on the immaterial, creating and even selling areas of invisible energy. A year earlier he had first exhibited such a place, guiding friends through an empty chamber on the second floor of Colette Allendy's gallery during his exhibition Pigments Purs. Yet this room was an afterthought, and the focus of the Colette Allendy exhibition was the intense blue pigment that Klein would patent in May 1960 as *I.K.B.* (International Klein Blue), used very physically to coat a variety of objects.[3]

Blue for Klein, as for his Rosicrucian teachers, was the most spiritual of colors, and this embrace of a special variety of ultramarine marked his route toward the immaterial. Klein's *époque bleue* had been introduced to Paris four days earlier. For the exhibition at Colette Allendy was paired with a major public effort at self-definition, and at self-promotion: Yves le Monochrome, his first show at the galerie Iris Clert. On opening day, Friday, May 10, 1957, with the sidewalk in front of the small gallery painted blue, there was a parade down the rue des Beaux-Arts to the Romanesque church of Saint-Germain-des-Prés, where 1,001 blue balloons were released. In the gallery itself, nine blue monochrome paintings were mounted on thin poles, displayed about eight inches from the walls in supposed defiance of gravity. A recording of the artist's *Monotone Symphony* played in the background.

With this exhibition Klein hoped to achieve the notoriety he had garnered in Milan four months before, where eleven identical blue monochromes were displayed

Arman's invitation to the exhibition Le Plein ("Full-Up"), October 1960, was an accumulation of metro refuse in a sardine can, 4⅛ x 2⅜ x 1⅛ in. The label directs the recipient to open the can before the date of the vernissage, October 25. Inside, along with the trash, was a handwritten invitation to come contemplate "the total force of the real condensed into a critical mass." Photograph courtesy Arman Studio, New York

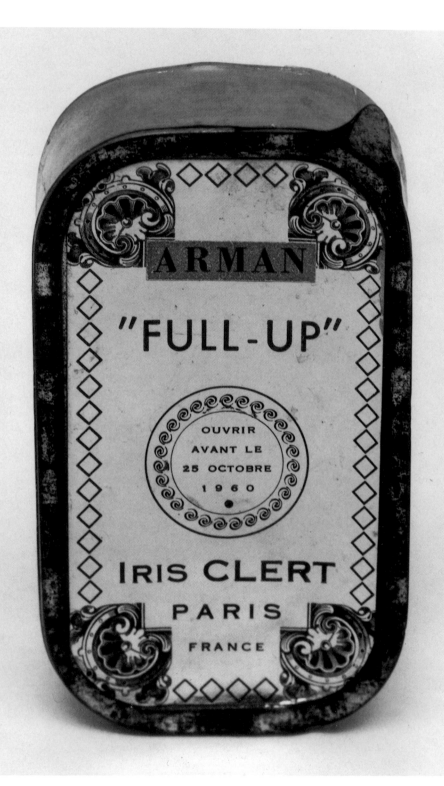

by critic Pierre Restany's friend Guido Le Noci at the Galleria Apollinaire. Klein wrote that these identical paintings had different prices since they were of diverse immaterial qualities, though evidence suggests that they each cost about $56.[4] But his intention was one of myth making, and there was no question of the importance of the Milan show to Italian artists. Lucio Fontana purchased a picture, and the young Piero Manzoni was converted to monochromy and a career mimicking Klein's conceptual efforts, later signing people as artworks and even selling his own excrement. From Milan and Paris, the blue monochrome exhibition traveled to Germany and England, opening the new Düsseldorf gallery of Alfred Schmela on May 31 and moving to London's Gallery One at the end of June. Everywhere the paintings were called *Monochrome Propositions*, a term coined by Pierre Restany to suggest the autonomy of Klein's color from its physical support.

Each invitation to the double exhibition at the Galerie Iris Clert and the Galerie Colette Allendy in May 1957 was mailed with a blue monochrome stamp. Here Klein began his practice of bringing announcements to the local post office, paying the appropriate postage, and then bribing the clerk to allow the use of the artist's own stamps.[5] The idea of the blue stamps came from Klein's friend Robert Godet. An occultist and airplane pilot, rumored to live by running guns, Godet was a member of the group that formed around the charismatic artist. Eating Chinese dinners together, drinking in Montparnasse at La Coupole, Klein's circle—also including Iris Clert, Jean Tinguely, Arman, Restany, and Klein's companion at the time, architect Bernadette Allain—constantly generated new ideas, elaborating on them in group discussion. One night Klein told his friends that he wanted to present an entire gallery of pictorial sensibility. Iris Clert asked him how he would proceed, and he sketched the details. Immediately enthusiastic, she suggested that they call it Le Vide.[6]

Preparations for the exhibition were elaborate, despite actual work in the space beginning only three days before the opening. Arrangements were made for two billboards on the Place Saint-Germain-des-Prés and for ads in French and American art magazines. Since, as Tinguely remarked, "For Yves, megalomania was just a natural state," Klein decided that a great public spectacle should accompany Le Vide.[7] To make clear that he was abandoning the purely physical use of blue, he proposed the blue illumination of the obelisk in the Place de la Concorde. With her incredible energy and promotional ability, a happy complement to Klein's own, Iris Clert was able to obtain permission from the authorities. A trial run was conducted on April 23rd at 11 P.M., with blue filters placed on the existing lights. In the end this grandiose gesture was not to be—for an hour before the opening Klein received a call from the police that the permit had been withdrawn. Rushing to the Prefecture, Clert found no one in authority able to rescind the order, so on April 28th all action was on the rue des Beaux-Arts. But plenty was to be seen there—except, of course, on the walls of the gallery.

The artist and his dealer were able to arrange for two members of the Republican Guard, in full dress uniform, to be stationed outside during the opening. Arriving at nine o'clock to take their posts, the soldiers were offered a special blue cocktail that Klein had La Coupole prepare for his guests. Like others who accepted these drinks, they would urinate blue for a week, since the mixture of gin and Cointreau also contained methylene blue, a biologist's dye. According to Klein's calculations, the effect would last almost as long as the show's original eight days, a consequence diluted by the extension of Le Vide for an additional week, until May 12.

The guards stood under a blue canopy installed over the building entrance, one of a number of physical changes that the artist made. Ordinarily one entered the Galerie Iris Clert directly from the street, but Klein wanted that door sealed and all

access through a small door off the interior lobby. He painted blue the outside of the gallery window and door, denying a view to passersby and creating a monochrome advertisement for the show. A blue cloth covered the gallery door in the lobby. Once one entered, all was white. Using pure white pigment mixed with the medium he had developed for his monochromes, applied with a house painter's roller, Klein made the gallery his own. Leaving untouched only the metal frame on a display case, the ceiling, and Iris's new gray carpet, he covered the inside of the front window and the glass of the outside door along with the walls. With mental effort, the artist attempted to "stabilize" the same sort of pictorial space within the gallery as he had realized in front of his blue monochromes. While the room might appear wholly white, it actually enclosed, the artist wrote, "the immaterialization of Blue."[8]

With the purification and transformation of the gallery, enhanced by his meditative exercises, Klein sought to create "an individual, autonomous, stabilized pictorial climate" within those four white walls. Walking into this space "literally impregnated by the sensitive pictorial state," receptive visitors were to experience the essence of what could be felt before any great painting. Klein would display the "radiance" of painting without the mediation of gross matter. It was an enterprise requiring spiritual power, and before its commencement he embarked on a special journey.

In early April, the artist made the first of four pilgrimages to Umbria, to the shrine of Saint Rita of Cascia. The Italian saint had many devotees in the south of France, and from his childhood the artist had held her in special esteem. Known as the patron saint of lost causes, Saint Rita would receive gifts from Klein on each of his visits. And once he emerged from preparing the gallery, Klein was confident that his request for spiritual strength had been granted, as years later museums and the market would answer his additional prayer to Saint Rita, that "the blue may be accepted everywhere."[9]

A formal announcement had been engraved in blue script, with Pierre Restany inviting recipients to witness, between nine and midnight on April 28th, a "demonstration of perceptive synthesis sanction[ing] . . . the pictorial quest for an ecstatic and immediately communicable emotion."[10] Sent with blue stamps, of course, the 3,500 invitations included cards each admitting two people to the gallery that evening. Those without cards would be charged 1,500 francs, about $3. With all but 500 of the invitations sent to Paris addresses, and with the public billboards and general word-of-mouth, close to 3,000 people thronged the rue des Beaux-Arts that night.

Expecting a great crowd, as well as possible trouble from the unreceptive and the skeptical, Klein had brought four of his advanced judo students as personal guards. His plan was to station two of them with the ornamental Republican Guards at the lobby entrance, and two more at the gallery door allowing only ten people to enter at a time.[11] The artist himself was to remain in the gallery, in formal dress, explaining the exhibition and encouraging visitors to stay only a few minutes so that others could come in. But the crowd was so great that the system soon collapsed. Klein found his void filled with people, whom he repeatedly implored to leave more quickly. Before the first hour was out, he discovered someone drawing on the blank wall and, to a suddenly hushed crowd, led him to the door to be expelled by his guards. At around ten o'clock three vans of police and a fire truck arrived, but they could not get near the gallery because of the mass of people in the street. Attempts were made to clear the area, and the police investigated complaints from some who had paid admission only to find an empty gallery. By ten-thirty the irate Republican Guards abandoned their post, having been sufficiently tormented by mocking art students. With the stock of blue cocktails replenished at about eleven, the gallery remained open until a half-hour past midnight, when the principals retired to La Coupole. There, at a table of forty set

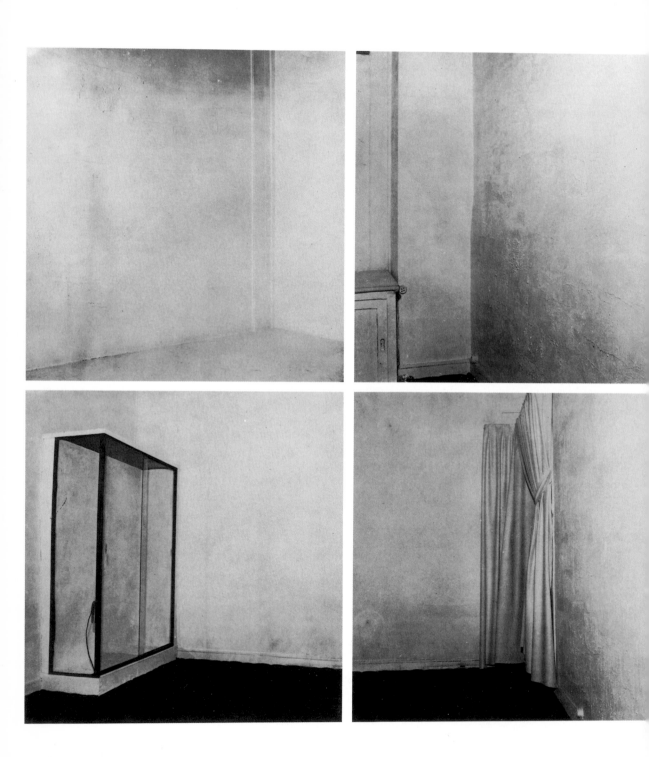

in the back, the artist delivered a speech written that afternoon, announcing a new age for the human spirit, the age of sensibility.

The next day Iris Clert was called to the headquarters of the Republican Guard, accused of demeaning the elite corps. While nothing came of the charge, even critics sympathetic to Klein found the Republican Guards objectionable, detracting—as did the blue cocktails—from the seriousness of his enterprise. As Michel Ragon, who had shown a red Klein monochrome in the 1956 Marseilles Festival of the Avant-Garde, wrote in *Cimaise*, "It is up to Yves to choose between Dadaism and Zen, which are two radically opposed states of mind."[12] But Restany defended the use of the Republican Guards as a reference to the revolutionary character of Klein's work, and they suggest much else. Like the aristocratic bearing of the Knights of Saint Sebastian, which Klein himself joined in 1956 and who would provide the pomp at his wedding in 1962, the Republican Guards signify the elite character of avant-garde art, its general inaccessibility to the uninitiated.[13] Klein twisted this point back on itself, for he was not unaware of how such figures would appear to the crowd on the evening of April 28. He would turn the derision accorded these "puppets" (the term is Ragon's) into a mockery of those who scoffed, transposing their ridicule into a critique of avant-garde snobbery—for The Void was open to anyone sufficiently receptive to sense its content.

This is part of the richness of Le Vide, an openness to interpretation symbolized by the very form of its emptiness. An occult enterprise mounted by a Rosicrucian initiate, in displaying a gallery itself as art it also tells a Duchampian tale emphasizing the creation of art by social context. An egotistical expression of individual power, another step in the creation of Klein's personal mythology, for many the show pointed to Zen's annulment of self. And while the product of an esoteric avant-garde project, these invisible pictorial states were to be perceptible to those without any artistic sophistication. Klein reported that the exhibition was extended one week to accommodate the great public interest, and that every day brought more than two hundred people "rush[ing] to the interior of the century."[14] He says that some visitors cried, and others remained for hours. Apparently Jean Tinguely came many times, and, while the two had known each other since 1955, Le Vide led to their collaborative exhibition Pure Speed and Monochrome Stability at Iris Clert the following November. There, Tinguely's machines would rotate Klein's monochrome disks at speeds ranging from 450 to 10,000 r.p.m.

The most striking exhibition to come out of Le Vide took place two and a half years later, when Arman filled the galerie Iris Clert to the ceiling with garbage. The concept of the show emerged from the same group discussion as Le Vide, after Klein had explained his idea. Arman, who at that time was impressing objects dipped in paint onto canvas, saw his focus on physical things to provide the perfect complement to Klein's flight from matter: "You know, Iris, Yves is working at immaterialization, and I am always working with something that is very much material, so why don't I fill up the gallery with objects, and call it Le Plein, Full-Up?"[15] He proposed to completely fill the gallery with discarded objects and with refuse, so that immediately after emptiness would come plenitude. One aspect of reality would supplant another, urban detritus replacing Rosicrucian spirit. Her response was immediate and unequivocal—too dirty, and too smelly. The void was one thing, but rank garbage was another. Instead of trash, the month after Le Vide Arman exhibited his *Cachets*, all-over paintings made with rubber stamps.

It took two years for Clert to relent, years in which Arman moved from pressing and throwing paint-covered objects against canvas, to accumulating masses of objects and presenting them in boxes or on a support. He had begun to make his *Poubelles*, heaps of trash dumped into glass vitrines, some taking the form of portraits

Installation views of Yves Klein's Le Vide *at galerie Iris Clert, Paris, April 28–May 12, 1958. 1 and 2: walls; 3: window; 4: canopy and entrance curtain.*

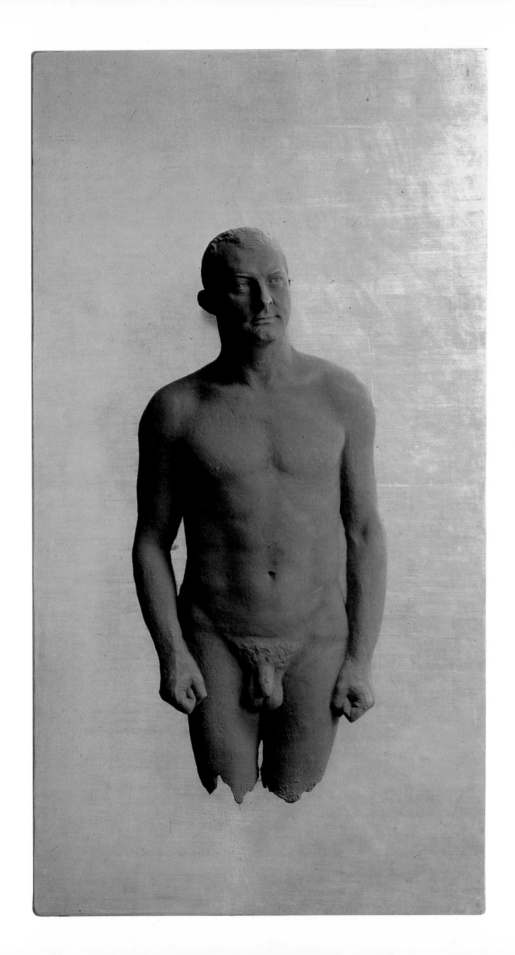

Iris Clert atop the exhibition Le Plein in her gallery, Paris, October 1960. Photograph by Harry Shunk

opposite:
Yves Klein. Portrait-Relief of Arman, 1962. Paint, plaster, gold leaf, 68⅞ x 37⅜ x 10¼ in. Musée National d'Art Moderne, Centre Georges Pompidou, Paris

Arman collecting garbage for the exhibition Le Plein, October 1960. Photograph by Harry Shunk

Martial Raysse and Arman carrying material for the exhibition Le Plein in front of galerie Iris Clert, Paris, October 1960, which is almost filled for the exhibition. Photograph by Harry Shunk

opposite:
Installation of the exhibition Le Plein at galerie Iris Clert, Paris, October 25–November 6, 1960. Photograph courtesy Arman Studio, New York

Jacques de la Villeglé. Angers, Septembre 21, 1953, *1959. Décollage on canvas, 63¾ x 51⅛ in. Musée d'Art et Histoire, Genève*

opposite:
Arman. Robot-Portrait of Iris Clert, *1960. Accumulation of various objects, mixed media, 16⅛ x 16½ in. Galerie Beaubourg, Paris*

of friends, assembled from their cast-off possessions. In June 1960 Arman had a very successful show of such trash pieces in Düsseldorf with Schmela, selling out the exhibition and generating much publicity. For Iris Clert, the time seemed right for Full-Up. The exhibition was scheduled for October.

The revival of Full-Up renewed the group brainstorming. For the exhibition announcement Arman thought of sending out a match box of junk, but Klein suggested a sardine can full of garbage. With characteristic energy, Clert contacted canneries and found someone to produce 3,000 of them. For filler, Arman went into the Paris metro and collected waste paper from trash cans. The sardine tins were labelled *ARMAN, "FULL-UP," Open Before 25 October, 1960*. Inside, along with trash from the subway, there was a copy of a hand-written invitation to the gallery on Monday, October 25, from nine to midnight: "Iris Clert asks you to come contemplate in 'the full' the total force of the real condensed into a critical mass." Each sardine can was sent with a typed message from Pierre Restany directing the recipient to open the tin, and relating his own view of Arman's project: "Arman gives new realism its total architectonic dimension. . . . Until now no act of appropriation radically inverting the 'Void' had circumscribed so narrowly the genuinely organic nature of contingent reality."[16]

Arman's idea now was to have Parisian garbage trucks back up to 3 rue des Beaux-Arts and spill their contents into the gallery. He would not touch the garbage but would direct workers from outside the art world to create his show, much as Klein conducted naked models as "living brushes" without handling any materials. This plan, however, proved unworkable as well as somewhat disgusting. So Arman enlisted the help of his artist friend Martial Raysse, and laboring together for a week, they collected enough refuse from the streets to fill the gallery. While by weight most of what they accumulated were household cast-offs, a fair amount of organic garbage found its way into the growing mass. So as time went on the gallery began to smell more and more. After thirteen days it was decided to close the exhibition, cutting short its one-month run.

During the collection of material and construction of the exhibition, Arman kept track of what they carried into the gallery. He intended his list to constitute a poem, and this catalogue of the city's contribution to the project does have its poetic resonance: "6 oyster shells, 3 cubic yards of used bulbs, . . . 200 pounds of old records, 48 walking canes, 7 coffee mills, . . . 5 bidets, 6 slices of bread, 3 flower pots, 180 bird cages, . . . 10 old hats, 12 pairs of shoes, 1 ice bucket, . . . 70 pounds of curtains, 5 hula hoops, 1 ashtray with ashes, . . . 1 cubic yard of metal shavings." There were pieces of contemporary culture: "1 cubic yard of magnetic tape from the musical works of Pierre Henry," and along with lots of magazines and old gallery announcements, "1,000 copies of a pamphlet by Mathias Goeritz, *L'Art votif contre l'art merde*." Most pointedly, Arman threw in fifty tiny paintings from Iris Clert's Microsalon of the previous year. To the dealer's consternation, mixed with the old auto parts and olive oil bottles, the pile contained paintings by Parisian classics like Picasso and Hartung.[17] In counterpoint, a few of Arman's own *Accumulations*—see-through boxes of radio transistors, keys, false teeth, and electric razors—were displayed in the office to the side.

The vernissage on the night of October 25 resembled a kind of block party, since most viewing was done from the street through the gallery window. Of course, there was a line to enter the three empty feet at the rear of the gallery, to get a better look at the pile of trash rising straight up from the floor. Here Clert kept a book in which visitors wrote their comments. Many, as one might expect, took the exhibition to be a load of garbage, and most of the remarks were highly critical. An older woman wrote that as a French grandmother she was disgusted at how low the country had sunk. The head of the art-school student body, the *Grand Massier*, protested that it was

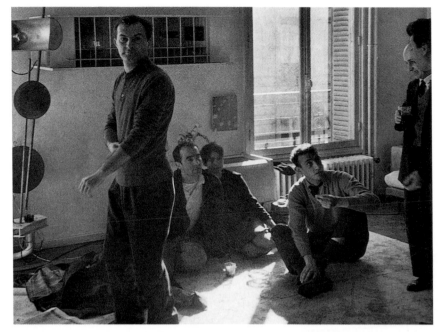

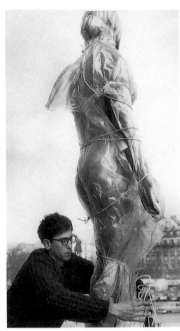

shameful to hold such an exhibition so close to the École des Beaux-Arts. But Arman's friends received it well. Tinguely was especially positive, reacting to Le Plein as revelatory in its rich juxtaposition with Le Vide.

For these exhibitions stood as contrary paths to a similar end, opposite practices of negation undercutting fundamental tenets of middle-class art and its appreciation.[18] The two artists displayed the empty and the full, the pure and the sullied, but they were united in their antagonism to the accepted art of the time. Klein's rejection of matter complemented Arman's rejection of the elegant art object. Consigning the paintings of the Microsalon to the junkheap, Arman negated the painterly as effectively as did Klein's display of the immaterial. And in their different ways, each show commented on the gallery space itself, as a container that, through a strange inversion, had become more important than the art that it was supposed to serve.

Yves Klein, of course, had his own view on how the exhibition completed the significance of Le Vide: "After my Void, Arman's Full-Up. The universal memory of art lacked this definitive mummification of quantitavism. Reassured at last, all of nature will from this moment begin, as of old, to address us directly and with clarity."[19] This talk of nature with reference to a pile of industrial and domestic refuse seems crazy, but Pierre Restany saw both Klein and Arman to be engaged in a movement redefining the natural. For the group of artists whose work he promoted, Restany believed that nature was the city, a landscape of human activity structured by the consumer culture of postwar Europe. Since they engaged this new kind of natural world, he called their work *Nouveau Réalisme*, New Realism.

Restany sought to show that there was a viable alternative to the lyrical abstraction of the Parisian mainstream, and two days after the opening of Full-Up, on October 27, he gathered eight artists in Klein's apartment. There were the three *affichistes* who exhibited posters ripped from the city walls—Raymond Hains, Jacques de la Villeglé, and François Dufrêne. From Nice, along with Klein and Arman, came Martial Raysse, who constructed sculptures from plastic bottles and other pristine

above left:

Meeting arranged by critic Pierre Restany at Yves Klein's apartment, 14 rue Campagne Première, Paris on October 27, 1960 for the signing of the Nouveau Réaliste declaration: (left to right) Arman, Jean Tinguely, Rotraut Uecker, Daniel Spoerri, Jacques de la Villeglé, Pierre Restany. Photograph by Harry Shunk

above right:

Christo wrapping the statue of Minerva in Paris, February 14, 1961. Photograph by Harry Shunk

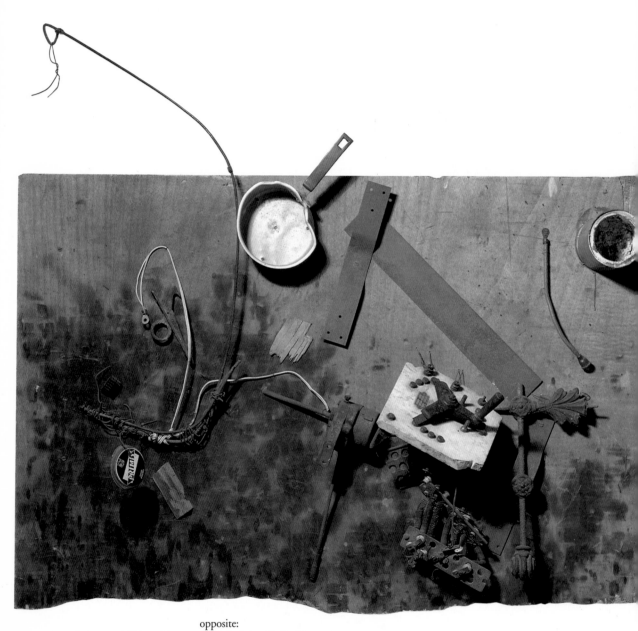

Daniel Spoerri. Tableau-Piège chez Tinguely, *1960. Mixed media. 42½ x 47¼ x 8¼ in. Städtisches Museum Abteiberg Mönchengladbach*

opposite:
Niki de Saint-Phalle. Tir. *1961. Plaster, object, paint on wood panel, 130 x 82⅝ x 13¾ in. Musée d'Art Contemporain, Nice*

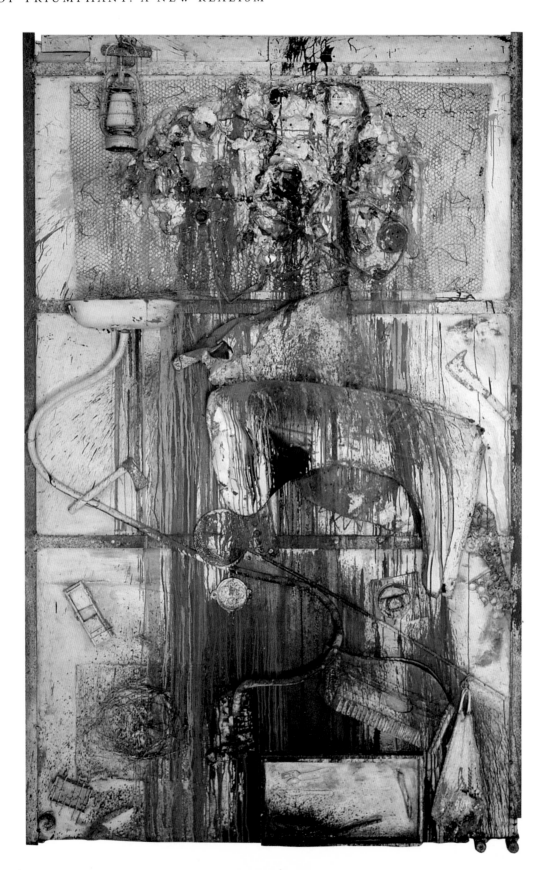

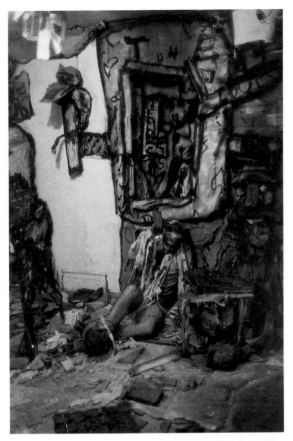

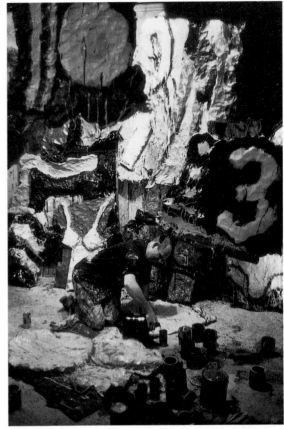

above left:
Claes Oldenburg in his first happening "Snapshots from the City," performed in his environment The Street, Judson Gallery, Judson Memorial Church, New York, February 29, 1960

above right:
Claes Oldenburg working on reliefs for The Store, 107 East 2nd Street, New York, December 1961–January 1962.

right:
Claes Oldenburg in The Store, 107 East 2nd Street, New York, December 1961–January 1962.

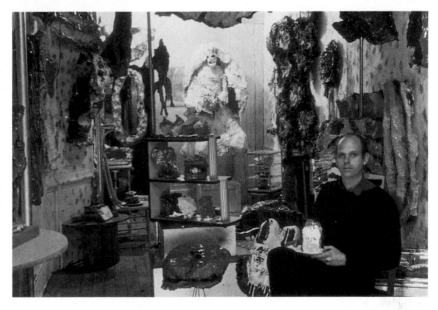

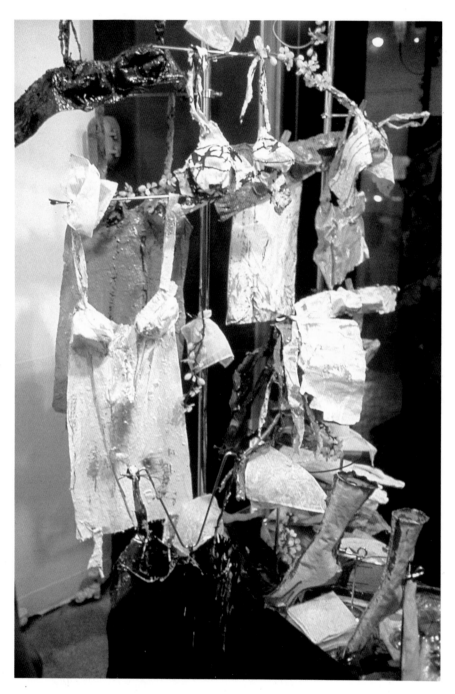

Installation of underwear by
Claes Oldenburg in the front
window of 19 West 57th Street,
New York, for the exhibition
New Realists.

household goods. Joining Tinguely from Switzerland was the Romanian Daniel Spoerri, whose *tableaux-pièges* ("snare-pictures")—everyday objects glued in their found arrangements, and displayed as paintings—would first be exhibited the next month at the second Paris Festival of Avant-Garde Art. Restany also had invited two who could not attend, the Italian *affichiste* Mimmo Rotella and the sculptor of crushed car bodies, César.

Other than Yves Klein, whose art was of a type all its own, each of these artists incorporated actual elements of the urban world, choosing to present the new reality instead of picturing it. But they hardly were a united front. After Restany had them sign the nine copies of a simple declaration—seven written in white chalk on a ground of I.K.B., one on a pink and another on a gold monochrome background—the critic left his associates in Klein's apartment. Within twenty minutes they had, in Raysse's words, flown "into violent, spectacular argument."[20] Raymond Hains asked to see some of Raysse's work, and verbally attacked him, before repudiating Klein's zones of immaterial sensibility. Klein slapped him, and the meeting disintegrated. When Arman saw Restany in a café two hours later, he informed him that his movement was dead.[21]

Yet the next day Klein managed to get five members of the group together to make a collective *anthropométrie*—impressions of their bodies in I.K.B. on a white shroud—that he would display in November at the second Paris Festival of Avant-Garde Art. There they were explicitly presented for the first time in France as *Nouveaux Réalistes*, although the previous spring Restany had shown the work of Arman, Klein, Tinguely, Hains, Villeglé, and Dufrêne under this title at the Galleria Apollinaire in Milan. With the addition of Niki de Saint-Phalle, who began living with Tinguely the month of Full-Up; Gérard Deschamps, who manipulated and collaged fabric and clothing; and Christo, who had come to Paris in 1958 and would propose the first of his great public wrappings in 1961, the most advanced and exciting French art revolved around the *Nouveaux Réalistes*.

Following the lead of Klein, Tinguely, and Arman, their exhibitions became events and the gallery a site for creation. Much of the activity was centered at the Galerie J, run by Jeanine Restany, the wife of the critic, which opened in May 1961 with a promotional exhibition of the group called *40° au-dessus de Dada* ("40° above Dada"). At the end of June Niki de Saint-Phalle transformed the place into a shooting gallery for her show *Feu à volonté* ("Fire at Will"), where the guests shot rifles at plaster-and-object constructions to puncture hidden pockets of paint, another riff on action painting. Spoerri, who was a fine chef, converted the gallery into a restaurant in March 1963, preparing a series of dinners whose remains were made into "snare-pictures" later displayed on the walls. (Outdoors, on the night of June 27, 1962, Christo had blocked the rue Visconti with a wall of 240 oil barrels—his *Iron Curtain* responding to the construction of the Berlin Wall the previous year.)

Among the marksmen at Niki's shooting gallery were Jasper Johns and Robert Rauschenberg, who had come to Paris for exhibitions of their own that month. On June 20 they participated with her and Tinguely in David Tudor's performance of *Variations II* by John Cage at the American Embassy, and Restany took advantage of their presence to stage an exhibition at Jean Larcade's Galerie Rive Droite. Called *Nouveau Réalisme* in Paris and New York, the exhibition displayed work by Klein, Arman, Tinguely, Niki de Saint-Phalle, Hains, César, Johns, Rauschenberg, Richard Stankiewicz, John Chamberlain, Lee Bontecou, and Chryssa. Pairs of French and American works were juxtaposed—a sculpture of car parts by Chamberlain and a César compression, junk metal sculpture by Stankiewicz and Tinguely, a Chryssa letter relief and the dislocated words of a Hains lacerated poster. For Restany, there was a

similar sensibility at work on both sides of the Atlantic, "a new sense of our contemporary industrial, mechanical and urban nature."[22] He saw his French artists working alongside what was called Neo-Dada in New York, the assemblage tradition that focused on the funky remains of mass consumption. Yet when Restany had occasion to transport his vision to New York, times had changed and a new mode of cultural commentary had emerged.

It was natural for Restany to associate *Nouveau Réalisme* with American assemblage, for he had seen much in Paris—Stankiewicz, in fact, was showing at the Galerie Neufville the month that Restany gathered his group at Klein's—and he had learned in detail from Tinguely about what was going on in New York the previous year, when Tinguely had created his self-destructing *Homage to New York* at the Museum of Modern Art. Klein was lured to New York for a monochrome show with Leo Castélli in April 1961, an abortive effort in which neither his person nor his work was received well by either artists or public. But when he accompanied his exhibition to Virginia Dwan's gallery in Los Angeles—where Arman, Raysse, Tinguely, and Niki de Saint-Phalle also would show—Klein found the atmosphere and the artists more congenial. It was from Los Angeles that Klein wrote an angry letter to Restany, after reading his statement for *40° au-dessus de Dada* associating the *Nouveaux Réalistes* with the Dadaists. At home, however, Restany's comparisons between *Nouveau Réalisme* and Neo-Dada were reinforced by William Seitz when the Museum of Modern Art curator came to Paris during that first Galerie J exhibition. In search of material for his exhibition to be held in the fall, the Art of Assemblage, Seitz visited Restany and his artists, and he decided to include in the MOMA show everyone from *40° au-dessus de Dada* except Klein.

A year later Restany received another visitor, Sidney Janis. The renowned dealer of modern and contemporary masters had decided to mount an exhibition exploring in more detail the contemporary territory of Seitz's massive historical survey. He asked Restany's help with selecting the French artists and commissioned an essay for the catalogue. Together, they decided that the exhibition would be called New Realists. Naturally, the French critic believed that the *Nouveaux Réalistes* would be shown alongside Rauschenberg, Johns, Stankiewicz, Chamberlain, et al. In this he, and his artists, would be sorely disappointed.

The Neo-Dada and assemblage that Restany was expecting had been given its classic exposition at the Martha Jackson Gallery in 1960. In a two-part exhibition in June and September–October, New Media–New Forms, the gallery displayed almost 150 objects by 71 artists. Moving what had largely been a downtown phenomenon to a classy uptown space on East 69th Street, the show elicited much public attention and, anticipating things to come, was covered by CBS television. In the catalogue Allan Kaprow sketched a new conception of the artwork "as a situation, an action, an environment or an event." Kaprow saw such ephemerality in political terms, subverting the financial ground and divisive ethos of traditional art, but in the *New York Times* John Canaday railed against the political evasion of gluing tacks to a mirror or stuffing nylons with trash. Having just pushed his way toward the second of the Martha Jackson exhibitions through demonstrators gathering for Khrushchev's appearance at the United Nations, where the Russian leader attacked America and demanded the admission of Communist China, Canaday felt that it was "baloney" to call this an "art of protest."[23]

Jackson's catalogue cover was done by Claes Oldenburg; it was a funky collage of old newspapers with the artists' names scrawled in dripping black ink, evoking the rough urban imagery of his recent environment, The Street. This aggressive installation of cardboard silhouettes and gritty refuse had been installed in the basement of

the Judson Memorial Church, a center of downtown art and performance. And it had been accompanied by a series of six theatrical events by artists who would make the "happening" one of the most dynamic forms of the time. One of these was Allan Kaprow, whose highly structured *18 Happenings in 6 Parts* had introduced the term, and the genre, when it opened the Reuben Gallery in October 1959. Kaprow had moved from painterly assemblage to environments incorporating sound and light, and from there to theatrical events designed to engage and expand viewer experience. He saw this as a natural extension of Jackson Pollock's dispersion of the painterly image, with the next logical step lying beyond the canvas in the lived world. Ironically, in embracing so much of the world around them, these artists would help push art from the urban to the suburban, from the shabby and rusting to the spic and span.[24]

The rise of Pop can be emblemized in Oldenburg's transition from The Street to The Store, from the site of debris to the site of commerce. From the junk aesthetic Oldenburg moved to present art and its objects as destined for the consumer market, where "Museum in b[ourgeois] concept equals store in mine."[25] First embodied as brightly painted reliefs in the stairwell and front gallery of Martha Jackson's large exhibition early in the summer of 1961—Environments, Situations, Spaces—the concept demanded a place all its own. And when Oldenburg moved his studio to an old storefront at 107 East 2nd Street, he decided to instantiate it right there. On Friday, December 1, from seven to ten P.M., he opened his own store, just in time for the Christmas shopping season.

Incorporated as The Raygun Manufacturing Company, The Store originally was to close at the end of December, conducting business Fridays through Sundays from one to six o'clock and by appointment. Due to popular demand Oldenburg extended it through January, followed by a series of happenings—for an audience of thirty-five crowded amidst his lively works—that lasted until the end of May. Eighty feet long and ten feet wide, The Store was filled with 107 objects, ranging in price from $21.79 for a painted plaster oval mirror to $899.95 for the large figure of a bride. The reliefs from the Martha Jackson show were supplemented by all sorts of free-standing objects, everything messily painted in bright commercial enamel right out of the can. There were shoes, doughnuts, sneakers, candy bars, pants, shirts, letters, hats, sandwiches, ties, dresses, fried eggs, girdles, disembodied legs and jacketed torsos, cakes and pies in glass cases.[26] As Sidney Tillim wrote in *Arts*, "It was the very simulacrum of the ultimate in American variety stores, a combination of neighborhood free enterprise and Sears and Roebuck."[27] For Tillim, The Store exemplified artists' recent discovery that the American Dream could be avant-garde, too. Here he had subject matter in mind, images of consumer goods and media imagery that were proliferating in vanguard galleries. But soon the financial aspect of the connection would become more apparent, and more controversial.

The Store was presented in conjunction with the Green Gallery, which had agreed to pay half of the expenses and take a commission of one-third after sales had reached $200. With total sales of $1,655 and expenses of about $400, Oldenburg ended his two months of business owing the gallery $285.[28] This debt readily would be made good, however, as 1962 turned into a boom year for the art that would become known as Pop. The year began with Jim Dine at Martha Jackson in January, moved in February to the Pop introductions of James Rosenquist at the Green Gallery and Roy Lichtenstein at Castelli, George Segal's plaster figures at the Green Gallery in May, Andy Warhol's thirty-two paintings of Campbell's Soup cans at the Ferus Gallery in Los Angeles in July, Oldenburg's huge soft sculptures at the Green Gallery in September–October leading into Sidney Janis's New Realists, Andy Warhol's silkscreen paintings at the Stable Gallery and Tom Wesselmann's *Great American Nudes* at the Green

The opening of the New Realists exhibition at Sidney Janis Gallery, New York, October 31, 1962, showing Tom Wesselmann's Still Life # 17.

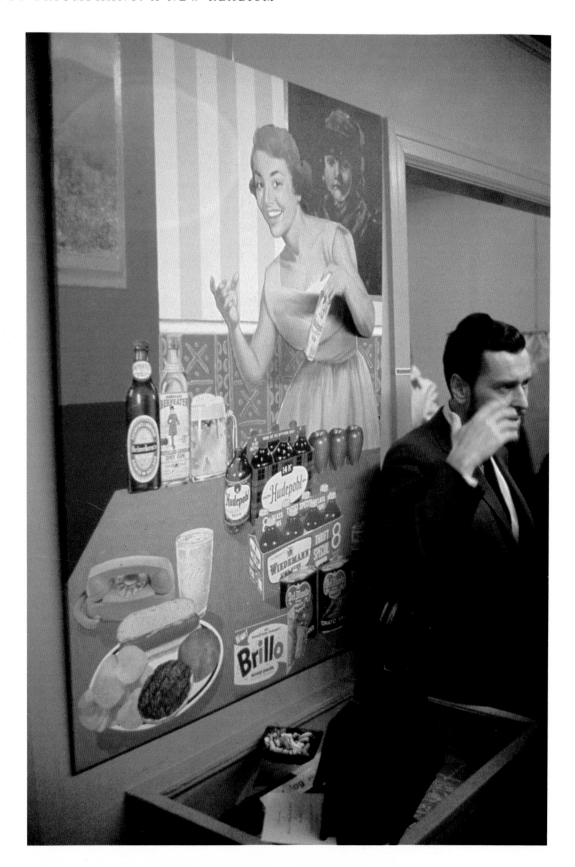

Gallery in November. The year of Pop ended in Los Angeles at the Dwan Gallery, with a group show of thirteen artists, *My Country 'Tis of Thee.* There, with eerie foreboding, a vandal shot the figure of JFK in Marisol's sculpture *The Kennedys.*[29]

Oldenburg himself spent the summer of 1962 working in the lofty 57th Street space of the Green Gallery, preparing for his opening-of-the-season exhibition. Here he had room to enlarge the kind of objects that he had shown at The Store, creating the gigantic stuffed canvas hamburger, ice cream cone, and slice of cake that so impressed the collectors a month before the Janis show. Run by the former director of the Hansa Gallery, Richard Bellamy, the Green Gallery was backed anonymously by the first major collector of Pop Art, Robert Scull. Wealthy owners of a taxi fleet, Scull and his wife, Ethel, epitomized the collectors who would become art-world celebrities during the sixties. In fact, the first book on Pop, by John Rublowsky, featured photographs of the new collectors living on Park Avenue and in the suburbs with their Rosenquists, Lichtensteins, and Warhols.[30] On those walls images from comic books, advertisements, and packaging looked back with nostalgia to the America of their youth, with facture clean enough to enter the suburban world into which postwar prosperity had moved them, along with about a third of the American population. And these new buyers would be purchasing their art with a new attitude. As *Life* happily quoted Leon Kraushar, one collector whose home was shown in Rublowsky: "[T]hese pictures are like IBM stock . . . and this is the time to buy."[31]

That the first group show of the new artists was held at the establishment Sidney Janis Gallery was a matter for much critical comment when the exhibition New Realists opened on the last day of October.[32] In *The New Yorker*, Harold Rosenberg said that the show "hit the New York art world with the force of an earthquake," attributing the "sense of art history being made" to the prestigious venue. Tom Hess in *Art News* remarked that it was "the reputation of the gallery which added a certain adrenaline quality to the manifestation," since Janis "assumed a status for living painting that resembles the old Duveen's of the Master trade." Most emphatic was Sidney Tillim in *Arts*, who noted that "dealer Sidney Janis has moved in on the 'pop' craze at harvest time," and that, as the preeminent dealer of Abstract Expressionism, he "is capable of certifying a trend." For Tillim the European work, which all critics considered less innovative than the American, had been included to certify the existence of "a new International Style" now led by the New York artists.[33]

Because the exhibition was to include at least two works from each of fifty-four artists, and the American paintings were so large, the gallery at 15 East 57th Street was much too small. Janis therefore rented an empty store across Fifth Avenue at 19 West 57th Street, through whose glass front the public could survey the installation. In the window he placed Oldenburg's array of brightly painted women's underwear, an ironic transposition of The Store from the Lower East Side to classy 57th Street, via the aesthetics of 14th Street shop display.

Although the show was called New Realists, the translated French appellation coming from Restany, there was much discussion of what these artists should be called. In his own catalogue essay Sidney Janis seemed to prefer Factual Artists, also mentioning the use of Pop Artist in England and Polymaterialist in Italy, and in a footnote he refers to Commonists as another alternative. Eventually, of course, Pop triumphed, a term first used by English critic Lawrence Alloway to refer to the culture rather than to the art derived from it. Brian O'Doherty's second *New York Times* review of the show was entitled "'Pop' Goes the New Art," and the term soon would appear in headlines in *Time*: "Pop Art—Cult of the Commonplace," "Art: Pop Pop."[34]

While some critics, such as Dore Ashton, tended to view the exhibition as just more Neo-Dada of the sort seen at Martha Jackson, the recent work of Lichten-

stein, Warhol, Indiana, Wesselmann, and Rosenquist clearly pointed in a new direction. As Tom Hess reported: "The point of the Janis show . . . was an implicit proclamation that the New had arrived and that it was time for the old fogies to pack. . . . the New Realists were eyeing the old abstractionists like Khrushchev used to eye Disneyland—'We will bury you' was their motto." And Janis's stable of Abstract Expressionist masters did not take the challenge lightly. After the exhibition, as the gallery continued to take on Pop artists, a protest meeting was held and Guston, Motherwell, Gottlieb, and Rothko left the gallery. Only de Kooning remained.[35]

In the catalogue Janis identified three themes exemplified by work in the exhibition—the everyday object, the mass media, and repetitive imagery evoking mass production—but the two installations made little attempt to group the pieces by these categories. The sense of an international movement was emphasized through the intermingling of European and American work, and most artists appeared in both gallery spaces. Certainly there were some telling juxtapositions of a thematic kind. Just past the Oldenburg underwear display in the window of the storefront space, Arman's rows of faucets hung next to Warhol's painting of 200 Campbell's Soup cans, the antiquated look of the European hardware contrasting with the slick reproduction of American packaging. Further along, past James Rosenquist's huge painting of a car grill over a mass of spaghetti, *I Love You with My Ford*, the *EAT* of Robert Indiana's *Black Diamond American Dream #2*—which would be acquired by the president of MOMA for his personal collection—sat behind Oldenburg's luscious pastry display case, across the room from the enlarged sliced white bread, Lipton soup mix, Del Monte catsup and canned fruit, and Schmidt's beer of Tom Wesselmann's *Still Life #19*. Toward the end of the space sat George Segal's eerie group of six plaster figures around the dinner table, life casts encasing interior likenesses of their models. Positioned next to a refrigerator by Jean Tinguely, they bore mute witness to the shock of those who opened the fridge door to a screaming siren. Appropriately enough, the theme was introduced at the front door, as one passed Lichtenstein's comic book close-up of a woman cleaning the inside of her refrigerator, below Spoerri's funky *Le Parc de Marcelle*, a "snare-picture" comprised of a chair and folding table, to which were glued beer bottles, a coffee cup, and a full ashtray.

The display was more elegant in the Sidney Janis Gallery at 15 East 57th, without the ad hoc lighting and exposed sprinkler pipes of the temporary space down the street. In the smaller rooms of the gallery the large American paintings were even more striking, completely overwhelming the intimately scaled work of most of the European artists. Here such clean and bright paintings as Lichtenstein's *Blam*, Rosenquist's *Silver Skies*, Wayne Thiebaud's *Salads, Sandwiches, and Desserts*, and Warhol's paint-by-numbers daffodils and irises, *Do It Yourself*, took all attention away from works like Tinguely's relief of radio parts, Christo's wrapped burlap package, Yves Klein's pink and blue sponge sculptures, and the Italian Gianfranco Baruchello's mounted pile of newspapers, *Awareness II*. Of course, some European pieces acquitted themselves well in terms of scale and power, with Arman's accumulation of sabres more than holding its own across a doorway from Jim Dine's painting with attached lawnmower, and the Swede Oyvind Fahlstrom's surreal-psychedelic cartoon imagery bearing up across from Warhol's unfinished flowers.

In both spaces the overall impression was that the European work was old-fashioned, akin to earlier New York Neo-Dada in its use of discarded and rough materials, and in painterly feel closer to the legacy of Abstract Expressionism than to the clean lines of American media images. The Italian Mario Schifano might paint the Coca-Cola logo, but his messy drips looked dated alongside Warhol's soup cans. Mimmo Rotella and Raymond Hains used actual advertising posters, but their ripped

Installation view of New Realists exhibition at Sidney Janis Gallery, New York, 1962, showing (left to right) Jim Dine's Lawnmower; *Enrico Baj's* Style Furniture; *(through doorway) Tom Wesselmann's* Still Life #17; *Claes Oldenburg's* The Stove; *and Wayne Thiebaud's* Salads, Sandwiches & Desserts.

Installation view of New Realists exhibition at 19 West 57th Street, New York, 1962. On the left is Jim Dine's panel of bathroom fixtures, on the far wall is I Love You with My Ford *by James Rosenquist, to the right hangs Claes Oldenburg's painted plaster* Mu Mu *and Andy Warhol's painting of 200 Campbell Soup cans.*

patterns were more like *Tachiste* gesture than the pristine ads in Wesselmann's collages or than Rosenquist's billboard fantasies. As for the English artists, certainly John Latham's reliefs of abused books seemed much like late fifties assemblage. And while Peter Blake's large *Love Wall* of postcards, pin-ups, and Pop image of a heart looked neat and new between the Klein sponge sculptures and Christo's package, and Peter Phillips's *Wall Machine* used comic book panels, their visual restraint was obvious when compared with the boisterous American way of recycling media imagery. As Hess remarked in *Art News*, the Europeans "look feeble in this line-up. Some Englishmen do comic-strips that try to say 'WOW' but can only manage the equivalent of 'Coo, matey.' "[36]

The other critics concurred that the Americans dominated the exhibition, and even Restany in retrospect agreed that his *Nouveaux Réalistes* "look[ed] like venerable ancestors" of the New York artists.[37] The shock was especially great for the three French artists who came to New York for the exhibition—Martial Raysse, Jean Tinguely, and Niki de Saint-Phalle, who was showing concurrently at the Iolas Gallery. Although he had been taken on by Janis the previous summer, Arman was unable to leave Paris, but he received an outraged letter from his friends: Their pieces looked small, dusty, and antique next to the aggressive American work. The exhibition had

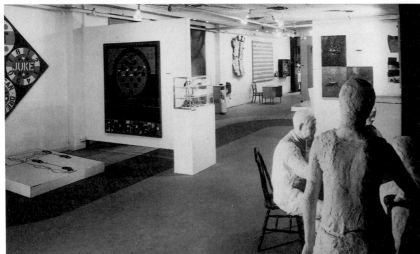

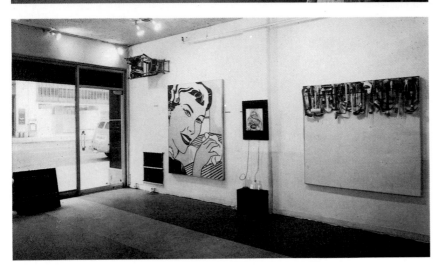

Installation view of New Realists exhibition at Sidney Janis Gallery, New York, 1962, showing (left to right) Roy Lichtenstein's Blam; Arman's Accumulation of Sabres; *(through doorway) works by Yves Klein and Alberto Giacometti; and Jim Dine's* Lawnmower.

Installation view of New Realists exhibition at 19 West 57th Street, New York, 1962. On the left—above Andy Warhol's dance diagram, Fox Trot—is Black Diamond American Dream #2 *by Robert Indiana, with British artist Peter Phillips's* Wall Machine *next to Claes Oldenburg's pastry display case. In the right foreground is George Segal's* The Dinner Table.

Installation view of New Realists exhibition at 19 West 57th Street, New York, 1962. On the left Daniel Spoerri's Le Parc de Marcelle *hangs above Roy Lichtenstein's* Refrigerator. *On the right is* Five Feet of Colorful Tools *by Jim Dine.*

been designed to make them look bad, and they had been unfairly vanquished. Raysse, whose displays of pristine plastic commodities looked especially fresh compared to the work of his fellows, nonetheless was very upset. He wrote to Arman about Warhol, even including sketches of particular pieces, and told his friend to begin painting groups of brightly colored French objects so as to reclaim his position.[38] In retrospect, the French were to feel that they had been used by Janis to give his establishment gallery an avant-garde air, making it more attractive to the younger American artists.[39]

Restany himself responded to the exhibition with an article in the January 1963 *Art International*, an issue devoted to the Janis show and to the new Pop artists. There he criticized the Americans for developing the *Nouveau Réaliste* investigation of "the expressive autonomy of the object" into a monotonous "modern fetishism of the object." For him most of the Pop painters just worked in another trompe-l'oeil style, modern in look but retrograde in substance. In addition to displeasure over the way that his artists had been shown up, he could not have been happy about the treatment of his catalogue essay. Only a small portion of the long piece was printed, for Janis had found the wordy tract virtually untranslatable and largely irrelevant to the content of his exhibition.[40] The only long critical text to be included was that of John Ashbery. He, ironically, had written it in Paris.

Naturally, there was a great deal of press surrounding the show. Critics such as Hilton Kramer, Dore Ashton, Irving Sandler, and Thomas Hess, closely associated with the ethos of Abstract Expressionism, were largely negative, especially concerning the painting of Warhol, Lichtenstein, and Rosenquist. While in various ways supportive of such work as that of Oldenburg and Segal, who, in Sandler's words, "infuse commonplace objects with new imaginative meanings," for them the general movement seemed to repudiate any search for transcendence or higher significance. What some viewed as social commentary Kramer saw as feigned, a vision "too tame and accommodating[,] . . . the usual attempt to disguise an essentially conformist and Philistine response to modern experience under a banner of audacity and innovation." In spirit if not in tone, many critics echoed Max Kozloff's view in the first article discussing the new art as a whole, "Pop Culture, Metaphysical Disgust and The New Vulgarians": "The truth is, the art galleries are being invaded by the pin-headed and contemptible style of gum chewers, bobby soxers, and worse, delinquents." Even Brian O'Doherty, whose enthusiasm for the exhibition seemed to know few bounds, found much there to be throwaway art, expendable once its clever journalistic work was done.[41]

On December 13, just after the Janis show and culminating the year of Pop, a symposium on the subject was organized by curator Peter Selz at the Museum of Modern Art.[42] A major issue was the speed with which Pop art had appeared and become commercially successful. Henry Geldzahler, a young curator at the Metropolitan Museum of Art and a firm Pop supporter, noted that a year and a half ago he had visited the studios of Lichtenstein, Warhol, Wesselmann, and Rosenquist to find them all working in the new mode unaware of one another, and that now there was a symposium on their "movement" at MOMA. To resent such rapid success, he thought, was to subscribe to an outmoded myth of the alienated artist, a notion obsolete since a significant class of collectors had appeared seeking to patronize advanced art. This "instant art history," and the participation of museums in the process, was decried by Kramer and Stanley Kunitz, and Kramer attributed much of Pop's success to the ease with which the work could be spoken about. For him, it marked "a kind of emancipation proclamation for the art critic[,] . . . the conversation piece *par excellence.*"

Yet both Geldzahler and Leo Steinberg thought that the triumph of the Pop artists reflected more than ease of verbal and imagistic reference. Rather, the Pop phenomenon signaled a shift in the nature of the avant-garde. Steinberg saw it as a change

in strategy, a move from attacking the bourgeoisie to embracing its values with a vengeance. For Geldzahler the point was that advanced art now had its own establishment, one that had been educated to expect and to desire the new, and thus one that no longer could be shocked. The avant-garde had triumphed, and in its success it had eliminated the ground of its own existence.

A few months later, *Time* reported that "Collectors, uncertain of their own taste, find pop art paintings ideal for their chalk-walled, low-ceilinged, $125,000 co-op apartments in new buildings on Park Avenue. . . . [S]ince the avant-garde public is so hungry for more and more avant, the pop artists are in the chips."[43] And certainly it was these chips that inspired much of the resentment toward the Pop artists. Members of the Club had slaved for years before selling a painting, and here young artists were finding financial success with their first shows. The grapevine and the journals reported "wild buying," and Pop artists socialized with wealthy collectors who, the critic Barbara Rose remarked, were "as frequently collecting artists as art."[44] The fifties had brought America into a different world, and the sixties had brought it a different kind of art world.

As Allan Kaprow would note in 1964, "If the artist was in hell in 1946, now he is in business."[45] The growing university system had hired artists trained on the G.I. Bill, and for the first time large numbers of artists could expect to earn a decent living. Widespread university education had expanded general cultural awareness, and an enlarged middle class was able to support what they were being taught to value. Museum activity grew, popular media gave more coverage to the new art scene, gallery sales and prices of successful artists increased. With Pop the pattern that would recur throughout the seventies and eighties was formed—new art providing new status to those of new wealth. Not only had Pop packaged the imagery of the American dream, it had wrapped itself up in the same bundle. For the rest of the decade advanced art would attempt to untie the twine.

Theory on the Floor
Primary Structures
The Jewish Museum, New
York, New York
April 27–June 12, 1966

In addition to the apparent commitment of Pop art to the society of mass consumption, many artists and critics also were disturbed by its detachment. Roy Lichtenstein had called their work "industrial painting," and the impersonal facture seemed an ironic rebuke to the impassioned engagement of an earlier generation. Ivan Karp, who had brought Lichtenstein to Leo Castelli's attention on the advice of Allan Kaprow, summed up the new attitude in his article on Pop painting: "Sensitivity is a bore." But three years later Dore Ashton would compare a very different kind of work with Pop, presenting as "current cool alternatives" an image of three huge geometric forms alongside a photograph of Tom Wesselman's exhibition at Janis. The great slanting objects were by Ronald Bladen, and they were installed in the exhibition Primary Structures at New York's Jewish Museum.[1]

While it seems strange to ally Pop with the reductive sculpture of the mid-sixties, at the time the connection was a natural one. An affiliation based on opposition to the expressive art of gestural abstraction, it extended even to literary associations. John Ashbery had introduced the New Realists exhibition with reference to the novels of Alain Robbe-Grillet and Nathalie Sarraute, writers who avoided analysis and emotion through an art of coldly objective description. Three and a half years later Mel Bochner would invoke Robbe-Grillet in his review of Primary Structures, opening with a remark by the novelist: ". . . there is nothing behind these surfaces, no inside, no secret, no hidden motive."[2]

Bochner confined his account to a group of artists who would become known as Minimalists, and Primary Structures often is mentioned as the first group presentation of this kind of sculpture. In fact it contained much else. Subtitled "Younger American and British Sculptors," the exhibition displayed fifty-one works by forty-two artists in the voluminous galleries of the former Warburg mansion on Fifth Avenue at 92nd Street. There were Minimalists, to be sure, but there also were New York sculptors working in the heroic spirit of Abstract Expressionism, California artists utilizing advanced techniques of industrial fabrication, and British sculptors seeking to escape the hold of Henry Moore with bright colors and new materials. Some called themselves sculptors, others refused the label. Together their work constituted, Hilton Kramer wrote in the *New York Times*, "one of those exhibitions that defines a period, and fixes it irrevocably in one's consciousness."[3]

The show was assembled by the museum's new curator of painting and sculpture, Kynaston McShine, who at thirty-one was younger than many of the "younger" artists in the exhibition. After six years at the Museum of Modern Art, to which he would return in 1969, the Trinidad-born McShine had come to the Jewish Museum the previous fall. He arrived at an institution with a surprisingly strong history of exhibiting advanced work. It was at the Jewish Museum that a Jasper Johns painting first was shown—*Green Target*, in Meyer Shapiro's 1957 exhibition Artists of the New York School: Second Generation—and in 1963 the dynamic new director, Alan

Carl Andre. Lever, 1966. 137 fire-bricks, each 4½ x 8⅞ x 2½ in.; assembled: 4½ in. x 8⅞ in. x 29 ft. 5 in. National Gallery of Canada, Ottawa

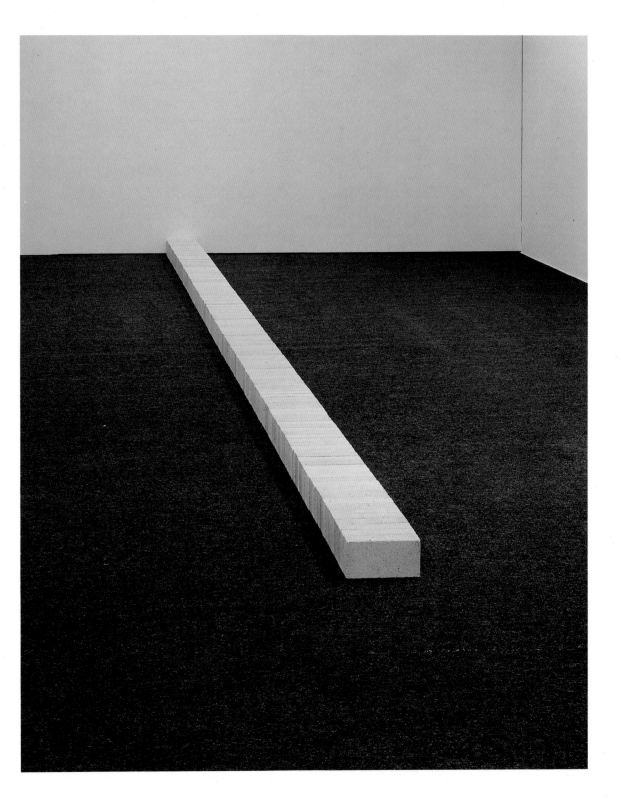

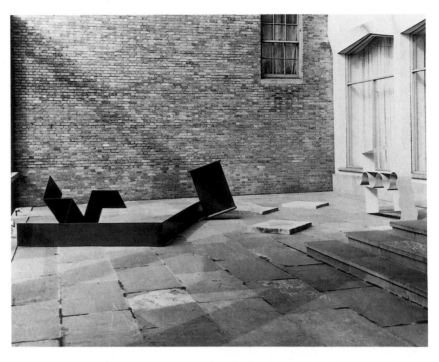

Entrance to the Jewish Museum, New York during Primary Structures, April 27–June 12, 1966, showing (left) Anthony Caro's Titan, and (right) David Annesley's Swing Low.

Solomon, opened the enlarged museum with the first Rauschenberg retrospective. That same year Solomon was put in charge of the United States pavilion at the 1964 Venice Biennale, where Rauschenberg notoriously won the grand prize for painting. He followed Rauschenberg with an exhibition of the new color-field painting, Towards a New Abstraction—featuring Kenneth Noland, Morris Louis, and Frank Stella—and marked his second year at the Jewish Museum with a retrospective of Jasper Johns. Solomon left the museum in 1964, and he was succeeded as director by Sam Hunter, who would continue its role as New York's chief *Kunsthalle*. For rather than exhibiting a permanent collection, the Jewish Museum functioned primarily as an exhibition space, and Hunter understood the museum to have a special responsibility in the contemporary arena: "to define relevant new tendencies in art as they crystallize and gather momentum, rather than after they are on the downslope of collective impulse."[4] Certainly, this was the function of Primary Structures.

McShine sought to assemble the first large exhibition of a new sculptural aesthetic, and while it did not start out to be an Anglo-American show, he soon began to view the new British sculpture as presenting a useful dialogue with the Americans. The juxtaposition was announced as visitors entered the museum courtyard on their way inside, where the rigorous black geometry of Tony Smith's *Free Ride* confronted Anthony Caro's 12-foot-long steel *Titan*, which was painted blue. For Smith and Caro were the symbolic fathers of the show, both teachers who influenced many of the younger artists in the exhibition. To Kynaston McShine they encapsulated a new attitude, an alternative to the expressive welders, carvers, and casters who had dominated Anglo-American sculpture. Taking a suggestion of critic Lucy Lippard's, he titled his exhibition with a new term for what seemed to be a new kind of object.

The previous year, Donald Judd had announced a category of works that were neither paintings nor sculptures—"Specific Objects."[5] While he included under this rubric a diversity ranging from George Segal and Lucas Samaras to Larry Bell and

Anne Truitt, in his programmatic statements here and elsewhere, Judd sketched a tighter view. Along with the writings of Robert Morris, Judd's remarks presented a theoretical basis for the most radical art in Primary Structures. After being called by many names—ABC Art, Cool Art, Low-Boredom Art, Idiot Art, Know-Nothing Nihilism—this art ultimately would be denominated "Minimalism." Coined by the English philosopher Richard Wollheim to characterize such artists as Duchamp and Warhol, whose work had "minimal" artistic content of a traditional kind, the term was adopted for very different use. And while Judd and Morris resented talk of their work as reductive and minimal—Judd, in fact, devoted his catalogue statement to a repudiation of these terms—*minimal* was the word by which their art would be known.[6]

Taking off from the rejection of standard compositional practices by Frank Stella, whose friend Carl Andre would create one of the outstanding pieces in Primary Structures, Judd and Morris sought an escape from the European artistic tradition. As Judd said in a joint 1964 radio interview with Stella, "It suits me fine if that's all down the drain. . . . I'm totally uninterested in European art and I think it's all over with."[7] In a move combining, ironically, the European avant-garde search for purity with an American denial of Old World values, they eliminated complexity of image for the sake of phenomenological enrichment. For Judd, whose philosophical education at Columbia had allied him to the honesty of Humean empiricism, the point was to confront directly what is experienced, abolishing illusionism, emotionalism, and other dissembling of the old order. For Morris, whose roots in the world of new dance and performance were infused with the influence of Cage and Duchamp, reduction of detail opened the viewer to fundamentals otherwise obscured by complex composition and expressive intent. With less to interpret, the focus became the basic sculptural facts of shape, size, mass, illumination, and spatial orientation. More importantly, the viewer would come to see himself as part of the picture, a being whose physical and experiential relations with these simple elements were essential to the sculpture itself. Often mentioned in the contemporary literature, the philosophers Ludwig Wittgenstein and Maurice Merleau-Ponty joined Duchamp to mark the viewer as constitutive of the art object.

Morris, in fact, had described his first minimal sculpture in a Duchampian proposal written in 1960–61 for the essays and avant-garde performance scripts compiled by La Monte Young, Jackson Mac Low, and George Maciunas and called *An Anthology*. Under the heading of "Blank Form Sculpture" he described three simple objects to which viewers would respond differently according to whether or not they were called "art." While he refused to have the piece included in *An Anthology* after becoming disaffected with Maciunas's Fluxus activities, Morris constructed one of the objects for a performance at The Living Theater in January 1962—"A column with perfectly smooth, rectangular surfaces, 2 feet by 2 feet by 8 feet, painted gray." After the column sat vertically on stage for three and a half minutes, Morris pulled it to the floor where it lay on its side for another three and a half minutes. Not only did a falling pillar become theater because it was said to be such, but the object itself changed its perceived character when its spatial relation to the viewer shifted.[8]

In Primary Structures Morris made this latter point in an even more dramatic way, when he exhibited two large wooden L's. Substituted for the 24-foot-long gray beam listed in the catalogue, a work from Morris's important 1964 exhibition at the Green Gallery, the two right-angled forms were from a group of three that had been shown at Castelli in 1965. Despite being identical in shape and size, they looked like two completely different objects. Yet their sole distinction lay in spatial orientation—one rested on its ends to form an inverse V, and the other stood on one arm with the second arm sticking straight up in the air. The fact that these objects looked

Donald Judd. Untitled, *1966.*
Galvanized iron and blue lac-
quer on aluminum, each unit
H: 40 x 40 x 40 in., W: 190 in.,
D: 40 in. Norton Simon Mu-
seum, Pasadena

Installation of Robert Morris exhibition at the Green Gallery, New York, December 1964. The large floor beam from this exhibition was to be shown in Primary Structures but was replaced by Morris's two large L's.

so dissimilar exemplified an approach that he said was shared by much of the new sculpture, which "takes relationships out of the work and makes them a function of space, light, and the viewer's field of vision."[9] Characteristic of the 1960s, with its call to personal responsibility, this focus on situation and context would broaden from perceptual to institutional concerns as the decade progressed. What began as phenomenology would end as social critique.[10]

The emphasis on viewing situation was part of an investigation of the basic facts of sculpture *qua* sculpture, an extension of Clement Greenberg's "Kantian" project. As Greenberg took progress in painting to involve those features unique to painting as a medium, so in a way Judd and Morris sought to isolate and emphasize sculptural essentials.[11] For both artists, these features were revealed most plainly when internal detail was removed and overall form simplified. While they differed on particulars—for instance, Judd believed that color was critical, and Morris that it should be neutralized—together they presented a theoretical stance able to encompass great sculptural diversity.

Yet for those used to the personal touch of gestural painting and assemblage, or to the brashness of Pop, much of this sculpture seemed uniform and dry. Many, no doubt, came away from Primary Structures as did Hilton Kramer, who felt that he "had not so much encountered works of art as taken a course in them." Barbara Rose, in fact, remarked that the work of Judd and of Morris looked like illustrations of Wittgenstein. In the *Wall Street Journal*, John J. O'Connor also noted that many pieces in the show were "visual presentations of ideas; the activity is more conceptual than aesthetic." But he emphasized that the issues were fundamental ones—"The question soon becomes, What is space? And ultimately becomes, What is art?"[12]

Ironically, this study of sculptural essentials denied itself the use of the term, preferring three-dimensional objecthood allied with neither of the traditional art forms. The point was made by Judd's two nearly identical works in the exhibition,

225

Robert Smithson. The Cryosphere, *1966. Green paint on metal mirrors, 6 units each 17¼ x 16½ in. Courtesy John Weber Gallery, New York. Suitable for installation either on the wall or on the floor, this work was presented in the catalogue with elaborate mathematical and physical detail. Yet Smithson slipped into the numbered scientific specifications, just before his list of the chemical constituents of the paint, some conceptual directions for viewing: "Invent your sight as you look. Allow your eyes to become an invention."*

each an assembly of four 40-inch-high galvanized steel boxes attached underneath a 190-inch aluminum bar.[13] Indifferent to traditional positioning as painting or sculpture, one hung on the wall and the other sat in front on the floor. Similarly, the six identical painted steel and reflective chrome modules that made up Robert Smithson's *The Cryosphere* could be displayed in either position. Connected in Smithson's mind with ice crystals, these elements thus formed a wry comment on the "coolness" of the new art.[14] In Primary Structures they were mounted on the wall, and their structure and constitution were specified with scientific precision by Smithson as his catalogue statement, which included the chemical composition of the green spray paint. Along an adjacent wall ran six pastel elements of decreasing length, diagonally connecting wall and floor. Its title—*Rainbow Picket*—contrasted with the more forbidding title of its companion, and the artist, Judy Gerowitz, in a few years would embrace a very different aesthetic under the name of Judy Chicago.

The use of the floor was important for most of the artists in the show, a repudiation of the base being essential to the many aesthetic programs represented here. For no one was this more critical than Carl Andre. In the summer of 1965 Andre had a revelation while canoeing on a lake in New Hampshire. Rather than the vertical constructions that he had made by geometrically piling uniform timbers or blocks of styrofoam, he decided that henceforth his sculpture would be as flat as the surface of the water. This decision resulted in the first of his works to cause public controversy, the piece that he created for Primary Structures. It was called *Lever*, a title punning on the name for the simplest of all tools and the French word for "raise." Beginning at a wall and extending 34½ feet along the floor, *Lever* consisted of 137 firebricks stacked horizontally side-to-side. Andre had been heavily influenced by Brancusi early on, and here he sought to transpose his mentor's most monumental image, adding his own sexual take on the sculptural tradition: "All I'm doing is putting Brancusi's *Endless Column* on the ground instead of in the sky. Most sculpture is priapic with the male organ in the air. In my work, Priapus is down on the floor. The engaged position is to run along the earth."[15] Originally installed through a doorway, reinforcing the sexual allusion, *Lever* was moved after that location proved a problem for crowd flow. More aesthetically disruptive was Andre's use of uniform manufactured objects merely set side-by-side on the floor, his total rejection of craft and of the traditional notion of what sculpture should be. For *Time*, it "had the look of an old-fashioned surrealist leg pull," and certainly it evoked the Duchampian ready-made.[16] But more importantly, *Lever* epitomizes the new sculpture's use of unaltered industrial materials, as well as Andre's own investigation of the horizontal site.

Another sculpture designed for the exhibition was Dan Flavin's *corner monument 4 for those who have been killed in ambush (for The Jewish Museum) (to P.K. who reminded me about death)*. Like Andre, Flavin used readily available, repeatable units as material components of his work—in his case, fluorescent lighting tubes. His first fluorescent piece had been an 8-foot gold bulb set at a 45-degree angle on the wall, done in May 1963, which the artist also compared with Brancusi's *Endless Column*.[17] The Primary Structures work was his first to span a corner, and consisted of four red fluorescent tubes—two lines running along the walls from the corner at a height of 66 inches, another bulb cutting across as hypotenuse to form a triangle by intersecting the first two, and a fourth coming straight out from the corner. The construction was 16 feet across, and its red illumination affected the color of everything nearby, especially the clear blue of Ellsworth Kelly's sheet aluminum disk sitting alongside.

The use of color was a prominent feature of Primary Structures, and the exhibition title, in fact, was in part a pun on "primary colors."[18] This was nowhere truer than with the younger English artists. Behind the blue Caro in the outside court sat David Annesley's *Swing Low*, a ribbon-like form painted bright blue and sea green, sandwiched between two luminous yellow geometric frames. Striped ribbon shapes also were used by Peter Phillips in his *Tricurvular*, each one flowing through a Plexiglas triangle set before a triangular background. Phillip King cut a great fiberglass cone into nine sections, arranging them on a series of ascending steps, and painting the whole red and green. Tim Scott showed an assembly of two peach-colored wheels-and-axles positioned on either side of a sheet of clear Plexiglas, and Isaac Witkin's *Nagas* consisted of two vertical snakelike forms in fiberglass, one purple and the other yellow. Yellow also was the prominent color of William Tucker's three variations on an open pyramid of curvilinear forms, *Meru I, II,* and *III*. Michael Bolus and Gerald Laing similarly used polychromed, wacky, curvaceous imagery, though the two other Englishmen, David Hall and Derrick Woodham, were more geometric. For them all, Anthony Caro's influence was clear in the concern with the relation between sculpture and the

right:

Installation view of Primary Structures at the Jewish Museum, New York, April 27–June 12, 1966, showing (left to right) Phillip King's Through; *Daniel Gorski's* Fourth Down; *and Peter Pinchbeck's* Space Jump

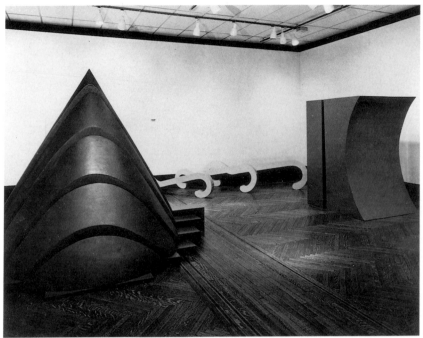

Opening night of Primary Structures at the Jewish Museum, New York, April 27–June 12, 1966, showing Tim Scott's Peach Wheels.

floor, and in the striking use of color. Caro had been a teacher of most of these artists at St. Martin's School of Art in London, but in its playful look the sculpture of the younger artists departed from that of his more sober compositions of painted steel beams. This festive mood and intense color had been much remarked upon when many in the younger group came to public notice the previous year at The New Generation: 1965 at the Whitechapel Gallery in London, seven of whose nine participants would reappear in Primary Structures.[19] Quite a few pieces were shown in both exhibitions, but in New York the English sculpture, apart from Caro, was dismissed as lightweight in both concept and scale.

To the sectarian New York art world the work of these English artists seemed "slight and finicky," as Corinne Robins put it in the most extensive account of the exhibition. Apart from one article in the *Washington Post*, "English Sculptors Outdo Americans," all of the critical press logged in with views similar to Robins's.[20] It was, of course, unsurprising for the Americans to get the most attention in a New York exhibition, but in this case the ground had been especially well prepared in the art press. The English never really had a chance.

Beginning in early 1965 a stream of critical writing appeared on the new sculpture of simplified form, from negative accounts by Irving Sandler and Max Kozloff to more detailed exposition by friendly critics Lucy Lippard and Barbara Rose. Rose's "ABC Art," published in the fall, was especially important in situating the reductive mode as a coherent movement, and during Primary Structures Hilton Kramer would call this article "a sort of Baedeker to the new art." Married to Frank Stella, and friend of Andre and Judd, Barbara Rose had intimate knowledge of the thinking behind their work, and along with the artists' own writings, hers did the most to disseminate their theoretical perspective. *Time* naturally interviewed Rose when covering Primary Structures, and her remarks echo the uncompromising spirit of traditional avant-gardism: "Nobody really likes this new art. . . . It is uningratiating, unsen-

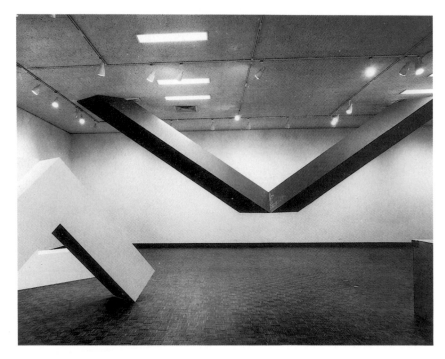

Installation view of Primary Structures at the Jewish Museum, New York, April 27–June 12, 1966, showing (left) Robert Morris's two L's and (right) Robert Grosvenor's Transoxiana

timental, unbiographical and not open to interpretation. If you don't like it at first glance, chances are you never will, because there is no more in it than what you have already seen."[21]

The case with the new sculpture, then, was similar to that of Pop art, where a great deal of published commentary appeared before any significant group exhibition.[22] With Minimalism, however, there was extensive theoretical writing by the artists themselves, who no longer left public explication to the critics. At the time, Kynaston McShine characterized the artists in his exhibition as "hip, sophisticated, articulate. Most are university-bred. They've read philosophy, have a keen sense of history, and know what they're supposed to be reacting to." Less than a year later, with Minimalism fully ascendent, Harold Rosenberg marked the social import of this circumstance: "[I]t reflects the new situation of art as an activity that . . . has become a profession taught at universities, supported by a public, discussed in the press, and encouraged by the government." In this regard, despite its oppositional rhetoric, Rosenberg saw Minimalism as "post-vanguard," completing a process that had begun with Pop. Reporting to the English about the work that had bested their own at Primary Structures, critic Brian O'Doherty concurred: "To be avant-garde now is to be old-fashioned."[23]

While much of the work in Primary Structures came verbally articulated, for one group of artists the theoretical reticence and expressive intention of gestural abstraction remained an emotional model, if not a formal one. And their sculpture included the most visually powerful in the show. Suspended from the ceiling, in counterpoint to Morris's neighboring inverted L, was Robert Grosvenor's 31-foot-wide *Transoxiana*. It was an immense V, 10½ feet deep, and the ambition and structure of the piece owed something to the artist's experience in naval engineering. Previously installed downtown at the Park Place Gallery, it hung overhead with powerful effect in the great space of the Jewish Museum, a long black form with one facet painted red.

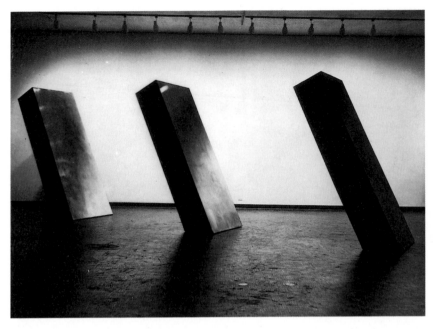

Ronald Bladen. Three Elements, *1965. Black painted steel and polished aluminum, each: 9 ft. 4 in. x 4 ft. x 2 ft. Courtesy Washburn Gallery, New York*

Grosvenor said in the catalogue that his work was not to be thought of as "large sculpture," but as "ideas which operate in the space between floor and ceiling." But he was castigated by his friends for attempting to explain his work at all, especially in such theoretical terms. On this point, Salvatore Romano used his catalogue statement to utter a view rarely heard anymore outside the precincts of Abstract Expressionism: "I don't think artists should talk about their work."[24]

Romano's *Zeno II* was a 10-foot rectangular beam floating at an angle above a column-like structure, a black and white diagonal pattern reinforcing its gesture. Like many of the New York artists in the show, he had been an abstract painter and through the early sixties had seen his work move out from the wall onto the floor. Yet unlike the artists associated with Minimalism, Romano and his colleagues had a romantic sensibility and aspired to the sort of heroics that had been achieved by the painting of the early New York School. The look was hard-edged and quasigeometric, but the impulse was expressive, and in their vast lofts they were able to realize pieces of impressive scale.[25] The most dramatic example was made for Primary Structures by Ronald Bladen.

Bladen's untitled three elements was widely reproduced in the press, even appearing on the title page of Robert Smithson's idiosyncratic aesthetic manifesto, "Entropy and the New Monuments."[26] Forty-seven years old at the time, Bladen developed a geometric sculptural means of presenting the gesture that had animated his paintings on 10th Street in the late fifties. In his studio he constructed three 9-foot wooden monoliths, each slanting at a 65-degree angle and positioned in a row about 10 feet apart. Held at this angle by internal blocks of lead and concrete, the diagonal masses were painted black, with the broad upper face of each one covered by a subtly reflective surface of sheet aluminum. For Irving Sandler the piece suggested Stonehenge designed by a master of the International Style, and Bladen actually had been thinking of an ancient sculpture when constructing his work—a 9-foot Olmec head displayed outside the Seagram Building the previous summer. Sandler was especially alive to the gestural and heroic aspects of Bladen's work, having been involved in the

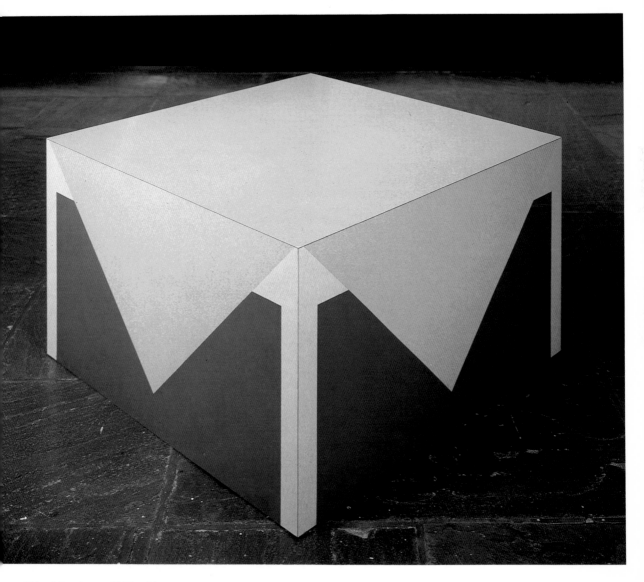

Richard Artschwager. Table with
Pink Tablecloth, *1964. Formica
on wood, 25½ x 44 x 44 in.
Saatchi Collection, London*

Club and 10th Street both as participant and as sympathetic critic, and he knew how far this work was from that of Judd and Morris. Bladen originally planned to have only two elements, but he added one more for compositional and rhythmic reasons. Still more contrary to Minimalist doctrine, for Sandler the angles evoked the "heroic diagonal" of Rodin's *Balzac*, and the precarious slant was a sign of human vulnerability.[27]

Certainly Bladen's was not a depersonalized work, and despite its size, it attracted buyers. At the opening or soon after, the piece was sold three times in a steel and anodized aluminum edition that could be installed outdoors. Purchasers included the Museum of Modern Art, and the Pasadena Museum of Art, whose director, Walter Hopps, also acquired the Judd wall piece for his museum. The third went to collectors Albert and Vera List, strong supporters of the Jewish Museum who had funded the 1963 three-story addition and had moved the institution into the forefront of contemporary art by encouraging the appointment of Alan Solomon as director. This multiple sale of the exhibition's largest work was particularly ironic, for Kynaston McShine just had told the *New York Times* that the show was composed of "anti-collector, anti-museum art" that was too massive to sell.[28]

The dynamic gesture of Grosvenor, Romano, and Bladen was anathema to Donald Judd, who associated it with the "anthropomorphic kind of space" of traditional sculpture. Judd made the connection responding to sculptor Mark Di Suvero, at the symposium that McShine organized in conjunction with his exhibition. The panel was an odd one, with Judd, Morris, and their advocate Barbara Rose lined up against Di Suvero, whose work was not even in the show. Di Suvero, however, was an articulate spokesman for a more romantic conception of abstract sculpture that activated space and was made by the artist's own hand. This last point was an issue of special contention, for much work in the exhibition had been industrially fabricated. In his catalogue introduction McShine marked this as a critical move for the new sculpture, rejecting the precious quality of the traditional art object and implicitly condemning the social system of which it was a part. For someone like Di Suvero, however, it was the end of real art making, and he stated that Judd "can't qualify as an artist because he doesn't do the work."[29]

Di Suvero also was included in the symposium because of his influence on the artists of the cooperative Park Place Gallery. Park Place had been organized by Forrest (Frosty) Myers, a twenty-five-year-old artist whose large red, blue, and yellow structure of interlocking geometric forms was suspended in the center of the large gallery whose corner was controlled by the Flavin. It hung between, on one side, the Romano and David von Schlegell's floating *Wave* of painted wood, and, on the other, Peter Forakis's *JFK*. Another Park Place artist, Forakis had made the piece in 1963, a week or so after the president's assassination, cutting a sheet of aluminum and rolling himself inside to create the shape. Located three blocks from City Hall on West Broadway, Park Place had opened the previous November with a manifesto introducing the public to "space warp," "optic energy," and "four-dimensional color."[30] Its director was Paula Cooper, whose own gallery a few years later would be a landmark in the development of Soho as an art center.

The expressive curves of von Schlegell and Forakis were unique in Primary Structures, where even the English use of the nonlinear was characterized by the slick look of plastic, Formica, and fiberglass. Such new materials could be seen throughout the exhibition, appearing with rare wit in Richard Artschwager's Formica send-up of a table with pink tablecloth. But they seemed especially right for the artists from Los Angeles, like John McCracken, David Gray, and Tony de Lap, whose *Ka* was a great arch of fiberglass and lacquered stainless steel. Most innovative of the Californians was Larry Bell, whom Walter Hopps had selected along with Judd for the American exhibi-

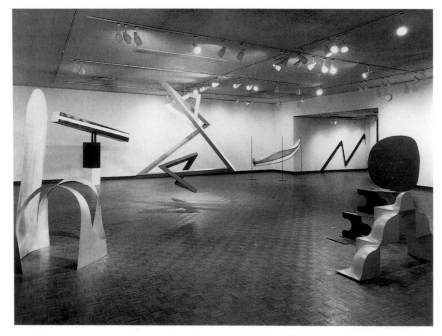

Installation view of Primary Structures at the Jewish Museum, New York, April 27–June 12, 1966, showing (left to right) Peter Forakis's JFK; *Salvatore Romano's* Zeno II; *Forrest Myers's* Zigarat & W. & W.W.W.; *David von Schlegall's* Wave; *Ellsworth Kelly's* Blue Disk; *and (right foreground) William Tucker's* Meru I, Meru II, *and* Meru III

tion at the 1965 São Paulo Bienal. Bell showed three glass cubes, each with a tinted high-tech coating that allowed it to appear both reflective and transparent. The multiple reflections and prismatic effects were enhanced by the only bases used in the exhibition, clear plastic supports permitting light to enter the bottom of each piece.

The open feel of Bell's closed forms was reinforced by two works exhibited nearby, Walter De Maria's *Cage* and Sol LeWitt's large gridded cube. McShine had seen a wooden version of *Cage* in De Maria's studio, but for the show the piece was fabricated in stainless steel with financial help from Robert Scull, who had expanded with Richard Bellamy and the Green Gallery from Pop to Minimalism. Like Morris, De Maria had made simple geometric sculpture in connection with the reductive aesthetic of early Fluxus performance, and he had shown an unpainted 8 x 4 x 4 foot plywood box in July 1961 when he delivered a lecture at Maciunas's AG Gallery.[31] But in his *Cage* De Maria used the new sculptural idiom to more disturbing psychological effect, moving toward the threatening presence of his *Beds of Spikes* shown two years later at the Dwan Gallery, which required visitors to sign a release of liability before entering the exhibition.

The contained space of Sol LeWitt was more cerebral than that of De Maria, and its use of simplified form was more aestheticized. Exhibited as *Untitled*, this was LeWitt's first modular cube, created during the previous winter. At 6 feet, it was approximately of human scale, but there all anthropomorphic association ended. With the pristine structure of a pedagogical Euclidean model, it consisted of white wooden bars displaying the geometrical analysis of a 6-foot cube into twenty-seven 2-foot cubes. LeWitt's first show at Dan Graham's Daniels Gallery in May 1965 had occurred too late for Barbara Rose to discuss his work in "ABC Art," but its intellectual rigor and purity of form soon would be seen as a paradigm of Minimalist sculpture. LeWitt was less interested than were Morris and Judd in the experiential aspect—though after Primary Structures at the Park Place Gallery he did place a 60-inch version of this cube about 12 feet away from another of 58 inches, creating a visual illusion of identity.

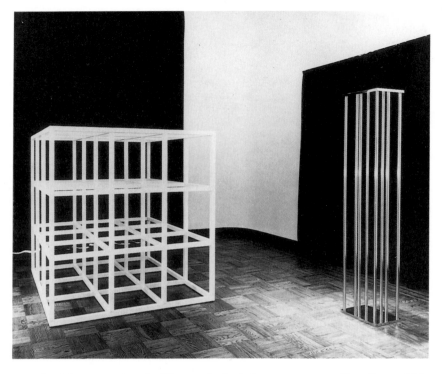

Installation view of Primary Structures at the Jewish Museum, New York, April 27–June 12, 1966, showing (left) Sol LeWitt's Open Modular Cube, *1966; and (right) Walter De Maria's stainless steel* Cage.

Instead of phenomenology LeWitt emphasized abstract structure, ideas from which physical works could be generated, and the fact of their being so engendered. As he stated that year in an issue of the experimental publication *Aspen Magazine*, he "does not attempt to produce a beautiful or mysterious object, but functions merely as a clerk cataloguing the results of a premise."[32] Complementing this process designed to avoid the influence of chance, choice, and personal idiosyncrasy, his "premises" were taken from geometry, the model of purity and uncontaminated knowledge from the Greeks to Kant. At Primary Structures LeWitt's cube seems to have descended from the world of Forms to the floor of the Jewish Museum, where the perceptual changes wrought by moving perspective and shadow focused the Platonic contrast between idea and appearance.

The emphatic use of the floor was evident throughout the show. In addition to Andre and Caro, another artist working along the ground was Tom Doyle, whose *Over Owl Creek* was a broad undulating bridge meant to be walked on as well as walked around. The abandonment of the base was especially striking in the group of four low objects shown alongside Artschwager's table—Derrick Woodham's table-like *Siviley*, Paul Frazier's *Pink Slit*, Douglas Huebler's open Formica structure, which could be displayed with any side up, and Anne Truitt's painted aluminum *Sea Garden*. Two years later, in fact, Clement Greenberg would suggest that Truitt—who lived in Japan from 1964 to 1967—was the progenitor of Minimalism, a charge warmly disputed by Judd. But Greenberg was watching his color-field painters displaced from the vanguard by Morris, Judd, and their friends, and he was looking to deflect attention elsewhere.[33]

Much of the work in Primary Structures, in fact, was connected with color-field painting, the art stemming from the nongestural side of Abstract Expressionism that Greenberg had promoted as the next stage of modernist advance. McShine noted in his catalogue essay the importance to the new sculpture of Barnett Newman and his

234

progeny, and Hilton Kramer suggested that a great deal of the show was "a species of abstract painting aspiring to the condition of architecture."[34] The British work actually descended from Greenberg in an odd way, for he had visited Caro's studio in the summer of 1959, leading to the sculptor's trip to the United States that fall and his embrace of the aesthetic program of Kenneth Noland and Morris Louis. On the American side, the new work was as much a reaction to the felt limitations of painting as a development within sculpture. Further progress could come only by moving down onto the floor, where the sort of abstract objects placed on the wall by Stella and Noland would escape the illusionism endemic to painting.

Following Primary Structures the new sculpture seemed to take over the New York art world. That fall it was the subject of the annual Art in Process exhibition at the Finch College Museum, and in the galleries artists from Primary Structures appeared everywhere. In September Richard Feigen exhibited the Englishmen David Hall and Derrick Woodham, their colleague Michael Bolus showing at Kornblee in October. That month Betty Parsons mounted Modular, featuring her artist Lyman Kipp whose T-shaped beams had sat alongside Andre's Lever at the Jewish Museum, and Virginia Dwan's exhibition of ten artists formalized the classic Minimalist group. In November Tony De Lap showed with Robert Elkon, and at Cordier & Ekstrom Walter De Maria had his first one-man exhibition. And December brought Robert Smithson's initial one-man show to the Dwan Gallery. By the spring John Perreault would report in Arts that New York galleries were refusing to take on anything non-minimal.[35]

Of course, things were hardly that homogeneous, and the seeds of what would come were being sown as the reductive form settled into commercial success. The September after Primary Structures the critic who had coined the title curated a show of another sort of abstraction at the Fischbach Gallery. Lucy Lippard's Eccentric Abstraction gathered together artists working in new materials as well, but their forms were soft, floppy, and unpredictable.[36] While formally powerful, much of the work suggested a sexual dimension far from the world of the primary structure, evoked by the flow and flexibility of material and process. In works like Keith Sonnier's inflating and deflating clear vinyl forms, Louise Bourgeois's flesh-colored latex molds, Gary Kuehn's melted fiberglass rectangles, Eva Hesse's structure of tangled string and geometric blocks, Lindsay Decker's plastic extrusions, and Alice Adams's hanging womb of chainlink fencing, Lippard saw a "non-sculptural style" able to constitute a new future for sculpture.

Such works, however, soon would seem very sculptural compared with another alternative arising out of the breakdown of categories and traditional media that was extolled in Primary Structures. While the sources of what would be known as Conceptual Art were wide-ranging—a notion of "concept art," in fact, had been presented by Henry Flynt in an essay published in An Anthology, and much inspiration came from Fluxus event scores and projects—in 1967 a kind of manifesto appeared from the heart of the new reductive sculpture. Sol LeWitt's "Paragraphs on Conceptual Art" emphasized ideas over physical instantiations, even viewing unrealized concepts as works in their own right.[37] He allowed the theoretical foundations for much of Minimalist art to assume primacy, turning what had been a point of hostile criticism into a position of strength. To view works now as realizations of ideas was no longer an attack but an avenue of aesthetic renewal. And as concepts became focal their linguistic presentation moved to center stage. Artworks could be embodied by statements, and a collection of statements could become an exhibition. It was a radical transformation of the exhibition format, and in its questioning of both work and context, the catalogue as exhibition would culminate—and encapsulate—the spirit of the sixties.

Dematerialization: The Voice of the Sixties

January 5–31, 1969
44 East 52nd Street, New York
When Attitudes Become Form:
Works-Processes-Concepts-
Situations-Information
(Live in Your Head)
Kunsthalle, Bern,
March 22–April 27, 1969

With 1969 we reach a watershed in the course of the avant-garde, and of avant-garde exhibitions. On the one hand, advanced art was accepted—even craved—by a significant public, and a strong commercial and institutional system had come to support it. At the same time, the cultural and political disaffection of the late sixties pushed things in exactly the opposite direction. Early on, the community of artists enthusiastically embraced the new social forms and personal practices, and naturally it engaged in political agitation against the Vietnam War. Radical artistic means developed to complement such social change, the energy of the broader counterculture combining with traditional avant-garde impulses to generate new artistic modes, anticommercial and extreme in form. While artists of the time might have rejected the label *avant-garde*, they did so in the spirit of avant-gardism, refusing to be associated with the now-acceptable art of the past. But their repudiation of the term was grounded in a deeper truth, for the days of the oppositional avant-garde were numbered.

These changes also spawned an important development in the world of advanced exhibitions, the rise of the curator as creator. While there had been many earlier attempts to subvert the traditional exhibition format, these efforts were made by the artists themselves—the Early Dada Spring of Ernst and Baargeld, Duchamp's 1938 Paris installation and his web of string in New York four years later, transformations of the galerie Iris Clert by Klein and by Arman, Oldenburg's Store. In the late sixties such alternative exhibition forms proliferated, but major innovations also would be generated by exhibition organizers. Like the work displayed, their exhibitions sought to undercut the standard way of framing art for the public, the manner and mode of presentation becoming part of the content presented. In this they were engaged in the same sort of critical enterprise as the artists, and their exhibitions became works on a par with their components. More than assemblers of the new or impresarios of the avant-garde, people like Seth Siegelaub and Harald Szeemann set the stage for the curatorial assumption of the artist's creative mantle. The phenomenon would expand with the international art world over the next two decades, part of the growing commercial and institutional activity.[1] The same changes that would spell the end of the

The artists of Seth Siegelaub's exhibition January 5–31, 1969: (left to right) Robert Barry, Douglas Huebler, Joseph Kosuth, Lawrence Weiner.

oppositional avant-garde would spawn a new kind of curatorial power.

Between 1964 and 1966 Seth Siegelaub had a standard sort of art gallery in New York on West 56th Street, where painting and sculpture were displayed in the "white box" of the modernist exhibition space. Among the painters he showed was Lawrence Weiner, and at the time that the gallery closed he was planning an exhibition of Douglas Huebler's Formica sculpture, à la Primary Structures.[2] When the dealer contacted Huebler again after a year or so, Siegelaub was involved with a new kind of art and had a different conception of his own enterprise. That notion took its lead from the sort of work that his artists were doing, work emphasizing ideation over realization. With ideas primary—ideas for a disparate variety of projects, from the creation of objects and events to the investigation of the notion of art itself—the most direct mode of presentation was essentially linguistic, and the most pointed form was the catalogue. For the catalogue connected verbal means and concomitant documentation with the notion of the exhibition, making clear that this was a new sort of art existing outside the old system of object and gallery. The nature of conceptual art allowed Seth Siegelaub to make the catalogue into a new kind of exhibition space.

Huebler himself had been moving in this direction from a base in Zen practice, and his first conceptual form was the map drawing, a route marked on a road map with the instruction that one could take or not take the trip, but if one did so, it had to be by the path indicated.[3] Siegelaub wanted to "exhibit" such new work, and combining an antiestablishment disposition, his lack of a gallery space, and the nature of the work itself, he decided to do Huebler's show in the form of a catalogue alone. The result was *Douglas Huebler: November, 1968*, in which the works were presented in terms of verbal description, maps, and other sorts of documentation. One piece described a variable, three-dimensional site delimited by stickers placed on both fixed and randomly moving objects at marked locations in New York City. Another was *42nd Parallel*, which involved the exchange of postal receipts to and from the Chambers of Commerce of fourteen towns along that line of latitude, a work lasting two months and extending over 3,000 miles. The publication listed Siegelaub's apartment address at 1100 Madison Avenue, where the typescripts and documentation were stored in the closet. And to Siegelaub's surprise, two or three people a week arrived expecting to see an exhibition, most notably collector Alan Power, who actually purchased three pieces. According to Lucy Lippard, such visitors were met by "a rather seedy 'dealer' . . . in his usual working costume—bathing suit or undershorts."[4]

A month later Siegelaub published *Lawrence Weiner. Statements*, not explicitly introduced as an exhibition but certainly functioning in a similar way. Weiner's pieces were presented in words alone—"Two minutes of spray paint directly upon the floor from a standard aerosol spray can."—and the book included no documentation or other visual aid to conceptualization. But while these works seemed more concrete than the space-time constructions of Huebler, being material entities created by particular processes, Weiner attached an ontological ringer to his verbal descriptions. In every case the "receiver" was to determine whether the piece would be constructed by the artist, made by someone else, or not realized at all.

That December Siegelaub also published what came to be known as the *Xerox Book*, entitled *Carl Andre, Robert Barry, Douglas Huebler, Joseph Kosuth, Sol LeWitt, Robert Morris, Lawrence Weiner*. Each of these artists was asked for a 25-page work produced by the xerox process, and 1000 copies of the book were printed. Since the *Xerox Book* actually contained the works themselves, it played another variation on the theme of publication as exhibition, in a sense forming the third volume of an exhibition trilogy. Yet Siegelaub could not help wanting to put work in a public space, and the next month he did so, albeit in highly nonstandard surroundings.

January 5–31, 1969 was not the first indoor exhibition that Siegelaub had done since closing his gallery, for in February 1968 he had organized a show of Andre, Barry, and Weiner at Bradford Junior College in Massachusetts, where Huebler was teaching.[5] Through one of his students Huebler had obtained a grant from the Weyerhauser Corporation for a program of new art, independent funding that allowed him to bring the most radical of artists to this conservative New England academy. At the time Robert Barry was working to incorporate emptiness in painting, positioning four 2-inch square canvases at the corners of a large expanse of wall. Soon he would further reduce visibility with single strands of wire or nylon monofilament stretched between walls or from floor to ceiling, before embracing complete invisibility by working with forms of energy and imperceptible gases. When Siegelaub came with the participants to hold a symposium on the exhibition, he brought another artist to whom Weiner had introduced him, Joseph Kosuth. With the addition of Barry and Kosuth, what dealer John Gibson referred to as the "Siegelaub Mafia" was complete, a group that would debut the next year in an empty office building on 52nd Street.

What has come to be called the January Show is just one of Siegelaub's many 1968–69 activities, but in retrospect it stands as the classic group exhibition of conceptual art. Of course, the emphasis on ideas from which physical works were generated was fundamental to the Minimalists concentrated at the Dwan Gallery, and Virginia Dwan had mounted two important shows focusing on language in the summers of 1967 and 1968.[6] And Joseph Kosuth and Christine Kozlov had established the Lannis Gallery in 1966, later dubbed the Museum of Normal Art, where a number of group shows displayed work of conceptual intent, including an exhibition of the favorite books of fifteen artists. But Siegelaub's January 5–31, 1969 explicitly presented these four varieties of conceptualism as a new art form, and it did so while denying the primacy of the standard exhibition format. As he insisted in the information sheet accompanying the show, "The exhibition consists of (the ideas communicated in) the catalogue; the physical presence (of the work) is supplementary to the catalogue."[7]

That the show "consisted" of ideas governed the format of the exhibition itself. In line with the fact that the artists' ideas could be instantiated either in printed or in more direct material form, the exhibition was divided into two parts: a reception room where catalogues could be perused, with a "receptionist" available to answer questions, and a gallery space where two works by each artist were to be installed. The receptionist was Adrian Piper, a young artist who had been recommended for the job by Sol LeWitt. With an acute analytic mind, Piper was highly qualified to play the role of expositor—her 1967 *Drawings about Paper and Writing about Words*, for instance, explored the self-reflexive properties of these representational forms, and she would go on to earn a doctorate in philosophy from Harvard.[8] The reception area contained a desk with a telephone, and a couch alongside the coffee table on which sat a pile of catalogues and the visitors book. Open from 11:00 to 5:30, Tuesday through Saturday, the exhibition attracted from seven to thirty visitors a day. By the end of the month it had been seen by 488 people, and the names in the visitors book suggest the increasingly international character of the vanguard art world.[9]

Siegelaub began looking for a space for the show in the fall, and as late as the end of November he was expecting the exhibition to be somewhere in the vicinity of Madison Avenue and 79th Street. But in December he was offered the use of an office in the otherwise vacant McClendon Building at 44 East 52nd Street, a small brownstone between Madison and Park. He rented the space for the month of January for $350. The place had come through a client of fellow dealer Manny Greer, who also introduced Siegelaub to collectors who would purchase enough work to fund the exhibition and the catalogue. This midtown office suited his purposes perfectly, for Siege-

ROBERT BARRY

4. 88 mc Carrier Wave (FM)
 1968
 88 megacycles
 5 milliwatts
 9 volts DC battery

Collection: Mr. and Mrs.
Manuel Greer, N.Y.

ROBERT BARRY

5. 1600 kc Carrier Wave (AM)
 1968
 1600 kilocycles
 60 milliwatts
 110 volts AC/DC

Collection: Mr. and Mrs.
Robert M. Topol, Mamaroneck,
N.Y.

Installation labels for two invisible works at the January 5–31, 1969 exhibition, 44 East 52nd Street, New York: Robert Barry's 88mc Carrier Wave (FM) *(1968) and* 1600kc Carrier Wave (AM) *(1968)*

laub wanted something other than a traditional gallery so as to avoid the aesthetic expectations attached to such territory.

Siegelaub's practice in all of his projects was to determine things collectively, and through many meetings he and the artists settled the format and the content of the exhibition. Originally there were to be five artists—Barry, Huebler, Kosuth, Weiner, and Ian Wilson, whose art took the form of verbal utterance. But in the last month Wilson dropped out, and the final plan was concluded without him. The catalogue would list eight pieces by each artist, include two photographs each, and reserve another page for an artist's statement. Appropriately enough for an artist whose work was invisible, Robert Barry left his statement page blank. Every artist was to select two of his works for installation in the second office room. For Siegelaub, however, the catalogue was the exhibition—for only there were all thirty-two pieces to be found—and physical works were purely illustrative, reversing the normal relationship between exhibition and catalogue.

In a conscious marketing ploy, every piece was shown in the catalogue as already placed in a private collection. Six of them had been purchased by a collector of Greer's, Robert Topol, and on Sunday, December 1, Siegelaub and the artists drove up to the Topols' house in Mamaroneck, New York to install some of the work. Robert Barry attached screw eyes to trees about 15 feet above the ground and connected them with nylon monofilament. A photograph of the piece, apparently showing only a suburban house and yard, appears in the catalogue. Another catalogue photograph presents the Topols' driveway, with Lawrence Weiner's *A 2" wide 1" deep trench cut across a standard one car driveway.* Watching these antics, Mrs. Topol doubted the artists' sanity, and she refused to allow *Life* to do a story on the work. Mr. Topol himself seemed more interested in the Giants football game on television than in the suspension of fishing line and the excavation of his driveway.[10] But whatever their attitude toward the work, collectors like Robert Topol and another stockbroker, Raymond Dirks, somehow were convinced by Greer and Siegelaub to support the new art.

The announcement for the exhibition, also appearing as a *New York Times* advertisement, was modeled after Dan Graham's 1966 poem-generating *Schema*, which began its columnar listing of twenty-eight variables "(number of) adjectives, (number of) adverbs, (percentage of) area not occupied by type, . . ." Modified and applied by Siegelaub, it consisted of a column of fourteen elements, including 0 OBJECTS, 0 PAINTERS, 0 SCULPTURES, 4 ARTISTS, 1 ROBERT BARRY, 1 DOUGLAS HUEBLER, 1 JOSEPH KOSUTH, 1 LAWRENCE WEINER, 32 WORKS, 1 EXHIBITION, 2000 CATALOGS, 44 e. 52 st. NEW YORK, 5–31 JANUARY 1969, (212) 288–5031 SETH SIEGELAUB.[11] Other advance publicity included a panel organized by Kosuth at the Club, which miraculously still was meeting, with all the artists from the show plus another conceptualist, Frederick Barthelme, brother of the novelist. Needless to say, among those maintaining the tradition of gestural abstraction, their ideas were roundly attacked. At the show itself, visited primarily by the cognoscenti and the converted, the reception was much more positive.

Those entering the display room found four distinct kinds of conceptual work. Robert Barry presented two imperceptible pieces, only the wall labels informing the public of their presence. Each consisted of a radio carrier wave, one AM (1600 kilocycles) and the other FM (88 megacycles), generated by equipment constructed by his father, who was an electrical engineer. The two transmitters sat out of sight in a closet at the far end of the room, next to which Barry's texts were posted. Photographs of both works also appeared in the catalogue, shown simultaneously occupying his apparently empty studio. These were actual art objects, but they consisted of energy beyond human sensibility. On the day of the opening Barry installed another such piece listed

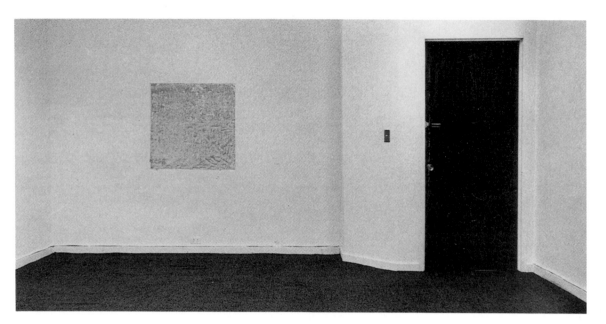

in the catalogue, this time using nuclear decay rather than electromagnetic transmission—half a microcurie of barium-133 buried in Central Park. Less than three months later he would have Siegelaub place a similar amount of another radioactive isotope, uranyl nitrate, on the roof of the Kunsthalle in Bern.

Lawrence Weiner showed the most physically intrusive work in the office: *A 36" x 36" removal to the lathing or support wall of plaster or wallboard from the wall,* located around a corner on the right as you entered the room. A kind of negative painting, it suggested the paradox of creation through destruction, a notion that he had addressed nine years earlier with his Mill Valley, California "exhibition" of a hole made by explosives. Weiner would travel to Bern in March to raise the issue in the stairwell of the Kunsthalle. An ironic comment on the assumption that art must produce substantial objects of positive form, it was a kind of indoor transformation of early earthworks, such as Claes Oldenburg's *Placid Civic Monument*—a deep rectangular hole dug and refilled by union grave diggers behind the Metropolitan Museum of Art—and Michael Heizer's trenches in the Nevada desert.[12] Weiner's second work was more visually elusive, *An amount of bleach poured upon a rug and allowed to bleach.* Subtly marking the carpet in front of the window, it is the least clearly remembered piece in the exhibition. But this seems appropriate given the artist's attitude toward the construction of works that are essentially concepts. In his interview with the fictitious Arthur R. Rose, published in *Arts Magazine* the month after the exhibition—one of four interviews in which each of Siegelaub's artists asked and answered his own questions—Weiner denied any concern with making objects. Since these works are ideas encapsulated in verbal statements, it just does not matter whether they ever are physically realized.[13]

In Kosuth's interview he claimed that the only role for an artist in 1969 was to investigate critically the nature of art itself. One cannot do this through painting and sculpture, he argued, because as particular forms of art they assume the validity of a general conception of art. Instead, Kosuth was engaged in a series of works entitled *Art as Idea as Idea*, a reference to Ad Reinhardt's purist focus on "art-as-art," with the double use of "idea" meant to avoid the reification of the art object as a thing, even if an

Installation view of the January 5–31, 1969 exhibition at 44 East 52nd Street, New York, showing Lawrence Weiner's A 36" x 36" removal to the lathing or support wall of plaster or wallboard from a wall

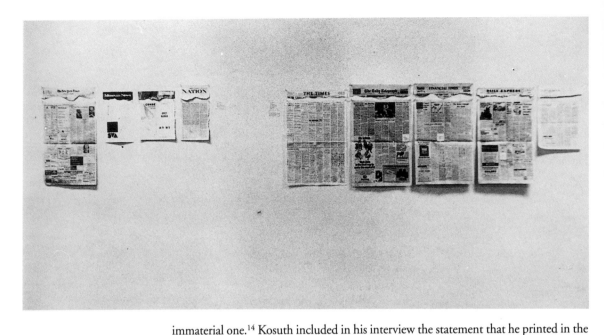

Installation view of the January 5–31, 1969 exhibition at 44 East 52nd Street, New York, showing Joseph Kosuth's (left) I. Existence (Art as Idea as Idea) *and (right)* VI. Time (Art as Idea as Idea). *Kosuth exhibited the pages from the newspapers and magazines where he had printed thesaurus entries for these terms, though, strictly speaking, the work was over on publication.* Existence *appeared in the* New York Times *on the first day of the exhibition (January 5, 1969), after being printed in* Museum News *(January 1, 1969), the* Nation *(December 23, 1968), and* Artforum *(January 1969).* Time *was published in five London newspapers on December 27, 1968—the* London Times, *the* Daily Telegraph, *the* Financial Times, *the* Daily Express, *and the* Observer.

immaterial one.[14] Kosuth included in his interview the statement that he printed in the catalogue, which explained the sets of newspaper pages hanging on the long wall between Weiner's missing square and Barry's labels. Having previously shifted from using actual water to presenting a photostat of the dictionary definition of *water*, and then to more loaded terms such as *meaning*, Kosuth moved to dematerialize his work further by purchasing advertising space in newspapers and periodicals. Here he merely printed without explanation a list of synonyms for an abstract term, abstract ideas replacing abstract imagery in Kosuth's conceptual update of Reinhardt's program. Four such projects were listed in the catalogue, using thesaurus entries for *existence, time, order,* and *number*. This new format avoided the association with painting attached to his mounted dictionary definitions, perhaps prompting him to reproduce in the catalogue the one of *painting*, done as a commission for Roy Lichtenstein. It also served other purposes, advertising Kosuth's work to those in the know—space was taken out in art magazines as well as in newspapers—and functioning both as ephemera and as collectible. But Kosuth disavowed involvement with any subsequent use of these pieces: "My role as an artist ends with the work's publication." Strictly speaking, then, the display of newspapers on 52nd Street was not part of Kosuth's artistic practice, and when asked to participate in Harald Szeemann's show in Bern, his synonyms for *space* appeared only in the city's newspapers.

On the one windowsill in the room lay a notebook of photographs, Douglas Huebler's *Haverhill-Windham-New York Marker Piece*. Such documentation was the only way to apprehend Huebler's work, for the pieces themselves were, he noted in his catalogue statement, "beyond direct perceptual experience." Consisting of thirteen locations along a 650-mile route connecting the three cities, marked by photographs of the ground that Huebler took every fifty miles, the work resulted from the artist's conceptual unification of preexisting entities. As he said at the beginning of his catalogue remarks, "The world is full of objects, more or less interesting. I do not wish to add any more." But sometimes Huebler did add more things, at least for a limited period of time, and Polaroid photographs of one of these were hung on the wall to the left as visitors entered the display area. It had begun with a neat rectangle of sawdust placed in

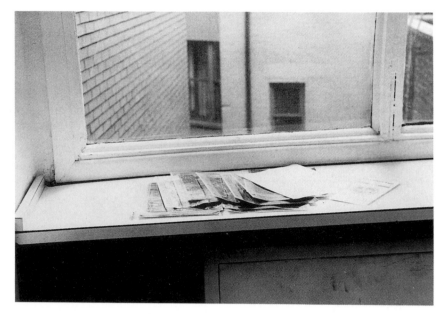

Installation view of the January 5–31, 1969 exhibition at 44 East 52nd Street, New York, showing documentation from Douglas Huebler's Haverhill-Windham-New York Marker Piece *(1968), which were photographs taken every fifty miles along a 650-mile route connecting these three cities.*

the hallway at eleven in the morning on the opening Saturday. Adrian Piper was assigned to photograph the sawdust every thirty minutes for the next six hours. After taking each picture she taped it within an area that Huebler had indicated on the wall, making sure not to position the images in temporal order. At the end of the well-attended afternoon there were thirteen Polaroids, and after sweeping up the sawdust the piece was complete.[15]

The energy and high spirits at the opening, and the attendance of such respected figures as Claes Oldenburg, suggested that interest in conceptual work was widespread. And while critics like Dore Ashton thought that Siegelaub's artists were "bored with art," across the international vanguard there was broad experimentation with such nonstandard forms.[16] One factor encouraging internationalization was the format of the work, documents easily mailed and ideas fully describable in letters or over the telephone. And Siegelaub's next two projects involved the sort of international mix last seen in the intermedia activity of the early sixties, itself a phenomenon essentially dependent on texts and publications.[17] Before the end of the January Show he solicited contributions for the first group exhibition to exist in catalogue form alone, *March 1–31, 1969*, in which thirty-one international artists each was assigned a different day on which to execute a work. Siegelaub distributed the exhibition/publication without charge around the world, as well as in New York at the artists' hangout of Max's Kansas City and at the Wittenborn Book Shop. For the summer he produced a fully international exhibition, *July, August, September 1969*, presenting projects by eleven artists installed in Europe and the Americas during these months. As an exhibition, the work existed together only in catalogue form, and in line with the international character both of participants and audience, all information was printed in English, French, and German.[18]

One person following Siegelaub's activity with interest was a museum director from Switzerland, Harald Szeemann, who visited the dealer and his artists in New York just as the the *Xerox Book* appeared. Szeemann had done a number of experimental shows at the Kunsthalle in Bern, and in the summer of 1968 he began formulating plans for a comprehensive international presentation of the new art. Guided by the

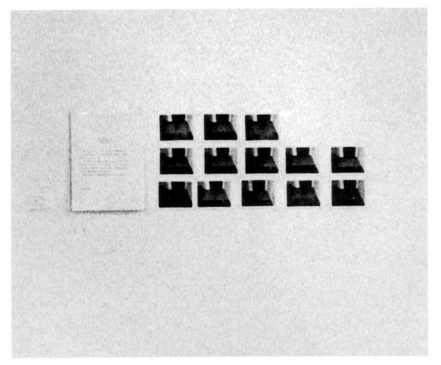

Installation view of the January 5–31, 1969 exhibition at 44 East 52nd Street, New York, showing documentation from Douglas Huebler's Duration Piece No. 6, *which were polaroid photographs taken by "receptionist" Adrian Piper every half hour on the opening day of the exhibition that recorded the dispersion of a rectangle of sawdust at the gallery entrance.*

rebellious nature of worldwide artistic activity, Szeemann believed that no standard exhibition of objects could accurately present what these artists were doing. More than this, Szeemann himself was an advocate of these developments that grew naturally from the counterculture of the late sixties. His was not to be a disinterested picture of current art but an impassioned involvement with the artists and their iconoclasm.

With traditional notions of self and community expanded by drugs, by rock and roll, and by political agitation, the art of this time respected few boundaries. The fundamental dictum was that of personal responsibility, which involved a basic questioning of the nature and the use of one's work. For the artist, this jibed with the historical avant-garde's call for the overthrow of traditional forms. Radical social, political, and aesthetic impulses merged, and Szeemann's goal was to display this confluence in all its diversity.[19]

His first idea was to unify the work under Robert Morris's term "Anti-Form," the title of the artist's important manifesto published in *Artforum* in April 1968. But many of the participants objected to being shown under this rubric, associated as it was with a particular sort of sculpture. More importantly, the term subverted the notion that their activity was meant to create new kinds of form. It was not until December 18 in New York that Szeemann found his solution, pressed by Nina Kaiden of the public relations firm of Ruder and Finn to supply a title for the exhibition that would be funded by her corporate client. Appropriately, the title was an inclusive one, capturing what Szeemann saw as the essence of the new work and indicating the variety of its manifestations: *When Attitudes Become Form: Works-Processes-Concepts-Situations-Information.*[20] Atop the title page of the catalogue Szeemann would condense his message in a timely motto, suggested to him by artist Keith Sonnier: *Live in Your Head.*

As the curator stated in his catalogue essay, the show was unified by something that was missed by each of the names used to characterize its components, terms

like Anti-Form, Arte Povera, Concept Art, and Earth Art. This was the primacy of process and activity, an emphasis fundamentally rooted in the salience of the artists' "inner attitudes." For Szeemann, these attitudes essentially were the works, variously realized in material and immaterial form. While the attitudes of artists like Mondrian and Pollock, of course, had generated their works, their goal was the creation of autonomous art objects. But without a persisting product, attitude became primary. This is what grounded the aesthetic significance of a sentence typed on a piece of paper, the collecting and burning of flammable material, a smashed sidewalk, some fat smeared in a corner, the mailing of a package, thirteen sheets of empty graph paper, or a walk in the mountains. Here the important thing was the act produced by an "attitude," not an object made for consumption by a market, even if some of these actions did produce salable goods. As Szeemann presented it in the catalogue, the new work was meant to disrupt the basic structure of the art world—the triad of studio, gallery, and museum. It was a utopian conception that would have difficulty surviving the social and cultural circumstances of its birth.

Both the exhibition and the catalogue displayed this emphasis on attitude and process, and the corresponding demotion of the object. Szeemann's plan was to turn the Kunsthalle into a giant studio where the artists would produce their works, and from there extend their activity into the staid Swiss city. He also presented his own curatorial process in the catalogue. It reproduced the address list he had used to visit artists in New York, along with many of the letters written in response to invitations to participate in the exhibition. Szeemann's catalogue, in fact, functioned as did those of Seth Siegelaub, for the exhibition contained more than ever would be physically realized in Bern. Of the sixty-nine artists in the show, fifteen were represented by information or documentation alluding to works elsewhere, both physical and nonphysical, including Ed Kienholz's account of the immaterial sensibility zone that he had been given by Yves Klein. The catalogue pulled this all together, along with other works whose existence was as fully instantiated there as it was on sheets of paper in the Kunsthalle. Unlike Siegelaub's catalogues, however, this one contained critical essays giving some account of the exhibition and the developments that it represented. In addition to Szeemann's piece, there were essays—each published in a different language—by Scott Burton, Grégoire Muller, and Tommaso Trini.

Szeemann traveled throughout Europe and the United States seeking artists for his exhibition, and twenty-eight of them went to Bern for the installation.[21] The action began with Michael Heizer and his family arriving on March 15, followed by Keith Sonnier the next night. On the 17th Richard Serra came to town with his friend Philip Glass, and together they installed Serra's pieces of lead plate and pipe propped against the wall. After Szeemann made necessary arrangements with the city and with a demolition company, the 18th found Heizer directing a wrecking ball to smash part of the sidewalk near the Kunsthalle, creating the *Berne Depression*. That same day Serra threw close to 500 pounds of molten lead along the base of the wall in an elegant skylit gallery, recreating the *Splash Piece* that had appeared a month before on the cover of *Artforum*. Meanwhile, Richard Long set off on an extended hike in the mountains above the city, his contribution to the exhibition that would be marked only by a statement on the Kunsthalle wall. On March 19 the Italians Giovanni Anselmo, Mario Merz, and Gilberto Zorio arrived, artists whose work of impoverished materials—Arte Povera—had been championed for some years by the critic Germano Celant. Now, as Szeemann wrote in his diary, "The coming and going begins. The Kunsthalle becomes a construction site."

Over the next two days more and more artists arrived, along with dealers like Siegelaub, Richard Bellamy, and Ileana and Michael Sonnabend, and the Kunsthalle

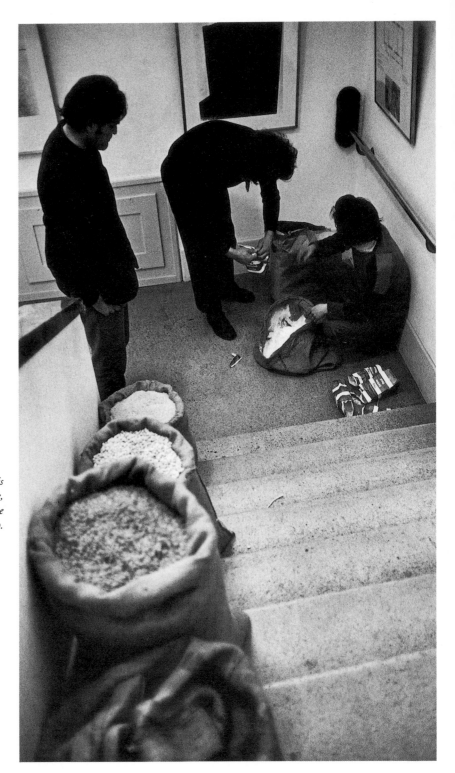

Bags of grain by Jannis Kounellis in the stairwell of the Kunsthalle, Bern, in When Attitudes Become Form, March 22–April 27, 1969. Photograph by Harry Shunk

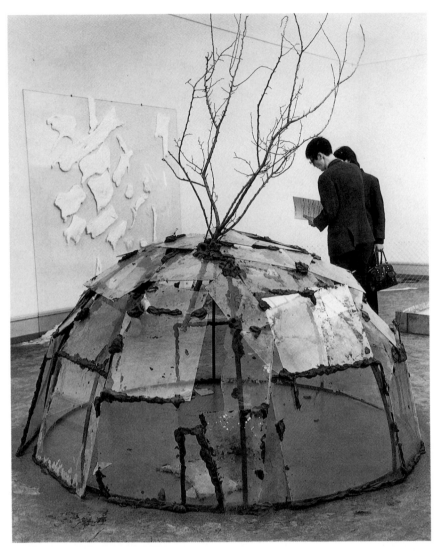

Installation view of the Arte Povera gallery in When Attitudes Become Form, Kunsthalle, Bern, March 22–April 27, 1969 showing Mario Merz's igloo, Acqua Scivola, *and, against the wall and on the floor, untitled works by Giovanni Anselmo. Photograph by Harry Shunk*

became as much an international meeting place and discussion center as a workshop. Naturally much talk was generated by the charismatic German artist Joseph Beuys, who viewed his primary role as that of a teacher, and who had been the professor at Düsseldorf of many of the German artists in the exhibition. There was activity throughout the entire building, in the hallways and staircases as well as in the galleries. Beuys smeared margarine along the edge of a floor and into the corner, Jannis Kounellis filled bags with grain, Merz built a glass igloo, Barry Flanagan laid out sixty feet of thick rope, Anselmo arranged bricks in a basin of chalky water, Reiner Ruthenbeck set a network of wire and metal rods atop a great pile of ashes, Weiner removed a square of stairwell wall. Ger van Elk replaced a square meter of asphalt outside the building with a large photograph of the section of ground that he had removed. Robert Smithson had a mirror placed in Bern and photographed, and a geometric pattern of marks was drawn on the wall according to a plan sent by Sol LeWitt. Richard Artschwager, the American speaking the best German, stuck forty of his fuzzy oval *blps* onto walls

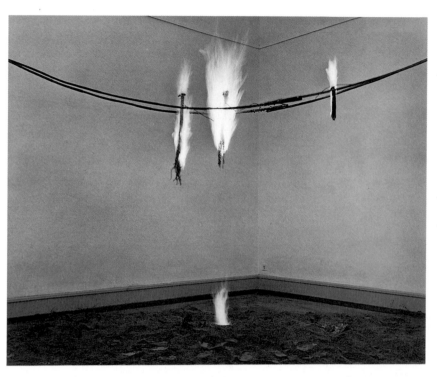

around the city and throughout the Kunsthalle. Like Huebler's contribution to the show, Burton noted in the catalogue—the traveling of a package through the United States postal system over forty-two days—Artschwager's installation of *blps* defied momentary perception. Similarly, Stephen Kaltembach's "artist's lips" were stamped through the city, with a stamp he had initially made for use on Fruit of the Loom stocking posters in the New York subways.

This temporal element was important for much of the work in the exhibition, such as Robert Morris's project with combustible material. Every day during the show another kind of stuff was added to a messy pile placed alongside Allen Ruppersberg's *Travel Piece*, a table displaying four newspapers from across America. On the last day the accumulation was burned next to a city monument, amid a crowd of onlookers and local firemen. In another instance, during the five weeks of the exhibition Walter De Maria would call a telephone placed on a gallery floor, speaking to whoever picked up the receiver.

De Maria had done such a telephone piece a year before at the Museum of Contemporary Art in Chicago, and Szeemann's show was filled with works and events that had gained notoriety elsewhere. This is not surprising in a large survey exhibition that took place at a time of highly concentrated vanguard activity. But it does generate tension with the attempt to get beyond the fine art object, for multiple re-creations of ephemeral works begin to function as persisting entities, playing the old role in new ways. Other than the Siegelaub artists and the Italians, the most notable case is work that had been shown in Leo Castelli's 108th Street warehouse space the previous December, assembled by Robert Morris. Under the banner of Anti-Form, nine artists presented works of nonstandard materials, whose imagery displayed and was in large part a function of its process of creation. All of these artists were included in Attitudes, for Szeemann had seen the show while visiting New York in preparation for his exhibi-

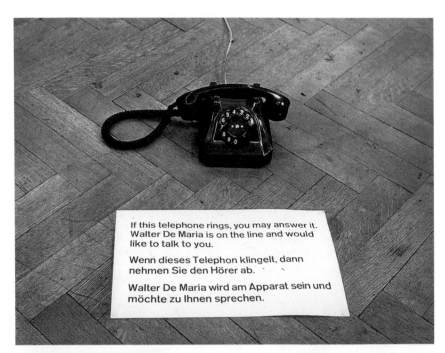

If this telephone rings, you may answer it.
Walter De Maria is on the line and would
like to talk to you.

Wenn dieses Telephon klingelt, dann
nehmen Sie den Hörer ab.

Walter De Maria wird am Apparat sein und
möchte zu Ihnen sprechen.

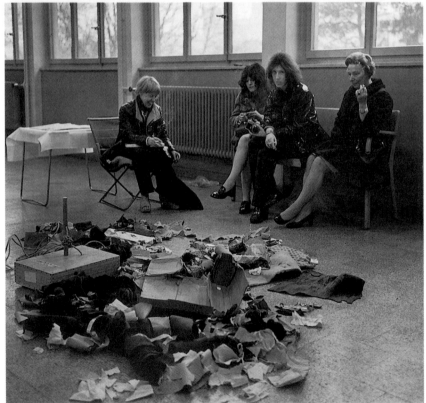

Walter De Maria. Art by Telephone, *in When Attitudes Become Form, Kunsthalle, Bern, March 22–April 27, 1969. Photograph by Harry Shunk*

Robert Morris's work using combustible materials, from When Attitudes Become Form, Kunsthalle, Bern, March 22–April 27, 1969. Each day a single item was added to the pile, and at the end of the exhibition the accumulation was burned in front of the Telegraph Union Monument. At the left is Allen Ruppersberg's Travel Piece *of four newspapers from December 1968 placed on a folding table: the* Salt Lake City Desert News, *the* Omaha World Herald, *the* Chicago Tribune, *and the* Cleveland Plain Dealer. *Photograph by Harry Shunk*

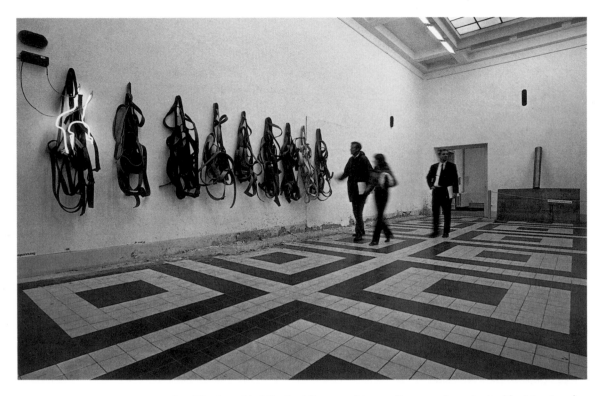

tion. He also added Raphael Ferrer to his own list, an artist uninvited by Morris, who had piled dead leaves in the staircase during the Castelli opening. Serra's splashed lead first had appeared at the Castelli warehouse, where in a wholly physical way it evoked Weiner's conceptual focus on materials and process.[22] On the floor sat Eva Hesse's nineteen overlapping rectangles of latex on canvas, *Augment*, and Keith Sonnier's latex was peeled partially from the wall. Hesse and the other artists, among them Anselmo and Zorio, showed additional works in Bern.[23] But in a sense Szeemann reproduced a number of the classic exhibitions of the time, combining them to show the coimplication of idea and impulse across the international avant-garde.

The installation that merged all of this work looked a mess by museum standards, despite the wife of Dutch conceptualist Jan Dibbets having led a thorough cleaning of the halls late into the night of the twenty-first. Above Serra's lead splashes on the elegant tile floor hung nine tangles of rubber strapping, one intermixed with neon, echoing Neil Jenney's disjointed neon configurations installed elsewhere. In the next room Joseph Beuys had added a bed of warm felt to his smeared fat, an invocation of his personal rebirth myth of being swaddled in felt and fat by Tartars after his bomber crashed in the Crimea in 1943.[24] Alongside, he placed a tape recorder endlessly repeating "Ja-ja-ja-ja-ja, nee-nee-nee-nee-nee." To emphasize their status as father figures for the new attitude in art, Szeemann placed Beuys in a gallery with Claes Oldenburg, who sent a giant pair of men's pants, a soft medicine cabinet, and an early head from The Street.

From that room Barry Flanagan's rope led toward Robert Morris's hanging pile of felt, its shape governed by the effect of gravity on the heavy fabric. The thick rope snaked past Bruce Nauman's *Collection of Various Flexible Materials Separated by Layers of Grease with Holes the Size of My Waist and Wrists* lying on the floor, and by his

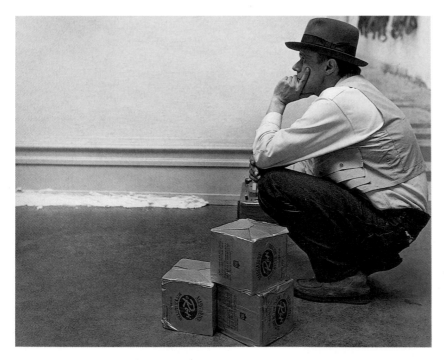

Joseph Beuys contemplating his installation of fat for When Attitudes Become Form, Kunsthalle, Bern, March 22–April 27, 1969. Through the exhibition, the tape recorder next to him would intone "Ja-ja-ja-ja-ja, nee-nee-nee-nee-nee." Photograph by Harry Shunk

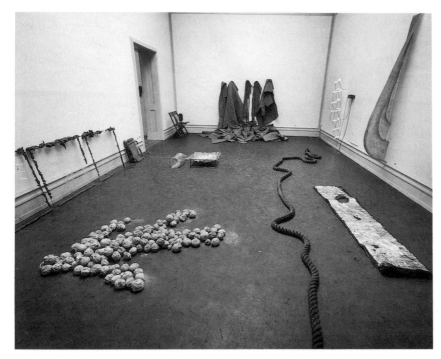

Works installed in When Attitudes Become Form, Kunsthalle, Bern, March 22, 27, 1969: (on the floor, left) Alighiero Boetti's I Who Take the Sun in Torino, February 24, 1969; (left wall and by door) works by Mario Merz; (rear wall) Robert Morris's Felt Piece No. 4 (1968); (on the floor, center) Barry Flanagan's Two Space Rope Sculpture (1967); (on the floor, right) Bruce Nauman's Collection of Various Flexible Materials Separated by Layers of Grease with Holes the Size of My Waist and Wrists (1966); (right rear) Neon Templates of the Left Half of My Body Taken at Ten Inch Intervals (1966); and (near right) Untitled (1965). Photograph by Harry Shunk

Eva Hesse. (on the floor) Aug-
ment, *1968. Latex on canvas, 19
units, each: 78 x 4 in. and (on the
wall)* Aught, *1968. Double sheets
of latex stuffed with polyurethane,
4 units, each: 78 x 40 in. Kaiser
Wilhelm Museum, Krefeld*

Neon Templates of the Left Half of My Body Taken at Ten Inch Intervals. On the other side lay Alighiero Boetti's image of his body in balls of concrete, *I Who Take the Sun in Torino, February 24, 1969,* and some sheets of glass laid against the wall by Mario Merz. But most of the Arte Povera was clustered together in another room, which had appeared the most workshop-like during the previous week. Among other things, in addition to Merz's glass igloo, stuck together with mastic and brandishing a tree branch, there were various objects by Anselmo, including a fenced-in electrified sandwich of stone, and a Zorio hanging from the ceiling that actually was set afire in the gallery. Ruthenbeck's pile of ashes was installed in a skylit gallery with mostly American work, including Sonnier's neon and latex pieces, three Eva Hesses, Alan Saret's tangle of wire, Richard Tuttle's irregularly shaped pieces of dyed cloth, Bill Bollinger's curves of taped rope, and Gary Kuehn's cut sawhorses covered by a fiberglass blanket. There also was much that looked more cleanly Kunsthalle-like, even if nonstandard, such as Carl Andre's square of thirty-six steel plates and a case displaying six of Hanne Darboven's books of obsessive numerical computation. But the general impression was that of a wild array spreading through the entire building, punctuated by Artschwager's fuzzy *blps* and various words and photographs alluding to peculiar events.

One striking thing about the American work was that much of it was listed in the catalogue as coming from German galleries. German dealers had begun traveling to New York during the heyday of Pop, and by the late sixties advanced American art could as readily be seen there as in New York. The most active dealers for the work shown by Szeemann were Rolf Ricke in Cologne and Konrad Fischer in Düsseldorf. Ricke started with Gary Kuehn in 1966, with whom he began his practice of inviting artists to produce their shows in Germany, and by 1969 he was representing Artschwager, Bollinger, Hesse, Serra, and Sonnier. Konrad Fischer also brought Americans over to create their shows, working mainly with the Dwan group—in the Bern show, Andre, LeWitt, Sandback, and Smithson—as well as with Robert Ryman. These dealers, along with Heiner Friedrich in Munich and Rudolf Zwirner in Cologne, the moving force behind that city's commercial art fair, created an atmosphere of excitement around current American work, placing pieces by their artists in many German museums as well as in private collections. By Documenta IV in 1968—the international survey of contemporary art that Szeemann was concerned to update with his Bern exhibition—forty-five of the one hundred and seventeen artists were American.[25]

As a result of having been to Germany to make work for exhibitions, some Americans already knew the German artists and art world figures who came to Bern. While the various national artists socialized with one another, Americans and Germans being the closest, the Italians largely kept to themselves.[26] Many of the artists had met a week before in Amsterdam, where Wim Beeren of the Stedelijk Museum staged a concurrent show, with Szeemann's permission, taking advantage of his having brought the group of advanced American artists to Europe. Entitled *Op Losse Schroeven: Situaties en Cryptostructuren* (loosely translated as "Square Pegs in Round Holes: Situations and Cryptostructures"), all but two of its thirty-four artists would appear in Bern. Like the international Surrealist exhibitions of 1936, a core collection formed the heart of these shows, though in 1969 that core consisted of artists instead of particular works. Some pieces done by these artists for Amsterdam were the same as in Bern—Serra splashed his lead on the curb outside the museum—yet most were different, such as Lawrence Weiner's residue of a flare ignited at the city limit. In comparison with the Kunsthalle, however, the Stedelijk installation would seem sanitized and museum-like, an exhibition seeking to tame the transgressive spirit of its contents.

Attitudes itself assumed yet other forms when it traveled to Germany and to England. Szeemann was not entirely happy with the exhibition at the Museum Haus

Lange in Krefeld during May and June. There the installation showed less respect for the artists' intentions than did Bern, with Bruce Nauman's template displayed upside down because the local director thought that orientation more convincing. In London at the Institute of Contemporary Art in the fall, Charles Harrison added some British work left out of the Bern showing. Szeemann was in London for two or three days before the September 28 opening, and he felt better about his show at the ICA than about its visit to Krefeld.[27] But in essence the exhibition existed in pure form only in Bern.

The reception in Bern certainly was more striking. On March 22 a crowd of one thousand arrived for the opening, many more than the Kunsthalle could handle. That day the press and television covered the show, and the public turmoil began. The conservative Swiss were outraged at Heizer's destruction of the sidewalk—though the city ruled that, since it had harmed no one, no law had been broken—and there was general anger at the use of public funds to show such abominations. Bags of excrement soon would be left on the Kunsthalle steps, and threatening letters were sent to the director. The fallout from Attitudes prompted the Kunsthalle exhibition committee to cancel the Joseph Beuys show that Szeemann already had planned, and he submitted his resignation in May.

An artist whose work Szeemann had not included in the exhibition was the Frenchman Daniel Buren, who since 1966 had made nothing but vertical 8.7 centi-meter-wide stripes on white backgrounds. These he installed in public places so that art could be seen outside the museum and gallery "frame," which for him allowed only the "single viewpoint" of the establishment. Buren could not miss this opportunity to so criticize work touted as radical, and for the opening he illegally posted striped sheets throughout the city, often covering military draft notices that listed those called to ser-vice.[28] Such transgression was especially offensive in law-abiding Switzerland, and Buren was arrested that day and his stripes removed. This only served to reinforce his claim that "Every act is political and . . . the presentation of one's work is no excep-tion." And with this particular exhibition of art, which broke with tradition in both concept and installation—art that moved out into the city in the same physical way as Buren did—such attention to context was especially revealing. For When Attitudes Become Form was funded by Philip Morris Europe, and in this, as much as in its con-tent, it prefigured the future.

The president of the corporation wrote in the catalogue of that key element shared by the new art and the business world, "innovation." More than this, he saw the support of experimental art as "an integral part" of his firm's "commercial function."[29] When Attitudes Become Form was one of four shows supported by the cigarette giant in 1969, their first since beginning an exhibition program in 1965 with two Pop presen-tations. The others also included artists like Hans Haacke, who submitted his new son's birth certificate as his piece for the Attitudes catalogue, displaying vanguard work of new form and material. And while it was a time of heightened political awareness among artists—during the Bern show, in fact, three hundred artists turned out in New York for a meeting of the radical Art Workers' Coalition, including many shown by Szeemann—no one seemed concerned with the source of exhibition financing. If any-thing, with much of their work meant to defy standard collecting and commercial interests, the artists believed that they were putting one over on the forces of corporate power. After all, apropos of Philip Morris, they all smoked, and packs of cigarettes were given away at the opening.[30]

But if the artists were amused by the fact of corporate support for an exhibi-tion of radical work, in the end the forces of the cultural establishment were to have the last laugh. Works that were deemed noncommercial soon would be sold and resold

in a growing international market. By 1973 Lucy Lippard was lamenting the disappointed aspirations of 1969, and over the next two decades the oppositional impulse of advanced art was to be largely coopted by commercial and institutional expansion.[31] A similar phenomenon, of course, had been seen many times before, and assimilation into the mainstream was an essential condition for the perpetuation of an avant-garde. But after the sixties the scale of things changed, and what began in a small way with Pop broadened and came to characterize a much larger world of artistic practice.

That world was one in which exhibitions were less able to disrupt expectation than to confirm acceptance, if only because collectors and the press were moving so quickly in their hunger for the new. In 1958 it was a fluke when Jasper Johns's target appeared on the cover of *Art News* before his first one-man exhibition, placed there at the last moment because the intended cover failed to arrive. But such events eventually became the norm. By the eighties large numbers of exhibitions would be sold out before they opened, their contents long known by many. Even artists whose work was born in opposition could not resist the system, nor the way in which it subverted radical impulse. Robert Smithson's *Spiral Jetty* became a beautiful photographic object, Daniel Buren's studies in cultural context became home and corporate decoration. After working for a year to produce an artist's-rights contract, Seth Siegelaub departed the art world to found a leftist publishing house in Paris.[32] Soon his four artists all would be with Leo Castelli.

Exhibitions still played a crucial role in the art world, of course, and large survey and theme shows proliferated with growing institutional support for new art. When Attitudes Become Form was a model for such events, and for the increasingly central role of the curator as creative participant. But the difference in spirit between 1969 and what was to come is epitomized by Jan Hoet's *Chambres d'Amis*.[33] Mounted in Ghent, Belgium in 1986, the exhibition consisted of installations in private homes throughout the city. The artists were some of the hottest on the international scene, and with its innovative format it is among the most significant exhibitions of the decade. But what exactly was the show? It was fifty-one artists designing work to show off homes of the Belgian haute bourgeoisie. Nicely housed and fed, unlike their scruffy predecessors turned away by the restaurateurs of Bern, they were looking at significant prices for their art in an expanding market. For these artists, it was a very different world than that of 1969.

Afterword

From its earliest days in the Impressionist salons of Paris, the avant-garde had existed in symbiotic relation with the bourgeoisie, a dynamic interdependence of provocation and support. Close to a century later Claes Oldenburg could be found obsessing about the situation, decrying the middle class need to be disturbed by an artistic vanguard that it eventually would absorb.[1] His Store sought to subvert this process through parody of its commercial mechanism, and with insubstantial and unwieldy forms the artists of 1969 attempted to avoid the same fate. But as the seventies moved into the eighties, this oppositional impulse, with all its historical resonance, was diluted. Eventually it would come to seem outmoded, as the social forms that had encouraged resistance were integrated into a cultural system that embraced all novelty. Vanguardism ultimately became little more than a stylistic matter, the development of a new look.

This was hardly a consequence of rising careerism and personal ambition, for these traits have coexisted with deep opposition to prevailing social and aesthetic norms—witness the behavior of Kandinsky or Malevich or Breton. Rather, the expansion of the cultural marketplace, and the increased media attention, shifted the center of momentum. Galleries and cultural institutions became the moving force. From groundbreaking shows assembled by the artists themselves, to those conceived by dealers, curators, and impresarios, artists would become increasingly less able to control the circumstances under which their work came before the public. Ironically, here artists found themselves disempowered just as their commercial and social prospects were improving. It was one of the many ways in which art would suffer in a world of intense promotion, fast glance, and quick purchase.

However there is another pattern suggested by our narrative, a recurring faith in the possibility of fundamental change. Despite a variety of intentions, in all of these shows art and its display were to be means of personal and social reconstruction. Across radically different circumstances these artists and organizers believed that their work would have significant effect in the world around them. Such faith is more difficult to come by now than in the past. But it stands at the heart of the diversity that is the avant-garde enterprise. Approaching the millennium, this extraordinary heritage challenges artists to meet the end of the century with the same courage that their modernist forebears displayed from its beginning.

Notes

Introduction

1. Quoted in Nan Rosenthal, "Assisted Levitation: The Art Of Yves Klein," in Institute for the Arts, Rice University, *Yves Klein 1928–1962: A Retrospective* (Houston: Institute for the Arts, Rice University, 1982), p. 100.

2. On the social character of the avant-garde, see Harold Rosenberg, "Collective, Ideological, Combative," in Thomas B. Hess and John Ashbery, eds., *The Avant-Garde, Art News Annual* XXXIV (New York: Macmillan, 1968), pp. 75–78.

3. On the role of the market, see Robert Jensen, "The Avant-Garde and the Trade in Art," *Art Journal*, Winter 1988, especially pp. 360–361.

4. Barbara Rose and Irving Sandler, "Sensibility of the Sixties," *Art in America*, January–February 1967, pp. 44–57, 60–62. The article includes extensive selections from the artists' responses.

5. John Ashbery, "The Invisible Avant-Garde," in Hess and Ashbery, p. 132.

6. Harold Rosenberg, "Collective, Ideological, Combative," in Hess and Ashbery, p. 78. For a cogent elaboration of this view from the opposite political camp, see Hilton Kramer, *The Age of the Avant-Garde* (New York: Farrar, Straus and Giroux, 1973), pp. 3–19.

Chapter 1

1. For Apollinaire's mockery of Jourdain, see Guillaume Apollinaire, *Apollinaire on Art: Essays and Reviews 1902–1918*, ed. LeRoy C. Breunig (New York: Viking, 1972), pp. 18–36.

2. The story is related in many places. See, for instance, John Elderfield, *The "Wild Beasts": Fauvism and Its Affinities* (New York: Museum of Modern Art, 1976), p. 43, and Alfred H. Bart, Jr., *Matisse: His Art and His Public* (New York: Museum of Modern Art, 1951), p. 56. The exact words Vauxcelles used in *Gil Blas* to describe the artless look of Marque's sculptures amidst "the orgy of pure tones" were "Donatello chez les fauves."

3. Rousseau showed two landscapes along with this large painting, which he entitled in the catalogue "The hungry lion throws himself on the antelope, devouring him, the panther anxiously awaits the moment when she too can have her share. The carnivorous birds have each torn pieces of flesh from the poor animal who sheds a tear! Sun sets." See Donald E. Gordon, *Modern Art Exhibitions 1900–1916*, 2 vols. (Munich: Prestel-Verlag, 1974), 2:139.

4. Ibid., 1:28.

5. Roger Benjamin, "Fauves in the Landscape of Criticism: Metaphor and Scandal at the Salon," in Judi Freeman, *The Fauve Landscape* (Los Angeles: Los Angeles County Museum of Art, 1990), p. 252.

6. Elderfield, pp. 32, 43.

7. Ibid., p. 65.

8. Crespelle, *The Fauves* (London: Oldbourne Press, 1962), p. 15.

9. Ellen C. Oppler, *Fauvism Reexamined* (Ann Arbor: University Microfilms, 1972), p. 101.

10. Marcel Giry, "Le Salon Des Indépendants de 1905," *L'Information d'Histoire de L'Art*, May–June 1970, p. 110. Also see Judi Freeman, "Documentary Chronology, 1904–1908," in Freeman, pp. 67–68.

11. Marcel Giry, "Le Salon d'Automne de 1905," *L'Information d'Histoire de L'Art*, January–February 1968, p. 16. Also see Freeman, "Chronology," in Freeman, p. 81.

12. These room identifications are taken from Vauxcelles's review in the October 17, 1905, supplement to *Gil Blas*. The identification of Louis Valtat and Georges Rouault with Fauvism largely stems from their being reproduced on the Fauve page of *L'Illustration* of November 4, 1905. On their misidentification as Fauves, see Elderfield, pp. 24–29, 61–62.

13. For the catalogue list of works shown at the 1905 Salon d'Automne, see Gordon, 2:136–140.

14. Leo Stein, *Appreciation: Painting, Poetry, and Prose* (New York: Crown, 1947), p. 158, and Gertrude Stein, *The Autobiography of Alice B. Toklas* (New York: Vintage, 1936, 1960), p. 35. On another account, Matisse sent his wife to observe and report back to him the public mockery (Crespelle, p. 15). For conflicting stories of the purchase of *Woman with the Hat*, See Barr, pp. 37–58.

15. Elderfield, p. 32.

16. Jack Flam, *Matisse on Art* (London: Phaidon, 1973), pp. 132 and 74, respectively.

17. Letter to Signac, September 28, 1905, in Pierre Schneider, *Matisse* (New York: Rizzoli, 1984), p. 222.

18. James D. Herbert, "Painters and Tourists: Matisse and Derain on the Mediterranean Shore," in Freeman, pp. 162–163.

19. Crespelle, p. 14.

20. Elderfield, p. 43, and Gaston Diehl, *The Fauves* (New York: Harry N. Abrams, 1975), p. 26.

21. Oppler, p. 27.

22. G. Jean Aubry, quoted in Marcel Giry, *Fauvism: Origins and Developments* (New York: Alpine Fine Arts, 1982), p. 103.

23. For the reviews of Denis and Gide, see Barr, pp. 63–64.

24. The Fauve page is reproduced in Ibid., p. 19, and the other is shown in Caroline Lanchner and William Rubin, *Henri Rousseau* (New York: Museum of Modern Art, 1985), p. 167.

25. Elderfield, p. 61.

26. Crespelle, p. 111.

27. Ibid., p. 113.

28. Carl R. Baldwin, "The Fauves: Reflections on an Exhibition, a Catalogue, and a History," *Arts*, June 1976, p. 99.

29. Maurice Vlaminck, *Dangerous Corner* (London: Elek Books, 1961), p. 11.

30. Oppler, p. 111.

31. Diehl, p. 100.

32. For an account of Derain's two trips to London in the fall of 1905 and in early 1906, see Judi Freeman, "Far from the Earth of France: The Fauves Abroad," in Freeman, pp. 185–201.

33. Crespelle, p. 112.

34. Elderfield, pp. 31–32.

35. For the works shown at Berthe Weill, October 21–November 20, 1905, and at the Galerie E. Druet, October 23–November 11, 1905, see

Gordon, 2:140–141.

36. In 1905 Matisse and Valtat were 36, Manguin 31, Marquet 30, Vlaminck and Puy 29, Van Dongen and Dufy 28, Camoin 26, and Derain 25.

37. For a succinct account and dating of Vlaminck's, Derain's, and Matisse's discovery of African art, and its introduction to Picasso, see Jack D. Flam, "Matisse and the Fauves," in William Rubin, ed., *"Primitivism" in 20th Century Art,* 2 vols. (New York: Museum of Modern Art, 1984), 1:213–217.

38. Gelett Burgess, "The Wild Men of Paris," *Architectural Record,* May 1910, pp. 400–414. Although obscure, Burgess had a one-person exhibition of watercolors at Alfred Stieglitz's gallery '291' in December 1911.

39. Elderfield, p. 131.

Chapter 2

1. Picasso had refused to exhibit in the salons before his association with Kahnweiler, apparently out of an unwillingness to compete with Matisse in public after his *succès de scandale* at the 1905 Salon d'Automne. Kahnweiler, however, encouraged his unwillingness to exhibit in Paris, preferring to place his work privately while promoting its exhibition abroad. John Richardson, *A Life of Picasso,* vol. 1 (New York: Random House, 1991), pp. 357, 389, 411.

2. Christopher Green, *Cubism and Its Enemies* (New Haven: Yale University Press, 1987), p. 134.

3. Daniel Robbins, "Jean Metzinger: At the Center of Cubism," p. 13, in Joann Moser, *Jean Metzinger in Retrospect* (Iowa City: University of Iowa Museum of Arts, 1985).

4. Lynn Gamwell, *Cubist Criticism* (Ann Arbor: UMI Research Press, 1980), p. 21.

5. John Golding, *Cubism: A History and an Analysis, 1907–1914,* 3rd ed. (Cambridge, MA: Harvard University Press, 1988), p. 6.

6. Ibid., p. 20. As usual, Apollinaire slights the achievements of Braque, as he would do again in his 1913 book, *The Cubist Painters.*

7. Jean Metzinger, "Note on Painting," in Edward F. Fry, ed., *Cubism* (New York: McGraw-Hill), p. 60.

8. See Daniel Robbins, "From Symbolism to Cubism: The Abbaye de Créteil," *Art Journal,* Winter 1963–64, pp. 111–116.

9. Robbins, "Jean Metzinger," p. 17.

10. Fry, p. 173.

11. Guy Habasque, *Cubism* (Geneva: Skira, 1959), p. 92.

12. Pierre Cabanne, *The Brothers Duchamp: Jacques Villon, Raymond Duchamp-Villon, Marcel Duchamp* (Boston: New York Graphics Society, 1976), p. 76.

13. Gamwell, p. 44.

14. Habasque, p. 93.

15. Fry, pp. 174–175.

16. Virginia Spate, *Orphism: The Evolution of Non-Figurative Painting in Paris, 1910–1914* (Oxford: Clarendon, 1979), p. 25.

17. Fry, p. 67. For a discussion of Bergson's influence on Gleizes and Metzinger in *Du Cubisme,* see Robert Mark Antliff, "Bergson and Cubism: a Reassessment," *Art Journal,* Winter 1988, pp. 341–349.

18. "The Exhibitors to the Public," preface to the Italian Futurist exhibition at the Galerie Bernheim-Jeune, February 1912, in Herschel B. Chipp, ed., *Theories of Modern Art* (Berkeley: University of California Press, 1968), p. 295.

19. For a compelling discussion of Marinetti's manifestos, see Marjorie Perloff, *The Futurist Moment: Avant-Garde, Avant Guerre, and the Language of Rupture* (Chicago: The University of Chicago Press, 1986), chapter 3.

20. F.T. Marinetti, "The Foundation and Manifesto of Futurism," in Chipp, p. 286.

21. Francis Steegmuller, *Apollinaire, Poet Among the Painters* (New York: Penguin Books, 1986), p. 220.

22. On December 1, 1911, Boccioni wrote to Apollinaire about their activity since arriving back from Paris: "As for us, the Futurist painters, we are working furiously to finish preparing for our exhibition at Bernheim's, the battlefield where in two months we will array our cannons. . . ." Françoise Cachiun, "Futurism in Paris 1909–1913," *Art in America,* March/April 1974, p. 40.

23. Anne d'Harnoncourt, *Futurism and the International Avant-Garde* (Philadelphia: Philadelphia Museum of Arts, 1980), pp. 17–18.

24. Golding, p. 28.

25. Spate, pp. 174–175.

26. Golding, p. 97.

27. Spate, p. 249.

28. For detailed analysis of Gris's *Le Lavabo* and *Watch* (*Sherry Bottle*) in these terms, see William A. Camfield, "Juan Gris and the Golden Section," *Art Bulletin,* March 1965, pp. 128–134.

29. Fry, p. 97.

30. For the scientific background, see Linda Dalrymple Henderson, "X Rays and the Quest for Invisible Reality in the Art of Kupka, Duchamp, and the Cubists," *Art Journal,* Winter 1988, pp. 323–340.

31. Golding, p. 19.

32. Spate, p. 35.

33. For conflicting accounts of its composition, see Steegmuller, pp. 203–204.

34. Spate, p. 37.

35. On the question of whether Kupka was included in the Section d'Or, see Ibid., pp. 367–369, where Spate concludes that he was.

36. Albert Gleizes and Jean Metzinger, "Cubism," in Robert L. Herbert, ed., *Modern Artists on Art* (Englewood Cliffs, NJ: Prentice Hall, 1964), pp. 3, 13.

37. Gamwell, p. 47. For Vauxcelles's reaction to Gris's mirror, see p. 177–50.

38. Richard V. West, *Painters of the Section d'Or* (Buffalo: Abright-Knox Art Gallery, 1967), p. 37.

39. William A. Camfield, "*La Section d'Or,*" unpublished M.A. thesis, Yale University, 1961, pp. 97–155.

40. On the *Maison Cubiste,* see William C. Agee and George Hamilton-Heard, *Raymond Duchamp-Villon, 1876–1918* (New York: M. Knoedler

and Co., 1967), pp. 65–69.

41. Pierre Daix, *Cubists and Cubism* (New York: Rizzoli, 1982), p. 86.

42. William Robin, *Picasso and Braque: Pioneering Cubism* (New York: Museum of Modern Art, 1989), pp. 407, 412.

43. Carl F. Baldwin, "The Fauves: Reflections on an Exhibition, a Catalogue, a History," *Arts*, June 1976, p. 103.

44. *Gil Blas*, March 19, 1912, in Daix, p. 82.

45. Robert S. Lubar, "Cubism, Classicism and Ideology: The 1912 Exposició d'Art Cubista in Barcelona and French Cubist Criticism," in Elizabeth Cowling and Jennifer Mundy, *On Classic Ground: Picasso, Léger, de Chirico and the New Classicism, 1910–1930* (London: Tate Gallery, 1990) p. 313.

46. Perloff, p. 6.

47. Armin Zweite, *The Blue Rider in the Lenbachhaus, Munich* (Munich: Prestel-Verlag, 1989), p. 51. For Malevich, see Perloff, p. 12.

Chapter 3

1. Letter to Paul Westheim, published in *Das Kunstblatt*, vol. 14, 1930, in Hans K. Roethal, *The Blue Rider* (New York: Praeger, 1971), p. 31.

2. In her memoirs Elisabeth Macke describes group glass painting sessions with her husband, Franz and Maria Marc, and Heinrich Campendonk in the neighboring village of Sindelsdorf. Armin Zweite, *The Blue Rider in the Lenbachhaus, Munich* (Munich: Prestel-Verlag, 1989), notes to plate 93.

3. On the commercial support for avant-gardists moving from Secession-type organizations to establish more advanced forums for exhibition and promotion, see Robert Jensen, "Selling Martyrdom," *Art in America*, April 1992, pp. 143–144.

4. Peter Selz, *German Expressionist Painting* (Berkeley: University of California Press, 1957), p. 201.

5. Zweite, notes to plate 98.

6. Selz, p. 196.

7. Roethal, p. 39.

8. Selz, p. 193, asserts that this was the first such exhibition, but in December 1909 eight hundred works were assembled by Vladimir Alekseevich Izdebsky and shown in Odessa. Largely consisting of works by Russian artists—including Kandinsky, Jawlensky, and von Werefkin, who were working in Munich—the exhibition also contained paintings by Matisse, Rousseau, Gleizes, Balla, Münter, and other Western Europeans. The show then traveled to St. Petersburg and Kiev. In 1910–1911 Izdebsky put together another large exhibition of 440 works, 53 by Kandinsky, including other members of the NKVM and such members of the Russian avant-garde as the Burliuks, Larionov, Goncharova, and Tatlin. The catalogue was an ambitious publication, containing Kandinsky's essay "Content and Form," and an advanced excerpt from Schönberg's *Theory of Harmony* (solicited by Kandinsky). On Izdebsky and his activities, see Jelena Hahl-Koch, ed., *Arnold Schoenberg, Wassily Kandinsky: Letters, Pictures and Documents* (London: Faber and Faber, 1984), p. 189. For works included in these exhibitions, see Donald E. Gordon, *Modern Art Exhibitions 1900–1916*, 2 vols. (Munich, 1974), 2:401ff., 439ff.

9. Zweite, p. 29.

10. Wassily Kandinsky, *Concerning the Spiritual in Art*, trans. M.T.H. Sadler (New York: Dover, 1977), pp. 1–2.

11. Wassily Kandinsky, "Reminiscences," in Robert L. Herbert, ed., *Modern Artists on Art* (Englewood Cliffs, NJ: Prentice-Hall, 1964), p. 42.

12. From the 1930 letter to Westheim, in Paul Vogt, *The Blue Rider* (Woodbury, NY: Barron's, 1980), p. 92.

13. Weiss, p. 66.

14. Hahl-Koch, p. 137.

15. Klaus Lankheit, "A History of the Almanac," in Wassily Kandinsky and Franz Marc, *The Blaue Reiter Almanac*, ed. Klaus Lankheit (New York: Da Capo, 1989), pp. 15–16.

16. Ibid., p. 18. On the name *not* originating from a 1903 painting of Kandinsky's, see p. 18 n8. It seems that the name was a while in coming, however, as it first appears in correspondence on September 21.

17. Ibid., p. 20.

18. Hahl-Koch, pp. 136–137.

19. Ibid., p. 21.

20. Ibid., p. 36.

21. From Otto Fischer, *Das neue Bild* (Munich, 1912), quoted in Selz, p. 197.

22. Vogt, p. 25.

23. Lankheit, p. 13.

24. Weiss, p. 70 n49.

25. Lankheit, p. 14.

26. Janice McCullag, "Disappearances, Appearances: The First Exhibition of the 'Blaue Reiter,'" *Arts*, September 1987, p. 47.

27. Ibid., p. 46.

28. Caroline Lanchner and William Rubin, "Henri Rousseau and Modernism," in Caroline Lanchner and William Rubin, *Henri Rousseau* (New York: Museum of Modern Art, 1985), pp. 68–69.

29. Ibid., p. 71. Delaunay replied with a letter criticizing Kandinsky and Marc's German spiritualist interpretation of Rousseau, viewing him rather as the last of the great French classicists.

30. Lankheit, p. 29.

31. Zweite, notes to plate 7.

32. Klaus Lankheit, *Franz Marc: Watercolors, Drawings, and Writings* (New York: Harry N. Abrams, 1960), p. 16. Marc continues in more detail: "For instance, if you mix blue—so serious, so spiritual—with red, you intensify the red to the point of unbearable sadness, and the comfort of yellow, the color complementary to violet, becomes *indispensable* (woman as comfort-giver, not as lover!). . . . If you mix red and yellow to obtain orange, you endow the passive and female yellow with a termagantlike, sensual power, so that the cool, spiritual blue once again becomes the indispensable male principle; a blue now automatically falls into place next to the orange; these colors are in love with each other. Blue and orange—that is the color harmony of celebration."

33. Kandinsky, *Concerning the Spiritual in Art*, p. 57.

34. McCullag, p. 52.

35. Ibid., p. 48.

36. Hahl-Koch, p. 150.

37. McCullag, p. 52.

38. For Macke's satirical drawing and criticism of the Blaue Reiter, see Zweite, pp. 48–49. On Delaunay's color theory, and its contrast with that of Kandinsky and Marc, see Herschel Chipp, "Orphism and Color Theory," *Art Bulletin*, March 1958, pp. 55–63.

39. Although the catalogue gives the dates of the Blaue Reiter exhibition as December 18 through January 1, the show seems actually to have run December 19 through January 3. Kandinsky wrote to Delaunay on the 18th saying that the Rousseaus had arrived safely and that they were hanging the exhibition that day, and the card sent to Delaunay by the "Blauen Reiters" announcing the successful opening was dated the 19th. Kandinsky also wrote to Schönberg on the 15th about the exhibition opening on the 19th. As for the closing, there is a newspaper notice that the show was extended until January 3. See Mario-Andres von Luttichau, "Der Blaue Reiter," in *Stationen der Moderne* (Berlin: Berlinische Galerie, 1988), p. 117 n2.

40. The first NKVM exhibition traveled to Brno, Elberfield-Barmen, Hamburg, Düsseldorf, Wiesbaden, Schwerin, and Frankfurt in 1910; and the second was shown in Karlsruhe, Mannheim, Hagen, Berlin, and Dresden after leaving Munich. See Zweite, p. 26.

41. For a list of the Der Sturm exhibitions and the artists included in the *Herbstsalon*, see Selz, pp. 262–263, 265–266.

42. The exact dates of the exhibition at Goltz's are unknown, and scholars differ as to when it was held. All agree that it was on the walls in March. Some believe that it opened in February, others that it extended into April.

43. Lankheit, "A History of the Almanac," p. 20.

44. Ibid., p. 20.

45. Hahl-Koch, pp. 41–42.

46. Anton von Werner, quoted in Klaus Lankheit, "Franz Marc and the Blue Rider," in Marc Rosenthal, ed., *Franz Marc: 1880–1916* (Berkeley: University Art Museum, 1979), p. 50.

47. Kandinsky and Marc, *The Blaue Reiter Almanac*, p. 259.

48. Ida Katherine Rigby, "Franz Marc's Wartime Letters from the Front," in Rosenthal, p. 60.

Chapter 4

1. Milton W. Brown, *The Story of the Armory Show*, 2nd ed. (New York: Abbeville, 1988), p. 65. This work provides the definitive account of the exhibition, and I have relied on it heavily in this chapter. For simplicity I have kept references to Brown to a minimum, generally citing only quotations.

2. For details of the Cologne Sonderbund, see Peter Selz, *German Expressionist Painting* (Berkeley: University of California Press, 1957), pp. 240–249.

3. Brown, pp. 49–50.

4. Attracting much less publicity that same month was Stieglitz's first group show of his American modernists—Arthur Dove, Marsden Hartley, John Marin, Alfred Maurer, and Max Weber.

5. Brown, p. 58. As Brown discovered, Davies was more than he seemed in another way, for he kept a secret household on East 52nd St. with Edna Potter and their child, while living a traditional married life with family in Congers, New York.

6. Jerome Myers, *Artist in Manhattan* (New York: American Artists Group, 1940).

7. Brown, p. 91.

8. Brown, p. 163.

9. For details of the organization of the rooms, see Brown, pp. 115–117.

10. Ira Glackens, *William Glackens and the Ashcan School* (New York: Crown Publishers, 1957), p. 183. For a complete list of the works displayed at the Armory, including information on lenders, retail prices, and purchases, see Brown, pp. 244–328.

11. Brown, p. 108. *Evening Post*, February 20, 1913.

12. For the derivation of this figure, see Brown, p. 118.

13. Ibid., pp. 171–172.

14. Kenyon Cox, "The 'Modern' Spirit in Art, Some Reflections Inspired by the Recent International Exhibition," *Harper's Weekly*, March 15, 1913, reprinted in *1913 Armory Show 50th Anniversary Exhibit 1963* (New York and Utica: Henry Street Settlement and The Munson-Williams-Proctor Institute, 1963), p. 168; and "The New Art; Kenyon Cox on 'Futurism' and 'Cubism,' " from *New York Times*, reprinted in Frederick James Gregg, ed., *For and Against: Views on the International Exhibition Held in New York and Chicago* (New York: Association of American Painters and Sculptors, 1913), p. 36.

15. Reprinted in *For and Against*, p. 58.

16. Clara T. MacChesny, "A Talk with Matisse, Leader of Post-Impressionism," *New York Times*, March 9, 1913, p. 12.

17. Margaret Hubbard Ayer, *New York Evening Journal*, March 3, 1913, p. 17.

18. Aaron Sheon, "1913: The Forgotten Cubist Exhibitions in America," *Arts*, March 1983, p. 97.

19. Bennard B. Perlman, *The Immortal Eight* (New York: Exposition Press, 1962), p. 216.

20. Theodore Roosevelt, "A Layman's View of an Art Exhibition," *the outlook*, March 22, 1913, reprinted in *1913 Armory Show 50th Anniversary Exhibit 1963*, p. 161.

21. Walt Kuhn, *The Story of the Armory Show* (1938), reprinted in Bernard Karpel, ed., *The Armory Show, International Exhibition of Modern Art 1913*, 3 vols. (New York: Arno, 1972), 3:17.

22. William Carlos Williams, "Recollections," *Art in America*, February 1963, p. 52.

23. *1913 Armory Show 50th Anniversary Exhibit 1963*, p. 95.

24. *Camera Work*, April–July 1913, published Nov. 1913, p. 47.

25. *Art and Decoration*, March 13, 1913, p. 172.

26. The idea for the huge Paterson Strike Pageant, held at Madison Square Garden in support of the striking silk workers on June 7, was Mabel Dodge's, and the event was directed by her soon-to-be companion, John Reed. For an account linking the Pageant with the exhibition, see Martin Green, *New York 1913, The Armory Show and the Paterson Strike Pageant* (New York: Charles Scribner's Sons, 1988). For a good discussion of Mabel Dodge and her salon, see Patricia R. Everett, *Mabel Dodge: The Salon Years 1913–1917* (NY: Barbara Mathes Gallery, 1985).

27. Royal Cortissoz, "The Post-Impressionist Illusion," *Century Magazine*, April 1913, p. 809.

28. Christian Brinton, "Evolution not Revolution in Art," *International Studio*, April 1913, p. 34.

29. Brown, p. 152.

30. Details on purchases made at the exhibition come from Brown, pp. 120–139, and sales information from his catalogue of the show, pp. 244–328.

31. For the complete Torrey story, see Francis M. Naumann, "Frederic C. Torrey and Duchamp's *Nude Descending a Staircase*," in Bonnie Clearwater, ed., *West Coast Duchamp* (Miami Beach: Grassfield Press, 1991), pp. 11–23, which corrects much misinformation passed along by earlier accounts.

32. Linda Dalrymple Henderson, "Mabel Dodge, Gertrude Stein, and Max Weber: A Four-Dimensional Trio," *Arts*, September 1982, p. 106.

33. Brown, p. 206.

34. For an account of this exhibition, see Sheon, pp. 93–107.

35. See Judith Zilczer, " 'The World's New Art Center': Modern Art Exhibitions in New York City, 1913–1918," *Archives of American Art Journal* 14, no. 3 (1974): 2–7; and "Modern Art and Its Sources: Exhibitions in New York, 1910–1925, A Selective Checklist," in William Innes Homer, ed., *Avant-Garde Painting and Sculpture in America 1910–1925* (Wilmington: Delaware Art Museum, 1975), pp. 166ff.

36. On this exhibition, see Francis Naumann, "The Big Show, The First Exhibition of the Society of Independent Artists," *Artforum*, February 1979, pp. 34–39, and April 1979, pp. 49–53.

Chapter 5

1. All dates cited for Russian events are in the "old style" used before the October Revolution, which can be converted to standard Western dating by adding 13 days. This means that for those in Paris or Munich, for instance, the exhibition 0–10 opened in 1916. My use of "old style" dating conforms to that of the standard literature on Russian art, however, and it seems least confusing to adopt this practice. On designating this exhibition 0–10, rather than as 0.10, a mistaken form which had established itself due to a mistake in printing the exhibition catalogue and poster, see Larissa A. Zhadova, *Malevich, Suprematism and Revolution in Russian Art 1910–1930* (London: Thames and Hudson, 1982), pp. 123–125.

2. Kasimir Malevich, *From Cubism and Futurism to Suprematism: The New Painterly Realism*, in John E. Bowlt, ed., *Russian Art of the Avant-Garde, Theory and Criticism 1902–1934* (New York: Thames and Hudson, 1988), p. 118.

3. Charlotte Douglas, *Swans of Other Worlds, Kasimir Malevich and the Origins of Abstraction in Russia* (Ann Arbor: UMI, 1980), p. 54.

4. The Neoprimitivists also were aware of Western precedents in this direction. Larionov had accompanied Sergei Diaghilev to Paris for his exhibition of thirteen elegant rooms of Russian art at the 1906 Salon d'Automne, where he had seen the Gauguin retrospective along with the work of the Fauves. And most of the artists had visited the great Shchukin and Morosov collections of French painting in Moscow. On Diaghilev's Russian section of the 1906 Salon d'Automne, see John E. Bowlt, *The Silver Age: Russian Art of the Early Twentieth Century and the "World of Art" Group* (Newtonville, MA: Oriental Research Partners, 1979), pp. 169–171.

5. It has been suggested that the Knave of Diamonds was named for the diamond-shaped designs on the uniforms of prisoners—emphasizing the artist's role as outcast—but this designation also contrasted with the effete titles of the more established artists' organizations, Diaghilev's World of Art and the Symbolist Blue Rose group.

6. The donkey (Lolo) belonged to Frédé, proprietor of the Lapin Agile in Montmartre, where Picasso and his friends gathered. For the full story and a photo of Lolo at work, see John Richardson, *A Life of Picasso*, vol. 1 (New York: Random House, 1991), p. 375.

7. About half of Tatlin's entries were costume sketches for the 1911 innovative production *The Play about the Tsar Maximilian and his Arrogant Son Adolf*. On Tatlin's designs, see John Milner, *Vladimir Tatlin and the Russian Avant-Garde* (New Haven: Yale University Press, 1983), pp. 28–32. Goncharova included a series entitled *Artistic Possibilities of a Peacock*, with the bird rendered in Chinese, Egyptian, Cubist, and Russian Embroidery styles. For the catalogue listing of the Donkey's Tail exhibition, see Donald E. Gordon, *Modern Art Exhibitions 1900–1916*, 2 vols. (Munich: Prestel-Verlag, 1974), 2:562–566.

8. Douglas, p. 7. The exhibition included work by David, Vladimir, and Ludmilla Burliuk.

9. Ellen Proffer and Carl Proffer, eds., *The Ardis Anthology of Russian Futurism* (Ann Arbor: Ardis, 1980), p. 179. In addition to poems and essays by the Russian Futurists, *A Slap in the Face of Public Taste* included a number of prose poems from Kandinsky's *Klange*, published without his permission. Conservative in demeanor and uncomfortable with the aggressive style of manifesto, he sent a letter to the *Russian Word* in May 1913 protesting his inclusion in the volume.

10. Both of these sources had been emphasized in Vladimir Markov's "The Principles of the New Art" with particular reference to Chinese art, pointing away from European precedents toward the East, the ground, according to Goncharova, of all the best in Russian art. Markov's essay was published by the Union of Youth in 1912, and is translated in Bowlt, *Russian Art of the Avant-Garde*, pp. 23–38. It is interesting to compare his emphasis on chance, and the general rejection of logic by the Russian Futurists, with the contemporary essay by Benjamin De Casseres, "The Renaissance of the Irrational," published by Stieglitz in his special Armory Show issue of *Camera Work*, June 1913. That essay ends: "Cut down the sacred Bo-tree of science with its mock orange and stuffed nightingales! . . . The blazing constellations in the zodiacs of the irrational are calling us, and up the sun-shaft of the ages we go dancing the lascivious dance of the atoms; we go like gods sweating stars, chanting a Te Deum—to Chance." (p. 24) On Goncharova's rejection of the West for the East, see Bowlt, pp. 55–60.

11. Douglas, p. 36, from the published report of "The First All-Russian Congress of Poets of the Future (The Poet-futurists)," in which Kruchenyck, Matiushin, and Malevich were the sole participants.

12. Malevich letter to Matiushin, May 1915, in Douglas, p. 64. For images of the square in *Victory over the Sun*, see Jean-Claude Marcade, "K.S. Malevich: From *Black Quadrilateral* (1913) to *White on White* (1917); from the Eclipse of Objects to the Liberation of Space," in Stephanie Barron and Maurice Tuchman, eds., *The Avant-Garde in Russia, 1910–1930: New Perspectives* (Los Angeles: Los Angeles County Museum of Art, 1980), pp. 20–21.

13. Milner, p. 84.

14. On Tatlin's knowledge and recitation of Khlebnikov, see V.B. El'konin, "What I Remember About Tatlin," in Larissa A. Zhadova, ed., *Tatlin* (New York: Rizzoli, 1988), p. 437.

15. In Bowlt, *Russian Art of the Avant-Garde*, pp. 80–81.

16. For Goncharova's remark, see Douglas, p. 23; and for an account of the Moscow event see Benedikt Livshits, *The One and a Half-Eyed Archer*, trans. John E. Bowlt (Newtonville, MA: Oriental Research Part-

ners, 1977), chapter 5.

17. This was Malevich's first statement in print. Troels Andersen, ed., *K.S. Malevich, Essays on Art*, 2 vols. (Copenhagen: Borgen, 1968), 1:241 n8. In Moscow, Marinetti's translator was the poet and linguist Roman Jakobson. See "Art and Poetry: The Cubo-Futurists. An Interview with Roman Jakobson by David Shapiro," in Barron and Tuchman, p. 18. For a first-hand account of Marinetti in Russia, see Livshits, pp. 181–210.

18. Tatlin also would have been able to see Boccioni's June exhibition at the Galerie de la Boétie. He might well have been directed there by Popova, who is known to have visited the show.

19. Charlotte Douglas, "0–10 Exhibition," in Barron and Tuchman, p. 36 n17.

20. Zhadova, ed., p. 331. For the original title of the exhibition, see Anatolii Strigalev, "The Art of the Constructivists: From Exhibition to Exhibition, 1914–1932," in Henry Art Gallery, *Art into Life: Russian Constructivism 1914–1932* (New York: Rizzoli, 1990), pp. 15–39.

21. George Costakis, "Collecting Art of the Avant-Garde," in Angelica Zander Rudenstine, ed., *The George Costakis Collection: Russian Avant-Garde Art* (New York: Harry N. Abrams, 1981), p. 56.

22. S.K. Isakov, "On Tatlin's Counter-Reliefs" (1915), in Zhadova, ed., p. 334.

23. For a list of Malevich's paintings in Tramway V and 0–10, see Troels Andersen, *Malevich* (Amsterdam: Stedelijk Museum, 1970), pp. 162–163.

24. Robert C. Williams, *Artists in Revolution, Portraits of the Russian Avant-Garde, 1905–1925* (Bloomington: Indiana University Press, 1977), p. 121.

25. Milner, p. 102.

26. Troels Andersen, *Vladimir Tatlin* (Stockholm: Moderna Museet, 1968), pp. 6–7.

27. Isakov, p. 334.

28. Attributed to Tatlin by Berthold Lubetkin, in Christina Lodder, *Russian Constructivism* (New Haven: Yale University Press, 1983), p. 12.

29. In Tatlin's pamphlet published for 0–10, it says that the corner counter-reliefs were first shown "at an exhibition assembled in Moscow and at the Last Futurist Exhibition in Petrograd" (Milner, p. 108), but there is no explicit mention of them in reviews of The Year 1915.

30. From Benois's review in *Rech*, January 9, 1916, in Milner, p. 240 n12.

31. Benois, from the *Rech* review, in John E. Bowlt, *Russian Art 1875–1975: A Collection of Essays* (New York: MSS Information Corp., 1976), p. 59.

32. Larissa A. Zhadova, *Malevich, Suprematism and the Revolution in Russian Art 1910–1930* (London: Thames and Hudson, 1982), p. 43.

33. Ibid., p. 49. For the text of Malevich's May 1916 letter to Benois, see Andersen, *Malevich, Essays*, pp. 42–48. Some of his statements to Benois, certainly, would not have calmed fears of nihilism: "But my happiness in not being like you will give me strength to go further and further into the empty wilderness. For it is only there that transformation can take place. . . . My philosophy is the destruction of old towns and villages every fifty years, the driving of nature beyond the limits of art and the destruction of love and sincerity in art." (p. 45)

34. Douglas, "0–10 Exhibition," p. 34.

35. Ibid., p. 35.

36. Two additional versions of this work were published, one in January 1916 in Petrograd, and the other in November 1916 in Moscow, by which time both text and title had expanded, then called *From Cubism and Futurism to Suprematism. The New Painterly Realism.* See Bowlt, *Russian Art of the Avant-Garde*, pp. 116ff.

37. Camilla Gray, *The Russian Experiment in Art 1863–1922* (New York: Thames and Hudson, 1986), pp. 206–207.

38. Bowlt, *Russian Art of the Avant-Garde*, p. 112. See p. 114 for the statements produced for 0–10 by Kliun and Menkov.

39. These reviews are printed in French in Herman Berninger and Jean-Albert Cartier, *Jean Pougny 1892–1956*, 2 vols. (Tubingen: Editions Ernst Wasmuth, 1972), 1:156, 159. Ivan Puni left Russia for Berlin in 1920, and changed his name to Jean Pougny when he moved to Paris in 1923.

40. Douglas, "0–10 Exhibition," p. 39.

41. The most complete list of works in the exhibition is in Berninger and Cartier, pp. 157–158, derived from Puni's copy of the catalogue, and containing more entries than Gordon, 2:883–885.

42. On the proper title of the work, see Marcade, p. 21; Margit Rowell and Angelica Zander Rudenstine, *Art of the Avant-Garde in Russia: Selections from the George Costakis Collection* (New York: Solomon R. Guggenheim Foundation, 1981), p. 165; W. Sherwin Simmons, "Kasimir Malevich's 'Black Square': The Transformed Self. Part Three: The Icon Unmasked," *Arts*, December 1978, p. 127; and Zhadova, *Malevich*, p. 43.

43. Rostislavov's review, the most intelligent of the show, is printed in French in Berninger and Cartier, 1:159–160.

44. Gordon, 2:884. I have used the translations of Malevich's titles in Andersen, *Malevich*, pp. 162–163, rather than those in Gordon.

45. Douglas, *Swans of Other Worlds*, p. 54.

46. Simmons, p. 129.

47. Linda Dalrymple Henderson, *The Fourth Dimension and Non-Euclidean Geometry in Modern Art* (Princeton: Princeton University Press, 1983), p. 288.

48. Bowlt, *Russian Art of the Avant-Garde*, p. 145.

49. Zhadova, ed., *Tatlin*, p. 331. The Wanderers were a group of thirteen artists who had seceded from the St. Petersburg Academy of Art in 1863, deriving their name from the traveling exhibitions that they organized to bring art to the provinces. See Gray, pp. 9ff. Perhaps they were on Tatlin's mind from an exhibition of The Wanderers held adjacent to the Tramway V exhibition at Petrograd's Society for the Encouragement of the Arts on Movskaia Street. *Russian Woman-Artists of the Avantgarde 1910–1930* (Cologne: Galerie Gmurzynska, 1980), p. 293.

50. S.K. Isakov, "On Tatlin's Counter-Reliefs," in Zhadova, ed., *Tatlin*, pp. 333–335.

51. The poem is printed in Milner, p. 120.

52. Douglas, "0–10 Exhibition," p. 38. For diagrams showing the composition of Rozanova's constructions, see Rowell and Rudenstine, pp. 138–139.

53. Williams, p. 121.

54. Costakis, p. 55, and Berninger and Cartier, 1:155–156.

55. Zhadova, *Malevich*, pp. 44, 123 n11.

56. Williams, p. 123.

57. For a discussion of The Store, see Milner, pp. 122–125; and for a partial list of works, see Gordon, 2:888.

58. Costakis, p. 59.

59. For Rodchenko's written account of The Store and his relations with Tatlin, see Barron and Tuchman, pp. 256–257.

60. Costakis, p. 56.

61. Zhadova, *Malevich*, p. 66.

62. Ibid.

63. On Chagall at Vitebsk, see Susan P. Compton, *Chagall* (London: Royal Academy of Art, 1985), pp. 40–42.

64. For these last developments, see John Elderfield, "Constructivism and the Objective World: An Essay on Production Art and Proletarian Culture," *Studio International*, September 1970, p. 78.

65. Lodder, p. 61.

66. M.N. Yablonskaya, *Women Artists of Russia's New Age 1900–1935* (New York: Rizzoli, 1990), p. 172.

67. Konstantin Umanskij, *Neue Kunst in Russland, 1914–1919* (Potsdam, Kiepenheuer, and Munich: Goltz, 1920). When Alfred Barr went to Russia in 1927, this was the book on which he had to rely, along with Louis Lozowick's slim volume, *Modern Russian Art* (New York: Museum of Modern Art/Société Anonyme, 1925). See Alfred Barr, Jr., "Russian Diary 1927–28," *October*, Fall 1978, p. 17. Umanskij would remain the best source until Barr's own presentation of the Russian avant-garde in his catalogue for *Cubism and Abstract Art* (1936). On Umanskij's piece in *Der Ararat 1* in January 1920, see Timothy O. Benson, *Raoul Hausmann and Berlin Dada* (Ann Arbor: UMI Research Press, 1987), p. 187.

Chapter 6

1. Richard Huelsenbeck, *En Avant Dada: A History of Dadaism* (1920), in Robert Motherwell, ed., *The Dada Painters and Poets: An Anthology*, 2nd ed. (Cambridge, MA: Harvard University Press, 1989), p. 39.

2. Roy F. Allen, *Literary Life in German Expressionism and the Berlin Circles* (Ann Arbor: UMI Research Press, 1983), p. 242.

3. Motherwell, pp. 77–78.

4. There is disagreement on the date and site of Ball's "magic bishop" episode, which is placed on June 23 at the Cabaret Voltaire by John Elderfield in his introduction to Hugo Ball, *Flight Out of Time: A Dada Diary* (New York: Viking, 1974), p. xxv.

5. For accounts of this climactic event, see Hans Richter, *Dada: Art and Anti-Art* (New York: McGraw-Hill), pp. 77–80, and Tzara in Motherwell, pp. 240–242.

6. Technically, the members of Berlin Dada used *photocollage*, in which separate photographs are cut and pieced together, rather than *photomontage*, by which images are superimposed by multiple exposure. However, in this chapter I follow the Dadaists' own nomenclature and refer to this work as *photomontage*.

7. For a discussion see Dawn Ades, *Photomontage* (London: Thames and Hudson, 1980), pp. 19–20.

8. Ibid., p. 12.

9. Some scholars date this event in February.

10. Roselee Goldberg, *Performance Art, From Futurism to the Present* (New York: Harry N. Abrams, 1988), p. 67. On this event also see Mel Gordon, ed., *Dada Performance* (New York: PAJ, 1987), p. 17, where the date is given as February 18, 1918.

11. Allen, p. 243.

12. Erica Doctorow, *Dada—in Berlin* (Garden City, NY: Adelphi University, 1978), p. 35. *The Green Cadaver* was printed on the back of copies of *Dada Against Weimar*.

13. Benson, p. 131.

14. See the account by Ben Hecht in Gordon, pp. 80–81. Baader offered to sell Hecht for $35,000 his lost two-volume collage diary of 1919–1920, the *Bucher zuhanden des Oberdada*, which according to Grosz eventually was buried behind Baader's house, and might have been shown at the Dada Fair.

15. George Grosz and Wieland Herzfelde, "Dadaism," in Lucy R. Lippard, ed., *Dadas on Art* (Englewood Cliffs, NJ: Prentice-Hall, 1971), p. 88.

16. Dawn Ades, *Dada and Surrealism Reviewed* (London: Arts Council of Great Britain, 1978), p. 106.

17. On the two Cologne exhibitions, see Angelika Littlefield, *The Dada Period in Cologne* (Toronto: Art Gallery of Ontario, 1988), and Ades, *Dada and Surrealism Reviewed*, pp. 104–106.

18. Grosz and Herzfelde, p. 81.

19. Benson, p. 187; and Helen Adkins, "Erste Internationale Dada-Messe," *Stationen Der Moderne* (Berlin: Berlinisches Galerie, 1988), p. 159.

20. On these points see Ades, *Dada and Surrealism Reviewed*, pp. 83–85, and Hans J. Kleinschmidt, "Berlin Dada," in Stephen C. Foster and Rudolf E. Kuenzli, eds., *Dada Spectrum: The Dialectics of Revolt* (Iowa City: University of Iowa, 1979), pp. 164–165.

21. Benson, p. 80.

22. Grosz and Herzfelde, "Art is in Danger," in Lippard, p. 81.

23. John Elderfield, *Kurt Schwitters* (London: Thames and Hudson, 1985), p. 41. For discussion of the Schwitters-Huelsenbeck antagonism, see pp. 36–42. The full text of "Merz" can be found in Motherwell, pp. 57–64, and in Lippard, pp. 99–108.

24. For discussion of Dada and Constructivism, see John Elderfield, chapter 6, and *Dada-Constructivism, The Janus Face of the Twenties* (London: Annely Juda Fine Art, 1984).

25. Motherwell, p. 246. For an account of Huelsenbeck and his work, see Hans J. Kleinschmidt, "The New Man—Armed with the Weapons of Doubt and Defiance," introduction to Richard Huelsenbeck, *Memoirs of a Dada Drummer* (New York: Viking, 1974).

26. Raoul Hausmann, "A Dadasoph's Opinion of What Art Criticism Will Say about the Dada Exhibition," in Lippard, p. 58.

Chapter 7

1. William A. Camfield, *Francis Picabia: His Art, Life, and Times* (Princeton: Princeton University Press, 1979), p. 139.

2. In *Littérature*, n.s., November 1922, cited in Dawn Ades, *Dada and Surrealism Reviewed* (London: Arts Council of Great Britain, 1978), p.

168.

3. Man Ray tells the story in his *Self Portrait* (New York: McGraw-Hill, 1988), p. 115.

4. Judi Freeman, *The Dada & Surrealist Word-Image* (Los Angeles: Los Angeles County Museum of Art, 1989), p. 37.

5. William S. Rubin, *Dada, Surrealism, and Their Heritage* (New York: Museum of Modern Art, 1968), p. 68.

6. Gaëtan Picon, *Surrealists and Surrealism, 1919–1939* (New York: Rizzoli, 1983), p. 136.

7. Rubin, p. 109.

8. Marcel Jean, ed., *The Autobiography of Surrealism* (New York: Viking, 1980), p. 270. On *The Great Masturbator*, see William S. Rubin, *Dada and Surrealist Art* (New York: Harry N. Abrams), p. 220.

9. *1936 Surrealism* (New York: Zabriskie Gallery, 1986), p. 9. It is interesting that Dali had written of Art Nouveau architecture as "solidified desires" in *Minotaure* in December 1933, and that Breton had proposed "The Precipitates" as the name of his and Soupault's first published automatic writings, *Les Champs magnétiques*.

10. Jean, p. 208.

11. Rubin, *Dada, Surrealism, and Their Heritage*, p. 50.

12. Marcel Jean, *The History of Surrealist Painting* (New York: Grove Press, 1960), p. 282.

13. Hélène Vanel was called *L'iris des brumes* ("the iris of mists") in the *Dictionnaire Abrégé du Surréalisme* (Paris: Galerie Beaux-Arts, 1938), p. 76.

14. *Beaux-Arts*, 21 January 1938, p. 2

15. Bettina Wilson, "Surrealism in Paris," *Vogue*, March 1, 1938, p. 144.

16. On the embrace of Surrealism by the fashion world, see Richard Martin, *Fashion and Surrealism* (New York: Rizzoli, 1987), which includes sections on the 1938 exhibition and the use of mannequins, and on Schiaparelli.

17. For Masson's own description see Carolyn Lanchner, "André Masson: Origins and Development," in William Rubin and Carolyn Lanchner, *André Masson* (New York: Museum of Modern Art, 1976), p. 145. Masson laments the fact that the pimentos dried up after the opening, ruining the phallic effect.

18. Man Ray, p. 240. The catalogue listed only sixteen artists making mannequins, leaving Paalen out. The other mannequins in the exhibition were by Arp, Matta Echaurren, Maurice Henry, Sonia Mossé, and Espinoza.

19. *New York Herald Tribune*, European ed. (Paris), January 18, 1938, p. 3.

20. *Life*, February 7, 1938, p. 57.

21. The piece is described in Rudi Blesh, *Modern Art U.S.A.: Men, Rebellion, Conquest, 1900–1956* (New York: Alfred A. Knopf, 1956), p. 199 n5.

22. Most cited in Jean, *The History of Surrealist Painting*, p. 286. Translations of many entries can also be found in Lucy R. Lippard, ed., *Surrealists on Art* (Englewood Cliffs, NJ: Prentice-Hall, 1970), pp. 207–211, and I have provided others from *Dictionnaire Abrégé du Surréalisme* (Paris: Galerie Beaux-Arts, 1938).

23. According to the artist, Helena Rubinstein offered to buy the work, but returned it after the advertising display. See Man Ray, pp. 257–258.

24. Duchamp showed *Pharmacie* (1914), a 1913 version of *Nine Malic Molds*, a ready-made from 1914, the object *The Brawl of Austerlitz* (1921), and what is often referred to in accounts of the show as a *Rotary Demi-Sphere*, a 1925 machine issuing from the experiments Duchamp began with rotating spirals in 1920. Its name in the catalogue, over which it is reproduced in the *Dictionnaire Abrégé*, is "*Rrose Selavy et moi nous esquivons les eccymoses des Esquimaux aux maux exquis.*" ("Rrose Selavy and I avoid the Eskimo bruises . . .").

25. On this exhibition, see Picon, p. 93.

26. Newer Super-Realism was then shown in January 1932 at the Julien Levy Gallery in New York, where both Dali and Giacometti would have their first U.S. exhibitions in 1934.

27. For general accounts of all of these exhibitions, with a fair amount of detail on the Museum of Modern Art show, see Jean, *The History of Surrealist Painting*, pp. 250–252, 270–274, and 281–286. For photographs of the New Burlington Gallery exhibition, see Roland Penrose, *Scrap Book 1900–1981* (London: Thames and Hudson, 1981), pp. 63–67.

28. Other works were shared by only London and MOMA. This information is derived from the catalogues of these exhibitions, but involves some guesswork given possible catalogue mistakes in dating and ambiguous titling.

Chapter 8

1. "Facsimile of the 'Entartete Kunst' Exhibition Brochure," trans. David Britt, in Stephanie Barron, ed., *"Degenerate Art": The Fate of the Avant-Garde in Nazi Germany* (Los Angeles: Los Angeles County Museum of Art, 1991), p. 360.

2. On Hitler's ideology, see Arno J. Mayer, *Why Did the Heavens Not Darken?* (New York: Pantheon, 1988), chapter 4. For a discussion of relations between modernism and modernization, see Marshall Berman, *All That Is Solid Melts into Air* (New York: Penguin, 1988), sec. 2. It is interesting to compare Hitler's reactionary opposition to both modernism and modernization with what we have seen of Kandinsky and Marc, who grounded their artistic modernism in a rejection of modernization and its associated materialism.

3. Read's comments were in *The Listener* of September 22, 1937. See Ian Dunlop, *The Shock of the New: Seven Historic Exhibitions of Modern Art* (London: Weidenfeld and Nicolson, 1972), p. 244.

4. Berthold Hinz, *Art in the Third Reich* (New York: Pantheon, 1979), p. 27. On the events in Thuringia and during the early years of National Socialist control, see pp. 25ff.

5. For an account of the earlier exhibitions of "Degenerate Art," see Christoph Zuschlag, "An 'Educational Exhibition': The Precursors of *Entartete Kunst* and Its Individual Venues," in Barron, pp. 83–86, 98–101.

6. For details of the structure of the Chamber of Culture, and the early years of Goebbel's ministry, see Hinz, pp. 31–38.

7. For Willrich's account of his efforts, see Dunlop, pp. 237–238.

8. For details on confiscated works, see Hinz, pp. 39–40.

9. Henry Grosshaus, *Hitler and the Artists* (New York: Holms and Meier, 1983), pp. 11, 107.

10. The following account of the installation and the texts is derived from the reconstruction of the exhibition by Mario-Andreas von Lüt-

tichau, "*Entartete Kunst*, Munich, 1937: A Reconstruction," in Barron, pp. 45–81. This masterful piece of research includes complete photographic documentation, and a painting-by-painting/text-by-text reconstruction of the exhibition.

11. See contrasting photographs of the Dada wall in Barron, p. 55.

12. For an account of the controversies, focusing on *The Trench*, see Dennis Crockett, "The Most Famous Painting of the 'Golden Twenties'?" *Art Journal*, Spring 1992, pp. 72–80.

13. Barron, p. 376.

14. Von Lüttichau, p. 45.

15. Barron, pp. 386–388.

16. Review in *Der Rühr-Arbeiter*, July 20, 1937, cited in Dunlop, p. 253.

17. To cite just two examples: Van Gogh's 1988 self-portrait now in the Fogg Museum at Harvard was acquired by Alfred Frankfurter, publisher of *Art News*, for New York collector Maurice Wertheim, and Matisse's *Bathers with a Turtle* now in the St. Louis Art Museum was purchased by Pierre Matisse for Joseph Pulitzer, Jr. For accounts of the activity of German dealers in disposing of confiscated art, and of the Galerie Fischer auction, see Andreas Hüneke, "On the Trail of Missing Masterpieces: Modern Art from German Galleries," and Stephanie Barron, "The Galerie Fischer Auction," both in Barron, pp. 121–169.

18. Georg Bussman, " 'Degenerate Art'—A Look at a Useful Myth," in C.M. Joachimides, N. Rosenthal, and W. Schmied, *German Art in the 20th Century: Painting and Sculpture 1905–1985* (Munich and London: Prestel Verlag and the Royal Academy of Arts, 1985), p. 121, raises doubts about whether the confiscated art actually was burned, but most sources assert this as unequivocal fact.

19. Stephanie Barron, "1937: Modern Art and Politics in Prewar Germany," in Barron, p. 15.

20. For details on the exhibition's travels, see Christoph Zuschlag, "An 'Educational Exhibition,' " in Barron, pp. 90–95, 102–103.

21. Jimmy Ernst, *A Not-So-Still Life* (New York: St. Martin's/Marek, 1984), pp. 94–96.

22. Cynthia Goodman, "The Art of Revolutionary Display Techniques," in Lisa Phillips, ed., *Frederick Kiesler* (New York: Whitney Museum of American Art, 1989), p. 65.

23. In a September 1939 article in *Architectural Record*, Kiesler defined his concept of "correalism" as "an investigation into the laws of the interrelationships of natural and man-made organisms." Cited in Lisa Phillips, "Architect of Endless Innovation," in Phillips, p. 24.

24. Frederick Kiesler, "Notes on Designing the Gallery", 1942, cited in Lisa Phillips, "Environmental Artist," in Phillips, p. 114.

25. Peggy Guggenheim, *Out of this Century: Confessions of an Art Addict* (London: André Deutsch, 1979), p. 273. In addition to Guggenheim and Schiaparelli, the catalogue listed as sponsors of the exhibition Sidney Janis, Mr. and Mrs. Walter Arensberg, Mr. and Mrs. Robert Allerton Parker, Marian Willard, Katherine Dreier, Mrs. George Henry Warren, Pierre Matisse, Princess Gourielli, Thomas F. Howard, Mr. and Mrs. John Latouche, Mary Jane Gold, Bernard Reis, James John Sweeney, John Barrett, and Isabelle Kent.

26. Rudi Blesh, *Modern Art U.S.A.: Men, Rebellion, Conquest, 1900–1956* (New York: Alfred A. Knopf, 1956), p. 200. Writing only three years after the exhibition, Harriet and Sidney Janis, who were closely involved

in its preparation, say that three miles of string were used. Perhaps, since there were three rooms, a mile was used in each. See Harriet and Sidney Janis, "Marcel Duchamp: Anti-Artist," in Robert Motherwell, ed., *The Dada Painters and Poets* (Cambridge, MA: Harvard University Press, 1988), p. 307.

27. Marcel Jean, *The Autobiography of Surrealism* (New York: Viking, 1980), p. 403. Harriet and Sidney Janis, p. 307. Robert Coates, "The Art Galleries, Sixteen Miles of String," *The New Yorker*, October 31, 1942, p. 72. Here Coates also discusses the opening of Art of This Century, and in both installations prefers the older, more classic work. In each exhibition he singles out early de Chiricos for praise, though he also likes more recent works by Matta, Masson, and Ernst. Among the "landmarks of the teens and twenties" at Art of This Century, he mentions Metzinger's *The Cyclist*, Gris's *Bottle of Martinique Rum*, and Picabia's *Infant Carburetor*. In a recent essay, Benjamin Buchloh has suggested that Duchamp's room of coal sacks at the 1938 Paris exhibition and his installation of First Papers are commentaries on the obsolete nature both of painting itself and of the retrospective as an exhibition form. See A.A. Bronson and Peggy Gale, eds., *Museums by Artists* (Toronto: Art Metropole, 1983), p. 46.

28. "Agonized Humor," *Newsweek*, October 26, 1942, p. 76.

29. Interview with Carroll Janis, December 21, 1990.

30. Ernst, p. 234.

31. *New York Times Magazine*, November 1, 1942; *Newsweek*, November 2, 1942, p. 66.

32. *New York Times*, October 25, 1942, p. x9; Jacqueline Bograd Weld, *Peggy, The Wayward Guggenheim* (New York: E.P. Dutton, 1986), p. 290. For some context, this issue of the *New York Times* began with the headline "Allies Gain in Big North African Offensive," and included an account of a protest by the Municipal Arts Society over the Brooklyn Museum's symbolic deaccession of two dozen Japanese swords, scabbards, and hand guards for scrap metal to help the war effort.

33. Interview with John Cage, November 29, 1990.

34. Martica Sawin, "The Cycloptic Eye, Pataphysics and the Possible: Transformations of Surrealism," in Paul Schimmel, ed. *The Interpretive Link: Abstract Surrealism into Abstract Expressionism* (Newport Beach, CA: Newport Harbor Art Museum, 1986), pp. 39–40.

35. Dore Ashton, "Crisis and Perpetual Resolution," in Schimmel, p. 31.

36. On the lecture series, see Sawin, pp. 37–38, and Irving Sandler, "Dada, Surrealism and Their Heritage: 2. The Surrealist Emigres in New York," in *Artforum*, May 1968, pp. 25–26. On the exhibitions, see Melvin P. Lader, "Howard Putzel: Proponent of Surrealism and Early Abstract Expressionism in America," *Arts*, March 1982, p. 89.

37. Their experimentation since 1940 involved dripping and swirling quick-drying lacquer, including sessions in the basement of Peggy's uncle Solomon's Museum of Non-Objective Art, where artist-employees dissolved the classical records that Hilda Rebay played in the galleries. See Martica Sawin, " 'The Third Man,' or Automatism American Style," *Art Journal*, 47, Fall 1988, pp. 181–184, for these early experiments of Pollock, Kamrowski, Baziotes, Jimmy Ernst, and others.

38. For a complete list of exhibitions at Art of This Century, see Melvin P. Lader and Fred Licht, *Peggy Guggenheim's Other Legacy* (New York: Solomon R. Guggenheim Museum, 1987), p. 17. Although Putzel left the gallery before the shows of Baziotes, Motherwell, and Rothko, he was instrumental in bringing on the artists, and he reportedly offered

exhibitions to Willem de Kooning and to Adolph Gottlieb which were never held. See Lader, "Howard Putzel," p. 92.

Chapter 9

1. Bernard Karpel, Robert Motherwell, and Ad Reinhardt, eds., *Modern Artists in America, First Series* (New York: Wittenborn Schultz, 1951). For an account of this publication, whose sole number was meant to cover the 1949–50 and 1950–51 art seasons, see Ann Eden Gibson, *Issues in Abstract Expressionism: The Artist-Run Periodicals* (Ann Arbor: UMI Research Press, 1990), chapter 5. Gibson also reprints the Studio 35 transcript, pp. 314–344.

2. Interview with Leo Castelli, December 5, 1990. For Castelli's account of his role in the Ninth Street Show, see Ann Hindry, ed., *Claude Berri rencontre/meets Leo Castelli* (Paris: Renn, 1990), pp. 85–88.

3. The manager attempted to prevent the artists from meeting at the Waldorf, where they often assembled after 9:00 PM through the forties. He allowed no more than four people at a table, and even prohibited smoking. For accounts of the founding and history of the Club, with some divergence of details, see Irving Sandler, "the Club," *Artforum*, September 1965, pp. 27–31, and L. Alcopley, "the Club," *Issue, A Journal for Artists 4*, 1985, pp. 45–47.

4. In 1951, Phillip Pavia's notebook records from the Club, on deposit at The Archives of American Art, list the charter members as Alcopley, Giorgio Cavallon, Charles Egan, Gus Falk, Peter Grippe, Franz Kline, Willem de Kooning, Ibram Lassaw, Landes Lewitin, Corrado Marca-Relli, E. Navaretta, Phillip Pavia, Milton Resnick, Ad Reinhardt, Jan Roelants, James Rosati, Ludwig Sander, Joop Sanders, Aaron Ben-Shmuel, and Jack Tworkov. (George Spaventa is added on a later list.) Sandler, pp. 27–29, cites this list, but Alcopley, p. 46, says that only 12 of the 20 were charter members.

5. For a list of some of the 1951–52 sessions, see Sandler, p. 30.

6. Among those interviewed on the following dates, Joop Sanders (March 4, 1991) and Conrad Marca-Relli (March 24, 1991) credit Kline and Marca-Relli together; Esteban Vicente (March 5, 1991) and Leo Castelli (December 5, 1990) credit Marca-Relli; Alcopley (February 22, 1991) remembers Kline; and Pat Passlof (March 4, 1991) points to Jean Steubing as suggesting 60 East 9th St.

7. According to Pat Passlof, Steubing went to the landlord, who Passlof believes was Sailors Snug Harbor, and obtained the space for $50 for the show. Castelli remembers the rent being $200/month for two months, though Marca-Relli and others remember $50/month. In his review of the exhibition ("New York's avant-garde," *Art News*, Summer 1951, pp. 46–47), Thomas B. Hess calls the location "a 90-foot former antique shop." Joop Sanders remembers it as a lamp and electrical fixture store, and Alcopley recalls the strong odor of feathers from its use as a mattress factory. Phillip Pavia (interview of June 19, 1991) says that it was Kiesler who insisted on building the wall, ordering the studs and sheet rock with which Kline and Pavia erected the partition.

8. Vicente remembers the committee meeting at Ferren's studio with himself, Ferren, Elaine de Kooning, Marca-Relli, and Kline. Pavia recalls Ferren and Resnick as particularly active; Castelli names himself, Marca-Relli, Tworkov, Kline, and Sander; Marca-Relli cites himself, Kline, Castelli, Ferren, Alcopley, and Resnick. (Interviews cited in notes 6 and 7 above.)

9. Castelli reports having covered the rent and additional costs to a total of $500–600, but at a group discussion in the home of Thomas and Marika Herskovic (March 24, 1991) both Marca-Relli and Alcopley denied that he paid the rent, as did Pat Passlof in conversation. Vicente

and Alcopley say that Castelli was not at all involved in artist selection, and most of the artists interviewed minimize his role here. Pat Passlof gave the story of the Resnick suggestion, and Joop Sanders recalls Castelli being asked in order to adjudicate the inevitable disputes that would arise in the hanging. (Interviews cited in notes 6 and 7 above.)

10. Rudi Blesh, *Modern Art U.S.A.: Men, Rebellion, Conquest, 1900–1956* (New York: Alfred A. Knopf, 1956), p. 247.

11. Irving Sandler, *The New York School: Painters and Sculptors of the Fifties* (New York: Harper & Row, 1978), p. 30.

12. Interview with Philip Pavia, June 19, 1991. According to Pavia, John Ferren was furious that Pavia gave Kiesler the key to the Club to use for organizational meetings.

13. Interview with Leo Castelli, December 5, 1990. According to Deborah Solomon, Pollock was back on Long Island at his house in The Springs for the opening, so he must have visited the show on a later trip into town. See Deborah Solomon, *Jackson Pollock, A Biography* (New York: Simon and Schuster, 1987), p. 221.

14. Seven Americans were shown in Venice. Alfred Barr chose de Kooning, Gorky, and Pollock; and Alfred Frankfurter, the publisher of *Art News*, selected Hyman Bloom, Rico Lebrun, and Lee Gatch. There also was a retrospective of the 80-year-old John Marin. Concurrently, at her villa Peggy Guggenheim showed her collection of Pollocks. The vanguard Americans created a sensation among the young Italian artists, and Morandi reportedly loved the Pollocks.

15. Thomas B. Hess, *Willem de Kooning* (New York: Museum of Modern Art, 1968), pp. 73–75.

16. John Ferren, "Epitaph for an Avant-Garde," *Arts*, November 1958, p. 25. In a letter printed in the December issue (pp. 7–8), Allan Kaprow commented that Ferren's nostalgic look backward is misguided, for a new generation of artists has "got something by the tail" and is accomplishing great things.

17. Hess, *Willem de Kooning*, p. 45. Motherwell quoted in Sandler, *The New York School*, p. 46.

18. The exhibition was Young Painters in the U.S. and France, and the other pairs were Brooks/Wols, Cavallon/Coulon, Ferren/Goebel, Ernst/Singier, Gatch/Pallut, Graves/Manessier, Kline/Soulages, Pollock/Lanskoy, Reinhardt/Nejad, Rothko/de Stael, Sterne/da Silva, Tobey/Bazaine, and Tomlin/Ubac. Late in 1951 Janis and Castelli collaborated on another show—American Vanguard Art for Paris Exhibition—previewing it on 57th Street before sending it to the Galerie de France in February 1952. The French critical reception was defensive, but younger French painters flocked to the show. See Blesh, pp. 247–249. Friedel Dzubas recalled the gleeful response of young artists in the early fifties on seeing contemporary French painting at Louis Carré's Fifth Avenue gallery: "It had nothing of the excitement, the freshness, the inventiveness of what we had been delivering for the last eight years here. For us, it was like a final triumph." Max Kozloff, "Interview with Friedel Dzubas," *Artforum*, September 1965, p. 51.

19. Manny Farber, "Art," *Nation*, February 17, 1951, p. 162.

20. *trans/formation*, vol. 1, no. 2, 1951, p. 89. Among the pieces of advice that Reinhardt next gives to artists in *trans/formation* (vol. 1, no. 3, 1952, pp. 148–149) are "Be romantic and let your divine spark defray expenses," "Make eyes at the elite until they pay through the nose," and "Let your monster subconscious make a quick buck for yourself."

21. Harold Rosenberg, "The American Action Painters," *Art News*, December 1952, pp. 22–23.

22. In his often-reprinted essay "Avant-Garde and Kitsch" (*Partisan Review*, Fall 1939, pp. 34–49), Greenberg wrote that " 'anti-Stalinism' . . . turned into art for art's sake, and thereby cleared the way, heroically, for what was to come." In a 1944 talk at Mount Holyoke College, published by Wolfgang Paalen in *Dyn*, Motherwell had seen the issue in related terms: "The artist's problem is *with what to identify himself*. The middle class is decaying, and as a conscious entity the working class does not exist. Hence the tendency of modern painters to paint for each other." On this lecture, "The Modern Painter's World," see Dore Ashton, *The New York School: A Cultural Reckoning* (New York: Viking, 1973), pp. 161–163.

23. While Greenberg is usually viewed as championing Pollock (and the field painting of Still, Newman, and Rothko) over de Kooning, who was supported by Hess and Rosenberg, as late as 1953 he introduced a de Kooning retrospective in Washington with the highest of praise. See Hess, *Willem de Kooning*, pp. 138–139 n11.

24. Sandler, *The New York School*, p. 259. In his review of the exhibition, Tom Hess sounded the Existential note in describing the curators' visiting the studios of impoverished artists in search of work for their show: "Rickety stairs and cold-water flats are not figures of speech; they exist, in the deepest Sartre sense, as do all the grey discomfort, bleakness, and economic insecurity that go with them." Thomas B. Hess, "Seeing the Young New Yorkers," *Art News*, May 1950, p. 23.

25. Sandler, *The New York School*, p. 37. Myers was introduced to Greenberg at the Pollocks' house in The Springs, where Lee Krasner had advised him to represent only younger artists. When Myers asked Tony Smith for suggestions, he seconded Greenberg's recommendations. (Leslie, Goodnough, and Rivers had been his students at NYU.)

26. Interview with Joop Sanders, March 4, 1991.

27. Robert Goodnough, "Pollock Paints a Picture," *Art News*, May 1951, p. 39.

28. "Words," *Time*, February 7, 1949, p. 51. (That same day, Emily Genauer in the *New York World-Telegram* compared his paintings at Betty Parsons to "a mop of tangled hair I have an irresistible urge to comb out."); "Jackson Pollock: Is He The Greatest Living Painter in the United States?" *Life*, August 8, 1949, pp. 42–43; "Rich Tastes," *Time*, August 27, 1951, p. 78; "Jackson Pollock's Abstractions," *Vogue*, March 1951, p. 159. For the contrast between the Luce publications and more upscale magazines, see Mary Lee Corlett, "Jackson Pollock: American Culture, the Media and the Myth," *Rutgers Art Review* 8, 1987, pp. 92–93.

29. On "The Irascibles" protest, see Irving Sandler, *The Triumph of American Painting* (New York: Praeger, 1970), p. 213; and B.H. Friedman, *Jackson Pollock: Energy Made Visible* (New York: McGraw-Hill, 1972), pp. 152–153. The Summer 1950 *Art News* contained an editorial by Alfred Frankfurter agreeing with the artists' criticism, but objecting to their strategy of refusal. The artists signing the original letter were the following, with participants in the Ninth Street Show starred: Painters—Jimmy Ernst*, Gottlieb, Motherwell*, Baziotes, Hofmann*, Newman, Stamos*, Still, Pousette-Dart, Reinhardt*, Pollock*, Rothko, Tomlin*, Willem de Kooning*, Hedda Sterne, James Brooks*, Weldon Kees, and Fritz Bultmann; Sculptors—Ferber*, David Smith*, Lassaw, Mary Callery, Day Schnabel*, Lipton*, Grippe*, Roszak, Hare, and Louise Bourgeois.

30. Barbara Rose, "Richard Pousette-Dart: Expression in Paint," *Journal of Art*, March 1991, p. 50. Pousette-Dart is listed among others in the *New York Times* notice of the show on May 23, 1951, p. 33, but the writer might well have taken his name from the announcement without seeing his work there.

31. Interview with Michael Goldberg, December 7, 1990.

32. A copy of the poster in the Museum of Modern Art Library has the following additional artists written in by hand: Karoly, Dienes, Albert, Nichols, Florence Grippe, Anita, Cornell, Rauschenberg, Siskind, Finkelstein, Farber, L. Sander, and A. Kent.

33. For this painting and its inclusion in the Ninth Street Show, see Calvin Tomkins, *Off the Wall: Robert Rauschenberg and the Art World of Our Time* (New York: Penguin, 1981), pp. 52, 61–62; and Roni Feinstein, "The Unknown Early Rauschenberg: The Betty Parsons Exhibition of 1951," *Arts*, January 1985, pp. 126–131. Castelli has said in an interview on Dec. 5, 1990, and in Ann Hindry, p. 86, that he chose this painting for the exhibition. While on most accounts the artists are said to have selected their own work, Thomas Hess's review in *Art News* (Summer 1951, p. 46) says, "Some pictures were chosen by the artist himself; others picked by a small delegation of colleagues." Alcopley, interview of Feb. 22, 1991, says that he was at 60 E. 9th St. when Rauschenberg came with his picture, and that both Castelli and Vicente wanted to reject it, but were persuaded by Alcopley to hang the painting. Vicente does not remember this, and Rauschenberg was unavailable for comment.

34. Ellen G. Landau, *Jackson Pollock* (New York: Harry N. Abrams, 1989), p. 264 n19.

35. This attitude was expressed in interviews with Marca-Relli, Vicente, Goldberg, Alcopley, and Sanders. For the objective ground of the situation in the art market, see Deidre Robson, "The Market for Abstract Expressionism: The Time Lag Between Critical and Commercial Acceptance," *Archives of American Art Journal*, vol. 25, no. 3, 1985, pp. 19–23.

36. Hess compares him to van Gogh and Soutine, and describes de Kooning's painting in a manner typical of his promotion of the artist: ". . . when the picture finally emerges from the thousands of notations that have appeared and disappeared on its surface, it bears a living, human statement, sometimes fragmented, often mysterious, always expressed as a complex of culture (instead of the usual simplification of Paris)." *Art News*, April 1951, p. 52. A year earlier Hess had compared Pollock's entry unfavorably with de Kooning's *Attic* in his review of the Whitney Annual, "8 excellent, 20 good, 133 others," *Art News*, January 1950, pp. 34–35.

37. Gibson, p. 344. The topic of naming was pressed by Alfred Barr, and Motherwell had just mentioned three possibilities: Abstract-Expressionist, Abstract-Symbolist, and Abstract-Objectionist.

38. *Art News*, January 1952, p. 43. Among those in the exhibition were de Kooning, Pollock, Goodnough, Gorky, Brooks, Motherwell, Matta, Tobey, Tomlin, Vicente, Hofmann, Baziotes, Kline, Reinhardt, and Tworkov. It was shown at Janis in December 1951, and in Paris at the Galerie de France in January 1952.

39. The term first seems to have been used in Germany in 1919–1920, and was adopted by Barr in his 1929 lecture at Wellesley College "Kandinsky and Abstract Expressionism in Germany," and in subsequent writings in Museum of Modern Art catalogues through the thirties. See Peter Selz, *German Expressionist Painting* (Berkeley: University of California Press, 1957), p. 342 n49. On the Club panels and this term, see Phillip Pavia, "The Unwanted Title," *It Is*, Spring 1960, pp. 8–11.

40. Ferren, p. 24.

41. *New York Times*, May 23, 1951, p. 33. The piece lists as the familiar names in the show Brooks, Cavallon, the de Koonings, Guston, Hofmann, Lippold, Ernst, Ferber, Lipton, Margo, Fine, Motherwell, Pol-

lock, Reinhardt, Stamos, Tomlin, and Pousette-Dart.

42. Thomas B. Hess, "New York's avant-garde," *Art News*, Summer 1951, pp. 46–47; Belle Krasne, "Ninth Street Event," *Art Digest*, June 1, 1951, p. 15. Hess gives some feeling for the "hit-or-miss informality" of the show: "A few entries were accepted because 'so-and-so' is 'such a nice fellow'; a few because 'such-and-such' was a 'great help'. . . . Some out-of-town guests were invited; some in-town ones were simply forgotten. . . ."

43. Thomas B. Hess, "The New York Salon," *Art News*, February 1954, pp. 25, 56.

44. John Ferren, "Stable State of Mind," *Art News*, May 1955, pp. 22–23.

45. For details of these cooperative galleries, see Joellen Bard, *Tenth Street Days: The Co-ops of the 50's* (New York: Education, Art & Service, 1977).

46. On discussions of this subject, see Irving Sandler, *The New York School*, pp. 279–289.

47. Friedel Dzubas statement is from "Is There a New Academy?" *Art News*, September 1959, pp. 37, 59.

48. *Life*, November 1959, p. 69. The magazine explained that these painters were involved with the universal concerns of all art—"nature, man and the spirit"—but rather than depicting, for example, a suffering man, they would try to evoke feelings of suffering in the viewer.

Chapter 10

1. Barbara Bertozzi, "On the Origin of the New Avant-Gardes: The Japanese Association of Artists Gutai," in Barbara Bertozzi and Klaus Wolbert, eds., *Gutai: Japanische Avantgarde/Japanese Avant-Garde, 1954–1965* (Darmstadt: Mathildenhöle Darmstadt, 1991), p. 51.

2. For an example, see the untitled work from 1936 reproduced in Joseph Love, "The Group in Contemporary Japanese Art—Gutai and Jiro Yoshihara," *Art International*, Summer 1972, p. 126.

3. For a discussion of Gutai and Harold Rosenberg's "action painting," see Akira Tatehata, "Tableau qui se génère—Les années de l'Association d'Art Gutai," in *Action et Emotion, Peintures des Années 50: Informel, Gutai, Cobra* (Osaka: Musée National d'Art, 1985), pp. 119–120.

4. With Jiro Yoshihara as chairman, the founding members of the Gutai Art Association were Shozo Shimamoto (secretary), Sadami Azuma, Kei Isetani, Tamiko Ueda, Chiyu Uemae, Hiroshi Okada, Yoshi Sekine, Toichiro Fujikawa, Yutaka Funai, Masatoshi Masanobu, Tsuruko Yamasaki, Toshio Yoshida, Hideo Yoshihara, and Michio Yoshihara.

5. See the work designated as "Holes," in *Reconstructions: Avant-Garde Art in Japan 1945–1965* (Oxford: Museum of Modern Art Oxford, 1985), p. 53. Yoshihara would compare a later work of Shimamoto's from their third indoor exhibition, a piece of sheet metal pierced by holes, to the paintings of Fontana, mentioning that his colleague's work is much dirtier than the Italian's, which has "an elegant snobbish effect." Jiro Yoshihara, "Protocol of the Third Gutai Exhibition" (1957), reprinted in Bertozzi and Wolbert, p. 424.

6. Bertozzi, p. 20.

7. Yozo Ukita, "Experimental Outdoor Exhibition of Modern Art to Challenge the Burning Midsummer Sun," *GUTAI* 3, October 20, 1955, p. 24 (re-translated in Bertozzi and Wolbert, pp. 408–410). The quoted characterizations of works in the text are from this account.

8. Jiro Yoshihara, "On the First 'GUTAI-TEN' (The First Exhibition of 'GUTAI' Art Group)," *GUTAI* 4, July 1, 1956, p. 2 (re-translated in

Bertozzi and Wolbert, pp. 410–414). Quotations in the text are from Yoshihara's account. The artists who went to Tokyo early were Shiraga, Kanayama, Motonaga, Tanaka, Yamazaki, Sumi, and Murakami.

9. I.G. Edmonds, "Art Is a Hole in the Ground," *Pacific Stars and Stripes*, Tokyo, October 22, 1955, p. 16, reprinted in Bertozzi and Wolbert, pp. 443–444.

10. Jiro Yoshihara, "On the Second Outdoor Exhibition of 'Gutai' Art Group," *GUTAI* 5, October 1956, p. 1 (re-translated in Bertozzi and Wolbert, pp. 418–422). Quotes following in the text are from this account.

11. Shozo Shimamoto, "The Theory of the Curse of the Brush," from *GUTAI* 6, April 1, 1957, in Bertozzi and Wolbert, p. 398.

12. Yasuo Sumi, "In Search of Beauty," from *GUTAI* 7, July 15, 1957, in Bertozzi and Wolbert, p. 405.

13. Jiro Yoshihara, "Protocol of the Third Gutai Exhibition," *GUTAI* 7, July 15, 1957, in Bertozzi and Wolbert, pp. 423–425.

14. Jiro Yoshihara, "The Gutai Manifesto," from *Geijutsu Shincho*, December 1956, in Bertozzi and Wolbert, pp. 364–368.

15. Yoshihara's program and account of the event in *GUTAI* 7 (July 15, 1957, pp. 1–2; re-translated without the program in Bertozzi and Wolbert, pp. 425–429) dates the Tokyo performance on July 17, but Bertozzi cites July 29 (Bertozzi and Wolbert, p. 39). Kaprow says that he learned of the Gutai from Alfred Leslie, and that he only received detailed information on their stage performances in 1963. For his account of the Gutai in the context of Happenings, based on material sent to him by Yoshihara, see Allan Kaprow, *Assemblage, Environments and Happenings* (New York: Harry N. Abrams, 1966), pp. 210–224. Of the 42 Happenings presented in the last section of Kaprow's book, almost one quarter were Gutai events.

16. Ray Falk, "Japanese Innovators," *New York Times*, December 8, 1957, p. 24x, reprinted in Bertozzi and Wolbert, pp. 445–448.

17. Masa'aki Iseki, "Historical Background and Development of the Gutai Group as a Central Question," in Bertozzi and Wolbert, p. 87.

18. For an account of the Gutai acceptance of Tapié, see Shinichiro Osaki, "Painting Between Action and Material," in Bertozzi and Wolbert, pp. 71–74.

Chapter 11

1. For a close study of the Rosicrucian influence on Klein, and of the detailed parallels between his work and the doctrine of Max Heindel's *La Cosmogonie des Rose-croix*, which Klein began seriously studying in 1948 in Nice with his friends Armand Fernandez (Arman) and Claude Pascal, see Thomas McEvilley, "Yves Klein: Conquistador of the Void" and "Yves Klein and Rosicrucianism," both in Institute for the Arts, Rice University, *Yves Klein, 1928–1962: A Retrospective* (Houston: Institute for the Arts, Rice University, 1982). This catalogue also includes a translation of Klein's own account of Le Vide, pp. 225–228.

2. McEvilley, "Yves Klein and Rosicrucianism," p. 247. The paintings, of course, were blue, as he later spoke of Le Vide as an exhibition of "an immaterial blue color." McEvilley, "Yves Klein: Conquistador," p. 58.

3. On International Klein Blue, see McEvilley, "Yves Klein: Conquistador of the Void," p. 85 n53, and Carol C. Mancusi-Ungaro, "A Technical Note on IKB," in *Yves Klein*.

4. Nan Rosenthal, "Assisted Levitation: The Art of Yves Klein," in *Yves*

Klein, p. 108.

5. Rosenthal, pp. 109–110. Noting that their proportion of 5/4 was the same as that of most of Klein's blue monochrome paintings, Rosenthal views these stamps as original monochromes belonging to a very large series.

6. Interview with Arman, June 19, 1991.

7. McEvilley, "Yves Klein: Conquistador," p. 27.

8. Quoted phrases in this and the next paragraph are from Klein's own account of the exhibition. Yves Klein, "Preparation and Presentation of the Exhibition of 28 April 1958," in *Yves Klein*, pp. 225–227.

9. On another trip Klein would leave an elaborate ex-voto containing the gold that he obtained from the first four sales of his "zones of immaterial sensibility." For Klein and his devotion to Saint Rita, including an account of this ex-voto, see *Yves Klein*, pp. 22–23, 255–257, 273.

10. Klein, p. 225.

11. McEvilley, "Yves Klein: Conquistador," p. 86 n73, notes that Iris Clert remembered people entering in threes, and that Claude Pascal, the third member of the trio who met at the Nice judo class, recalled groups of five.

12. *Cimaise*, May–June, 1958, quoted in Pierre Restany, *Yves Klein* (New York: Harry N. Abrams, 1982), p. 50.

13. For the aristocratic character of the historical avant-garde, see Renato Poggioli, *The Theory of the Avant-Garde* (Cambridge, MA: Harvard University Press, 1968), p. 39.

14. Klein, p. 228.

15. Interview with Arman, June 19, 1991.

16. Inside the sardine can: "*Iris Clert vous prie de venir contempler dans 'le plein' toute la force du réel condensé en une masse critique.*" The complete text of Restany's typed message reads: "*Un évènement capital chez Iris CLERT en 1960. En faisant le 'PLEIN' de la Galerie, ARMAN donne au nouveau réalisme sa totale dimension architectonique. Dans un tel cadre, le fait est d'importance: Jusqu'à présent, un geste d'appropriation à l'antipode du 'Vide' n'avait cerné d'aussi près l'authentique organicité du réel contingent.*" For the translation of Restany that appears in the text, I thank Anthony Davenport.

17. The entire list is printed in Henry Martin, *Arman, or Four and Twenty Blackbirds Baked in a Pie, or Why Settle for More When You Can Settle for Less* (New York: Harry N. Abrams, 1973), pp. 26–29.

18. For the notion of "practices of negation" as essential to the modernist avant-garde, see T.J. Clark, "Clement Greenberg's Theory of Art," in Francis Frascina, ed., *Pollock and After: The Critical Debate* (New York: Harper and Row, 1985), p. 55.

19. Interview with Arman, June 19, 1991. Arman also remembers Klein sending him a note saying, "Hail Arman, who mummifies quantity." Klein's statement in the book was: "*Après mon Vide, Le Plein d'Arman. Il manquait à la mémoire universelle de l'art cette momification décisive du quantitativisme. La nature tout entière enfin rassurée va commencer, comme dans les temps anciens, à nous parler en direct et avec clarté dès à présent.*" Otto Hahn, *Arman* (Paris: Fernand Hazan, 1972), p. 12. For the English translation in the text, I thank Anthony Davenport.

20. Martial Raysse, "Refusing Duality. 'The Impeccable Trajectory of Yves Klein,'" *Arts*, February 1967, p. 35.

21. Interview with Arman, October 11, 1991.

22. Pierre Restany, "Modern Nature," in *Breakthroughs: Avant-Garde Artists in Europe and America, 1950–1990* (New York: Rizzoli, 1991), p. 43. For a detailed chronology of events in Paris and New York involving these artists from 1957 to 1963, see *Nouveaux Réalistes* (New York: Zabriskie Gallery, 1988), pp. 16–21.

23. Martha Jackson Gallery, *New Forms–New Media I* (New York: Martha Jackson Gallery, 1960). John Canaday, "The Blind Artist—In a Crucial Time He Plays at Games," *New York Times*, October 2, 1960, section 2, p. 21. He remarked, "At a time when the front page is filled with the kind of news it is just now, a show like this one is downright embarrassing." The paper's headline that day read "Khrushchev Warns U.N. of War Peril of China Issue," and the traffic of which Canaday complained in his review seems to have been a consequence of the police bomb squad investigating a suspicious apple pie sent to Khrushchev as a gift.

24. For Kaprow's groundbreaking perspective, see his "The Legacy of Jackson Pollock," *Art News*, October 1958, pp. 24–26, 55–57. The best overall source on Happenings is Michael Kirby, *Happenings: An Illustrated Anthology* (New York: E.P. Dutton and Co., 1965), which includes scripts for many of the classic performances. Kaprow's own *Assemblage, Environments and Happenings* (New York: Harry N. Abrams, 1966) contains important theoretical exposition and is a powerful evocation of the period. For interviews with important figures, see Richard Kostelanetz, *The Theatre of Mixed-Means* (New York: RK Editions, 1980). For an overview of the period in all its variety, including a full chronology of exhibitions and performances, see Barbara Haskell, *BLAM! The Explosion of Pop, Minimalism, and Performance 1958–1964* (New York: Whitney Museum of American Art, 1964).

25. Barbara Rose, *Claes Oldenburg* (New York: The Museum of Modern Art, 1969). Also see the artist's 1961 notebook remarks in Claes Oldenburg and Emmett Williams, *Store Days* (New York: Something Else Press, 1967), pp. 8, 49, 81.

26. For the full inventory of The Store, with prices, see Oldenburg and Williams, pp. 31–34.

27. Sidney Tillim, "Month in Review," *Arts*, February 1962, p. 36.

28. Oldenburg and Williams, p. 150.

29. John W. McCoubrey, *Robert Indiana* (Philadelphia: University of Pennsylvania, Institute of Contemporary Art, 1968), p. 54.

30. John Rublowsky, *Pop Art*. Photography by Ken Heyman. (New York: Basic Books, 1965). In addition to photographs of the Sculls, the book showed the home of Leon Kraushar, whose widow would sell his Pop works through Munich dealer Heiner Friedrich in 1968 to German collector Hans Stroher, who would circulate them throughout Germany before their installation in the Hessischen Landesmuseum in Darmstadt. Phyllis Tuchman, "American Art in Germany: The History of a Phenomenon," *Artforum*, November 1970, p. 59.

31. "You Bought It—Now Live with It," *Life*, July 16, 1965, p. 59.

32. Actually, this was the first group show *in New York* to feature the newly emerged form of Pop. The previous April and May, the Dallas Museum for Contemporary Art had presented the exhibition 1961, whose 36 artists included Dine, Lichtenstein, Oldenburg, and Rosenquist. There The Store was partially re-created, and Oldenburg presented a second version of his Happening, *Injun*.

33. Harold Rosenberg, "The Art Galleries: The Game of Illusion," *The*

New Yorker, November 24, 1962, p. 162. Thomas B. Hess, "New Realists," Art News, December 1962, p. 12. Sidney Tillim, "The New Realists," Arts, December 1962, pp. 43–44. Four years later the show was cited in these terms by Lucy Lippard in her early overview of the movement, where she noted that at Janis "Pop was consecrated as fashionable. . . ." Lucy Lippard, "New York Pop," in Lucy Lippard, Pop Art (New York: Praeger, 1966), p. 84.

34. Sidney Janis, "On the Theme of the Exhibition," in New Realists (New York: Sidney Janis Gallery, 1962). On Alloway's use of the term Pop, see Lawrence Alloway, "The Development of British Pop," in Lippard, p. 27. Alloway's misleading use of the Independent Group activities in England as a precursor of American Pop is discussed in Lynn Cooke, "The Independent Group: British and American Pop Art, A 'Palimpcestuous' Legacy," in Kirk Varnedoe and Adam Gopnik, eds., Modern Art and Popular Culture: Readings in High and Low (New York: Museum of Modern Art, 1990), especially pp. 197–202. For the four exhibitions of the Independent Group, which include the important This Is Tomorrow of 1956, see Graham Whitham, "Exhibitions," in David Robbins, The Independent Group: Postwar Britain and the Aesthetics of Plenty (Cambridge, MA: MIT Press, 1990), pp. 123–161. The cited articles appeared in the New York Times on November 4, 1962, Section 2, p. 23, and in Time on May 3, 1963, pp. 69ff. and August 30, 1963, p. 40.

35. Dore Ashton, "New York Report," Das Kunstwerk (16), November–December, 1962, p. 69. Hess, p. 12. "Sidney Janis," in Laura de Coppet and Alan Jones, The Art Dealers (New York: Clarkson N. Potter, 1984), pp. 39–40.

36. Hess, p. 13.

37. Restany, "Modern Nature," p. 44.

38. Interview with Arman, October 11, 1991.

39. According to unpublished interviews conducted by Susan Hapgood in Paris in April 1992, both Pierre Restany and Daniel Spoerri hold this view. I thank Hapgood for the use of her transcripts, in which Restany also suggests that it was Leo Castelli who convinced Janis to focus on the new Pop artists instead of Neo-Dada.

40. Pierre Restany, "Le Nouveau Réalisme à la Conquête de New York," Art International, January 25, 1963, pp. 33–36. Janis cabled the Galerie J about Restany's text being largely "irrelevant" on September 25, explaining in a letter the same day that they had been unable to get an "intelligible translation" of the whole essay, but that Georges Marci (who worked with Jean Larcade, and had introduced Arman to Janis) had managed to render part of it into understandable English. Janis felt that to print the whole piece would damage the reputations of both Restany and the Nouveaux Réalistes. Sidney Janis Gallery Archives, New York.

41. Dore Ashton, "New York Report," Das Kunstwerk, November–December 1962, pp. 69–70. Irving Sandler, "In the Galleries," New York Post, November 18, 1962, magazine, p. 12. Hilton Kramer, "Art," Nation, November 17, 1962, p. 335. Max Kozloff, "Pop Culture, Metaphysical Disgust and the New Vulgarians," Art International, February 1962, p. 38. Brian O'Doherty, "Art: Avant-Garde Revolt: 'New Realists' Mock U.S. Mass Culture in Exhibition at Sidney Janis Gallery" and " 'Pop' Goes the New Art," New York Times, October 31, 1962, p. 41 and November 4, 1962, section 2, p. 23. Much of the published criticism of Pop is reprinted in Carol Anne Mahsun, ed., Pop Art: The Critical Dialogue (Ann Arbor: UMI, 1989), and discussed in Carol Anne Mahsun, Pop Art and the Critics (Ann Arbor: UMI, 1987).

42. The proceedings were published a few months later in "A Symposium on Pop Art," Arts, April 1963, pp. 36–45. The participants were Henry Geldzahler, Hilton Kramer, Dore Ashton, Leo Steinberg, Stanley Kunitz, and Peter Selz, and at the symposium slides were shown of the artists' work. Jill Johnston reported that Marcel Duchamp was in the audience, and that after Kramer called him "the most overrated figure in modern art," Duchamp remarked to his neighbor that the critic seemed "insufficiently light-hearted." Jill Johnston, "The Artist in a Coca-Cola World," The Village Voice, January 31, 1963, p. 24.

43. "Pop Art—Cult of the Commonplace," Time, May 3, 1963, pp. 69–70. The article was occasioned by Lawrence Alloway's exhibition at the Guggenheim Museum, "Six Painters and the Object." (The artists were Dine, Johns, Lichtenstein, Rauschenberg, Rosenquist, and Warhol.) Time goes on to quote Philip Johnson calling Pop "the most important art movement in the world today," and Max Ernst derisively remarking, "It is just some feeble bubbles of that Coca-Cola, which I consider less than interesting and rather sad."

44. Both remarks are from the Art International number of January 25, 1963, devoted to the Janis exhibition. The sales situation is reported by Sonya Rudikoff, "New Realists in New York," p. 41, and the comment on the collectors is from Barbara Rose, "Dada Then and Now," p. 27.

45. Allan Kaprow, "Should the Artist Become a Man of the World?" Art News, October 1964, p. 34. Summarizing the New York art scene a few years later, Alan Solomon, who had mounted the early retrospectives of Johns and Rauschenberg at the Jewish Museum, remarked that with the "analysts' bills, sports cars, Barcelona chairs, summer houses, travel abroad, [and] custom clothes . . . [i]t has become ever more difficult to tell the artists from the collectors." Alan Solomon, text, and Ugo Mulas, photographs, New York: The Art Scene (New York: Holt Rinehart Winston, 1967), p. 67.

Chapter 12

1. Roy Lichtenstein in interview with G.R. Swenson, "What Is Pop Art?" Art News, November 1963, p. 25. Ivan Karp, "Anti-Sensibility Painting," Artforum, September 1963, p. 27. Dore Ashton, "The Distance from 1926 to 1966," Arts, December 1966–January 1967, p. 33.

2. M. Bochner, "Primary Structures," Arts, June 1966, p. 32. In the first detailed critical discussion of the art of Judd, Morris, Andre, et al., Barbara Rose's "ABC Art" in Art in America, October–November 1965, the "French objective novel" of, e.g., Robbe-Grillet is mentioned as close in sensibility to the new work. Rose remarks, however, that there was not actual influence here—her ABC artists were more directly influenced by reading the philosopher Ludwig Wittgenstein. See the reprinting of the piece in Gregory Battcock, ed., Minimal Art: A Critical Anthology (New York: E.P. Dutton, 1968), p. 292.

3. Hilton Kramer, " 'Primary Structures'—The New Anonymity," New York Times, May 1, 1966, p. D23. In her generally even-tempered account of the exhibition, however, Corinne Robins presents the show in more grandiose terms—"A social and artistic event comparable only to the Armory Show half a century before." Corinne Robins, "Object, Structure or Sculpture: Where Are We?" Arts, September–October, 1966, p. 33.

4. Sam Hunter, "A Statement," in The Museum World, Arts Yearbook 9, 1967, p. 36. Hunter also was interested in showing historical work that was of particular relevance to current concerns of younger artists, and to this end he mounted a show of Ad Reinhardt's "black" paintings in 1966 and an Yves Klein retrospective in 1967.

5. Donald Judd, "Specific Objects," Arts Yearbook 8, 1965, reprinted in Donald Judd, Complete Writings 1959–1975 (Halifax: Nova Scotia College

of Art and Design, 1975), pp. 181–188.

6. Richard Wollheim, "Minimal Art," *Arts*, January 1965, reprinted in Battcock. Judd wrote in the catalogue, "I don't think that anyone's work is reductive. The most the term can mean is that new work doesn't have what the old work had." Kynaston McShine, *Primary Structures: Younger American and British Sculptors* (New York: The Jewish Museum, 1966), n.p. Morris made the essential point clearly a few months before: "Simplicity of shape does not necessarily equate with simplicity of experience." Robert Morris, "Notes on Sculpture, Part I," *Artforum,* February 1966, reprinted in Battcock, p. 228.

7. The interview by Bruce Glaser was broadcast on WBAI in New York in February 1964, and was entitled "New Nihilism or New Art?" Edited by Lucy Lippard, it was printed under the more minimal title "Questions to Stella and Judd" in *Art News*, September 1966, and reprinted in Battcock, where Judd's quoted remarks are on pp. 150 and 154.

8. Barbara Haskell, *BLAM! The Explosion of Pop, Minimalism, and Performance 1958–1964* (New York: Whitney Museum of American Art, 1984), pp. 100–101. For an illuminating comparison of the new dance and the new sculpture, see the list of analogous elements drawn by Yvonne Rainer in "A Quasi Survey of some 'Minimalist' Tendencies in the Quantitatively Minimal Dance Activity Midst the Plethora, or an Analysis of *Trio A*," Battcock, p. 263.

9. Robert Morris, "Notes on Sculpture, Part II," *Artforum*, October 1966, reprinted in Battcock, p. 232.

10. For this perspective on Minimalism, see Kenneth Baker, *Minimalism: Art of Circumstance* (New York: Abbeville, 1988), especially pp. 21–22, 71, and 89. Also see Hal Foster, "The Crux of Minimalism," in *Individuals: A Selected History of Contemporary Art* (Los Angeles: Museum of Contemporary Art, 1986), pp. 177–178.

11. Notwithstanding this Greenbergian motivation, the most sustained criticism of Minimalist sculpture was marshalled by Greenberg acolyte Michael Fried in his "Art and Objecthood" (*Artforum*, June 1967; reprinted in Battcock), who argued that in its inclusion of the viewer within the sculptural field Minimalism was essentially "theatrical," a repudiation of Modernism by denying self-sufficiency to the work itself.

12. Kramer, p. D23. Rose, p. 291. John J. O'Connor, "Exploring Space," *Wall Street Journal*, June 6, 1966, p. 18.

13. The two works by Judd differed only in the cross bar of the hanging piece being painted blue. At the symposium held in conjunction with Primary Structures, Frank Stella asked Judd whether he experienced the volumes of the two works differently. He replied that the work seemed larger on the floor, since one could observe the back along with the front, sides, and top, whereas the wall piece appeared somewhat flattened. But Judd says that the work can be displayed any way, "on the ceiling, wall, or floor." "The New Sculpture," symposium held May 2, 1966 at the Jewish Museum, transcript in the Archives of American Art, n.p.

14. Robert Hobbs, *Robert Smithson: Sculpture* (Ithaca: Cornell University Press, 1981), p. 65.

15. David Bourdon, "The Razed Sites of Carl Andre: A Sculptor Laid Low by the Brancusi Syndrome," *Artforum*, October 1966, reprinted in Battcock, p. 104.

16. "Engineer's Esthetic," *Time*, June 3, 1966, p. 64. The issue's cover story was "Viet Nam and the Class of '66."

17. Dan Flavin, "'. . . in daylight or cool white.' an autobiographical

sketch," *Artforum*, December 1965, p. 24. In another similarity with Andre on *Lever*, Flavin referred to the angle of this first neon piece as "the diagonal of personal ecstasy." See Anna C. Chave, "Minimalism and the Rhetoric of Power," *Arts*, January 1990, p. 45.

18. Interview with Kynaston McShine, February 18, 1992.

19. Bryan Robertson, *The New Generation: 1965* (London: The Whitechapel Gallery, 1965). For contemporary accounts of this group of artists, see Gene Baro, "Britain's New Sculpture," *Art International*, June 1965, and "Britain's Young Sculptors," *Arts*, December 1965; Andrew Forge, "Some New British Sculptors," *Artforum*, May 1965; Norbert Lynton, "Latest Developments in British Sculpture," *Art and Literature*, Summer 1964; and Jaisa Reichardt, "Color in Sculpture," *Quadrum* XVIII, 1965, which includes color photographs of many pieces.

20. Robins, p. 36. Andrew Hudson, "English Sculptors Outdo Americans," *Washington Post*, May 8, 1966, p. G7. Although Hilton Kramer marked Caro as the most impressive artist in the show, he did not think *Titan* a particularly strong piece and was not interested in the other English artists. Kramer, p. D23.

21. The following three essays were prompted by the Whitney Sculpture Annual: Irving Sandler, "The New Cool Art," *Art in America*, February 1965; Max Kozloff, "The Further Adventures of American Sculpture," *Arts*, February 1965; Barbara Rose, "Looking at American Sculpture," *Artforum*, February 1965. For sympathetic detailed exposition focusing on Judd and Morris, see Lucy Lippard, "The Third Stream—Constructed Paintings and Painted Structures," *Art Voices*, Spring 1965. Phyllis Tuchman emphasizes the way in which "lengthy discourse really preceded prolonged observation" of such sculpture in her "Minimalism and Critical Response," *Artforum*, May 1977, p. 26. For quoted remarks, see Hilton Kramer, "An Art of Boredom?" *New York Times*, June 5, 1966, p. D23; "Engineer's Esthetic," *Time*, June 3, 1966, pp. 64–67.

22. There were a few group shows involving Minimalist sculpture before Primary Structures, most notably Black, White, and Grey at the Wadsworth Athenaeum, Hartford, Connecticut, Jan.–Feb. 1964, and Shape and Structure at Tibor de Nagy in 1965. A more underground early exhibition was organized by Dan Flavin at the Kaymar Gallery on West Broadway in March 1964, in which he placed work of his friends, including Judd, Stella, LeWitt, and Robert Ryman. On this show, see Lucy R. Lippard in Alicia Legg, ed., *Sol LeWitt* (New York: Museum of Modern Art, 1978), p. 25.

23. McShine is quoted in Grace Glueck's article appearing just before the exhibition opened, which announced that already "it's being hailed as This Year's Landmark Show." "Anti-Collector, Anti-Museum," *New York Times*, April 24, 1966, p. x24. Harold Rosenberg, "Defining Art," *The New Yorker*, February 25, 1967, reprinted in Battcock, p. 303. Brian O'Doherty, "Minus Plato," *Art and Artists*, September 1966, reprinted in Battcock, p. 254. A number of the artists concurred with this view of the avant-garde. Witness Dan Flavin: "The term 'avant-garde' ought to be restored to the French Army where its manic sense of futility propitiously belongs. It does not apply to any American art that I know about." Dan Flavin, "Some Remarks," *Artforum*, December 1966, p. 27. A similar view is expressed by Sol LeWitt in "Comments on an Advertisement Published in *Flash Art*, April 1973," in Legg, p. 174.

24. Robins, pp. 34–35. McShine, n.p.

25. Interview with Corinne Robins and Salvatore Romano, February 14, 1992. For Romano, these huge, inexpensive lofts provided artists with a truly "American space." For Robins, the lofts supplied them with a "macho space."

26. Robert Smithson, "Entropy and the New Monuments," *Artforum*, June 1966, p. 26. The essay reproduced quite a few works from Primary Structures, which provided the occasion for its publication.

27. Irving Sandler, "Ronald Bladen: '. . . sensations of a different order,'" *Artforum*, October 1966, pp. 33, 35.

28. Glueck, p. x24. In his catalogue essay, McShine stated that the scale of the work involves "an implicit social criticism" of the commercial art system, since most collectors and museums would be unable to acquire sculpture of this size. He also noted that the use of easily fabricated or store-bought components by Andre, Judd, and Flavin has a similar effect, subverting the precious character of the fine art object through ready reproducibility. McShine, n.p. Barbara Rose had remarked that the work in Morris's 1964 Green Gallery show was "flagrantly uncommercial," and much of the sculpture of the time was seen this way. Rose, "Looking at American Sculpture," p. 35. Information on the immediate sale of the Bladen edition is from an interview with the artist's companion, Connie Reyes, February 25, 1992.

29. "The New Sculpture," symposium on Primary Structures, Jewish Museum, May 2, 1966. Moderator, Kynaston McShine. All quotations are from a transcript of the panel discussion on deposit in the Archives of American Art. Di Suvero saw work like Judd's and Morris's to be a "commercial acceptance of the technological world that disavows all of the joy and the tragedy and accepts regimentation." But when asked by Rose whether his work has "expressive quality," Judd replied, "Yes, of course," but that he didn't like using terms such as "spirit" or "mysticism" to talk about it.

30. Corinne Robins, "Four Directions at Park Place," *Arts*, June 1966, p. 20. Robins notes that the gallery seems a response to a public desperately seeking the new, and "With its 'art buttons,' press releases and elegantly illustrated invitations, it does indeed speak for a new gallery concept and the art scene of the sixties: an uneasy blending of the serious and the slick."

31. Haskell, pp. 98–99. It seems likely that this sculpture had an unseen gold ball on top. Eight verbal pieces by De Maria were published by La Monte Young and Jackson Mac Low in *An Anthology* (1963), including one dated February 1961 describing an 8-foot high column that had a small gold ball on top, the ball's presence being known only to De Maria.

32. Sol LeWitt, "Serial Project No. 1 (ABCD)," in Brian O'Doherty, ed., *Aspen Magazine*, Nos. 5–6, 1966, reprinted in Legg, p. 170.

33. Clement Greenberg, "Recentness of Sculpture," in Maurice Tuchman, ed., *American Sculpture of the Sixties* (Los Angeles: Los Angeles County Museum of Art, 1967), pp. 25–26. Donald Judd, "Complaints: Part I," *Studio International*, April 1969, reprinted in Judd, *Complete Writings*, pp. 197–198. Here Judd also states that he "hated the Primary Structures show," which he says was originally to include only Judd, Morris, Flavin, Andre, Bell, and a few others. This is not how it is remembered by the curator, however. I owe to Corinne Robins in conversation the suggestion that Greenberg gave priority to Anne Truitt in response to the displacement of color field painting by Minimalism.

34. Kramer, "'Primary Structures'—The New Anonymity," p. D23.

35. John Perreault, "Union-Made, Report on a Phenomenon," *Arts*, March 1967, p. 31. He begins the article by noting that Primary Structures was "the event that most clearly brought this Minimalist tendency into public focus."

36. For photographs and an account of the exhibition, see Lucy R. Lippard, "Eccentric Abstraction," *Art International*, November 20, 1966, pp. 28–40.

37. Sol LeWitt, "Paragraphs on Conceptual Art," *Artforum*, June 1967. LeWitt encapsulated his position in "Sentences on Conceptual Art," published in *0–9*, 1969, and in *Art-Language*, May 1969. Both pieces are reprinted in Legg, pp. 166–168. For a clear statement of LeWitt's importance in the move from Minimalism to Conceptualism, see Robert Pincus-Witten, "Sol LeWitt: Word ↔ Object," *Artforum*, February 1973, p. 69.

Chapter 13

1. In 1969, Peter Plagens suggested that in her huge show that took place throughout the city of Seattle, *557,087* (the title came from the city's population), Lucy Lippard "is in fact the artist and . . . her medium is other artists." Cited in Lucy R. Lippard, ed., *Six Years: The Dematerialization of the Art World from 1966 to 1972* (New York: Praeger, 1973), p. 111. The phenomenon of curator as artist culminated in the 1980s with such European shows as Jan Hoet's *Chambres d'Amis* in Ghent in 1986, and with the market-oriented activities of curators like Tricia Collins and Richard Milazzo in New York. Needless to say, this took place in very different ideological and economic circumstances than those of the late sixties counterculture.

2. Huebler taught and ran the lecture/exhibition program at Bradford Junior College in Massachusetts, and when speaker Dore Ashton saw his work there she suggested that he write to Kynaston McShine, who was assembling sculpture for Primary Structures. At the same time she told Huebler about Seth Siegelaub, who eventually visited and offered him an exhibition. Huebler worked for many months preparing the show—he had only recently begun his reductive Formica pieces—but in the interim Siegelaub had closed his gallery. Later, Siegelaub appealed to Huebler to allow him to handle his work as a private dealer. Interview with Douglas Huebler, March 22, 1992.

3. Interview with Huebler, March 22, 1992.

4. Frederik Leen, "Seth Siegelaub," *Forum International*, September 1991, p. 66. Lucy Lippard, "Douglas Huebler: Everything about Everything," in *Douglas Huebler* (Eindhoven: Van Abbemuseum, 1969), n.p.

5. The Bradford show was followed in May by an outdoor exhibition of these same artists at Windham College in Putney, Vermont, organized by Chuck Ginnever and Seth Siegelaub. For these two exhibitions, see Lippard, *Six Years*, pp. 40–42 and 46–48.

6. Language to be looked at and/or things to be read, June 3–28, 1967, and Language II, May 25–June 22, 1968. A third installment was held a year later, May 24–June 18, 1969, at which Huebler mounted a sheet of gray paper on the wall, and typed on the bottom, "The sound of every word spoken within the space of this room will accumulate and remain fixed on the above surface for the entire time that it is located on this wall." Peter Schjeldahl, "New York Letter," *Art International*, October 1969, p. 76.

7. Lippard, *Six Years*, p. 71.

8. For an account of Piper's conceptual work, see Claudia Barrow, *Adrian Piper: Space, Time and Reference 1967–1970* (New York: John Weber Gallery, 1991).

9. They included Kaspar König, Jan Dibbets, and Bernard Venet along with Dennis Hopper and New Yorkers like Richard Bellamy, Katherine Kuh, Brian O'Doherty, Mel Bochner, Kim Levin, Michael Kirby, Robert Mangold, Fred Sandback, David Diao, Dennis Oppenheim, Robert Ryman, and John Chamberlain. Information in this and the following paragraphs comes from an interview with Siegelaub on January

12, 1992, and from documents in the Seth Siegelaub Archives.

10. Interviews with Seth Siegelaub, January 12, 1992, and with Robert Barry, March 28, 1992.

11. Dan Graham's *Schema* was conceived in March 1966, and first published in *Aspen Magazine*, 1966–67. It is reproduced in Ursula Meyer, ed., *Conceptual Art* (New York: E.P. Dutton, 1972), p. 128. The announcement and ad for January 5–31, 1969 can be seen on the bottom of the cover of *Arts*, February 1989, below Duane Michal's photograph of Siegelaub's shadow. Michals shot the January Show as a freelance photographer, spending half an afternoon there and becoming very interested in the work. Interview with Seth Siegelaub, January 12, 1992.

12. Oldenburg's project was done in Central Park for the 1967 exhibition "Sculpture in the Environment," and photographs are reproduced in *L'Art Conceptuel, Une Perspective*, Second Edition (Paris: Musée d'Art Moderne de la Ville de Paris, 1990), p. 219. Oldenburg's other proposals for the exhibition were the naming of Manhattan as an art work, and a "scream monument" broadcasting a piercing cry through the city streets at 2:00 A.M. It is interesting that the exhibition jury that accepted Oldenburg's refilled hole in the ground rejected Robert Morris's proposal for displaying jets of steam as sculpture. Lucy R. Lippard and John Chandler, "The Dematerialization of Art," *Art International*, February 20, 1968, p. 32. William Anastasi had done an earlier wall removal of 17 x 14 inches in three incarnations before the January show: in 1966 in his studio at 133 Green Street, in John Weber's office at the Dwan Gallery in 1967, and in Klaus Kertess's office at the Bykert Gallery in 1967 or 1968. Interview with William Anastasi, April 24, 1992, and Thomas McEvilley, *William Anastasi* (New York: Scott Hanson Gallery, 1989), pp. 32–33.

13. Arthur R. Rose, "Four Interviews with Barry, Huebler, Kosuth, and Weiner," *Arts Magazine*, February 1969, p. 23. Reprinted in *Arts*, February 1989, p. 45, and in Gregory Battcock, ed., *Idea Art: A Critical Anthology* (New York: E.P. Dutton, 1973), p. 149.

14. For Reinhardt's "Art-as-Art," see Barbara Rose, ed., *Art as Art: The Selected Writings of Ad Reinhardt* (Berkeley: University of California Press, 1975), section 2. Kosuth clarified his terminology in a 1970 WBAI interview with Jeanne Segal, reprinted in Joseph Kosuth, *Art after Philosophy and After: Collected Writings, 1966–1990* (Cambridge, Mass.: MIT Press, 1991), p. 48.

15. The 13 photographs and Huebler's documentary statement are reproduced in *L'Art Conceptuel*, p. 176.

16. Dore Ashton, "New York Commentary," *Studio International*, March 1969, p. 136. For other reactions of the critical press, see Gabriele Guercio, "Formed in Résistance: Barry, Huebler, Kosuth, and Weiner vs. The American Press," in *L'Art Conceptuel*, pp. 74–81.

17. For a sense of the broad international character of *intermedia*, a term coined by Dick Higgins, through a full chronology of event and performance, see Hanns Sohm and Harald Szeemann, *happening & fluxus* (Cologne: Koelnischer Kunstverien, 1970). For its rich manifestation in the Fluxus publications of George Maciunas, see Jon Hendriks, *Fluxus Codex* (New York: Harry N. Abrams, 1988).

18. For Siegelaub's *March 1–31, 1969* and *July, August, September 1969*, see Lippard, *Six Years*, a documentary history of the period from one of its most active critics and exhibition organizers. Lippard and Siegelaub lived together during 1968–69, and there was much mutual influence.

19. For a picture of the political and cultural forces affecting the art of the late sixties, and a sense of the number of people involved in the conceptual movement, broadly construed, see Seth Siegelaub's response to Benjamin Buchloh in *L'Art Conceptuel*, pp. 257–258.

20. For one response to Morris, pointing out that everything has some sort of form, see Allan Kaprow, "The Shape of the Art Environment: How Anti Form Is 'Anti-Form'?" *Artforum*, Summer 1968, pp. 32–33. For Szeemann's problem with this title, see Jean-Marc Poinsot, "Harald Szeemann, 'Quand les attitudes deviennent forme' et quelques problèmes du musée d'art contemporain," in *Christian Boltanski, Daniel Buren, Gilbert & George, Jannis Kounellis, Sol LeWitt, Richard Long, Mario Merz* (Bordeaux: Musée d'art contemporain, 1990), p. 26. Szeemann relates the titling process in the diary of his travels assembling the exhibition, published in Stedelijk Museum, *Op Losse Schroeven: situaties en cryptostructuren* (Amsterdam: Stedelijk Museum, 1969), n.p.

21. Szeemann traveled to New York, San Francisco, Los Angeles, Chicago, and Washington, D.C. in December 1968, with stop-offs in Las Vegas for Christmas gambling (he made $90) and in Dallas to see the site of the Kennedy assassination (he dissented from the Warren Commission's view of the single gunman). January took him to Paris, Milan, Turin, Genoa, Bologna, Rome, and London. Details are presented in his diaristic account in *Op Losse Schroeven*. For excerpts from Szeemann's diary of the installation, see Harald Szeemann, "When Attitudes Become Form, Bern 1969," in Bernd Klüser and Katharina Hegewisch, eds., *Die Kunst der Ausstellung* (Frankfurt am Main and Leipzig: Insel Verlag, 1991), pp. 216–217. For assistance with the translation of this material, I would like to thank Klaus Ottmann and Regina Cherry.

22. Joseph Kosuth has said that Robert Morris went to Weiner's studio seeking work for the Castelli warehouse exhibition, where he saw the "materialist" conceptual works to be published in *Statements*. According to Kosuth, while Morris did not put Weiner in the exhibition, he told Serra about Weiner's pieces, and that this gave Serra the idea for the splashed lead. Interview with Joseph Kosuth, October 8, 1991, and 1970 notes recently published as "Influences: The Difference Between '*How*' and '*Why*,'" in Kosuth, p. 81. While Lawrence Weiner (interview, March 24, 1992) denies this account, Douglas Huebler remembers Weiner complaining about the matter at a planning meeting for the January Show (interview, March 22, 1992) and Robert Barry remembers him being upset by Serra's lead piece (interview, March 28, 1992). Whatever the truth of this story, clearly Serra's concerns with material and process were completely different than Weiner's and predate his splash piece.

23. The artists in the Castelli exhibition, in which Morris showed none of his own work, were Giovanni Anselmo, Bill Bollinger, Eva Hesse, Stephen Kaltembach, Bruce Nauman, Alan Saret, Richard Serra, Keith Sonnier, and Gilberto Zorio. Eva Hesse completed two additional pieces for Bern in January (*Sans III* and *Vinculum II*), during a period of disability from an undiagnosed brain tumor. During the course of the exhibition her illness was diagnosed and she underwent surgery, and she died a year later in May 1970. Lucy Lippard, *Eva Hesse* (New York: New York University Press, 1976), pp. 135, 141, 148, 154, 216 n23.

24. For Beuys's plane crash, see Götz Adriani, Winfried Konnertz, and Karin Thomas, *Joseph Beuys: Life and Works* (Woodbury, NY: Barron's, 1979), p. 16. In an interview later in the year, Beuys said that his Bern pieces were of a kind that he had been doing for a long time, and whose value he now questioned. Willowby Sharp, "An Interview with Joseph Beuys," *Artforum*, December 1969, p. 46.

25. For information on the German involvement with American art, see Phyllis Tuchman, "American Art in Germany: The History of a Phenomenon," *Artforum*, November 1970, pp. 58–69.

26. Interview with Gary Kuehn, March 31, 1992.

27. Letter from Harald Szeemann, May 11, 1992. For Charles Harrison's

new catalogue introduction for the ICA showing, see his "Against Precedents," *Studio International*, September 1969, pp. 90–93.

28. A photograph of the stripes across from the Kunsthalle appears in Klüser and Hegewisch, pp. 212–213. I learned of Buren's covering draft posters from Lawrence Weiner, interviewed March 24, 1992. For the terms and phrases quoted in this paragraph, see Buren's long manifesto, "Beware!" in *Art International*, March 1970, pp. 100–104.

29. The point is amplified in a recent company publication marking its decision to identify with contemporary art as "a bold act but one that paid off handsomely." *Philip Morris and the Arts: A 30-Year Celebration* (New York: Philip Morris Companies, 1990), p. 6. See pp. 28–49 for an account of the corporation's exhibition program.

30. Interviews with Joseph Kosuth, October 8, 1991, and with Lawrence Wiener, March 24, 1992. On the meeting of the Art Workers' Coalition, see Lucy Lippard, "The Art Workers' Coalition," in Battcock, p. 103.

31. Lippard, *Six Years*, p. 263.

32. Seth Siegelaub, "Artists' Reserved Rights Transfer and Sale Agreement," *Studio International*, April 1971, pp. 142–144, 186–188.

33. The exhibition was held June 21–September 21, 1986. For a complete account, see Jan Hoet, *Chambres d'Amis* (Ghent: Museum van Hedendaagse Kunst, 1986). The show included ten artists who were seen in Bern in 1969: Buren, Fabro, Kosuth, Kounellis, LeWitt, Merz, Nauman, Panamarenko, Ruthenbeck, and Zorio. On the basis of *Chambres d'Amis* Jan Hoet was made head of Documenta IX (1992), as Szeemann twenty years earlier was given Documenta V (1972) following the achievement of When Attitudes Become Form.

Afterword

1. Claes Oldenburg and Emmett Williams, Store Days (New York: Something Else Press, 1967), p. 8.

Bibliography

CHAPTER 1

Barr, Jr., Alfred H. *Matisse: His Art and His Public*. New York: Museum of Modern Art, 1951.

Burgess, Gelett. "The Wild Men of Paris." *Architectural Record*, May 1910.

Crespelle, Jean-Paul. *The Fauves*. London: Oldbourne Press, 1962.

Dunlop, Ian. *The Shock of the New: Seven Historic Exhibitions of Modern Art*. London: Weidenfield and Nicolson, 1972.

Duthuit, Georges. *The Fauvist Painters*. New York: Wittenborn, Schultz, 1950.

Elderfield, John. *The "Wild Beasts": Fauvism and Its Affinities*. New York: Museum of Modern Art, 1976.

Freeman, Judi. *The Fauve Landscape*. Los Angeles: Los Angeles County Museum of Art, 1990.

Giry, Marcel. "Le Salon d'Automne de 1905." *L'Information d'Histoire de L'Art*, January–February 1968.

Giry, Marcel. "Le Salon des Independants de 1905." *L'Information d'Histoire de L'Art*, May–June 1970.

Gordon, Donald E. *Modern Art Exhibitions 1900–1916*. Vols. I and II. Munich: Prestel-Verlag, 1974.

Leymarie, Jean. *Fauves and Fauvism*. New York: Rizzoli, 1987.

Oppler, Ellen Charlotte. *Fauvism Reexamined*. Ann Arbor: University Microfilms, 1972.

CHAPTER 2

Breunig, LeRoy C., ed. *Apollinaire on Art: Essays and Reviews 1902–1918*. New York: Viking, 1972.

Camfield, William A. *"La Section d'Or"*. M.A. Thesis, Yale University, 1961.

Chipp, Herschel B., ed. *Theories of Modern Art*. Berkeley and Los Angeles: University of California Press, 1968.

Daix, Pierre. *Cubists and Cubism*. New York: Rizzoli, 1982.

Fry, Edward F. *Cubism*. New York: McGraw-Hill, 1966.

Leonard Hutton Galleries. *Albert Gleizes and the Section d'Or*. New York, 1964.

Gamwell, Lynn. *Cubist Criticism*. Ann Arbor: UMI, 1980.

Golding, John. *Cubism: A History and an Analysis, 1907–1914*. 3rd Edition. Cambridge, Mass.: Harvard University Press, 1988.

Gordon, Donald E. *Modern Art Exhibitions 1900–1916*. Vols. I and II. Munich: Prestel-Verlag, 1974.

Henderson, Linda Dalrymple. *The Fourth Dimension and Non-Euclidean Geometry in Modern Art*. Princeton: Princeton University Press, 1983.

Johnson, R. Stanley. *Cubism & La Section d'Or, Works on Paper 1907–1922*. Chicago: R.S. Johnson Fine Art, 1989.

Moser, Joann, ed. *Jean Metzinger in Retrospect*. Iowa City: University of Iowa Museum of Art, 1985.

Robbins, Daniel. *The Formation and Maturity of Albert Gleizes: A Biographical and Critical Study, 1881 through 1920*. Ann Arbor: University Microfilms, 1974.

Spate, Virginia. *Orphism: The Evolution of Non-Figurative Painting in Paris, 1910–1914*. Oxford: Clarendon Press, 1979.

West, Richard V. *Painters of the Section d'Or*. Buffalo: Albright-Knox Art Gallery, 1967.

CHAPTER 3

Gordon, Donald E. *Modern Art Exhibitions 1900–1916*. Vols. I and II. Munich: Prestel-Verlag, 1974.

Hahl-Koch, Jelena, ed. *Arnold Schoenberg, Wassily Kandinsky: Letters, Pictures and Documents*. London: Faber and Faber, 1984.

Jacob, Mary Jane. *Naive and Outsider Art from Germany and Paintings by Gabriele Munter*. Chicago: Museum of Contemporary Art, 1983.

Kandinsky, Wassily. *Concerning the Spiritual in Art*. New York: Dover, 1977.

Kandinsky, Wassily, and Marc, Franz, eds. *The Blaue Reiter Almanac*. New Documentary Edition by Klaus Lankheit. New York: Da Capo Press, 1974.

Lindsay, Kenneth. "The Genesis and Meaning of the Cover Design for the First *Blaue Reiter* Exhibition Catalog." *Art Bulletin*, March 1953.

Luttichau, Mario-Andreas. "Der Blaue Reiter." In *Stationen der Moderne*. Berlin: Berlinische Galerie, 1988.

McCullag, Janice. "Disappearances, Appearances: The First Exhibition of the 'Blaue Reiter'." *Arts*, September 1987.

Roethal, Hans K. *The Blue Rider*. New York: Praeger, 1971.

Selz, Peter. *German Expressionist Painting*. Berkeley: University of California Press, 1957.

Solomon R. Guggenheim Foundation. *Kandinsky in Munich: 1896–1914*. New York: The Solomon R. Guggenheim Foundation, 1982.

Zweite, Armin. *The Blue Rider in the Lenbachhaus, Munich*. Munich: Prestel-Verlag, 1989.

CHAPTER 4

Art in America. 50th Anniversary Issue. February 1963.

Brown, Milton W. *The Story of the Armory Show*. New York: Abbeville Press and the Joseph H. Hirshhorn Foundation, 1988.

Camera Work. Special Number. June 1913.

Dunlop, Ian. *The Shock of the New: Seven Historic Exhibitions of Modern Art*. London: Weidenfield and Nicolson, 1972.

Gordon, Donald E. *Modern Art Exhibitions 1900–1916*. Vols. I and II. Munich: Prestel-Verlag, 1974.

Green, Martin. *New York 1913, The Armory Show and the Paterson Strike Pageant*. New York: Charles Scribner's Sons, 1988.

Homer, William Innes, ed. *Avant-Garde Painting and Sculpture in America 1910–1925*. Wilmington: Delaware Art Museum, 1975.

Karpel, Bernard, ed. *The Armory Show: International Exhibition of Modern Art, 1913*. 3 vols. New York: Arno, 1972.

1913 Armory Show, 50th Anniversary Exhibition 1963. New York and Utica: Henry Street Settlement and the Munson-Williams-Proctor Institute, 1963.

Schwartz, Constance H. *The Shock of Modernism in America, The Eight and Artists of the Armory Show*. Roslyn Harbor, NY: Nassau County Museum of Fine Art, 1984.

Watson, Steven. *Strange Bedfellows: The First American Avant-Garde*. New York: Abbeville, 1991.

Zilczer, Judith K. "The Armory Show and the American Avant-Garde: A Reevaluation." *Arts*, September 1978.

CHAPTER 5

Andersen, Troels. *Malevich*. Amsterdam: Stedelijk Museum, 1970.

Andersen, Troels. *Vladimir Tatlin*. Stockholm: Moderna Museet, 1968.

Berninger, Herman and Cartier, Jean-Albert. *Jean Pugny 1892–1956*. Vol I. Tubingen: Ernst Wasmuth, 1972.

Barron, Stephanie and Tuchman, Maurice, eds. *The Avant-Garde in Russia, 1910–1930: New Perspectives*. Los Angeles: Los Angeles County Museum of Art, 1980.

Bowlt, John E., ed. *Russian Art of the Avant-Garde, Theory and Criticism, 1902–1934*. New York: Thames and Hudson, 1988.

Bowlt, John E. *Russian Art 1875–1975: A Collection of Essays*. New York: MSS Information Corp., 1976.

Compton, Susan P. "Malevich's Suprematism: The Higher Intuition." *The Burlington Magazine*, August 1976.

Compton, Susan P. *The World Backwards, Russian Futurist Books 1912–16*. London: The British Library, 1978.

Douglas, Charlotte. *Swans of Other Worlds: Kasimir Malevich and the Origins of Abstraction in Russia*. Ann Arbor: UMI, 1980.

Gordon, Donald E. *Modern Art Exhibitions 1900–1916*. Vols. I and II. Munich: Prestel-Verlag, 1974.

Gray, Camilla. *The Russian Experiment in Art, 1863–1922*. New York: Thames and Hudson, 1986.

Livshits, Benedikt. *The One and a Half-Eyed Archer*. Translated by John E. Bowlt. Newtonville, Mass.: Oriental Research Partners, 1977.

Malevich, K.S. *Essays on Art, 1915–1928*. Vol I. Copenhagen: Borgen, 1968.

Milner, John. *Vladimir Tatlin and the Russian Avant-Garde*. New Haven: Yale University Press, 1983.

Rowell, Margit. "Vladimir Tatlin: Form/Faktura." *October*, Winter 1978.

Rudenstine, Angelica Zander, ed. *The George Costakis Collection: Russian Avant-Garde Art*. New York: Harry N. Abrams, 1981.

Sarabianov, Dmitri V. and Adaskina, Natalia L. *Popova*. New York: Harry N. Abrams, 1990.

Simmons, W. Sherwin. "Kasimir Malevich's Black Square: The Transformed Self." Parts I, II, and III. *Arts*, October, November, and December, 1978.

Smolik, Noemi. "Letzte futuristische Austellung, 0,10, Petrograd 1915," In Bernd Klüser and Katharina Hegewisch, eds. *Die Kunst der Austellung*. Frankfurt am Main: Insel Verlag, 1991.

Williams, Robert C. *Artists in Revolution, Portraits of the Russian Avant-Garde, 1905–1925*. Bloomington: University of Indiana Press, 1977.

Zhadova, Larissa A. *Malevich, Suprematism and Revolution in Russian Art 1910–1930*. London: Thames and Hudson, 1982.

Zhadova, Larissa A., ed., *Tatlin*. New York: Rizzoli, 1988.

CHAPTER 6

Ades, Dawn. *Dada and Surrealism Reviewed*. London: Arts Council of Great Britain, 1978.

Ades, Dawn. *Photomontage*. London: Thames and Hudson, 1980.

Adkins, Helen. "Ernste Internationale Dada-Messe." In *Stationen Der Moderne*. Berlin: Berlinisches Galerie, 1988.

Adkins, Helen. "Ernste Internationale Dada-Messe, Berlin 1920." In Bernd Klüser and Katharina Hegewisch, eds. *Die Kunst der Austellung*. Frankfurt am Main: Insel Verlag, 1991.

Allen, Roy F. *Literary Life in German Expressionism and the Berlin Circles*. Ann Arbor: UMI, 1983.

Benson, Timothy O. *Raoul Hausmann and Berlin Dada*. Ann Arbor: UMI, 1987.

Dachy, Marc. *The Dada Movement, 1915–1923*. New York: Rizzoli, 1990.

Doctorow, Erica. *Dada—in Berlin*. Garden City, NY: Adelphi University, 1978.

Elderfield, John. "Raoul Hausmann, four notes," and Hausmann, Raoul. "Dada riots moves and dies in Berlin." *Studio International*, April 1971.

Gordon, Mel, ed. *Dada Performance*. New York: PAJ Publications, 1987.

Huelsenbeck, Richard. *Memoirs of a Dada Drummer*. New York: Viking, 1974.

Institute of Contemporary Art, Boston. *Dada: Berlin, Cologne, Hannover*. Boston: Institute of Contemporary Art, 1983.

Lavin, Maud. "Heartfield in Context." *Art in America*, February 1985.

Lippard, Lucy R., ed. *Dadas on Art*. Englewood Cliffs, NJ: Prentice-Hall, 1971.

Motherwell, Robert, ed., *The Dada Painters and Poets: An Anthology*. Cambridge, MA: Harvard University Press, 1989.

Richter, Hans. *Dada: Art and Anti-Art*. New York: McGraw Hill.

Rubin, William S. *Dada and Surrealist Art*. New York: Abrams, 1969.

Rubin, William S. *Dada, Surrealism, and Their Heritage*. New York: Museum of Modern Art, 1968.

University of Iowa Art Museum. *Dada Artifacts*. Iowa City: University of Iowa Art Museum, 1978.

Verkauf, Willy, ed., *Dada: Monograph of a Movement*. New York: George Wittenborn, 1957.

CHAPTER 7

Ades, Dawn. *Dada and Surrealism Reviewed*. London: Arts Council of Great Britain, 1978.

Alexandrian, Sarane. *Surrealist Art*. New York: Praeger, 1970.

Breton, André. *Manifestoes of Surrealism*. Ann Arbor: University of Michigan Press, 1969.

Dictionnaire Abrégé du Surréalisme. Paris: Galerie Beaux-Arts, 1938.

Dunlop, Ian. *The Shock of the New: Seven Historic Exhibitions of Modern Art*. London: Weidenfield and Nicolson, 1972.

Finkelstein, Haim N. *Surrealism and the Crisis of the Object*. Ann Arbor: UMI, 1979.

Jean, Marcel, ed. *The Autobiography of Surrealism*. New York: Viking, 1980.

Jean, Marcel. *The History of Surrealist Painting*. New York: Grove, 1960.

Lippard, Lucy R., ed. *Surrealists on Art*. Englewood Cliffs, NJ: Prentice-Hall, 1970.

Martin, Richard. *Fashion and Surrealism*. New York: Rizzoli, 1987.

Nadeau, Maurice. *The History of Surrealism*. Cambridge, Mass.: Harvard University Press, 1989.

Picon, Gaëtan. *Surrealists and Surrealism, 1919–1939*. New York: Rizzoli, 1983.

Ray, Man. *Self Portrait*. New York: McGraw Hill, 1979.

Rubin, William S. *Dada, Surrealism, and Their Heritage*. New York: Museum of Modern Art, 1968.

Rubin, William S. *Dada and Surrealist Art*. New York: Harry N. Abrams.

Schneede, Uwe M. "Exposition Internationale du Surréalisme, Paris, 1938." In Bernd Klüser and Katharina Hegewisch, eds. *Die Kunst der Austellung*. Frankfurt am Main: Insel Verlag, 1991.

Sevareid, Eric. "Police Get Taste of Surrealism as Crowd Fights to See Show." *New York Herald Tribune* (Paris), January 18, 1938, pp. 1, 3.

"Surrealist Furniture Draws Paris Crowd." *Life*, February 7, 1938.

Wilson, Bettina. "Surrealism in Paris," *Vogue*, March 1, 1938.

CHAPTER 8

Barron, Stephanie, ed., *"Degenerate Art": The Fate of the Avant-Garde in Nazi Germany*. Los Angeles: Los Angeles County Museum of Art, 1991.

Blesh, Rudi. *Modern Art U.S.A.: Men, Rebellion, Conquest, 1900–1956*. New York: Alfred A. Knopf, 1956.

Bussmann, Georg. "'Degenerate Art'—A Look at a Useful Myth." In Christos M. Joachimides, Norman Rosenthal, and Wieland Schmied, eds. *German Art in the 20th Century, Painting and Sculpture 1905–1985*. Munich: Prestel-Verlag and London: Royal Academy of Arts, 1985.

Coates, Robert. "The Art Galleries, Sixteen Miles of String." *New Yorker*, October 31, 1942, p.72.

Dunlop, Ian. *The Shock of the New: Seven Historic Exhibitions of Modern Art*. London: Weidenfield and Nicolson, 1972.

First Papers of Surrealism. New York: Coordinating Council of French Relief Agencies, 1942.

Grosshaus, Henry. *Hitler and the Artists*. London: Holms and Meier, 1983.

Guide Through the Exhibition of Degenerate Art. Translated by William T. Bunce. Redding, Conn.: Silver Fox Press, 1972.

Guggenheim, Peggy. *Out of this Century: Confessions of an Art Addict*. London: André Deutsch, 1979.

Hinz, Berthold. *Art in the Third Reich*. New York: Pantheon, 1979.

Jean, Marcel. *The History of Surrealist Painting*. New York: Grove, 1960.

Lader, Melvin P. and Fred Light. *Peggy Guggenheim's Other Legacy*. New York and Venice: Solomon R. Guggenheim Museum and Peggy Guggenheim Collection, 1987.

Lüttichau, Mario-Andreas. "Entartete Kunst." In *Stationen der Moderne*. Berlin: Berlinische Galerie, 1988.

Messer, Thomas M. "Peggy Guggenheim 'Art of This Century'—New York, 57th Street, 20 Oktober 1942 bis Mai 1947." In Bernd Klüser and Katharina Hegewisch, eds. *Die Kunst der Ausstellung*. Frankfurt am Main: Insel Verlag, 1991.

Phillips, Lisa, ed. *Frederick Kiesler*. New York: Whitney Museum of American Art, 1989.

Schuster, Peter-Klaus, ed. *Nationalsozialismus und "Entarte Kunst." Die "Kunststadt" München 1937*. Munich, 1987.

Weld, Jacqueline Bograd. *Peggy, The Wayward Guggenheim*. New York: E.P. Dutton, 1986.

CHAPTER 9

Alcopley, L. "The Club." *Issue, A Journal for Artists* 4. 1985.

Bard, Joelle. *Tenth Street Days: The Co-ops of the 50's*. New York: Education, Art and Service, 1977.

Blesh, Rudi. *Modern Art U.S.A.: Men, Rebellion, Conquest, 1900–1956*. New York: Alfred A. Knopf, 1956.

Greenfield-Sanders, Timothy. With an essay by Robert Pincus-Witten. *The Ninth Street Show*. Toronto: Lumiere Press, 1987.

Hess, Thomas B. "New York's avant-garde." *Art News*, Summer 1951.

Hindry, Ann, ed. *Claude Berri rencontre/meets Leo Castelli*. Paris: Renn, 1990.

Karpel, Bernard; Motherwell, Robert; and Reinhardt, Ad, eds. *Modern Artists in America*. First Series. New York: Wittenborn Schultz, 1951.

Kozloff, Max. "An Interview with Freidel Dzubas." *Artforum*, September 1965.

Krasne, Belle. "Ninth Street Event." *Art Digest*, June 1, 1951.

New York Times. May 23, 1951, p.33.

Rosenberg, Harold. "The American Action Painters." *Art News*, December 1952.

Sandler, Irving. "The Club." *Artforum*, September 1965.

Sandler, Irving. *The New York School: Painters and Sculptors of the Fifties*. New York: Harper & Row, 1978.

Sandler, Irving. *The Triumph of American Painting*. New York and Washington: Praeger, 1970.

CHAPTER 10

Action et Emotion, Peintures des Années 50: Informel, Gutai, Cobra. Osaka: Musée National d'Art, 1985.

Bertozzi, Barbara. "Gutai: The Happening People." *Flash Art*, May/June 1991.

Bertozzi, Barbara and Wolbert, Klaus. *Gutai: Japanische Avantgarde/Japanese Avant-Garde, 1954–1965*. Darmstadt: Mathildenhohe Darmstadt, 1991.

Falk, Ray. "Japanese Innovators." *New York Times*, December 8, 1957, p.24x.

GUTAI. Numbers 1–14 (10 and 13 unpublished), 1955–1965.

Kaprow, Allan. *Assemblage, Environments and Happenings*. New York: Harry N. Abrams, 1966.

Love, Joseph. "The Group in Contemporary Japanese Art—Gutai and Jiro Yoshihara." *Art International*, Summer 1972.

1910 Japon des Avant Gardes 1970. Paris: Editions du Centre Pompidou, 1986.

Reconstructions: Avant-Garde Art in Japan, 1945–1965. Oxford: Museum of Modern Art, Oxford, 1985.

Roberts, James. "Painting as Performance." *Art in America*, May 1992.

CHAPTER 11

"A Symposium on Pop Art." *Arts Magazine*, April 1963.

Art International. January 25, 1963.

Ashton, Dore. "New York Report." *Das Kunstwerk*, November–December 1962.

Haskell, Barbara. *Blam! The Explosion of Pop, Minimalism, and Performance 1958–1964*. New York: Whitney Museum of American Art, 1984.

Hess, Thomas B. "New Realists." *ArtNews*, December 1962.

Institute for the Arts, Rice University. *Yves Klein 1928–1962: A Retrospective*. Houston: Institute for the Arts, Rice University, 1982.

Sidney Janis Gallery. *New Realists*. New York: Sidney Janis Gallery, 1962.

Kramer, Hilton. "Art." *The Nation*, November 17, 1962.

Lippard, Lucy, ed. *Pop Art*. New York and Washington: Praeger, 1966.

Martin, Henry. *Arman, or Four and Twenty Blackbirds Baked in a Pie, or Why Settle for Less When You Can Settle for More*. New York: Harry N. Abrams, 1973.

Mahsun, Carol Anne, ed. *Pop Art: The Critical Dialogue*. Ann Arbor: UMI, 1989.

Musée d'Art Moderne de la Ville de Paris. *1960: Les Nouveaux Réalistes*. Paris: Musée d'Art Moderne de la Ville de Paris, 1986.

O'Doherty, Brian. "Avant-Garde Revolt: 'New Realists' Mock U.S. Mass Culture in Exhibition at Sidney Janis." *New York Times*, October 31, 1962, p.41.

O'Doherty, Brian. "'Pop' Goes the New Art." *New York Times*, November 4, 1962, section 2, p.23.

Oldenburg, Claes. *Store Days*. New York: Something Else Press, 1968.

Restany, Pierre. "Modern Nature." In *Breakthroughs: Avant-Garde Artists in Europe and America, 1950–1990*. New York: Rizzoli, 1991.

Restany, Pierre. "The New Realism." *Art in America*, February 1963.

Restany, Pierre. *Yves Klein*. New York: Harry N. Abrams, 1982.

Restany, Pierre. "Yves Klein 'Le Vide'—Die Leere von Yves Klein—Paris, den 28 April 1958." In Bernd Klüser and Katharina Hegewisch, eds. *Die Kunst der Ausstellung*. Frankfurt am Main: Insel Verlag, 1991.

Rosenberg, Harold. "The Art Galleries: The Game of Illusion." *New Yorker*, November 24, 1962.

Sandler, Irving. "In the Galleries." *New York Post*, November 18, 1962, magazine p.12.

Seitz, William C. *Art in the Age of Aquarius: 1955–1970*. Washington, D.C.: Smithsonian Institution, 1992.

Tillim, Sidney. "Month in Review: The New Realists." *Arts Magazine*, December 1962.

Van der Marck, Jan. *Arman*. New York: Abbeville, 1984.

CHAPTER 12

Ashton, Dore. "The 'Anti-Compositional Attitude' in Sculpture." *Studio International*, July 1966.

Baker, Kenneth. *Minimalism*. New York: Abbeville Press, 1988.

Battcock, Gregory, ed. *Minimal Art: A Critical Anthology*. New York: E.P. Dutton, 1968.

Bochner, Mel. "Primary Structures." *Arts Magazine*, June 1966.

"Engineer's Esthetic." *Time*, June 3, 1966.

Glueck, Grace. "Anti-Collector, Anti-Museum." *New York Times*, April 24, 1966, p.x24.

Haskell, Barbara. *Blam! The Explosion of Pop, Minimalism, and Performance 1958–1964*. New York: Whitney Museum of American Art, 1984.

Hudson, Andrew. "English Sculptors Outdo Americans." *Washington Post*, May 8, 1966, p.G7.

Judd, Donald. *Complete Writings 1959–1975*. Halifax: Press of the Nova Scotia College of Art and Design, 1975.

Kramer, Hilton. "'Primary Structures'—The New Anonymity." *New York Times*, May 1, 1966, p.D23.

Kramer, Hilton. "An Art of Boredom?" *New York Times*, June 5, 1966, p.D23.

Lippard, Lucy. "10 Structurists in 20 Paragraphs." In *Minimal Art*. Haags Gemeentemuseum, 1968.

McShine, Kynaston. *Primary Structures: Younger American and British Sculptors*. New York: Jewish Museum, 1966.

O'Connor, John. "Exploring Space." *Wall Street Journal*, June 6, 1966, p.18.

Robertson, Bryan. *The New Generation: 1965*. London: Whitechapel Gallery, 1965.

Robins, Corinne. "Object, Structure or Sculpture: Where Are We?" *Arts Magazine*, September–October, 1966.

Rose, Barbara. "Post-Cubist Sculpture." In Maurice Tuchman, ed., *American Sculpture of the Sixties*. Los Angeles: Los Angeles County Museum of Art, 1967.

Sandler, Irving. "Ronald Bladen: '. . . sensations of a different order . . .'." *Artforum*, October 1966.

Seitz, William C. *Art in the Age of Aquarius: 1955–1970*. Washington, D.C.: Smithsonian Institution, 1992.

Smithson, Robert. "Entropy and the New Monuments." *Artforum*, June 1966.

Tuchman, Phyllis. "Minimalism and Critical Response." *Artforum*, May 1977.

CHAPTER 13

Ammann, Jean-Christophe. "Schweizer Brief." *Art International*, May 20, 1969.

Battcock, Gregory, ed. *Idea Art: A Critical Anthology*. New York: E.P. Dutton, 1973.

Celant, Germano. *Art Povera*. New York: Praeger, 1969.

Harrison, Charles. "Against Precedents." *Studio International*, September 1969.

January 5–31, 1969. New York: Seth Siegelaub, 1969.

Leen, Frederik. "Seth Siegelaub." *Forum International*, September 1991.

LeWitt, Sol. "Paragraphs on Conceptual Art." *Artforum*, June 1967.

Lippard, Lucy R., ed. *Six Years: The dematerialization of the art object from 1966 to 1972*. New York and Washington: Praeger, 1972.

Lippard, Lucy R. and Chandler, John. "The Dematerialization of Art." *Art International*, February 20, 1968.

Meyer, Ursula, ed. *Conceptual Art*. New York: E.P. Dutton, 1971.

Morgan, Robert C. "The Situation of Conceptual Art: The 'January Show' and After." *Arts*, February 1989.

Müller, Grégoire. *The New Avant-Garde: Issues for the Art of the Seventies*. New York: Praeger, 1972.

Musée d'Art Moderne de la Ville de Paris. *L'Art Conceptuel, Une Perspective*. Paris: Musée d'Art Moderne de la Ville de Paris, 1989.

Pincus-Witten, Robert. *Post-Minimalism*. New York: Out of London Press, 1977.

Poinsot, Jean-Marc. "Harald Szeemann, 'Quand les attitudes deviennent forme' et quelques problèmes du musée d'art contemporain." In *Christian Boltanski, Daniel Buren, Gilbert & George, Jannis Kounellis, Sol LeWitt, Richard Long, Mario Merz*. Bordeaux: Musée d'art contemporain, 1990.

Rose, Arthur R. "Four Interviews with Barry, Huebler, Kosuth, Weiner." *Arts Magazine*, February 1969. Reprinted in *Arts*, February 1989.

Stedelijk Museum. *Op Losse Schroeven: Situaties en Cryptostructuren*. Amsterdam: Stedelijk Museum, 1969.

Szeemann, Harald. *When Attitudes Become Form: Works-Concepts-Processes-Situations-Information (Live in Your Head)*. Bern: Kunsthalle Bern, 1969.

Szeemann, Harald. "When Attitudes Become Form, Bern 1969." In Bernd Klüser and Katharina Hegewisch, eds. *Die Kunst der Ausstellung*. Frankfurt am Main: Insel Verlag, 1991.

Index

284

INDEX

Photograph Credits

The author and the publisher wish to thank the libraries, museums, galleries, and private collectors named in the picture captions for permitting the reproduction of works of art in their collections and for supplying the necessary photographs. Photographs from other sources are gratefully acknowledged below. Numbers indicate page numbers.

Archiv für Kunst und Geschichte, Berlin: 144 (all); Archives of American Art, Smithsonian Institution, Washington, D.C.: 62, 63, 66 (both), 67, 73; Art Resource/The Jewish Museum, New York: 222, 228 (both), 229, 233, 234; La Bibliothèque Nationale, Paris: 22, 29, 30; Bildarchiv Preussischer Kulturbesitz, Berlin: 101, 104; Leo Castelli Gallery, New York: 225; Iris Clert Gallery, Paris: 196; Alexina Duchamp, Puteaux: 31 (top); German Information Center, New York: 103; Klaus Hurrgiimalla, Berlin: 80, 81 (both), 84 (both), 86, 87, 90, 91, 94; Sidney Janis Gallery, New York: 216 (both), 217 (all); Frederick Kiesler, New York: 150; Life Picture Service, New York: 159, 165; Robert McElroy, New York: 213; Francis Naumann, New York: 72; Claes Oldenburg, New York: 208 (all); Sinichiro Osaki, Kobe: 175, 177, 178, 179, 181, 182, 183 (both), 184, 185, 187, 188; Erich Pollitzer, New York: 109 (top); R.M.N., Paris: 20, 26, 53, 85, 88, 198; Arturo Schwartz, Milan: 126 (all), 127 (all); Harry Shunk, New York: 199, 200 (both), 205 (both), 209, 246, 247, 248, 249 (both), 250, 251 (both); Seth Siegelaub, Amsterdam: 237, 239, 241, 242, 243, 244; Aaron Siskind, Pawtucket, R.I.: 168 (both), 169 (both); Stadtarchiv, Munich: 138; Städtische Galerie im Lenbachhaus, Munich: 44, 45 (both), 48, 50 (both), 51 (both); Arthur Swoger, Providence, R.I.: 162, 163 (both); Ullstein, Berlin: 141, 146; Roger Viollet, Paris: 13 (both), 27; Washburn Gallery, New York: 230; John Weber Gallery, New York: 226.